SO-BSZ-023

# The Art of
# Cézanne

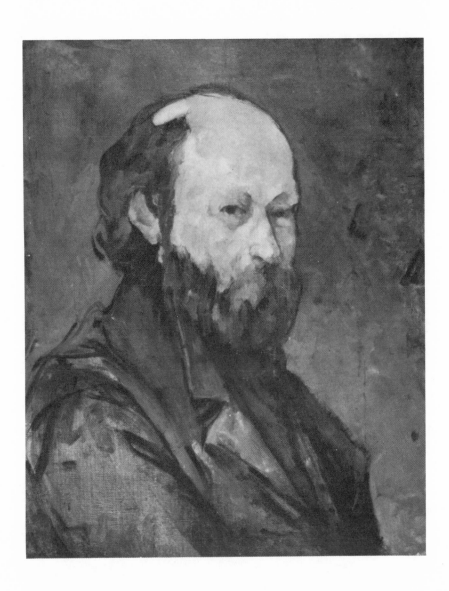

Self-portrait, about 1877 (V. 290), 21″ × 18″,
*Phillips Gallery, Washington, D.C.*

# The Art of Cézanne

*by*
Kurt Badt

*translated by*
Sheila Ann Ogilvie

Hacker Art Books
New York / 1985

Originally published in Germany as
DIE KUNST CEZANNES
© Prestel-Verlag, Munich 1956

First English translation
© Faber and Faber, London 1965

Reissued by
Hacker Art Books, Inc
New York, 1985

Library of Congress Catalogue Card Number 84- 82410

International Standard Book Number 0-87817-302-1

Printed in the United States of America

# CONTENTS

TRANSLATOR'S NOTE                                           *page* 15

BIOGRAPHICAL NOTES ON CÉZANNE                                       17

INTRODUCTION                                                        19

   *Notes*                                           36

I   CÉZANNE'S WATER-COLOUR TECHNIQUE                                37

   Shadow-paths and Contours                          49

   Blue                                               58

   Digression on the Subject of Distance              72

   *Notes*                                            83

II  THE CARDPLAYERS                                                 87

   Digression on the Subject of the Picture entitled

      *Mardi Gras*                      94

   *The Cardplayers* (continued)                      96

   The *Mardi Gras* Picture Again                    107

   Further problems of *The Cardplayers*             109

   *Notes*                                           128

III CÉZANNE'S SYMBOLISM AND THE HUMAN ELEMENT

   IN HIS ART                                        131

   Degrees of Loneliness                             132

   The 'Conversion'                                  143

   Cézanne's Portrayal of People                     181

   *Notes*                                           190

CONTENTS

IV  THE PROBLEM OF 'REALIZATION'                *page* 195

    *Notes*                                                226

V  CÉZANNE'S HISTORICAL POSITION AND SIGNIFI-

    CANCE                                                229

    Cézanne and Symbolism                                268

    Cézanne's Composition                                275

    Cézanne and Delacroix                                278

    Delacroix and Romanticism                            279

    Cézanne and Poussin                                  300

    The Style of Cézanne's Old Age                       311

    *Notes*                                              323

  INDEX OF PICTURES                                      335

  INDEX OF SUBJECTS                                      337

  INDEX OF NAMES                                         342

# ILLUSTRATIONS*

*Frontispiece* Self-portrait, about 1877 (*Phillips Gallery, Washington, D.C.*)

*Between pages 94 and 95*

1  La Montagne Sainte-Victoire, 1885–87 (*National Gallery, London*)
2  Trees agitated by the Wind, 1895–1900 (*Swiss private collection*)
3  Still-life, 1906 (*Collection of Paul Cézanne (son of the painter), Paris*)
4  In the Park of the Château Noir, 1900–1906 (*Collection of E. M. Remarque, Ascona*)
5  Page XXIII of a sketchbook (L'Écorché) (*The Art Institute of Chicago*)
6  Houses at L'Estaque, 1882–85 (*Collection of Marius de Zayas, New York*)
7  Scene in Hell (the 'Ugolino drawing') (*Collection of J. Leblond, Paris*)
8  The Cardplayers, 1890–92 (*Barnes Foundation, Merion, USA*)
9  The Cardplayers, 1890–92 (*Collection of Stephen C. Clark, New York*)
10  The Cardplayers, 1890–92 (*Collection of J. V. Pellerin, Paris*)
11  The Cardplayers, 1890–92 (*Courtauld Institute, London*)
12  The Cardplayers, 1890–92 (*Louvre, Paris*)
13  Man with Pipe, study for 'The Cardplayers', 1890–92 (*Marie Harriman Gallery, New York*)
14  Man Smoking, study for 'The Cardplayers', 1890–92 (*Boymans Museum, Rotterdam*)
15  Study for 'The Cardplayers' (*Formerly Matthiesen Ltd., London*)
16  Study for 'The Cardplayers', 1890–92 (*Museum of Art, School of Design, Providence, R.I., USA*)
17  French School: attributed to Louis Le Nain, 'The Cardplayers' (*Musée Granet, Aix-en-Provence*)

* The references given for paintings by Cézanne in the text and on the plates, e.g. V.290, etc., derive from the catalogue compiled by Lionello Venturi (*Cézanne, son art, son œuvre*, Paris, 1936).

# List of Illustrations

18 Man with his Arms Crossed, 1895–1900 (*Collection of Carleton Michell, Annapolis, Maryland, USA*)

19 Mardi Gras, 1888 (*Museum of Modern Western Art, Moscow*)

20 The Conversation, 1872–73 (*Collection of J. V. Pellerin, Paris*)

*Between pages* 174 *and* 175

21 The Temptation of Saint Antony ('La Tentation de Saint Antoine') (*Collection of J. V. Pellerin, Paris*)

22 Old Woman with a Rosary, 1900–1904 (*National Gallery, London*)

23 The Path, 1875–76 (*Durand-Ruel Collection, Paris*)

24 Landscape, 1879–82 (*Formerly Collection of Paul Signac, Paris*)

25 Reading aloud at Zola's, 1869–70 (*Collection of J. V. Pellerin, Paris*)

26 Portrait of Gustave Geffroy, 1895 (*Lecomte Collection, Paris*)

27 Bathers, 1879–82 (*Lecomte Collection, Paris*)

28 The Fishing Village of L'Estaque, about 1870 (*Collection of J. V. Pellerin, Paris*)

29 La Montagne Sainte-Victoire, 1898–1900 (*Collection of Miss Etta Cone, Museum of Art, Baltimore*)

*Between pages* 254 *and* 255

30 Landscape with Bridge, 1888–90 (*Museum of Modern Western Art, Moscow*)

31 Madame Cézanne, about 1877 (*Collection of Paul Rosenberg, Paris*)

32 Portrait of Ambroise Vollard, 1899 (*Musée de la Ville, Petit Palais, Paris*)

33 The Artist's Father, 1868–70 (*Lecomte Collection, Paris*)

34 Frenhofer showing his Work, 1873–77 (*Öffentliche Kunstsammlungen, Basle, print room*)

35 Landscape (L'Estaque) (*The Art Institute of Chicago*)

36 Portrait of the gardener Vallier, 1906 (*Collection of Leigh B. Block, Chicago*)

37 The Railway Cutting, 1867–70 (*Bayerische Staatsgemäldesammlungen, Munich*)

38 Pastorale, 1870 (*Collection of J. V. Pellerin, Paris*)

39 Camille Pissarro, L'Ermitage (Pontoise) (*Formerly Collection of A. Cassirer, Berlin*)

40 Cézanne, L'Ermitage (Pontoise), 1875–77 (*Museum of Modern Western Art, Moscow*)

## List of Illustrations

41  The Apotheosis of Delacroix, 1873–77 (*Collection of J. V. Pellerin, Paris*)

42  L'oncle Dominique, 1865–67 (*Collection of Adolph Levisohn, New York*)

43  Landscape at Pontoise (La côte du Galet) (*Collection of Carroll S. Tyson, Philadelphia*)

44  Landscape near L'Estaque, 1898–1900 (*Kunsthalle, Karlsruhe; Formerly Collection of Dr. Lewin, Guben*)

45  Bathers, 1900–1905 (*Formerly Collection of Alphonse Kann, St. Germain-en-Laye*)

# ACKNOWLEDGEMENTS

## (ILLUSTRATIONS)

Archives Photographiques, Paris: 14
The Art Institute of Chicago (USA): 5, 35
Museum of Art, Providence (USA): 16
Bayerische Staatsgemäldesammlungen, Munich: 37
J. E. Bulloz, Paris: 17, 32, 33
Durand-Ruel, Paris: 19, 23, 36, 39
Willy Gloor, Neuchâtel (Switzerland): 2
Home House Trustees, London: 11
J. Leblond, Paris: 7
Lecomte Collection, Paris: 26, 27, 33
Carleton Michell, Annapolis, Maryland (USA): 18
The Trustees, the National Gallery, London: 1, 22
Öffentliche Kunstsammlungen, Basle: 34
J. V. Pellerin, Paris: 28
Poplin, Villemomble (France): 3, 4, 15
J. H. Schaefer & Son, Baltimore (USA): frontispiece
Vizzavona, Paris (SPADEM): picture on jacket, 6, 8, 9, 10,
    12, 13, 20, 21, 24, 25, 26, 29, 30, 31, 38, 40, 41, 42, 43, 44

# TRANSLATOR'S NOTE

In the original German text of this book the author uses certain key-words which cannot easily be translated by English words in such a way as to convey the full significance which the author intends them to have. In order that the reader may understand precisely what the author has in mind—and this is essential in order to appreciate his analysis of Cézanne's art—the most important of these are briefly described below:

*Zusammenstehen* or *Zusammen-Stehen*. This is translated literally as 'standing together'. The particular importance of this expression is its indication that things *stand* and do not move.

*Zusammenbestehen* or *Zusammen-Bestehen*. This is translated literally as 'existing together'. Obviously the English term 'co-existence' cannot be used today because it has acquired political connotations.

*Sich-Erhalten*. This is translated as 'preserving itself or themselves' or 'being preserved'. The important thing about it is the idea of permanence and persistence and lastingness and eternity behind it.

*Zusammenhang*. This is translated by 'interrelationship' or 'relationship between . . .' or 'correlation'. It signifies a unity, indicating the relativeness of one object to another, a sort of interdependence of things, the way in which different objects in a picture are interwoven into a context.

*Umkehr*. This word is explained in Chapter III. It has been translated as 'conversion' but it means both more and less than this. It describes a turning point in Cézanne's life when he changed completely in his attitude to life, to art and to religion, changed his philosophy and manner of looking at the world, changed his style of painting and began to accept things against which he had formerly struggled, and returned to the Catholic church without undergoing what is commonly meant by 'conversion'.

# BIOGRAPHICAL NOTES ON CÉZANNE

## *Paul Cézanne*

Born on 19th January, 1839, in Aix-en-Provence.

During his schooldays was friendly with Zola.

Studied law in Aix 1859/61. Attended the École des Beaux-Arts, Aix, from 1858 to 1862.

1861, first stay in Paris. Studied at the Atelier Suisse.

Met Pissarro.

Returned to Aix and entered his father's bank.

1862, finally decided to become a painter.

Between 1862 and 1870 sometimes in Paris, sometimes in Aix.

1870/71, spent the war period painting in Aix and L'Estaque.

1872, birth of his son Paul. In autumn went to join Pissarro at Pontoise.

1872/74, in Auvers-sur-Oise, near Pissarro.

April 1874, the first impressionist exhibition, with three pictures by Cézanne.

1875, mostly in Paris.

1876, almost exclusively in Aix and L'Estaque.

1877, sixteen pictures by Cézanne in the second impressionist exhibition.

Cézanne in Paris and environs.

He spent the following years moving between Aix, Paris, Mélun, Pontoise, or in Médan with Zola; in 1885 he visited Renoir in La Roche-Guyon, and at the end of the year he painted in Gardanne (near Aix) where he also spent a part of 1886. While there he received Zola's *L'Œuvre* and wrote the last extant letter to his friend.

In the same year (1886) he married Hortense Fiquet in Aix.

At the end of the year his father died and left him a large fortune.

1887 to 1889, partly in Aix, partly in Paris and environs.

1890, the Cézanne family spent some time in Switzerland.

About this time the first exhibition of Cézanne's pictures in a foreign country took place (Brussels, 'Les XX').

Living in retirement in Aix, Cézanne travelled north a few more times to do some painting there.

1895, the first large Cézanne exhibition took place in Vollard's establishment in Paris (150 pictures).

1896, journey to Talloires on the Lac d'Annécy.

1897/98, spent almost the whole time in Aix.

1899, after the death of Cézanne's mother, the Jas de Bouffan, the family's country house where since 1859 Cézanne had lived when in Aix, was sold. Cézanne moved into the town and in 1902 had a studio built north of the town.

1906 (22nd October), death of Cézanne.

# Introduction

*'Je désirerais contribuer à apprendre
à mieux lire dans les beaux ouvrages'*
(Eugène Delacroix)

This book is an enquiry into the nature of Cézanne's art, and the fundamental question which it seeks to answer is (to borrow a form of words from Nietzsche): 'How deeply does Cézanne's art penetrate into the core of the world?'

This question makes a tacit assumption: that artists are beings who possess great intellectual power, have wide vision and are more knowledgeable than people credit them with being. Their vision and their gifts are frequently utilized, yet only half-heartedly. In those rare epochs when complete confidence is placed in them, they are able to show what they really are: at all other periods of time they are but vague shadows and now, in our own era, they are scarcely real at all.

To enquire into the nature of art—whether it is art as a whole or the art of one particular master—one must adopt a procedure of encirclement. One cannot start with a study of the artist, or of his technical proficiency, or of his works, and then follow a straight line of argument in the course of which all the relevant problems are elucidated one after another—and through one another. With this in mind I have not designed this book as a continuous series of ideas following on one another, but in circular form: in each of the five chapters I have set out from a different point on the circumference of a circle, seeking to find a path to the centre.

In view of the fact that such an enormous, indeed almost incalculable, amount has already been written about Cézanne, the appearance of any new book on him does require a word of justification. The ultimate justification of this particular one can of course come only from its conclusions. Yet it does have a second *raison d'être*, namely the reason for which the author wrote it. It was conceived, and, in the view of the author, had to be written, because in all the existing literature about Cézanne so many important

19

questions remained unanswered—indeed unasked—and because so much in his art had been rendered unintelligible by being wrapped up in verbiage, vague terms and paradoxes. Here are a few examples of the kind of thing I mean: 'Cézanne, the genius without talent'; 'the genius as Philistine'; 'a great but often bad painter'; 'the painter who started to paint like a blind man'; 'a rhetorician and a Roman'; 'a Chardin in decline'; 'an artist with diseased eyes who discovered the beginnings of a new art in his own embittered visual sensations'. Or: 'a conscientious painter without skill, completely absorbed in reproducing what he sees'; 'thanks to his careful and obstinate attention to detail he frequently succeeds in finding beauty'; 'he reminds one more of an old Gothic craftsman than a modern artist.' Then again: 'Cézanne, who effects a synthesis of Gothic intention and Doric art, in whose work we find the prototype of the entire architecture of the twentieth century. What style corresponds to that of the skyscraper if not his?' Or: 'Fundamentally Cézanne is only a character in a novel, and the only thing which differentiates him from one of Mauriac's characters is his flight into his innermost self, a flight which led him into the domain of pure art and the enigmatical realms of ingenuity'.

That is a selection of phrases which have caught my eye in the course of reading books on Cézanne. I refrain from naming the authors of all these strange statements—there is not a single insignificant name among them.

But let me ask the following questions: when an artist is the subject of such contradictory descriptions, can we say that he is known, explained and understood? Can we be content to accept such a state of affairs in the spheres of research and art criticism? Is not this situation a source of irritation?

*Facit indignatio versum.* The stimulus which gave birth to this book was just that—indignation at such clichés and abstruse utterances.

Yet is it perhaps possible that we ought to regard Cézanne simply as a paradox, a phenomenon not susceptible to any kind of reasoning or any rational understanding? Is his work incomprehensible and inherently contradictory when regarded as a whole, significant though each small fragment may be? Is it perhaps as great as it is just because it says everything that can be said about the conflict between art and an era hostile to art? Such a theory is admissible; but if this were really the case, the paradoxicality and obscurity of his art would be on an entirely different level from that suggested by the judgements quoted.

## Introduction

At all events it seemed to me that some fresh thinking on Cézanne was essential—not for the purpose of discovering new facts but in order to delve more deeply into material already well known, with a view to discovering the origins of a great artistic phenomenon; and to do this would mean the investigation of one of the fundamental aspects of art itself.

Maurice Denis said that Cézanne was 'a difficult artist, in particular for those who love him best', and this still holds good. Moreover, however valuable the existing serious literature about Cézanne may be, he himself seems to become an increasingly obscure figure, either because of the contradictions contained within these very writings or because of the contrast between what is said in them and the impression made by his pictures themselves. The majority of the legends which have grown up around the person of Cézanne have indeed been explained in those writings; we know the course of his life fairly precisely, and what sort of a man he was; yet little is known of the content and meaning of his art. Interpretations of the inner motives which caused him to paint as he did are still very unsatisfactory, and the significance of his aims—which every artist reveals in the works he creates—is still largely obscure. The origins of his painting are not clear. There has been no answer to the challenge to understand his aims as a whole in such a way that each of his works can be seen as a stage in his endeavour to achieve these aims.

It must, however, be said that a deeper meaning positively forces itself on us with Cézanne's paintings, and this is particularly noticeable when one compares his art with that of his contemporaries. By comparison with the works of Manet, Monet, Renoir, Gauguin and Van Gogh, and even Seurat and Cross, his works give one the impression—if only by their expression of the dignity of all that exists and of existence itself—that they contain an inner significance. This significance, rather than the objects themselves, seems to determine the external appearance of the objects depicted in his pictures. Indeed, it alone seems to have inspired him to paint them—the objects themselves could not have done so. One feels too that it is not simply a question of individual, brilliant new views of the real world, but of far-reaching assertions of an objective nature which reveal something 'essential'. Today,* almost fifty years after the death of Cézanne, one senses that this painter achieved more than a revolution in the construction of pictures and a new

* This was written in 1955.

revelation of the artist's relationship to the real world: one feels that his art (like that of all really great masters) contains an interpretation of the world, and that the note he sounds with such deep earnestness in his works is the most all-embracing theme in art. If we compare Cézanne with the other painters mentioned —even Renoir who occupies a special position—we see in his works the emergence of a style, in the fullest sense of the word: not merely some idiosyncrasy or wilfulness in forms, but an attitude which by its severity and gravity expresses something *enduring* and *permanently existing*. In Cézanne we perceive what Goethe called 'the science of architecture in the highest sense, the working force which creates, forms, constitutes'.

This book seeks to reveal to the reader the entire scope, individuality and significance of Cézanne's art. To achieve this we shall consider his art from different angles—first we shall consider its *technique* (in the creative, not the mechanical sense of the word), then its *inspiration* (the psychological origins), its *spiritual content* and its *'realization'* (Cézanne's problem of *'réalisation'*), and finally we shall demonstrate its *position in the history of the evolution of painting in Europe.*

Cézanne's *technique*—his handling of colour, line and perspective— has been the subject of much research and has even been described as the most important thing about his art—as though Cézanne had made it his business to investigate the relationship between form and colour, or, perhaps, to discover the closest possible link between representation of depth and the most stable disposition of forms possible in the surface of a picture. Such problems did indeed interest Cézanne in so far as they affected his methods of creation; but to set them up as ultimate aims is to misapprehend the nature of art itself in his works. This is what happened when for example William Gaunt wrote[1]: 'Cézanne . . . styled himself the primitive of a new school, and gave up a lifetime to the scrupulous notation of the effect of colour on form, irrespective of what form it might be'; or when R. H. Wilenski said[2]: 'Cézanne was . . . concerned . . . to record his personal experience of related forms and colours'.

Against this we must stress that the aims of a work of art (in so far as it represents anything) are inseparably connected with the things represented in it, and above all with the *interrelationships* between them. Every 'how' in a work of art receives its meaning from the 'what' of the interrelationships as a whole through which alone it emerges at all. When an artist illuminates or obscures, weakens or

intensifies outlines, and when he favours particular colours or perspectives, he always does so because of the relationships between objects through which his art acquires its significance. The whole point of art is the statement of these relationships.

Moreover, it is his insight into such relationships, and this alone, that provides the artist with a starting point for his research and studies.

Such a statement of relationships is itself in turn subject to certain conditions. If it does not successfully represent life or the meaning of life in some world which goes beyond our normal experience of objects, then, regardless of the accuracy of the results obtained by 'research', it remains meaningless. What is more, if these results lie in a sphere in which accuracy (i.e. conformity which is easily obtainable by other means) is important, then any such statement by an artist is without meaning or value and exposes the artist as someone who has no right to the name. For it is not accuracy but truth that matters.

But what really matters in art? In other words what is that *something* which makes use of technique as a means to an end?

In books of art criticism and art history one frequently comes across a sentence saying that the artist had no intention of slavishly imitating nature. It is generally accepted that it is both impossible and superfluous to attempt to do any such thing. The artist's purpose is, on the contrary, to preserve the true appearance of things, i.e. to interpret, expound and explain the real world as he sees it. This is usually regarded as a subjective performance, giving expression to nothing more than the artist's personal attitude and his personality. Many people believe that the whole meaning and purpose of a work of art should simply be to enable them to become familiar with the artist's personality.

Others, again, see the rôle of the creative artist in a work of art as that of elucidating what he portrays; they maintain that the artist's concern is 'to illustrate the impression made on the eye when it takes in at one glance the numerous lines and colours which are offered to it' (Gautier), or 'to clarify, give precision to, and bring to the notice of the conscious mind the picture of the real world that lies vague, unclear and buried in the unconscious' (Conrad Fiedler).

It is not at all clear how any such purely subjective performance is supposed to arrive at the truth: that is to say, how by portraying one's own ego, or by elucidating impressions and the elements which compose them, one can make truth manifest. In the former case all that one can possibly achieve is to speak out honestly, i.e. tell the

23

truth about oneself; in the latter, one can do no more than record clearly and accurately in one's conscious mind the appearance of things seen, without being able to prove anything about the truth of what one has apprehended.

Obviously the 'preservation of the true appearance of things' means something quite different. It has nothing to do with the appearance of this or that thing as presented to and perceived by the eye—neither the artist creating the picture nor such visual details as colour and line—but everything to do with the real world as a whole, and with these things in the context of that whole. There is an underlying assumption here, viz. that when things are looked at and portrayed in one great, continuous context they somehow explain themselves as they can never do when regarded in the way in which one ordinarily sees the real world. By dint of long and varied experience mankind has found that this hypothesis is correct. Art, as one of the spheres in which the greatest human values are made manifest, is founded on this very assumption.

The recording of that special view of things, seen in the unique context in which and through which their own nature is revealed, is thus the opposite of imitating real things. This sort of record represents them without the disguise which we accept as the real thing when they are presented to us as sections of the real world, as objects, even indeed when they are seen by us as parts of the beautiful, real world of nature.

This revelation of truth is, admittedly, the privilege of certain creative artistic personalities, but it is in no way identical with their self-revelation. There is a complicated interplay between the artist's personality and this discovery of truth, with the result that of all those who concern themselves with the technique of art the few who prove to be creative are those, and those alone, who are capable of surrendering their own personality so as to reveal the truth about objects in a universal context, whose truth they have apprehended.

This truth cannot, however, be contained in technique itself, technique alone is unable to reproduce it. Technique helps to bring truth to expression, but only if it is developed into a definite method, into a road leading to a goal which lies outside and ahead of itself. In order to be worth anything technique must be more than a self-sufficient process certain of making its effect. Therefore any analysis of an artist's technique must aim at discovering the artistic purpose which is simultaneously its goal and the foundation on which it is constructed.

# Introduction

So we shall try in the first chapter of this book to interpret Cézanne's technique, which is already well-known, as an artistic method, and to understand the extent to which certain of its characteristics, such as, for example, his way of applying paint, his preference for and handling of the colour blue, the individuality of his line, his representation of 'local' colours, and so on, contain an artistic significance which is determined by various important aspects of his creative activity.

The second chapter deals with the series of pictures entitled *The Cardplayers*, and attempts to make a psychological approach to the creative activity of the artist, starting out from a drawing made by Cézanne at the age of twenty. On the strength of this youthful sketch, preserved in a letter to Émile Zola to which Cézanne himself provided a detailed commentary, I have thought it possible to explain the psychological impulses and experiences which lie behind such an important group of paintings as *The Cardplayers*. Several conclusions have necessarily resulted from this, both about the motivation of certain self-portraits, disguised but already recognized, which date from his first years in Paris, and also about the choice of subjects for the works of his old age. This made it possible for me to demolish the conception of Cézanne as a *peintre pur* and to refute attacks recently[*] directed by Hans Sedlmayr against Cézanne as a 'pure' painter.

That conception originated with the painter Sérusier when he wrote[3]: 'Cézanne is the "peintre pur". His style is that of a painter, his poetry the poetry of a painter. The utility, indeed even the conception, of the subject depicted vanishes in his work before the charm of the coloured shape'. Octave Mirbeau's work on Cézanne (1914) propagated the same theory. He called Cézanne 'le plus peintre de tous les peintres', 'the purest of all painters', a painter who never encumbered his work with preconceived ideas which were alien to the art of painting. The same conception reappears in an essay written in 1920 by Maurice Denis[4], where we read: 'In contrast to the old masters and the painters of the seventeenth century, though he loved them, he wanted to achieve pure painting, i.e. painting without literature, without a meaning and without a subject.' True though it is that Cézanne neither related a story nor put abstract ideas into visual form in his mature works, it is nevertheless erroneous to maintain that his works are 'without a meaning'. He was, on the contrary, the very person who demonstrated that painting can be

[*] 1949

25

very 'meaning-full' merely by making visible the visible to the extent that it discloses a new, unusual, unknown and greater depth of significance in visible things. What is more than pictorial, what is meaningful, does not need to be expressed in a special way, as though it were material.

Maurice Denis did at least understand that Cézanne's pictures were not necessarily inhuman on account of the absence of meaningful subjects in them. He said: 'Cézanne is human only because he is a painter', and held the opinion that the artist had ensured a human element in his pictures by means of his subjective approach. In reality, however, the position was different.

What is more, the whole idea of 'pure' painting has deteriorated in its meaning since Maurice Denis's times and this is today the greatest obstacle to a proper understanding of Cézanne's art.

A brief examination of the historical background shows what is the point at issue: *le peintre pur* is a later incarnation of a master of the school of *l'art pour l'art*—on a lower level. The subject of a work of art was immaterial for the artists of the *l'art pour l'art* group; according to Théophile Gautier, the founder of this movement, 'no subject . . . has any merit save through the artist's addition to it of ideals, feeling and style'[5]. *L'art pour l'art* was altogether subjective and romantic, the self-deification of beauty, most subtly finished, smoothed and polished. This conception was the antithesis of Horace's theory of art, according to which a work of art ought either to be useful or to entertain. The Horatian theory held good for centuries. Then in the eighteenth century Diderot introduced a variation when he wrote: 'a painting must be instructive and contain a moral.' During the French Revolution this conception was further adapted for political purposes; art had to serve the people. Thereafter what was instructive and educative began to occupy more and more room in pictures: all religious and historical painting was ultimately based on these assumptions and prejudices, while didactic trends penetrated even paintings of landscapes, portraits and still-lifes. In short, all representational art had become allegorical. But as the allegories became increasingly more banal, conventional and empty, artists veered right round in their aims, and towards 1830 a new movement appeared in literature which called for 'perfect detachment', 'un désintéressement parfait', 'work which was concerned with nothing but beauty itself'. The ultimate aim of art now became to attain a subtle and 'precious' execution, which would result in the utmost refinement of the material, while at the same time

realization of this aim was not to be allowed to lead to any pleasure being derived from the experience. To transgress the bounds of pure apprehension of beauty was in itself inadmissible, was a departure from the sphere proper to the artist, and of course even more so were attempts to obtain an effect of anything more than mere beauty in any representation. 'Art forms are not paper wrappers intended to conceal the more or less bitter pills of morality and philosophy; and to seek in them some other purpose than beauty is to reveal a spirit to which all higher emotions are a closed book and which is incapable of ideas of a universal nature'[6].

When one reads this one is tempted to think that it represents Cézanne's confession of aesthetic faith. And when Gautier asks whether the artist must then turn in on himself completely, must cut himself off from all contemporary life and its problems, and then replies to his own question: 'No, an artist is above all a man, he can reflect in his works . . . love and hate, the passions, beliefs and prejudices of his time, on condition that art remains forever his sacred aim and not a means,' we might think that we have in Cézanne a disciple of the idea of *l'art pour l'art* more strict in his observance than Gautier himself was.

We shall see, however, that Cézanne did not regard beauty in artistic realization as the ultimate purpose of art, but as a means of arriving at a higher goal, one at first hidden in the term, and the process, of *réalisation* which were of such importance to Cézanne.

Among the followers of Gautier, whom he called his 'très-cher et très-vénéré maître et ami', Baudelaire stressed that art in its beauty had nothing to do with truth[7]. This is the point where a difference of principle between Cézanne's conception of art and that of the adherents of the *l'art pour l'art* school appears. Baudelaire saw that accuracy of expression had in essence no significance for art, but at the same time he confused accuracy with truth, which is the reason why he declared that truth was also an aim not proper to the artist. Cézanne's whole mission in life, however, consisted in the elaboration of what is true in what one sees, by contrast with and in relation to what the ordinary man regards as accurate and what can be proved to be so by other means.

Anticipating somewhat, we can at this point give an explanation of the significance of this truth, with the aid of a statement of Cézanne's, frequently quoted but never fully appreciated.

Of all the painters among his contemporaries Cézanne respected

Monet most. He described him in the well-known remark: 'Monet is merely an eye. But what an eye!' In saying this, he was tacitly comparing him with himself; for he no doubt implied by this statement that he, Cézanne, was more than an eye. But what did that 'more' consist of? It was the capacity to go beyond mere observation of what is visible. To express this more precisely I would remind the reader of the term *sensations* which was equally important to both painters. Feeling for colour formed the starting point for the work of both of them. Monet's concern was to arrange colours faultlessly in his pictures, to have no falsely observed nuance in the tone of a whole picture; but Cézanne taught us, according to a note of Maurice Denis's[8], 'to transpose the facts perceived ('données de sensation') into the components of a work of art'; we would say 'to transform them into the structural components from which a composition is constructed'—that is to say, something quite different.

Perhaps it may seem to the reader that we have not yet made this difference completely clear: Cézanne's remark about Monet gave an intimation that to him the difference between their two kinds of art was that he himself was working towards a goal which was something more than the painstaking execution of mere reproductions of the things he perceived.

Because of his struggle for truth it is impossible to claim Cézanne as a representative of *l'art pour l'art* and still less as a *peintre pur*, for those artists were experimenting with art and did so only for love of the difficulty of artistic problems; they sought to perfect their skill only in order to go on to acquire still greater perfection.

Yet over and over again we find writers defining Cézanne's art as exactly that. According to them his aim was 'control of volumes through colour nuances, reproduction of light and shade by means of colours', and his pictures—portraits, still-lifes and landscapes—were, according to John Rewald[9], 'simply excursions into the realms of plasticity.' Or there is Tolnay's[10] opinion that the merit of his art consisted in his attainment of 'a hitherto unknown homogeneity of colour in a picture as a whole, while using the greatest wealth of shades of colour imaginable.' Or let me quote an example from more recent times: the painter Gerard J. R. Frankl, in a talk broadcast from London in October 1951, asked: 'What has Cézanne done and how did he do it?' And immediately went on to reduce this infinitely wide and comprehensive enquiry to the following brief question: 'How did Cézanne apply colour to form?' The reply put forward by Frankl was a reference to Cézanne's 'formula', his optical experience:

that is, the complementary colour contrasts introduced into painting by the impressionists were adapted by Cézanne after prolonged observation, in the course of which he reinstated local colours while he let the contrasting shade evoked by the eye itself shrink to a narrow band surrounding the main colour. Frankl's opinion was that Cézanne's particular achievement lay in reproducing this natural phenomenon with an ever-increasing degree of perfection.

Assuming that it is correct that Cézanne did engage in such observation and that it had the effects on his representation of space which Frankl inferred, and assuming that Cézanne did make extensive use of it, it still did not by any means denote the epitome of his achievement in painting. It did not even represent the epitome of what Cézanne himself declared in so many words was the content and meaning of his art; and after all, when painters make pronouncements they usually discuss only technical matters, since they take spiritual aspects for granted. The spiritual achievement, the crucial point about Cézanne's work, could not possibly be simply his individual way of contemplating (apprehending) colour, that is to say his receptivity, however special, towards the real world. It would be more correct to say that this special way of apprehending and observing refers back to something else; it is the consequence of a metaphysically determined attitude, of seeing the appearances of real things as the expression of a meaning both concealed and revealed in them. It was only when he discovered this meaning that Cézanne arrived at his particular vision of nature which elevated him to a status far above that of his own early days and at the same time made him superior to the impressionists. Gerard Frankl said it was 'difficult to imagine an artist working at one fundamental conception for about thirty-five years', as Cézanne did. The difficulty is easily solved when one appreciates that that 'one . . . conception' was a glimpse into the truth of the nature of the world.

In certain of Cézanne's pictures, his inner experiences come to light in a more or less disguised form, and so I found myself compelled to see and understand his art in this particular way, primarily because of its subjective aspects. As a result his work came to appear to be a 'grand confession', like the work of Goethe and Delacroix, Stendhal and Flaubert, Stifter and Caspar David Friedrich, and its point of departure was—in a manner characteristic of the nineteenth century —the suffering of its creator and his victory over that suffering.

The purpose of the third chapter of this book is to determine this

personal content of Cézanne's art. Inevitably this raises the question of its *status*: whether it contains the basic prerequisite of genius, i.e. the ability to reflect the world as a compact, significant interrelationship of things seen.

The result of my studies was to convince me that what was most important was that the evolution of Cézanne's art was revealed as a *via dolorosa*, a road of suffering. This road started out from a revolt, and then a genuine 'conversion' took place. The road was a single-track one and continuous, despite the fact that in its course its direction was completely changed; it was the path taken by a personality which remained true to itself, a creative talent, single-minded from start to finish. The fundamental problem and destiny of this personality was loneliness. If it is true that at first Cézanne regarded this loneliness as something personal and fought passionately against it, he did, after his 'conversion', come to understand it as the universal destiny of his time and accept it as such. Once that had happened, passion was eliminated from the *world* which Cézanne portrayed, but not from his *methods* of portraying it and not from his way of capturing a subject: indeed passion continued to flourish in his methods, though always under strict control. On the other hand, from the moment when Cézanne learned to regard his personal destiny as representative and typical, every subject which he painted became a symbol representing his own apprehension of the whole and hence in that respect extremely important, though in other respects—because every subject itself had the limitations of an individual—it became to an ever-increasing degree a matter of indifference to him.

And now Cézanne's eyes were opened to a new conception of the nature of things and of people, in that he was the only artist of his day completely willing to stand alone. In nature he saw revealed an unchangeable interrelationship and unity, on which the very existence of things depended. In his isolation he could not reach and therefore could not influence objects, so he now perceived them as they were, within their particular setting in space and time. He now began to give a new interpretation to the everyday appearances of objects even in contexts where (as in *The Cardplayers*) these very objects were also an expression of his own experiences. From the detachment of solitude he saw even his own personal experience as being at the same time a symbol representing the meaning of the world. In the tranquillity of human solitude which was simultaneously also a tranquillity of things, the relations between objects which 'existed with one another' became visible and the principal

thing about them was the link which connected and united their separate existences.

Cézanne's 'objectivity' is demonstrated by this way of looking at things; he 'did justice' to things in a new manner and in consequence his personal point of view was transformed into an insight into objective truth, that is, into the 'existing together' to which even individual shapes were subordinated to such a degree that they might be disfigured or deformed thereby.

This continual and unwavering attention to the interrelationships within the real world pre-determined Cézanne's rigorous study of it.

In pursuing these thoughts I found that some study of Cézanne's attitude to religion now became unavoidable; for it was his own bonds with the metaphysical world which determined the meaning that Cézanne gave to man, whom he saw as a lonely creature. It will be demonstrated in this chapter that Cézanne's attitude to religion, which writers have hitherto noted as a curiosity and explained as an anxiety-symptom or as a relapse into provincial backwardness, served as a foundation for his art just as much as did the faith of Rubens or Rembrandt, Caspar David Friedrich or Philipp Otto Runge for theirs. And the metaphysical presence of God was always real to Cézanne when he was painting, though for that very reason he seldom mentioned it.

Nevertheless, I have no intention of classifying Cézanne as a neo-Catholic in art or counting him a member of the group of painters who began in about the year 1896 to attract attention in Paris and whose best known representative was Maurice Denis. These artists introduced a religious symbolism and a deliberate, idealizing stylization (in the manner of the Nazarenes) and followed a road which deliberately conflicted with that of the impressionists. Maurice Denis said[11] of them that 'they preached hatred of naturalism'. Their efforts did not bear fruit and no more did the attempt of the Benedictines in Beuron to revive the 'noble simplicity' of Byzantine painting through a modern study of nature. They did not succeed in revitalizing art by means of a derivative religious feeling and a stylized attitude, any more than the Nazarenes had succeeded.

But, while the impressionists and their followers were of the opinion that no other art than theirs could be sincere, since their art derived its strength from observation of nature alone and saw nature purely as a phenomenon, proof was now being given of the possibility of another new kind of religious painting, of which a man as intelligent as Camille Pissarro had no inkling, and the nature of which he

profoundly misunderstood: the art of Cézanne, which he so dearly loved and admired, but which he mistakenly regarded as an art dependent on and stimulated by nature, as was his own.

It is true that Cézanne *seemed* to paint by reproducing what he saw 'bêtement, comme il le voit' ('stupidly and as he sees it'); like the impressionists he gazed at his model, nature, and found the salvation of all art in nature. But he saw it with a completely different eye, as Gauguin correctly grasped when he wrote: 'Look at Cézanne, whom no one understands . . . he loves the mystery and the tranquillity of a man who has lain down to dream'[12]. We shall see that Cézanne's painting was not indeed religious or symbolical in the accepted meaning of the word, but that it was in a more profound and more original sense truly both of these.

Symbols were not first reintroduced into modern painting by Gauguin, Van Gogh and Odilon Redon; Cézanne was an artist who portrayed religious ideas and symbols long before them. He had nothing to do with the groups and movements which those painters represented; and yet he fulfilled their aims in a quite different manner from them and by his own methods, in that he alone attained the attitude towards life which these aims required.

Nietzsche said that in all human creative activity the important thing is whether the stimulus springs from an abundance of spiritual resources or from their lack and hence a need and longing for them. Let me give an example to illustrate this contrast. The 'symbolists' produced artificial figures which were intended to provide a counter-weight to compensate for the emptiness of their times, the individual's rootless existence, and their own instability. Cézanne faced the very same unavoidable situation of his age, this isolation, when he was producing his work, but he was richly endowed with the capacity to see, which he acquired from the very fact of being alone with things themselves. What made this possible was the fact that he still preserved unbroken his link with the metaphysical world.

The 'symbolists' believed that there was a plastic and decorative equivalent and an appropriate beauty for every emotion, every human thought. They thought that by means of a particular arrangement of lines and colours they could give expression to an object which in itself had no expression. From his vision of life, from his experience of things within his knowledge of the world, Cézanne on the other hand acquired the capacity to make the everyday subjects of his pictures, free from symbolical conventions, the bearers of the significance of his representation.

## Introduction

The fourth chapter is concerned with the problems of 'realizing' pictures which spring from Cézanne's conception of the world as existing through things 'standing together' and being in harmony. Because this interdependence of things took priority in his mind over the things themselves and because they were actually released into existence out of it, he inevitably experienced quite peculiar difficulties, since, when actually painting, he saw this interrelationship, first and foremost, establishing it first on the canvas and making it the foundation for his compositions as a whole. In that way he started off with something quite unrelated to any particular object yet by no means unreal or even abstract, as is repeatedly suggested. These are the patches of colour of which Renoir declared that just two of them on a white canvas already constituted a painting[13]. They are indeed painting, and painting which already holds within it the germ of a statement about the fundamental interrelationships of the things seen. But they contain no suggestion, or scarcely any suggestion, of anything in the nature of an object.

To represent the interrelationships which he discovered in the real world in such a fashion that clear images of objects ultimately emerged, with intelligible relationships to space everywhere in the painting, and to obtain the means to do this through observation of nature itself, was what constituted the essence of the problem of *réalisation* in Cézanne's mind, a problem which he himself frequently described as the crux of his endeavours.

In this process of realization 'nature' played three rôles *and each had a different significance*: it played the rôle of goal, medium, and starting point for an artistic interpretation of the appearances of real things. This fact explains afresh the contradiction between Cézanne's pictures and the everyday real world, and equally the close connexion with reality which photography has confirmed in his landscapes.

Cézanne actually established and maintained the objectiveness, the realness ('realitas'), of the real world with all its consequences for the relationships of things to space, as the limit determining his expressions of the true nature of the real world, those expressions which he wanted people to see as 'parallel' to nature, not as reproducing nature.

The fifth chapter deals with the position and significance of Cézanne's art in history. Here the main purpose is to examine Cézanne's whole *œuvre* as an entity, to overcome the contradictions which are supposed to exist between the different periods of his

activity and to get away from the generally prevailing impression of a number of disconnected pieces of work.

Two groups of historical problems stand out. First there is Cézanne's attitude to the type of art which he found holding sway at the beginning of his career, that is to say his attitude to the currents of romanticism, classicism and realism (or naturalism). He opted for Delacroix as against Ingres, then was greatly influenced by Courbet and Manet who helped him to discover the sphere in which he was to find subjects for his art. At the same time, however, he developed in a direction violently opposed to that taken by Manet. This now brings us to the second group of historical influences with which Cézanne's art is connected, i.e. his 'old-fashioned' manner of treating contemporary themes and real-life motifs. This has its roots in the two styles out of which French baroque evolved—Rubens' treatment of colour (for whom in Cézanne's case Delacroix stood proxy) and that influenced by Poussin, with particular reference to his fundamental divergence from Ingres. In word and in picture Cézanne has himself explicitly testified to the connexion between his art and that of Delacroix and Poussin; this connexion, indeed, seems to exist throughout his entire creative work and it is not true, as has hitherto been accepted, that Delacroix influenced essentially the work of his youth while Poussin influenced his classical period. The historical significance of Cézanne's art is rather contained in the fact that from about the year 1870 it represented a synthesis of the two currents of baroque, which are known as Rubenism and Poussinism, or as the baroque and the classical art of the seventeenth century. The Venetian element, Titian's art of colour, which was a source from which both those streams were fed, bubbled up again in Cézanne and enabled him to achieve a combination of those otherwise so contradictory movements in a field of artistic activity prepared by realism. Again, it was this synthesis alone which permitted Cézanne to develop his individuality and to bring to complete expression the content of what he as an artist had to say.

The result of this historical appreciation is that we are able to pronounce a judgement on Cézanne's relationship to impressionism; despite the fact that he learned so much from Pissarro, particularly on the subject of painting and of lengthy and unhurried observation, Cézanne was never an impressionist. For a short time his art was disturbed by the impressionists, that is to say diverted from its own aims. Yet even in the pictures which are nearest to Pissarro's, even in a copy by Cézanne of a picture by Pissarro, Cézanne's personal style

of observation is apparent—pointing in an essentially different direction and aiming at something absolutely un-impressionistic—a style out of which a different kind of painting naturally developed.

Generally speaking, the historical connexions of Cézanne's art are not with any school, but are with individual artistic personalities. This was an inevitable consequence of his antagonism towards schools in general. It was Zola who said[14] 'meurent les écoles, si les maîtres nous restent' ('let the schools die if only the masters are left to us'). There is no doubt that in saying this Zola was reproducing Cézanne's own convictions. But Cézanne sought in the 'masters' something which he could use in his art as a 'moral support' ('appui moral'—his own expression): in Delacroix boldness and freedom of conception in painting; in Poussin passion restrained by reason and will-power; in Courbet restriction to what is directly visible; and in Pissarro humble dedication and sincerity. Manet, on the contrary, Cézanne regarded as only a challenge to be met.

Though the fifth chapter of this book attempts to draw up a historical judgement of Cézanne's art as a whole, it does not extend to the influence which Cézanne exercised on later artists. There are several reasons why this has not been attempted. First, this influence has not yet ceased to have effect; so that discussion of it seems properly to belong to an analysis of the art of those younger painters. Only there could it be undertaken with the necessary exhaustiveness. Furthermore, Cézanne had indeed many imitators but no pupils for whom he might be held responsible. He left no school behind him, but an *oeuvre* inaccessible as a whole. His followers have adopted only sections of problems and peculiarities of style from the comprehensive synthesis of contradictory movements in French art achieved by Cézanne. Symbolists, fauves, cubists and neo-classicists—none of them formed any link with his achievements as a whole or with his fundamental attitude.

What followed from Cézanne's painting, however, shows plainly that his art marked the end of an epoch in painting. It is all the more appropriate that it should be treated as a termination in this book.

If any additional justification were required for thus restricting the theme of the book it might well be found in certain *longueurs* and attention to detail in it. The intention has been to deal with universal problems, which most certainly do appear in Cézanne's works but which might nevertheless, on account of their universality, have seemed, according to the general view, inappropriate to a book about one single artist. I would disagree. I should like to stress

explicitly that in passages which to many readers may appear to be digressions, I never in fact lose sight of the purpose of this book, but keep it firmly in mind. Such digressions are detours which I was compelled to make and which the reader cannot leave out to please himself, but indeed must follow in order to grasp the whole extent of the problems and the significance of Cézanne's art. The most important questions can be clarified only by means of deep and lengthy thought and studies extending over broad fields and long periods of time. The digressions are not merely superficial but are integral components of the study itself, since indeed the individual position of one great artist can be made clear only by constantly taking a new look at universal problems of art and ideology.

If one wants to become familiar with a mountain range it is not enough simply to take the shortest ascent to the peak and absorb what one sees on the way: it is necessary to follow many detours and sidetracks in order to become acquainted with its whole extent and formation; in such cases one must even penetrate far into the surrounding valleys and into the plains through which flow the waters that pour down the mountainside. It is exactly the same with Cézanne: we must perpetually move round him, circling both close and at a distance, penetrating into things which happened in the remote past—only so will it become possible for us to understand the 'peak' of his work.

### Notes (Introduction)

1. *Bandits in a landscape*, pp. 180-81, London, 1937.
2. *Modern French Painters*, p. 10. London, 1939 (also 4th edition, 1963).
3. Maurice Denis, 'Cézanne', *L'Occident*, 1907, reprinted in *Théories*, 1890–1910. *Du symbolisme et de Gauguin vers un nouvel ordre classique*, 4th edition, p. 245 et seq., Paris, 1920.
4. 'L'Influence de Cézanne', *L'Amour de l'Art*, reprinted in *Nouvelles théories sur l'art moderne, sur l'art sacré*, 1914–21, Paris, 1925.
5. Gautier, *L'Art moderne*, p. 150, Paris, 1856.
6. *L'Art moderne*, p. 152.
7. 'L'art n'a pas la Vérité pour objet, elle n'a qu'Elle-même.' *L'Art romantique*, p. 166.
8. *Théories*, 4th edition, p. 254, Paris, 1920.
9. John Rewald, *Paul Cézanne, Carnets de dessins*, p. 15, Quatre Chemins-Editart, Paris, 1951.
10. K. von Tolnay, 'Zu Cézannes geschichtlicher Stellung', *Deutsche Vierteljahrsschrift für Literaturwissenschaft und Geistesgeschichte* XI, 1933.
11. *Théories*, p. 26.
12. Quoted by Lionello Venturi, *Cézanne, son art son œuvre*, p. 13, Paris, 1936.
13. Quoted by Maurice Denis, *Nouvelles Théories*, p. 111, Paris, 1925.
14. *Mes Haines*, p. 214, Paris, 1866.

# CHAPTER I

## Cézanne's Water-Colour Technique

Cézanne's genius found its purest expression in water-colour painting—and what made this possible was partly the characteristics of the paints themselves and partly the technique of using them which he developed. The fact that all shades of water-colour paints were transparent, letting the light of the white ground gleam through their own darkness, enabled him to produce with them the most perfect example of those sweeping and rhythmical harmonies and that clear, continuous modulation at which he aimed in all his pictures.

Moreover, the transparency of Cézanne's aquarelles makes it easier for us to study his painting methods in them than in his oil paintings, which naturally have a more opaque texture. Here we can actually watch his style emerging and thus are able most easily to comprehend it, in the very field where it reaches its highest degree of perfection.

On the other hand, the openness of Cézanne's oil technique, his unconnected brush strokes and the unfinished condition of so many of his paintings, enable us to deduce that in composing his paintings he followed the same procedure for oils as for water-colours. The material construction of the oil paintings was of course more complicated because in them there were usually larger areas to be tackled and because oil paints tend to be immobile and heavy. But two facts show clearly that there was a basic similarity between them.

Cézanne gave up many of his paintings at an early stage and from the unfinished oils of the end of the 'seventies we can see that he began them with greatly diluted paints (see frontispiece). It was not that he was applying a ground colour, but that he started constructing the picture in colour from the outset, just as he did in his aquarelles. Every touch of paint and every brush stroke was intended, therefore, to aid in laying the foundation for an intensification of the relation-

37

ships within the picture and for an enrichment of the individual shapes. On the other hand, there are some oil paintings to which Cézanne put his signature—thus indicating that he regarded them as completed. In spite of their thick layers of paint, these pictures also appear to exhibit almost the same floating effects as the water-colours, because the colour has been applied in most delicately graduated nuances (Plate 1). All in all then, for any study of Cézanne's art, his water-colours remain important and instructive.

Cézanne made use of water-colours at all periods of his career. There are still extant two folios dating from his first decade, which Chocquet thought worthy of inclusion in his collection (V. 808 and 814). It is characteristic of this early period that Cézanne tried to reproduce the 'local' colours and all the variations which light and shade caused in them, by mixing paints on his palette. At that time his ideas and thus also his technique were still being determined by individual objects, which had basic colours to which names could be given—a white house, a red roof, a green tree. He seized on the mediant shade of these colours, i.e. the point at which their coloration appears at its most pure and intense, and made them paler towards the light or darker towards the shadows. Cézanne derived this technique from Delacroix—both the way in which he employed paint, water and brush and the manner of adapting the medium to the real world. Delacroix for his part learned water-colour painting from his friend Édouard Soulier, who was brought up in England and had there been taught by Copley Fielding. In water-colour painting, therefore, Cézanne may be said to have been a 'grandchild pupil' of the English painters, until the time when, having formed his own artistic judgement, he radically transformed their methods.

He had a long road to go before he reached that point. Yet by the end of this first period he was already engrossed in studying the effect of different colours on one another and the variations in colours from light to shade. He changed over to using complementary colours and contrasts to represent shadows, a device which Delacroix had already begun to adopt in his day. In Cézanne's case, unfortunately, the experiment made his paints turn opaque—the tones became muddy and dirty and the harmony of pure colours was lost.

At this time Cézanne was already actually capable of giving expression to his personal powers as an artist—his *tempérament*—but, like himself at that date, his technical methods were both vigorous and confused at the same time. It was only in the next phase of his

creative activity that he arrived at artistic clarity, at a pure and transcendental view of nature and the world. Then, too, he perfected his completely original water-colour style and his absolutely personal water-colour technique. This period began at the end of the 'seventies. Experimenting very cautiously he started to 'compose' colour combinations and harmonies with the aid of careful pencil drawings. In these studies he robbed natural objects of their usual rôle and subordinated them to conceptions of form which fitted into a pictorial composition. This he did in such a way that from then on the aim of a coloured drawing of this type was achieved when once the framework had been erected and established: it remained a matter of indifference how far any actual object had been reproduced. The sheets of paper took on the fragmentary look so characteristic of Cézanne.

Cézanne's method of working differed greatly from that of the older masters, in whose compositions solids were so arranged and grouped that their outlines produced an impression of unity and integrity; different too from those who brought formally organized masses into a harmonious relationship with one another by means of particular colour combinations and colour contrasts, based on the colours of the objects themselves; different yet again from those who employed a unity of space or of lighting to carry the burden of a composition; in his compositions he created relationships of a type completely independent of objects, by means of a few patches of colour strewn over the surface of the picture and only loosely associated (Plate 4). It is true that his pictures were constructed with components taken from the real world; he did not, however, take these from the particular forms, colours or outward appearances of individual things but from an analysis of their colour context in space. This aspect of colours was their most universal and at the same time their most simple property. It absorbed the representational series of values (which in other painters had a separate existence) progressing from white to black (degrees of lightness or of darkness) and so prevented things from being isolated or singled out as they ordinarily are by the differentiation between their being light or being dark and by modelling in the round. It eliminated the use of greys as a means of dimming colours and as mere absence of colour in a composition and preserved only those greys which contain colour. In Cézanne's pictures the colours and forms peculiar to each separate thing, the fact that it was just-so-and-not-otherwise, ceased to be important compared with its colour context in space; what Cézanne the artist had to say, and what his pictures were concerned with first and foremost, was

the fact that the colours and shapes of things were *there,* which, from an external point of view, meant that they were all equal in space and that a unity of space was created by this equality.

Thus, in the earliest water-colours of Cézanne's mature period we see light pencil strokes which delineate nothing explicitly but are preparatory work, merely indicating on the sheet of drawing paper the position of the objects which are to be represented there[1]. On top of these he applied unconnected dabs of colour, and it was they which first revealed the significance of what the artist had to say: in other words, they presented a harmonious, logically developing association, independent of objects. This was Cézanne's method of composition. In the earlier pictures it was still timid, primitive and imperfect, but fundamentally it was already just as it was to be when it dominated and formed the foundation of all his mature work. True, the unconnected touches of colour were placed in contact with the shapes outlined in pencil, but they floated freely away from them into the white parts of the picture where there were no outlines, and there they created groups of plastic forms. To begin with these were scarcely more than delicate hints, vague both in their dimensions and in their position in space. Nevertheless, the association between them was already determined and in their visual harmonies and clear-cut contrasts they were already related to one another.

The fact that Cézanne's colour compositions did not primarily represent any objects seems to give them an affinity to music. This is not merely a superficial resemblance, but an actual inner correspondence between his paintings and music. Such an affinity is in fact a phenomenon which has its own place in history and time.

Even before the advent of Cézanne an analogy between painting and music had already been perceived. Delacroix spoke of it in his diary (20th January, 1855). Baudelaire had in turn sensed it in Delacroix's works[2].

In the passage referred to, Delacroix compared painting and music and perceived a superiority in music, in that music is absolutely 'formal' ('de convention'), depends upon fixed forms and patterns and creates a complete language of its own. 'It suffices to enter into its domain in order to understand it immediately.' The achievement of Cézanne can be seen to lie in the very fact that he elevated painting into a kind of language of *colours,* by omitting all the other means of representation which were usual before his time: the framework of lines, the gradations of colours from light to dark and the lighting. He made objects emerge from coloured forms and patterns and

simultaneously made their interrelationship clear. But Baudelaire had already seen that Delacroix was progressing along the road towards this musical language of painting when he wrote: 'These miraculous chords of colour frequently make us dream of harmony and melody; the impression which his pictures leave with one is often, so to speak, a musical one.' That could be said of Cézanne's pictures too; only with him it is no longer a question of an analogy, no longer a *quasi*-musical effect—his compositions are actually musical, they *are* the music of colours.

Admittedly, in the early period of which we are now speaking, we do not yet perceive the polyphony and the close chromatics which he alone used in painting. Rather would it be true to say that nothing more than a simple melody, often merely the start of a melodic form, emerges from his portrayal of actual things in rough detail. The eye picks it up, as it moves forward from one shade of colour to another and so roams over the area of the picture. But just as every *melos* has a relevant position in the field of sound, so even these early colour melodies maintained their intrinsic interrelationships (which were distinct from their objective significance) as pure colour combinations in a definite field of the colour spectrum, and, by uniting the separate sections of a picture, created on each occasion a quite distinct unity of the surface. In this Cézanne's pictures differ from those of other colourists in which at certain focal points a concord of colours or a harmonious chorus of different tones bursts out over uniformly portrayed objects—over recognizable things—and thus, spreading over the entire surface of the picture but not occupying it, produces a superior form of unity; or in which colour harmonies are distilled out of and contrasted with a tonality of broken colours.

Moreover, Cézanne brought something else, an entirely new musical factor, into painting. In the tonal system every note of a melody possesses a particular significance which depends on which note in the scale has been selected as the keynote and on the intervals at which the notes occurring in the tune stand in relation to the key-note—a third, a fifth or some other interval. This, then, is exactly what Cézanne did with colours; he gave a meaning to the colours used, which could be varied like that of the notes in music, depending on the basic colour which set the key for the picture, quite regardless of what they portrayed.

Delacroix already knew something about setting a keynote in a picture (his diary, 8th February, 1850). By this he meant the tone which he desired to give to a picture as a whole, and to which the

'local' colours had to be subordinated, in such a way that a few outstanding colour combinations dominated the whole without breaking it up. But Cézanne was the first to 'realize' the whole of a picture in dependence on, and built up on, a key—a basic colour note. In fact he can be seen very early to be 'à la recherche de la justesse du ton', which means, as his pictures show, not 'rightness' in the ordinary meaning of the word—not placing a thing before one's eyes in its ordinary, everyday appearance, plain and undisturbed—but on the contrary the 'rightness' of a note of colour in its 'musical' context, which lets it fulfil the function appropriate to it within the melodic and harmonic context.

Cézanne himself sensed that his art possessed a musical structure and he intended it to be so. 'Le modelé, il n'y a que cela, on ne devrait pas dire modeler mais moduler', he said to Louis Le Bail[3] ('The thing modelled, it is the only thing that matters; but one should say modulate, not model'). This is, however, not intended to mean that mere reproduction of plastic forms should change over into musical terms, into colour harmonics. For *le modelé*, the modelling itself, is not merely a matter of making a faultless plastic reconstruction of individual objects or of producing a solid in relief. We have the evidence of the landscape painter Théodore Rousseau[4] to prove that there was more in it than that. He differentiated between such a limited conception and 'le modelé général, ou symphonique, ou modelé de l'universel' ('the general or symphonic or universal modelling'). This, of course, included the plasticity of all solids, but also the superimposition of an overall tone, as for example 'the grey of Ostade, the brown of Rembrandt, the silver of Veronese and the gold of Titian'. From such an overall tone, said Rousseau, 'every solid can borrow its own particular relief'. Therefore, 'Le modelé ne peut donc être qu'une conception, et la plus grande de toutes. C'est là l'épreuve absolue de l'art' ('Modelling can then be only an idea, indeed the greatest of all. This is the ultimate test of art') and thus, he added, 'the true goal of art'. These remarks show how close the older master came to Cézanne's conception of this problem. If in place of the words 'overall tone' we put 'overall tonality', an expression which comprises the plasticity of all solids, then we have Cézanne's idea of the modelling of the whole, on which everything depends, which 'is the only thing that matters'. It was this which he desired to see transcended into musical form.

So, when he 'modulated' his pictures, he produced the overall structure by means of sequences of tones, closely related and similar

to one another in colour and degree of lightness, yet clearly separated from one another, in a manner analogous to the notes of the chromatic scale. In other words, at the spot where the deepest darkness begins to lighten to half-shadow—which, on account of the way in which light is reflected, is frequently in the proximity of the edges of objects—he placed the notes of his chromatic scale in groups of small touches (in musical terms, 'short notes'). On the other hand, in the lighter areas, where an object tended to have a flattish appearance, he introduced his chromatic notes in larger patches, which corresponded musically to longer measures of time.

In setting up his chromatic scales Cézanne was helped by a fundamental piece of scientific knowledge which he was the first painter to exploit. The primary and secondary colours of the spectrum— yellow, blue, red and green, violet, orange—when seen in the way which we are accustomed to regard as normal (i.e., when they attain their purest and most intense effect) possess a light-dark relationship to one another which the imagination of the unscientific mind transforms spontaneously into a 'position'. Blue appears as a 'low' tone and so does brown; yellow high; red in the middle, while orange lies near red; green and violet on the other hand appear lower, in the blue region. In this way a 'natural' scale of colours can be constructed, beginning at the bottom with blue, brown, violet and green, then taking in a middle group of tones consisting of green, red and orange, moving on to the light ochres and ending at the top with the yellows. What is important and new in this scale is the fact that all the colours appear in a continuous series and neither as contrasts and mixtures (as in a colour triangle or rectangle) nor (as Goethe saw them) growing stronger or weaker. The same scale can also be repeated at varying heights (or depths) though this, of course, entails certain modifications; a pure yellow cannot appear in the low position, while the only form of brown which can be found in the highest one is very vague. In this respect colours are seen to be subject to the same kind of conditions as restrict certain musical instruments to a particular range of notes.

While, however, in the music to which we are accustomed it is a recognized principle that no interval of less than half a tone can ever occur, and we always know in advance what notes there are available for use, Cézanne was faced with the task of first establishing a chromatic scale for each picture and of himself fixing the compass of an 'octave', that is, the range of colour tones to be fitted in between the points where the same basic tone repeated itself in a higher or lower

level, and also of deciding what was to be the smallest permissible interval. This he had to do out of his own conception of the formal and colour relationships between the objects represented in his picture, according to what his *témperament* suggested to him during his contemplation of the object to be painted—in contrast to Wilhelm Ostwald's system of colour chromatics which was calculated so mathematically as to be worthless for the purposes of art.

It is not necessary to stress the obvious difficulty of this task; it is perhaps the most difficult a painter has ever set himself and it is in the light of this difficulty that the series of attempts and experiments undertaken by Cézanne may very well be examined; they were aimed at finding a sure and reliable procedure for establishing chromatic scales with intervals of absolutely equal value.

Once he had constructed his own chromatic scale of colour Cézanne was able to tackle the actual business of 'modulation'. This meant that one and the same colour could be given a different significance in different picture-keys, i.e. according to its differing relationship to the keynote; and the keynote could be changed in the course of the execution of the picture. Thus, by making the same colours reappear in different contexts, he could give an idea of inner relationships of a hitherto unsuspected nature between the things he painted in his pictures. For this reason the re-appearance of one particular colour or the presentation of one and the same colour now in a lighter and now in a darker tone has a significance quite different in a picture by Cézanne from that in pictures by all other painters. It does not indicate a material similarity, but a 'position' (with the entire connotation which is attached to this term in music), within a chromatic system which is repeated from dark (low) to light (high). Therefore, when colour patterns which are similar or are contrasted in a similar manner, reappear in different melodic, harmonic or rhythmic contexts in Cézanne's works, this indicates an alteration in the significance of their rôle and yet simultaneously a harmony underlying the alteration[5].

This is moreover valid not only for the recurrence of an actual colour, it applies also to forms of expression and of composition, to harmony and melody, to repeats, responses, inversions, abbreviations and extensions of melodic colour-sequences, to sustained notes, to half closes and full closes, such as Cézanne loved to use—all these terms being understood in their musical connotation and in their clearest meaning, without reservations. The musical construction of these works gave them an entirely new significance in the field of

painting, where for the most part they stood alone. There was, however, one great obstacle to their being generally understood: the fact that a completely unmusical person could never comprehend this kind of painting in certain very essential respects.

The musicality of Cézanne's method of composition is not something abstract. It is clearly related to the real world, it evolved out of what the painter had really seen and then used.

Where in the real world can we find the material features which make it possible for this kind of colour composition to evolve?

No later than the early 'eighties we can see in Cézanne's water-colours that he was feeling around the shadowed parts of objects when composing pictures in colour and was finding there the basic framework of his compositions (Plate 2). In the deep shadows of things, which appeared to his eyes as clearly definable areas of colour and not as a darkening or greying-over of particular local colours, he perceived the harmony—the recurrence of his basic colours—which permitted him to form musical associations between them. He saw these patches of coloured shadow emerging from the darkest parts of solids, from those areas which were turned away from the light; and he saw them equally in those places where a dark background was contrasted with a more brightly lighted point. In the latter case they showed up a part of the contour of the solid, although in fact they belonged to a plane lying behind it. Wherever a solid itself lay in shadow these patches of coloured shadow were produced in the neighbourhood of the contour, not following it exactly, but playing over it without in any way producing a closed outline. In these pictures definite contours, with their tendency to detach a solid from its surroundings, were expressly avoided. Essentially Cézanne stressed connexions and co-ordination and did this by modulation of the colours, progressing uniformly from several centres within the composition as a whole and ultimately creating a plastic effect. He allowed separating factors to emerge only out of this modulation and employed two methods to do this. In the one, he placed touches of colour of similar shape close to one another in a symmetrical arrangement so that the eye of the beholder is compelled to become aware of a solid, bulging forward between them, though not explicitly delineated. In such examples—very frequently nudes, fruits (Plate 3) or trees—he gave an effect of plasticity to the things he depicted by the use of freely floating spots of colour which in themselves were in no way plastic and which did not give contours to solids; and simultaneously he anchored them fast in the surface of the picture. When

45

he used the other method he allowed the spots of colour to advance, away from the neighbourhood of the contours, towards the lighter centres of the objects and, by carrying out the same kind of modulation from dark to light through clearly distinguishable graduated colour all over, he created partial pictures of the objects and bound them visually to one another[6].

Whichever method he was using, Cézanne first gave solids their 'there-ness' in space before taking any steps to develop their own particular forms. He seized on the manifestations of their existing in relationship and harmony with one another, while still not starting to treat them as individual items. This is the meaning of the fragmentary nature of Cézanne's painting. It was a pre-condition of his colour compositions, which were musical but whose keynote was not given by the significance of objects: because things were perceived only in terms of shadows, he gave only a general impression of them; and because their dark coloured areas were first portrayed plainly and the lighter parts then grew out of the dark ones, the lighter side of real things frequently remained vague and even did not get depicted at all.

The fragmentary nature of many of Cézanne's works can be seen, then, as the price to be paid for logical working out of the musical aspects of his colour composition, but it was also the result of an involuntary surrender. In fact, as Cézanne's art progressed and matured, his skill in constructing compositions increasingly developed, and he gradually gained a complete mastery over the world of objects with their individual characteristics, until, after many different successes at various stages, in the water-colours of his old age he achieved a perfect harmony between things which are each seen quite individually. If one examines Cézanne's works in chronological sequence, one becomes aware of a growing opulence of coloration and at the same time an increasing compactness of presentation. The more variety of shades he gave to colours and the more interrelationship he showed between colours, the more intense and individualized did the world he was depicting appear; he was able gradually to give expression to more and more details within the context of the composition; he found more and more equivalents in colour and form for things seen in real life.

From about 1885 on, this technique scarcely altered at all but it did become richer and freer as Cézanne's imagination achieved ever greater realization. He adhered faithfully to the following procedure: every water-colour was prepared with light pencil strokes, curves and

summary hatchings, which indicated the limits and dimensions of shadows and established their position in the picture plane. Wherever later the deepest or most sharply defined shadows were to be, the lines were applied twofold or threefold, so that their disposition illustrated the darkness shading off (not a contour). The lines, drawn with a beautiful and graceful momentum, approached intermittently the shadow areas around things and caused them to emerge out of the darkness by suggestion. The areas of chromatic middle tones were either left empty or indicated by light, wavy lines.

Even in this early stage of drafting, traces of which can be seen on many sheets of drawing paper, the principal points of the composition were announced as in a musical score, set down in broad outlines but not yet elaborated. In other words, the lines made the future composition gleam forth as if through a veil; one could scarcely yet see a recognizable object, but the rhythmic distribution of the masses, their interrelation and harmony, already made themselves felt.

Once Cézanne had established the essential points of his composition with his pencil, he began to elaborate them with colours, intensifying and defining the indications he had given with the pencil. He did not fill out the drawing, but covered it over with paint. He worked with his brush to obliterate the linearity of the pencil strokes. For this purpose he used all sorts of dabs and flourishes, straight, curved, jagged or undulating. They were of different dimensions and the size was independent of the objects which were depicted. They were placed wherever there was a piece of shadow which was homogeneous in colour and degree of darkness and they were fitted to the shapes of these homogeneous shadow patches of the motif. A sort of mosaic of spots of colour of unequal size emerged, in which occasionally strokes appeared in bands, but they too formed shadow areas, rather than the bounding lines of solid forms.

Cézanne always used very thin, transparent paint, either pure, or mixed in such a way that any impurity of tone was avoided. Starting with the areas of darkest colour, he applied separate spots of colour side by side, then he covered over those which he felt had too little depth. This he did in such a way that two or three shades laid on top of one another neither mixed nor fitted exactly over one another.[7] Thus he could produce three distinct, graduated tones from two colours, and from three colours up to six different tones; a blue and a green side by side had an effect of blue-green where

they overlapped; if an ochre was added then there was in addition a brownish shade, a muted blue and a yellow-green. In areas of deep tones he would frequently place coloured lines in order to emphasize the region of most intense darkness; then again he would soften them by using dabs to join up the strokes to their surroundings.

He never let the colours run into one another on the paper or become blurred; nor did he admit any showy display such as can be created by applying very wet paint or by skilful manipulation of the brush. He controlled his means of production, indeed was completely master of them. This is demonstrated in particular by the way in which he maintained the transparent effect on the sheets of drawing paper to which he had applied numerous dabs of paint in various layers (Plate 4), so that even in the areas of deepest darkness the white paper gleamed through; and by the way in which he could dilute various colours in such a range of gradations that he could make a blue and a yellow balance with a pink. For each change of value he used a particular colour and he scorned any transition from lighter to darker which was not achieved by a toning down of coloration. Thus he modulated the coloration of a leafy tree from yellow, through green and blue, to violet, in clearly distinct stages, each colour being, however, so closely related to the adjacent one that there was no break in the modelling and no discontinuity appeared in the chromatics. Within every composition it was the modulation, the plasticity of things in space, which established the smallest permissible colour-interval for him. Any nuance in the shape of the subject which was slighter than the smallest interval of brightness of colour necessary to produce an objective representation of the 'there-ness' of things, had to be excluded—just as quarter-tones are excluded from musical works composed in half-tones.

In aquarelles the direction of the brush stroke is generally more visible than in oil paintings; it is indeed practically impossible to conceal it entirely when using water-colour paints. Visible brush strokes, however, are inclined to create an impression of movement and to excite emotions, because they make one conscious of the manner in which they were produced. In Cézanne's aquarelles, too, the direction of the stroke can be perceived, yet the brush is so handled that the movement of the artist's hand does not appear as movement in the composition itself. The colours stand fast within the limits of the different patches of painting because their relationship with the other shades of colour, anchored firmly in other areas

of the composition, is expressed more strongly than the fact that they have been given any direction.

Because Cézanne gave things their solidity and their 'there-ness' in space by means of shadows and because each colour signified a degree of shadow to him—a shadow was simply light which had lost some of its brightness through the resistance of an object and so appeared shaded—it was logical for him to evolve his compositions out of shadows in order to attain unity and integrity; for, after all, he intended in his paintings on the one hand to represent things in their interrelationship in space (in Cézanne's view the essence of existence consisted in just this), yet on the other hand to employ colour in its original significance. That is why he based his compositions on 'shadow-paths',[8] in which he assembled the principal dark parts of a motif with rhythm, direction and colour harmony (Plates 27 and 44). Each such shadow-path contained colour differences within itself; it implied depth and a correlation of areas lying in different planes in space and it implied a flat surface and the first planned layout of the picture's surface. Corot recommended starting with the darkest shades and adhering to a scale of twenty steps (from dark to light) up to the maximum lightness, and so distinguishing emphatically between shadows, but he then desired to see the whole held together by the drawing, the outlines of things; in contrast to Corot, Cézanne combined darknesses of different degrees and different coloration in formative units. This, at first merely an imaginative organization of coloured darknesses, let the shapes of individual objects loom forth gradually and mysteriously as the formation of the picture advanced. Nowhere did one individual object reach complete plastic realization in advance of the rest; the whole picture progressed gradually towards realization as more and more shapes crystallized, upon the freely floating, musically formal substructure, making actual objects visible.

The meaning and significance of the shadow-paths is that they unite the separated objects of the real world and bring them into harmony with one another, relate them to one another and bind them together by the use of clear and explicit colour contrasts and by the repetition of identical colours in different degrees of darkness.

### Shadow-paths and Contours

When Cézanne started to use shadow-paths as the basic framework of his pictures, this had a decisive influence on the way he represented

the limits of solids and on their rôle in building up a composition so as to form an entity.

This can be explained as follows: we apprehend a solid by means of its surfaces; the surfaces which extend unbroken before our eyes are seen as indicating *general* qualities, such as mass, density or position; by contrast the surfaces which impinge upon another solid appear as *particular*, characteristic boundaries. If we make a scientific analysis of these perceptions, we see that these boundaries consist of an opposition and a confrontation of different patches of colour, which are distinguished from one another according to colour or degree of intensity, and as our analysis proceeds from point to point the differentiations between colours which are touching each other and the solids to which they belong become of equal value. This is not the same as perception aimed simply at finding one's way between solids, where a solid nearer the eye possesses a greater value and greater importance, so that it is given 'preference' in comprehension and its surfaces, even when they impinge upon another solid, seem to belong to it alone. Here it is not so much that one sees the contact of two solids, as that one observes them in a continuous process of sight within, that is along, the boundary of one particular solid, and so obtains an impression of one bounding *line*, running continuously, and circumscribing that solid, in other words a contour. This contour, we can then say, emerges from a kind of observation directed at 'preferring' one single solid and separating it from others; it is the result of a type of seeing, directed at picking out one particular solid before and among others having the same characteristic shapes. To fix the boundaries of solids as contours therefore means to stress the separation between things.

In the evolution of painting and drawing the contour as a line of separation takes different forms from time to time. It may run on with uniform strength and rigidity; it may grow stronger and weaker according to whether the outline is in shadow or in the light, so that it takes over the function of portraying shadows (in part, at least) along with that of defining outlines; it may be interrupted or in a continuous stream, thus exploiting the individual character of the line and the guidance of the hand, in a manner graphically beautiful or graphically full of character; finally, it may be blurred, hazy or veiled, disintegrated by light and overlaid by shadow, thus being subordinated to other means of representation. Although in this last case the outlines of the solids have been partly relieved of their rôle in the picture (because light and shadow seem to cancel out the

things themselves) nevertheless the power of separation is retained by what remains of the contour (and with Rembrandt and the impressionists alike that is always still a great deal).

Now when the things represented in a work of art are separated from one another they must afterwards be bound together again, in order to give the whole an ultimate overriding unity. There are various means of achieving this, including lines, which may do it by virtue of their own intrinsic qualities of form, by their being given a direction, by their converging, diverging, running parallel or meeting at an angle. If for the contouring of different solids in a picture one uses lines linked together by direction and easily related to one another by the eye, the contours have the simultaneous effect of separating and of uniting the solids.

Gerard Frankl has drawn attention to a particular case where the contour of a solid has the effect of separating and uniting simultaneously. He has pointed out that in Byzantine mosaics where the outlines of figures are strongly emphasized by lines, the disposition of the background material which is adjacent to the outlines of the figures follows the disposition of these bounding lines. Whereas the remainder of the background surface is arranged in horizontal rows, the little stones or little pieces of glass immediately surrounding the figures follow the arrangement of those which form the contours. In this way the figure is sharply distinguished from the background, yet it influences its structure and endows it with something of its own form and solidity. The contours of the solids are seen here as connected with the background and this particular disposition of the pieces of glass has been selected for the sake of this connexion. The importance of this phenomenon is that Frankl believed that it reappeared in Cézanne; he thought that in Cézanne's pictures, too, the foreground figures, through their contours, influenced the solids which were situated further back in the picture-space. In fact, however, Cézanne used other methods in his pictures: he did not first mark a separation between solids and then afterwards link them together. In contrast to the Byzantines he did not make use of contours in this way. Novotny has described very precisely what takes place in Cézanne's pictures. He speaks of a 'line which encloses each individual solid with continuously changing degrees of intensity; which sometimes achieves perfect graphic expression; sometimes on the other hand is reduced to a vague incidental element in the deliberate contact of two areas of colour; sometimes at certain points disappears entirely'[9]. He speaks of an 'outline which is not so much

intended to define the object which it encloses but rather the two coloured parts between which it lies'[10] (Plate 5). And 'in the formation of this outline the isolating effect of contours is restricted to a minimum and instead the opposite effect is achieved—each object is linked to every other one and the space represented on the picture is linked to the picture plane'[11]. In saying this Novotny is stating that through what he calls formation of outline, or contouring, Cézanne achieved first and foremost not a separation but a binding together of objects. Nevertheless, what Novotny described as contour, the line which encloses the solid, sometimes vaguely and incidentally, sometimes with intensity, and which sometimes at certain points disappears entirely—such a formation simply cannot be called an enclosing contour line at all; it does not belong to the solid on which it appears; it does not even belong to a solid at all, but is actually the result of Cézanne's new interpretation of how the boundaries of things appear in space—by means of the shadow-paths placed between them, which sometimes follow the outlines of a thing, sometimes go away out beyond them, according to the position of the shading parts, but which always belong to several solids and are determined by the fact that several solids are 'existing together'. They demonstrate that it was the fact of 'existing together' and of being linked together which Cézanne thought was of primary importance, all the more so because the individual solids with their formal outlines emerge only gradually and at a later stage from the connecting shadows as the execution of the picture progresses (Plate 5).

The things that emerge from these independently-realized shadows are—in Cézanne's representation of them—robbed of every relationship with each other which they may possess as objects in the real world; never in Cézanne's pictures does a group of trees near a house seem intended to give shade to that house, never is any kind of tree connected with any particular geological formation (as is the case in the real world), never is there any specific lighting. All such real-life relationships are excluded from Cézanne's art. Hence the mystery of things portrayed by Cézanne. Yet it would be wrong to explain this either as 'pure' painting or even as 'remoteness from life'. Their mystery is their perfect transcendence in 'there-ness'. Rilke guessed at the truth when he wrote on 8th October, 1907, 'they become so very objectively real, so simply indelible in their obstinate presence'; they are to an enhanced degree not only present and 'objectively real', but are in a state of 'there-ness' which eclipses and extinguishes

their practical rôle, overcomes their isolation and even often makes it impossible for them to develop into individual things. What the eye finds mysterious about them is actually their transcendence in 'there-ness', shadowing and shadowed, which permits them to attain unity and harmony by merely 'being there', relieved of all other relation-ships.

For Cézanne, however, a shadow was a phenomenon of intense coloration. This conception in turn determined the individuality of his art.

It is true that colourists of earlier centuries had already striven to create pictures largely out of colours. In so doing they conceived of colours as having individual values whose varying strengths they set against one another, achieving a balance by adjusting them quanti-tatively. The coloration of their pictures was never a result of the shadows, however; on the contrary the colour in the dark areas was lost in blackish grey or brown or, after Chevreul's discovery[12], was transformed into complementary contrasts.

Although Cézanne also took complementary colours into account and made use of them to compose in space when he applied a third shade of colour to bring something forward (for example yellow in the light, blue in the shade of a green tree; or green in the light, violet in the shade of a bluish mountain), they have no real significance for his art[13]. He saw colours in a uniform progression towards increasing darkness, tied to continuous scales, and saw shadows of equal depth though of different colour as being in harmony with one another. Out of these harmonically constructed series of colour tones and the chords which could be produced between different colours of similar degrees of darkness, he put together the basic framework of his com-position. Thus he placed dark patches of uniform depth though of different colour in harmony with one another, or assembled them into units by making the shapes and directions of the pattern similar to one another, without taking into account whether the dark patches belonged to different objects and to different areas in space.

By other means, such as intersections, linear and aerial perspective, he effected a simple disposition of his objects in spatial depth, but only in subordination to the colour framework of the shadow-paths. For their sake, because on them the whole composition of his pic-tures rested, he sacrificed the 'rightness' of the space depicted and also of the individual things, that is, the usual way of seeing them, which is necessary to enable the beholder to orientate himself in space. It

is precisely through a certain distortion of individual forms and space that he succeeds in creating the feeling that a basic framework of colour shadow in a picture gives it greater strength.

The shapes and positions of these shadow-paths are by no means stereotyped, they change from one picture to another; they are composed of spots, lozenges, star-shapes or flattened curves, and may often develop in a fan-like arrangement; yet they tend to emphasize the main axes of all picture orientation, the vertical and the horizontal.

Since, then, the shadow-paths are obtained from the dark parts actually present in the motif, they frequently, indeed almost regularly, lie in places which are in themselves not of great pictorial interest; *beside* tree trunks, in the *receding* parts of bushes, in a piece of background which appears *next* to a jug, or in the *least* visible parts of folds of cloth. Situated in sharp contrast to light patches, or themselves gradually becoming less dark through changing in colour, they allow the shapes of objects to grow out of them and at the same time give objects a position in space, so that as one follows the course of these shadow-paths as they wind or undulate over the paper and along the objects, one sees they have a double rôle. Dark areas which originally formed the framework of the flat surface of the picture thus become also a means of portraying space; and nearness and distance, so opposed in human feeling, here give evidence of a deeply exciting kinship, since it often appears as though something in the background were leaning forward, or a thing in the forefront of the picture were linking itself up with the distance.

Cézanne's method of advancing from shadow formations into lighter areas by introducing colours of decreasing degrees of darkness, led him in a very special way to local colours. Inevitably he found these in the so-called middle tones, where an object, lying between light and shade in a mildly subdued light as free as possible from reflections, showed its own colour. In our everyday real world it is this colour which is most important, which we name as the colour of the object. To Cézanne, however, it did not in any way offer a starting point for pictorial realizations; to him it was only one note, if an outstanding one, in a continuous chromatic scale. Since, however, the strongest and the lightest local colour are both still a form of shade, they have an affinity with the deepest darkness. Within a composition, shadow and local colour challenge each other as opposing poles and counterweights do. Coloured depths demand coloured highlights, indeed highlights of the greatest intensity of colour, which cannot be created by patches of light colour, for these always give an

effect of weakened colour. That is why Cézanne, according to his own statement, considered that strong local colours were part of the ultimate goal of his compositions; and that is why, thinking ahead as he painted, he decided on the coloration of his shadow-paths from the start, bearing in mind the dominating local tones at which he was aiming: he would insert these into his picture only at the last moment, but all the gradations of colour which he used were stages on the way towards them. This is demonstrated in his pictures in the following way: the shadows are flooded with deep purple, dark green, dark brown and dark blue, and so in the completed paintings (or those which have been taken to a fairly advanced stage) the local colours— yellow, red, green or blue—seem to stand out as highlights in relation to the depth of the shadow areas and not merely contrasted with them. If then the chromatic closeness of Cézanne's colours is the first cause, we have here a second cause of 'the consistent firmness of the colour harmony' (Novotny) in his pictures.

Because Cézanne's method of composition was dependent on shadow colours and local colours, he did not have to face the problem of 'things standing in the light'[14], which occupied the impressionists and the pointillists. As a consequence of the relationship between shadow depths and local shades of colour, the brightest parts of his pictures developed in colour according to the same rules; this included the establishment of the highest lights as reflections of colour, which were in turn related back to the local colour. This procedure explains why even in his Provençal landscapes, though we see plainly that a shadow is cast, we never get the impression that an unclouded sun is shining.

Cézanne gradually progressed towards realization of his basic formal aim, which was to achieve complete harmony between shadows, local colours and light, by using as a foundation freely placed units of colour shadow, which organized the picture's planes. When he began to work he sketched out the foundation of shadow- paths relatively lightly, but as soon as the middle tones were intro- duced on the surface of the picture, the shadow-paths needed to be strengthened and deepened, both in order to effect a plastic model- ling of individual things and to maintain the framework of the composition intact. Once this was done the partial shadows had to be given further differentiation and strengthening, until gradually they approached the intensity of the dominating local colours at which he aimed.

This method of working consisted of alternately blending and

contrasting and it did not permit Cézanne to seize on *individual* items in nature, although he worked almost exclusively from nature. When he was composing his harmonies only a visionary's or a poet's imaginative conception of the *whole* could be of help to him. It was impossible for him to start out from an isolated real thing seen, from a shade of colour to be found in his model. But he did after all require a stable starting point for his colour harmonies, so he relied on the colours which his palette offered him. More than any other painter Cézanne used paints in the form in which they came from the tubes he bought, and kept them so. In his paintings, the same 'normal' yellows, ochres, greens, blues and reds can always be found; whereas Van Gogh, for example, used many 'puzzling' colours, which he produced by complicated mixtures peculiar to himself. Naturally, Cézanne also mixed paints, yet always in such a way that the character of each colour in its original state was preserved. Moreover, his mixtures did not aim at creating new and peculiar shades of colour, but at producing stages between different given colours which could be harmonized with them and which had a clear connexion with them. Émile Bernard shed light on this point when he reported[15] that Cézanne 'did not mix much while he was working, but kept colours ready mixed on his palette for every gradation of shade he wanted'. It is significant that he used an extraordinarily large number of different tubes of paint—according to Bernard four yellows, seven reds, three greens and at least three blues—in order to keep mixing to a minimum and to have as many firm reference points as possible within the chromatic scale, to which he could return again and again.

The deepest shadow colour in Cézanne's paintings, the one which supports the composition and is most appropriate for shadows, is *blue*[16].

As early as 1885–86, Zola, describing Cézanne's art in his novel *L'Œuvre*, gave prominence to the rôle which blue played in it. In his description of a picture by Claude Lantier (who although not an exact reflection of Cézanne, possesses many of the artist's most essential traits) we read: 'the flesh colours are blue, the trees are blue, surely he went over the whole picture with blue.'[17] . . . this blue tone ('bleuissement'), this new representation of light, seemed an insult . . . the light tone of his picture, this blue of which everyone made fun'[18]. When someone dared to criticize this blue—'in particular on account of a poplar to which sky blue was applied'—

the painter showed him 'the tender bluishness of leaves' in nature[19]. It may well be that Zola was here confusing in his mind the blue of Cézanne with that of the impressionists, for there is no doubt that he did confuse characteristics of the work of Manet, Monet and other impressionists with those of Cézanne. All the same, Zola undoubtedly received his strongest impressions from the art of Cézanne, which he also understood the best, because he had learned about it in so many conversations with the friend of his youth. So Claude Lantier is in fact, as John Rewald writes, not an impressionist at all, neither is he a product of Zola's imagination, but: Cézanne. Indeed, Zola had a very shrewd grasp of the problem of colour in Cézanne's art and described it in such a way that we must attribute his description to information given to him by Cézanne. 'The awful problem,' he says, 'the adventure in which he (Cézanne) had engaged, had its origin in his dangerous theory of complementary colours. . . . In the persistent extravagance of his passion he had begun to exaggerate this scientific principle, according to which the three mixed colours orange, green and violet and a whole series of supplementary and similar colours besides, are the product of the three mixed colours, orange, green and violet, and a whole series of can be mathematically deduced. Thus science entered painting and a method of logical observation was created; one had but to take the dominant shade ('la dominante') of a picture, then to find the complementary colour or one like it . . .'[20]. Cézanne alone, however, took blue as the *dominante* of his pictures and he chose a blue which greatly exceeded in intensity the colour of the atmosphere.

In the year 1905, Maurice Denis[21] wrote: 'Recently we saw at Vollard's a number of water-colours, constructed out of lively contrasts on top of a basic design of Prussian blue. The characteristic tone of these sketches, which were composed and constructed with as much power as pictures, was already intense and forceful and of a marvellous resonance. They looked like old faïences.' Louis Le Bail informs us[22] that Cézanne in his old age 'drew with a brush loaded with aquamarine, greatly diluted with turpentine'. Cézanne wrote to Émile Bernard: 'Blue gives other colours their vibration, so one must bring a certain amount of blue into a painting'. To that Bernard[23] adds: 'in fact, the atmosphere is this blue; in nature it is always found over and around objects and they merge into it the more they draw away towards the horizon. The way in which Cézanne used this blue is not at all analogous to the procedure of the impressionists; they rather spoil their palettes by

exchanging the warm[24] scale for the cold[25] one; they practise an all too patent abuse of blue. Cézanne insists on letting objects keep their local colours, i.e. their own colours; he admits blue only as a stimulating element and in no way as a devouring agent'. Here we can plainly feel the difference between the blue of aerial perspective used (exaggeratedly) by the impressionists and that blue on which Cézanne's compositions are based. Finally, Rilke noted the outstanding importance of Cézanne's blue. In a letter to Clara Rilke (dated 7th October 1907) he wrote of his 'dense, padded blue' and pondered over its antecedents. He was of the opinion that 'it comes from the blue of the eighteenth century, which Chardin divested of its pretensions and which now, with Cézanne, is quite without irrelevant overtones'. And he said: 'one could imagine someone writing a monograph on blue; from the dense waxy blue of the murals of Pompeii to Chardin and then on to Cézanne'.

Rilke may well have recognized 'the purpose of Cézanne's inmost labour', 'the process of making a thing "become" a thing, the reality which, by his own experience of an object, was intensified until it became indestructible'; yet he did not fully appreciate the rôle of blue in this process of artistic realization. For Cézanne's 'colossal reality' reposes precisely on the fact that no object possesses actuality in its own intrinsic self, but that each is united with all the others in an 'indestructible there-ness'. And significantly, the unifying medium in all this is the deep blue of the shadows.

What this means can only become clear if we understand the historical significance of blue in European painting. It is therefore useful and necessary to probe into the past history of blue, both in the painting and in the intellectual life of Europe.

## Blue

The colour blue offers a multiplicity of remarkable characteristics to the observing eye and to the reflective mind alike. It is the only colour which can be seen as a close neighbour to and essentially akin to both dark and light, almost black in the night and almost white at the horizon by day; and it is also the colour of shadows on snow[26]. It can darken, it can obscure, it may float to and fro like a mist, dimming reality with sadness and concealing truth. 'Into the blue' means 'into the misty immeasurable distance'. 'Once in a blue moon' means 'in some remote and improbable time'. To 'blue' one's money is to see it disappear for ever. 'To be in a blue funk'

means 'to be afraid of something obscure, unintelligible, terrifying'.
'The blues' is a term for depression, when the spirits of night darken
the mind. In a poem by the German baroque lyric writer Philipp
von Zesen (1619–89) we find the expression 'death-blue' room.
By contrast light blue is the colour of loyalty and ecstasy—'true
blue' for example; and Théodore Rousseau wrote somewhere of the
'blue island of dreams'—of romantic mystery, of chastity and of
blessed loneliness. The reader should bear this last particularly in
mind. Rimbaud says the colour of the vowel 'O' is blue:

> '*O, suprême clairon plein de strideurs étranges,*
> *Silences traversés des Mondes et des Anges;*
> *O l'Oméga, rayon violet de Ses Yeux.*'
>
> (*Voyelles*, 1870–72)

> ('*O, last trumpet full of strange stridencies,*
> *Silences traversed by Worlds and Angels;*
> *O, Omega, violet ray from His eyes.*')

He too emphasizes the double significance of the colour blue.

Goethe's finding was that 'this colour has a strange and almost
indescribable effect on the eye. It is a colour which is a force (energy);
but it stands on the negative side, of the polarity of colours, where
deprivation, shadow, darkness, weakness, cold, distance, an attrac-
tion to and an affinity with alkalis are to be found. 'And at its highest
degree of purity it is like a stimulating negation. The sight of it
evokes contradictory feelings of excitement and repose'[27]. Goethe's
judgement sums up his experience: 'When we see the lofty sky and
the distant mountains as blue, it is as though a blue surface were
receding before us. Just as we gladly follow an agreeable object
which flees before us, so we look gladly at blue, not because it
advances to us, but because it draws us after it. Blue gives us a
feeling of cold, and reminds us of shade . . .'[28] In relation to the
positive colours, however, blue preserves its own special character:
close to darkness, in the dark lower region of the colour scale. 'The
tendency of blue to deepen is so strong that in fact it becomes
intrinsically more intense and characteristic in deep tones'[29]. At
its fullest degree of richness it appears dark and only in the dark
does it come entirely into its own; only the southern sky and the
southern ocean preserve the total effect of blue, a complete reconcili-
ation of the opposing qualities of 'excitement and repose'.

Originally, 'blue' is a term for heaven, which derives from the deep colour of the southern sky; in Homer, too, what we would call blue is designated 'dark'.

As it grows lighter the character of blue becomes more indifferent and less resonant, until in white it is finally extinguished. What is important for the effect created by blue is whether it is seen through another colour or is itself covering another; for it alters its character and creates particular moods according to this, more than do red, green or brown. In transparency, with ice shining through, and in waves, it appears sorrowful, with a power of attraction; when opaque, on the other hand, as in a cornflower, it is mild and static. Nietzsche must certainly have had such a blue before his eyes, when he wrote: 'in books there are blue shades of colour with which their author seeks to steady his taut sensitivity', and he was thinking of blues flooded with light when he noted: 'in Lohengrin there is much blue music'. The effect of such music he compares to 'the influence of opiates and narcotics'[30].

Different ages have shown a preference for different blues, according to the prevailing mood of the time. Even nations may adhere to their own special tastes in this matter. Thus it has been thought that the French have a special affection for that dense shimmering sky blue that the School of Paris particularly liked to use around 1400, which then remained a favourite of French painters for centuries and is seen in the works of Poussin, Nattier, Perronneau, Quentin de la Tour, until finally 'it culminates in Cézanne's water-colours'[31]. A certain variation within this persistent preference for a colour does, however, lead us to assume that a national taste has probably been influenced here by more general tendencies of the times. Thus Baudelaire, a typical romantic, speaks of the 'mystical oceans of blue' (1846). The blue of Cézanne is no longer the blue of Poussin or of Nattier and it seems also to have a different significance from theirs, for in his pictures it assumes a completely new rôle.

There is indeed no doubt that (in Goethe's words)[32] 'every single colour makes a particular impression on people and thus reveals its nature, both to the eye and to the mind. It follows then that colours can be used' not only to create effects through the senses, but also 'for certain moral and aesthetic ends. Such a use which, as it would be an entirely natural application, could be called symbolical', very often displaces the purely sensuous pleasure in a particular colour which may be developed by a nation. But it depends on more

universal thought-associations, perceptions, conceptions and needs for expression, which spring from religion and ideology. Only when a colour is employed for such ends in a manner appropriate to its evident intrinsic qualities can its use completely express the meaning intended. This, then, is true for the colour blue also, indeed perhaps to a special extent.

To demonstrate this, here is an extract from fiction—the description of the blue flower at the beginning of Novalis's unfinished novel *Heinrich von Ofterdingen*[33]. 'He found himself on a soft lawn beside a spring, which bubbled up into the air and so seemed to be consumed by it. Dark blue rocks with coloured veins rose up some distance away; the daylight which surrounded him was brighter and mellower than usual, the sky was deep blue and completely clear. But what powerfully drew his attention was a tall, light blue flower, which was growing by the spring and touching him with its broad shining leaves. Around it grew countless flowers of all colours and the most delicious scent filled the air. He saw nothing but the blue flower and contemplated it for a long time with inexpressible tenderness. Ultimately he made as though to approach it, when all at once it began to move and to change; the leaves became more brilliant and enfolded the growing stalk, the flower inclined itself towards him and the petals opened to reveal a blue collar in which a delicate face was nestling'. According to Ludwig von Tieck, the blue flower is Ofterdingen's youthful love who has been snatched from him by death. Here the aspect of blue which arouses sorrow, its power to attract to itself, and its withdrawal are used with symbolical power of expression to represent the frightening manner in which death can tempt one to leave life.

In more recent times we encounter the same phenomenon in Picasso. C. G. Jung (in a supplement of the *Neue Züricher Zeitung*) interpreted Picasso's 'blue period' as representing a *Nekyia*, a journey into hell. The artist 'dies and rides on a horse into the Beyond, into the kingdom of the dead. There reigns the blue of the night, of moonlight and of water, the Duat blue of the Egyptian underworld'.

The symbolic use of colour arising out of direct observation is something first achieved by the romantics with their enhanced awareness of human feeling; their ambition was to use their imagination to get beyond the real world, in order to capture the essence and the significance of what they saw by means of a vision penetrating into the infinite Beyond. In pursuit of this aim they were led

from the present to the past, from reality to dream and from the wealth of colour of the daytime and of things near to them, into the blue tones of night and distance, which acquired a quite over-whelming significance for them. That is why blue was the favourite colour of Novalis and Eichendorff, to whom even noon appeared to be a sultry blue.

> '*In the dark blue sultriness,*
> *Day's turmoil lies dreaming.*'

On the other hand Tieck (in *Zerbino*) makes the flutes say:

> '*Our spirit is blue like the sky,*
> *Leads thee into the blue distance*'     . . . and

> '*When the others are singing cheerfully,*
> *Blue mountains and clouds point*
> *Gently to our beloved Heaven* . . .'[34]

This 'romanticism' was still to be found in Picasso.

But even in earlier centuries men attributed a symbolic signifi-cance to colours, though admittedly of another kind; and the sym-bolism of blue in our own time can be traced back to interpretations which have been given to it since the middle of the first millennium of the Christian era.

Let us now examine these in the history of the evolution of painting[35] [36].

We know that the colour blue was used by painters even in ancient times[37]. Pliny and Vitruvius tell us that the ancients were familiar with four different blue paints; *armenium*, which was obtained by grinding *lapis armenius*, (this is *berg-blau* or mountain blue, carbonate of copper); *caeruleum* or sky blue (this is natural ultramarine manu-factured from lapis lazuli); *puteolanum* or Egyptian blue, a cupri-ferous glass frit (made of pulverized coloured glass); and *indicum*, the genuine natural indigo, a vegetable dye which was prepared from woad (*isatis tinctoria*). This information is sufficient to dispose of the hypothesis advanced about a hundred years ago (1858) by Gladstone and elaborated by Lazarus Geiger and Magnus, that the Greeks, the Indians and the Jews did not recognize blue as a specific colour and that it was only at a later stage of civilization that man's

colour sense developed to an awareness of the sensation of 'blue'[38]. We may be sure that since history began man's perception of colours has always been the same. What has differed is his preference for certain colours and it seems to be indisputable that one particular school of Greek painters avoided blue—for example, in the middle of the fifth century B.C. there was the four-colour painter Polygnotos, who used only white, black, yellow and red (the reason for this might be the psychological factor mentioned by Nietzsche in this context, that 'blue and green dehumanize nature more than any other colours'). Other painters of the same school did, it is true, introduce bluish shades into their pictures by the use of the indigo-type vine-black, but they hardly ever used a true blue[39]. At Pompeii, a return to the trio yellow, violet and light blue can be seen in pictures of the third style, that is, those showing the characteristics of painting in the first half of the fourth century B.C., yet even here blue did not play a decisive rôle; indeed blue was little used anywhere in the murals of Pompeii, and not at all in the main parts of the pictures. Occasionally it puts in an appearance as a pale colour of the atmosphere or of buildings situated in the distance, but it is always in a very subordinate position.

In the early Christian Roman frescoes, so far as the few which survive permit us to judge, an equally scanty use of blue is apparent at first. On the other hand, towards the end of the sixth century a schedule of the religious values of colours was drawn up in Rome, in pursuance of an older Mediterranean tradition. Admittedly the highest spiritual colour value was attributed to gold but next to it came blue, which ranked as equal in value to violet, red and green. Moreover, blue appeared at times as symbolic of heaven above a ground of gold (representing light), or even as a background to a picture. Thus blue signified heaven, not the atmospheric picture of it or the sky, but—according to the writings of the Christian authors of those days—the heavenly Creation, or that which had come to pass and had been brought about by heaven, divine wisdom operating from heaven, or divine omnipotence, the miracle of heavenly glory[40].

Now, it is remarkable that blue was the colour which was permitted to deputize for gold (symbol of divinity and its eternal light). First of all this proves that blue was accepted in these instances as possessing perfectly effective powers of expression, no doubt because of the impression of serenity and luminous power given by the southern sky. Then again it may also be due to the re-emergence

of a feeling of an inner affinity between blue and gold which mankind had already noticed thousands of years earlier, and which we can still perceive even today. It is as though these two colours, yellow gold and intense blue, were perfectly balanced and both possessed to the same high degree the precious characteristics of power and perfection shining from afar over the earth. And in this respect both appear to be of such exactly equal value that one of them may well be capable of being substituted for the other as a symbol of that illumination for which either the sun or the sky surrounding it can stand[41].

That the divine light could be represented in Christian times by either gold or blue is proved by the haloes of the angels in the mosaic in the apse of S. Maria in Dominica in Rome, which are coloured alternately blue and gold[42]. Both colours symbolize perfection which, unattainable on earth, comes from heaven and contains no taint of worldliness[43].

Yet soon, it seems, a second, empirical knowledge of the nature of blue began to be effective in its symbolic interpretation, namely, the coolness peculiar to this colour. This was applied to the nature of God, and the interpretation developed as follows: if gold represents the splendour of His omnipotence, red the ardour of His love, and if both together reflect divine majesty, then blue signifies the functioning of His wisdom. His wisdom was revealed in the works of Christ: in order to indicate this, Christ wears a sky-blue cloak. If, therefore, blue reveals God's wise care for man, then the sight of this particular colour holds out hope of rewards in heaven. So blue served as a warning note, reminding men to strive for these rewards and thus became a general colour of holiness, a colour of faith and hope, a symbol of the faithful perseverance of those who keep heavenly things in mind[44]. Dull blue acquired no symbolical meaning in the Middle Ages; only a violet blue appeared, used as a sign of mourning and occasionally as an indication of diabolical darkness. As the great majority of the paintings of those days were concerned with portraying the story of man's salvation, the lighter shades naturally predominated.

There is a representation of the Virgin Mary dating from about 700 A.D. in Rome (S. Maria Antiqua, the Annunciation) in which she wears a blue cloak, and here the symbolic meaning of blue for Christians is brought out by the fact that narrow blue strokes are used to indicate the shadows on white robes and at the same time to form a light blue background. Here blue has a three-fold signifi-

cance as the colour of a robe, of shadows and of the heavens, and so as a means of representing the whole glory of heaven. The colour of the Virgin's robe is hers by right as Queen of Heaven, while blue shadows are given to the snow-white robes of the *candidi*, the pure, the saints, to symbolize their celestial immaculateness.

It is possible that in a picture of the Virgin in the Basilica of S. Clemente (middle of the ninth century) we have the first isolated example of a composition built around blue. In this picture the Mother of God is seen clothed entirely in blue robes, the Child on her lap on the other hand entirely in yellow, while the background against which she stands out is again yellow.

In mosaics of the same period blue plays a much greater part. We find it not only in backgrounds of sky, but also as the colour of water and in haloes, thrones, clouds and angels, everywhere—the sapphire colour being used to indicate their relationship to heaven and to represent their celestial beauty. In addition we also find blue being used from time to time in lighter and darker shades to represent shadows on white[45], and pieces of deep blue glass often depict very dark interiors. By its frequent use in this way as a shadow colour (graduated from milky lightness to a near black) and by its emergence as a saturated local colour, blue acquired a predominance over other colours and thereby produced an artistic unity. From the pictorial point of view it also appeared to be concentrated more than other colours at particular places in a composition and was deliberately distributed over the surface as a whole. In order to add emphasis to extremely light areas, blue was placed around them as a dark contrasting colour; then again blue mountain tops in the distance would be given the same tone of blue as figures in the foreground. So artists made an important discovery about how to *compose* pictures with colour relationships and colour contrasts; also how to form a link between solids which were ranged behind one another and to anchor them in a picture plane.

Even though blue did not otherwise predominate to the same extent this was an era when shadows or solids were represented more and more perfunctorily till they were finally reduced to dark lines, spread out in such a way over the light blue parts of white robes that ultimately the white colour could be seen only on narrow ridges. For example, in the mosaics at Ravenna, angels or saints, figures which are supposed to be clothed in white, are actually wearing pale blue robes which gleam white only in their brightest parts.

If we now look at the earliest paintings of northern Europe, we do not find the colour blue again until the eighth century, that is to say in Carolingian miniatures, in which, however, it was used in varying gradations and in more or less muddy, often impure deviations from the true colour. The use of these shades of blue at that time seems to be subject to no comprehensible rules[46]. Particularly striking here are the imaginary buildings painted blue on blue.

The Ottonian artists used blue more frequently than the Carolingians. Their colours were clearer and their contrasts sharper; yet neither the Reichenau nor the Ratisbon school introduced anything radically new in colour composition. The two main types of blue used were ultramarine and blue black, both with many variations, some purer, some muddier. There was not yet an established palette. Probably all the more or less light blue colours were produced from ultramarine (lapis lazuli), that 'miraculous colour' of which a Venetian bishop at the end of the tenth century 'presented a bushel *pro caritate*'[47], for the painting of the convent church of Petershausen near Constance. To modern eyes, however, the various shades of blue used in these compositions resulted in tremendous eloquence as, combined into mighty linear patterns, they accompanied the commanding gestures and majestic poses which gave these figures their 'celestial' spirituality.

Blue assumed a new rôle when it became the obligatory colour for the Virgin's robes, both in Italy and in the north. The colour composition of every picture had then to be subordinated to this single dominating figure and not constructed as before out of the co-ordination of a range of figures. In such pictures blue became the starting point on which the symmetry of the whole colour scheme was built up; all other colours had to harmonize with it. What had begun as an iconographic prominence became an artistic one; so far as colour was concerned the planning of compositions started out from blue. This is most obvious in enthroned Madonnas, but it can also be noted in paintings of the Annunciation and of the Crowning of the Virgin. This influence remains perceptible long afterwards in romanesque and gothic glass windows, persisting even into a period when it seems as though pictures were already being composed 'naturally'.

When landscapes began to be depicted as background to figure compositions, the blue tones continued for a long period to retain their compositional priority[48] in European painting—because of the introduction of the blue of the sky to which the blue of distance

was in turn linked. Whether they dominated by their quantity or not, these blue tones determined the painter's organization of colours in certain parts of his pictures, as they were an inevitable factor against which the others had to be set. In the nature of things, solutions to this problem were extremely varied, since the blues became now lighter, now darker, were used in conjunction with various shapes and with other colours, and had to serve the changing aims of the artists.

With Giotto, the special power inherent in freely-related colours evenly applied, which had given the pre-gothic paintings their magic, was lost. The colour he used to portray solids and space now appeared in formative shapes, sometimes in the light, sometimes in shadow, but in either case weakened. Full coloration was retained only in half light (the local tone). Of course this meant that its potentialities for representing the real world were splendidly extended, but it had been given an element of humanism and of worldliness; except in a few traditional compositions depicting groups of sacred figures in the traditional colourings (Madonna, Christ, Peter), colour symbolism now practically ceased to exist. The expressiveness of colour was also considerably diminished. This was particularly the case with Giotto, because he sought to give his pictures a unity of colour by the use of light tones. Blue therefore now ceased to be differentiated from other colours as something special and it suffered when placed in opposition to other tones, often forfeiting all the richness and power of its 'dark' side.

From about the year 1400, colour used to portray figures gained in power and depth. The new conception of beauty as appealing to the senses, however, now went far beyond the last remaining links with the coloured images of holy personages, and by about the year 1500 these had lost all artistic value and relevance. At the same time, the autonomous representation of space now increasingly taken up, brought with it 'a comparatively restrained and neutral tone, grey brown in interiors and brownish green in landscapes, in order to make the unity (of space) absolutely clear'[49]; moreover colour became a means of giving an effect of relief to individual objects and so was isolated. The inevitable result was that for a long time blue could not be used as a universal basic colour in pictorial compositions. It made a reappearance as a local colour, however: for example in the paintings of Masaccio, who used a most intense blue, and, what is more, placed it next to a brilliant red. This constituted a decisive turning point in the history of the use of

colours, for the history of colorization as opposed to mere colour-fulness begins with the emergence of one overall tone to which individual colours were related. So long as patches of various colours were inserted into the drawing of a picture and given equal value, the effect of colourfulness was created, even if one colour appeared as a ground from which the others stood out. Thus, for example, we speak of a meadow strewn with flowers, as a 'colourful' one and in doing so treat the green of the grass as a sort of colourless foil to the other colours. Colourfulness can give joy but is frequently also painful to the eye. As a method of artistic disposition of colours it is subject to the principles of selection and arrangement; but it is bound to the surface. When our eyes apprehend colourfulness they are actually being diverted from any suggestion of an effect of depth.

On the other hand colorization is bound up with the representation of space by means of an uninterrupted scale of tones running from light to shadow. This is seen as an overall tone containing just *one* colour in many degrees of lightness or, of course, of darkness, *one* colour within which the contrast of white and black is comprehended. The colourists evolved their compositions out of this overall tone. A series of colour values was produced, by gradations, by intensification and attenuation, by lightening and darkening, which at the same time embraced colour differences, and these values reached their maximum in *pure*, saturated colours. Or again, the colour construction of a picture was split up into two parts, one of which, painted tone on tone, corresponded to space, the other, executed in the local colours, corresponded to the figures. This duality cried out for a synthesis, which was then achieved by varying the colour of the grey and brown tones so markedly that the pure, local colours (and of them particularly blue and red) were seen as the peak of a unified, general *movement* of colour, pressing up out of gloomy vagueness higher and higher into definition.

In Masaccio's pictures this duality is still sharply visible. Filippo Lippi and Mantegna bring local colours and brown shades nearer to one another by giving them a similar degree of darkness. Still, in the pictures of these masters the colours of space and the colours of the figures in space do frequently stand in unreconciled contrast to one another. In particular the sky, regarded purely as a phenomenon of space, frequently has the effect, in many of the masters of the Quattrocento, of being contrasted with the figures and quite unconnected with them. Even the pictures of Piero della Francesca, painted in an overall shade of shimmering sky blue, contain figures

painted in an intense blue unrelated to the blue of the sky and the atmosphere. Perhaps Giovanni Bellini was the first to bring about a harmony between the spatial blue in the sky and the plastically modelled local colour in a robe. Admittedly this only partly overcame the pictorial discordance between solids and space; the earth still remained isolated; but here, for the first time since the new way of representing space in pictures, blue brought about the union of the most remote distance with the foreground, linking the most extreme intervals of distance in spatial perspective into one plane. This was the first time a solution had been offered to a problem which was to be presented to painters afresh over and over again right down to the days of Cézanne.

Titian tackled it and, what is more, under particularly difficult conditions. It was the tendency of his time to employ sonorous, intense and saturated colours in order to increase the significant content of a picture and here Venice was the leader. Around the year 1500 the Venetian painters were in the course of turning back from the agreeable and pleasing colorization of the later Quattrocento to the colours with which painters expressed themselves in the Middle Ages. But what had in the Middle Ages been an *ethos* colour, a symbol of permanent nature, of the essence of the thing portrayed, now became a *pathos* colour, the expression of an inner emotion, of a transient condition, of an intensity of existence attainable only in supreme moments of life. Colours were, therefore, greatly intensified and contrasts were made between widely separated extremes[50]. So, naturally, intensified forms of colours were used: red and intense blue predominated. Green tended towards a smouldering brown; yellow, like white, was used only as a secondary contrast colour, isolated, outside of the main groups. And now Titian, in the middle of his career (1515–30), gave an entirely new meaning to the traditional cleavage between space colours and figure colours. He plunged the monochrome, formerly grey-brown, sphere of space into a brownish darkness out of which the greens of vegetation emerged in smooth conjunction, as well as pink and brown flesh colours. In his warm coloration, space, along with figures and vegetation, was now something close at hand, whose passionate power culminated in intense red, so that there seemed to be no place for blue except in the distance, on the horizon and in the sky, and it might be thought that no essential rôle was left for it in any composition. But that was not Titian's way. In his eyes the warm scale alone did not suffice for the perfect picture. So he intensified

the blue of the horizon beyond all natural verisimilitude, and in-
tensified the colours of the sky and the sea to such a degree that they
acquired completely equal status with the reds. Then he placed
robes of a brilliant blue in the foreground and, moreover, in the
very positions in the composition which were intrinsically and visually
the most important (for example in his *Ariadne* in the National
Gallery, London). By this means he united and interwove nearness
and distance. But he did not stop at this. As Hetzer has shown,
Titian led the way to new ideas because of his inclination to use the
colour blue to achieve homogeneity. He set out at first from the
figure colours, with which he matched the hues of the distance.
Then, however, 'the blue of the sky becomes the principal colour
value, indeed things start to work the other way round and the
colour of the figure develops out of the colour of the sky. It will be
evident without further explanation that this development was an
event (in painting), the importance of which can scarcely be over-
estimated. It was probably the first time in the history of colorization
that this blue, in its character of a light and extensive colour of air
and space, attained significance as a constituent in the realization
of pictures in colour'. Through blue, space acquired a completely
new kind of homogeneity; it was now opened up to its full depth
and portrayed unambiguously as extending in depth; freed from all
spatial perspective and explorations into time, it became present
as an entity in its whole extent *at one and the same time*, together with
the important key figures of the subject. An ideal vision of the world
emerged in which man and nature were in tune in timelessness,
and so were immortal. And so we see a state of extremely intensified
existence being turned by means of the 'pathetically' intensified
colours into this state of immortality. To recapitulate in Hetzer's
words: 'The colorization of which Titian was an originator is charac-
terized by the fact that its fidelity to nature is bound up with an
arrangement of colours which by its independent nature displays the
eternal order of the world in its associations, relationships and
connexions'. But here, posed for the first time, we have one of the
problems which moved Cézanne deeply; it is still not the whole of
his problem, but it is the first step on the path leading to it[51].

From Titian Poussin took over the idea of uniting spatial depth
and flat surface and of providing a link between figures by means
of colour. Like him he placed his blue-robed figures in front of a
blue sky and intensely blue mountains in such a way that to the
observing eye objects in the foreground are comprehended in one

entity with those in the distance. Now, Poussin is one of the two artists whom Cézanne regarded as masters to follow in creating his own compositions and this applied to his work in general, even the basic structure of his pictures. At this point it is important to record that Poussin's way of using blue constituted a first step leading directly towards the manner in which Cézanne used it.

Brief mention must still be made of Poussin's younger contemporary, the Delft painter, Vermeer, who—more than anyone else—had a predilection for blue. His pictures are perhaps the first in which blue is used with light yellow purely to create a specific atmosphere—cool, matutinal, withdrawn, pure and unsensual—this last particularly in themes with a love interest, for example, the young girl reading in a quiet corner a letter received secretly. The special charm of Vermeer lies in the contrast between the mood set by the colours and the significance of the theme; this contrast must be seen as a specifically baroque element of style and as such it is a 'symbolic' form.

Continuing chronologically in our study of painters' use of blue, we come to eighteenth-century France and find pictures which are based on the trio blue-white-red, little dots of red marking the high points, blue providing the soft background hue of broad planes. There is a persistent preference for a bright, cool, silky, metallic blue and a pale misty pink, between which white forms a bridge of light. With the painters of this period too, blue now appears as the colour of half-shadows on flesh. These tints match the other blues in the picture and the significance of this colour for a conception of the picture as a homogeneous whole is further strengthened. The impressionists later recalled this technique and reached back into the past for it, after the rôle of blue had been diminished by the French romantic painters. Because Delacroix sought to revive Rubens' *pathos* he was forced to use colours based on the warm scale, starting with brown and culminating in red and yellow. In his pictures, green was added to red as a complementary contrast, this in its turn being placed in conjunction with the undulating tones of the brownish coloured background of space. Blue on the other hand remained isolated, restricted to definitely limited areas, excluded from the general stream of colour relationships. But Ingres, like the pre-Raphaelites and the Nazarenes, in short, like all classicist painters who were dedicated to the line, painted 'colourfully', not 'in colour'. In their works *no* colour was strong enough to form the framework of a composition or to dominate it.

Moreover, despite all dissimilarities in other respects, the case of the French impressionists is the same. As, however, they were in the first instance landscape painters and in addition painters of light, and as they surrendered the warm space-colour (brown) in favour of the cold ones, they endowed blue with a new importance—not as the basis of composition in colour but as the tone of colour and light which gave a picture coherence and unity. Because they painted a great deal of sky and because the portrayal of atmospheric blue flooded by sunlight became their principal artistic problem, they succeeded in fusing their pictures into unity in a blue-hued space, in harmonizing them under the sway of different delicate and light blues. Yet, once they did this, all trace of the intense, deep, saturated and solemn blue was lost from their pictures.

In the nineteenth century, however, the blue of the air itself became a subject for painters. Starting out from landscapes it conquered all other domains; it became the medium through which all things were represented, even the things nearest to the beholder which had never before been observed to be affected by the blue of the air. This was because blue had now once again become a new 'symbolic form'. From being the symbol of the alluring faraway world, it was transformed into the symbol of the remoteness of man from objects; it now tinged the entire image of nature for those who lived outwardly separated from what was near to their hearts and who preferred to concern themselves with the outward forms of things as they receded into the distance. That was the significance of blue in the pictures of the impressionists, who painted what was near as though it were distant, simultaneously dividing and uniting; dividing in that they used blue to set the world at a distance from the beholder, uniting in that they used a homogeneous bluish hue to relate objects to one another.

Cézanne's blue too, which likewise resulted from the conception of remoteness, was symbolic; but, let it be said, in an entirely new manner.

## Digression on the Subject of Distance

The problem of distance in painting requires some clarification. The term covers the change in the beholder's reactions to his perceptions according to whether the things set before him in paintings are near to him or far from him; the alteration in the way he adjusts himself to the different degrees of separation between himself and

72

the objects represented to him. Distance does not mean measurement of a separation, but adjustment to a separation; not making some fact perceptible, but giving a form to something which could be seen in various ways, namely to what is near and what is far and their reciprocal relationships.

To the ordinary observer what is near seems large, definite and three-dimensional, what is far, on the other hand, small, indefinite and flat. Seen from near at hand each object has its own colour, but in the distance one uniform shade dominates, drawn from the atmosphere; it is impossible to observe things near and things far simultaneously.

Painters have sought in various ways to reconcile these sharp contrasts in one unified conception by disregarding the reduction in size of distant things, or their indistinctness, or their flatness or the colour tone they acquire. At other times they have suppressed the qualities of nearness. Both methods have placed the distance of one object from another and at the same time from the beholder in a sort of imaginary, 'ideal' relationship.

For instance, the way in which the figures in Byzantine frescoes and windows of mediaeval painted glass are set at a distance from the spectator which cannot possibly be translated into real life terms, is just such an adjustment, entirely positive, explicit and deliberate. The figures have in both cases the clarity and colourfulness of things seen near at hand, but not their plasticity. Indeed they have a sharpness of outline and intensity of colour which actually exceeds—and in the true sense of the word transcends— every known experience of things seen near at hand. For this reason the distance between these figures and the beholder seems impossible to express by any sort of measurement.

But the problem of composition in these pictures was quite different from that of portraying the real near and far. In European painting this cropped up for the first time when painters started to represent space, when considerable distances were introduced into pictures and objects in the background were placed in a clear relationship to those in the foreground, when a clarification of this relationship was elevated into a general pre-requisite of the composition itself.

Let us select some examples of the main solutions adopted. First, the qualities of distance were denied to objects in the background. The distance from the spectator was also disregarded. This is illustrated in Giotto's frescoes which, although on walls and partly

even high under ceilings, are seen as near to the spectator; in the same way the backgrounds, which often depict wide areas behind the figures, are seen with all their outlines distinct as if they were near. In fact the uniformly maintained nearness in which things are viewed makes any explicit or rational clarification of their context in space unnecessary. Moreover, Giotto was the first painter since ancient times who really comprehended nearness, including the relationships of his figures among themselves. Their movements and their gestures were directly sensed and freshly contrived from one figure to another.

More than a hundred years later, after the introduction of artificial perspectives, the problem of the contrast between near and far became more pressing and was solved in a different way. Masaccio placed his figures further from the observer than did Giotto. Their outlines became softer. Behind them stretched a more broadly extended distance, the pictures gained depth. Distance was made to serve nearness, it had to help to balance the distribution of the masses of the figures in the foreground, the plane on which the composition was based. This could be achieved only by making things seen in the distance match the figures in clarity. Generally we obtain a near view set at moderate distance. Items which belong to the distance, such as trees, take their place between the important groups of figures in the foreground, of which we grasp only one group at a time. Masaccio also conceived his frescoes group by group, each comprehensible in itself to near observation.

A new tendency emerged with Leonardo da Vinci, in whose pictures distant views appeared transposed into the visibility of nearness. The *Last Supper*, the *Madonna of the Rocks*, the *Mona Lisa*—none of these compositions, if regarded as portrayals of reality, can be comprehended when looked at close up. One would have to step back from them in order to survey them all at once, yet there they are before one, as if quite close, all their details given with complete clarity and plasticity. The influence of the Dutch painters is probably to be traced in this procedure of Leonardo's, for the Limburg brothers and the Van Eycks made use of these methods in the first decades of the fifteenth century, showing distant views as if they were seen near, as backgrounds to their compositions. They placed the main figures at the closest possible range, so that each little hair, each wrinkle, each precious stone in its setting could be seen precisely and clearly, and they set architectural constructions so closely around them that they could be perceived as

having the same nearness. However, this did not deprive the land-scapes of their feeling of distance; they were left plainly in the distance, but so painted as if they were being looked at piece by piece in the closest proximity. Thus they produce a mingled impression of fairy tale and realism. A picture by the Dutch painters of this period must therefore be taken in on two levels; the observer must let his eye leap from the nearness of the near figures to the other nearness of the distant background. Leonardo was able to bridge this gap by conceiving his principal figures also in the distance and then lifting them into the near view.

Raphael, on the other hand, increased the distance from the spectator in the *Stanze*. The eloquent structural forms of the main figures were unified, less differentiated, more generalized. Limits were set to distance, which nevertheless came into its own right, and the unity of the picture was achieved by a balance between the near and the far (particularly in the tapestry cartoons). The essential interest, the colour, the important parts of the linear structure were divided equally between the two. His *Transfiguration* is an outstanding example of an idealized conception achieved by this method, a symbolical play and counterplay of the forces of Here and Yonder.

Correggio retained the distance which Raphael had set between the figures in the foreground of a picture and the spectator, but he forced the distant objects in the picture to come near by eliminating the real distances and thereby swiftly shortening the perspective. Tintoretto and El Greco followed him and it was in their work that the underlying significance of this method became perfectly plain: the conquest of distance through movement, through figures (or things) which are bowed down, are flung up or are coming crashing down. The unreal amalgamation of near and far in the pictures of these masters, however, removes them to an immeasurable distance from the observer: they are unreal in their remoteness from him.

The evolution of these interpretations of space led ultimately to the type of fresco seen in domes and roofs of baroque or rococo churches, which open up a view into heaven. Here the beholder who stands looking up at them can see groups of figures mounting up towards a remote heaven apparently suspended somewhere below the actual dome or roof which, by means of this kind of painting, has retreated into a completely unreal distance from him and is lost to his view. But we cannot now pursue further investigation of what space meant in these instances. Instead it is necessary

to look, however briefly, at landscape painting, for it was there that the problem of distance was most explicitly posed.

Man first became fully conscious of landscape when he experienced the sensation of nearness and distance while looking at nature. This probably took place for the first time in the Christian era when Petrarch climbed Mont Ventoux; which distinguishes his hill-climbing from all the known mountaineering expeditions of the Middle Ages. Petrarch's experience on the mountain led to objects being endowed with a different form of expression and a contrasting significance according to whether they were near or far; and gradually, as a result of the poet's writings, the indisputable predominance of the near, the preference for dwelling on what is usual and familiar and the corresponding inclination of painters to subordinate the distant to the near and to assimilate the two visually, came to an end.

The important difference between nearness and distance as one experiences them is brought out by Leonardo. In contrast to familiar nearness, distance is strange and mysterious, yet also full of promise, and it lures one on to new discoveries and new knowledge. Thus Leonardo deliberately sought out the distant world of the mountains and brought it close to him and to us as something constructed in accordance with some law. Yet he did not go on to make landscape the subject of a picture in its own right because, as a seeker after structures made in accordance with some law, he did not yet appreciate the specific characteristics, the 'nature' of distance in contrast to that of nearness; nor did he grasp the inseparable interdependence of the two.

Dürer, the draughtsman, and such artists as Hans Weiditz and the Brueghels, too, did a great service when they first represented nature in the distance with a feeling for its special qualities. But even so, landscape had not yet won a place as a proper and justifiable motif for a painting. When this did occur in 1600 in Rome and in Holland the peculiar phenomenon of distance played a dominating rôle in both cases. The modern feeling of being remote comes for the first time to the fore in the landscapes of Polidoro da Caravaggio, Elsheimer, Bril, Claude, Poussin, and in the work of Rubens. Nature represented by them does not begin straight away at our feet; a considerable, often a great distance lies between the point where we are standing and that which our eye takes in. Our eye perceives the unity of the distance and we take pleasure in such a view of nature. We undergo a double experience of remoteness in

that we are aware both of the distance between our own existence (circumscribed by nearness) and the objects we are looking at and of the fact that earth is stretching away before us from the middle distance to the horizon. In this way distance became an important theme for pictures. True, many details were still carried over from the traditional way of depicting nearness, but they were now subordinated to what was seen in the distance and concentrated in groups, serving only to enrich the scene with living figures. The foreground alone, which now frequently framed the view like scenery in the wings of a stage, still for some time remained isolated by being represented in a too obvious close-up style, though it was already beginning to lose its plasticity and was being modified by the equalizing light of the distance. The distance between the observer and the view represented was, indeed, still clearly shown as a considerable interval which, though it could not be precisely calculated, nevertheless appeared quite easy to comprehend as an ordinary experience—yet in addition an access into the picture was deliberately held open (in, for example, the work of Claude Lorrain). The distance represented seemed attainable and thus a feeling of communication and a possibility of familiarity was created. The gap between the spectator and the scene depicted in the painting was 'bridged', not eliminated, and was enhanced by precisely the same charm which distinguishes the far bank of a river, lying opposite to us with a bridge leading to it. Only the tragic Ruysdael kept the observer of his landscapes from having any contact with the countryside he was representing, by the unapproachable formation he gave to his foregrounds. In his paintings the distance always appears to be shut away in gloomy sublimity.

And now, in the course of these reflections, we have come once again into the sphere of Cézanne's problems, even if we are still far removed from him in time. The baroque artists were already indicating in their pictures the same abstract relationships in the real world which it is essential to understand in Cézanne's art; nearness and distance in nature, its openness or its closedness, these are, one feels, the very questions which worried Cézanne and to which he endeavoured to find answers.

With the emergence of distant views as subjects of pictures, the organization of the far distance became a problem for the artist. All the solutions adopted for dealing with this problem can be traced back to two basic ideas and to a combination of them. One of these consists of a path or a river making its way into the picture,

growing narrower within the lines of perspective, along which the eye wanders until it reaches the horizon; the other operates by means of bands which lie horizontally across the picture, parallel to the two horizontal edges, and which are set at calculable distances from one another. By means of these ranges of hills or groups of trees or houses, the eye can press on to the horizon, led firmly by the diminution of dimensions, by differences in brightness and aerial perspectives. These two solutions differ radically from one another in their effect and significance. The first gives a friendly invitation, carries one on and stimulates one; the second waits in solemn repose. Like other painters, Cézanne faced this choice of alternatives and his decision, though of a general nature, was one of the first things which had a radical and most profound effect on his art.

In the seventeenth century, painters were still depicting the most remote distance in landscapes in the same way as the middle distance. The eye still finds clear shapes everywhere: the portrayal of the mysterious, dissolving quality of the ultimate horizon had scarcely yet been achieved. One is interested in what lies in the distance, and even allots it an appropriate place in the picture, but one does not yet experience to the full its special significance. Sky and clouds in the pictures of Dutch and Italian baroque painters alike (by comparison with one of Courbet's, such as *Sea and Sky*) are evidence of this. They painted the distance with which they were familiar and not that which was lost in the infinite. It was only the romantics of the eighteenth century who took the latter as a subject for painting.

If we now leap a whole century, however, up to the time of the impressionists, a completely different attitude appears. In Corot we see the first signs of the new, really modern way of seeing the distance, in which each motif is treated as though it lay far removed, even unattainably remote from the observer, with its half-dissolving shapes transformed by the atmosphere (and it is not solely in Corot's late, vague *Moods* and *Memories* that this is so). Here we find that not only is there a preference for distant views of nature, but indeed all views are pictorially transposed into the distance. The light playing over them does not bring them near to us but on the contrary removes them to a distance from us in that it dissolves their outlines and draws them together. Individual contours can no longer be distinguished here, they are only hinted at and they gain thereby in charm and value. In place of descriptive detail, we see picturesque phenomena, inventions of the artist's imagination, evolved from

faintly suggested impressions of nature into a perfect artistic medium. In this way distant views of nature are transfigured and new riches discovered in them. The sally into the unfamiliar ends in complete victory and the victor returns laden with rich booty. One of the greatest discoveries is the type of composition which is still universally regarded today as a 'random extract' from what the eye has seen. Actually it is the very opposite of random, it is as deliberate as any earlier type of composition, it is so designed that it creates an impression of distance, of objects receding into remoteness, which extends in every direction and not only into the depth of the picture. The subject of the picture is changed from 'Distant' into 'More and more distant'. Remoteness has been changed from something static into a movement of withdrawal into the distance.

With this historic phase of the significance of landscape in painting we have arrived at Cézanne's era; and simultaneously our investigations have arrived back at their starting point, the colour blue.

Dominating and carrying the composition, blue alone of all colours maintains in modern times the function of a symbol; or—looked at in another way—blue has become the main colour of paintings of this period, because it is the only colour which still preserves a symbolic value.

As for Cézanne himself, for a brief spell, while he was working under the guidance of Pissarro, he used blue in the same manner as the impressionists. Before and after that period he used it in a different way. For him blue was always an expressive colour, loaded with many possible interpretations—he was, as it were, the heir to memories from earliest times.

But before describing how Cézanne used blue in his mature years it would be appropriate to record a few observations on the actual materials, the blue paints, available to painters in the nineteenth century. They were no longer those known to the Ancients and still used in the Middle Ages and the Renaissance and by the baroque painters. Ultramarine blue was once made from lapis lazuli, a semi-precious stone which was very hard and exceedingly difficult to work. Because of this and because it had to be brought from the valley of the Oxus in central Asia, which was the only place where it was found, it was very scarce and costly: nowadays the perfect substitute is provided by a beautiful synthetic ultramarine. Certain of the blues of the Ancients such as mountain blue and Egyptian blue, with a copper base, are no longer used because they are

incompatible with other paints. The same is true of indigo. On the other hand there are new cobalt colours, cobalt blue and cerulean blue, clear, light shades by comparison with ultramarine with its blackish tinge. Lastly there is the very deep blue, Paris blue, also known as Berlin blue or Prussian blue, an extraordinarily intense blue. Émile Bernard says that Cézanne used ultramarine, cobalt blue and Prussian blue; cerulean blue seems also discernible in the last water colours he produced.

The special qualities of modern blue paints have a bearing on the composition of Cézanne's pictures. Modern blues, in contrast to the lapis lazuli of the Ancients which was so difficult to work, can very easily and advantageously be mixed with green, red, ochre, and so on, resulting in a number of beautiful light shades. From a practical point of view this was indispensable to Cézanne's method of painting.

From the middle 'eighties onwards, in every one of his pictures—portraits, still-lifes or landscapes—blue was the colour common to the shadows of all objects regardless of the colour of the article itself. Whether the object were red, green or brown, yellow, pink or white, all parts in shadow were to Cézanne of a blue shade, based on blue. So he started to paint a motif by applying different blues along the paths where he envisaged the shadows as falling, which formed the framework of the composition. Having applied these blues, he went on to modulate them by contrasts as necessary, or led from them into the colour of the thing itself. So he might take a deep crimson red, or brighter green, dark brown or light shades of ochre and apply them side by side with the blues. At the same time he added depth to the shadows by painting over the first light blues with more blue or with related colours, until gradually distinct forms began to detach themselves from the shadows.

The dominating rôle of blue is especially striking in Cézanne's figure compositions. A particularly good example of this is to be found in his numerous paintings of bathers (*baigneurs* and *baigneuses*) : these are painted from the imagination and so reflect most freely his pure ideas of a picture. Here the rule of blue is unrestricted. The light-coloured bodies and dark trees are alike drenched in blue; sky and water can only gradually be distinguished from foliage; bodies lightly touched with pink and ochre, but blue in the shadows, seem to be suffused by a swelling tide of surging blue. But even Cézanne's later water-colours, painted from nature, are based on a foundation of richly modulating blues.

## Digression on the Subject of Distance

K. von Tolnay[52] was indeed right when he said: 'This blue is not air, but something more, a sort of fluid made of matter, simultaneously solid and liquid, an element in which all substances are assimilated to one another'. In fact the colour blue, which for the impressionists made visible the effect of the atmosphere, for Cézanne signified something supernatural; what Monet, Pissarro or Sisley saw as separating objects from the spectator and from one another, Cézanne felt actually united them to one another and kept them near to the beholder. Yet at the same time it removed them into an unreal, immeasurably and unattainably remote part of existence. Cézanne achieved this effect by taking the blue which formed the framework of the picture and graduating and modifying it from coldest blue-green into a violet which surged towards red, and by using a series of related shades which he distributed over the surface of the picture, letting them sometimes escape into space and sometimes approach out of it. An impressionist picture, in which shapes float and gleam in the light, and which is veiled in a bluish atmosphere, lies always at a certain distance from the beholder, a distance which is known and to some extent familiar from our way of looking at things in the real world: Cézanne placed an object in a colour world which, to use his own expression, was 'parallel' to our real world, but which had not a single point in common with it and which, in Hetzer's previously quoted words referring to the world of Titian, 'displayed the eternal order of the world in all its associations, relationships and connexions'. Blue did indeed create distance in Cézanne's world too, but it also created nearness (and not an impressionistic generalization of phenomena in aerial perspectives), the common ground for all coloration, the foundation of plasticity, indeed of forms themselves. Yet this does not by any means imply that paintings by Cézanne give the impression of having been painted in a blue light. Indeed no light at all appears in them and there is no lighting in them which can be described in any way; the objects depicted, even those receiving the direct rays of a southern sun (as in V.397, Plate 6), exist in a state of shadow, but in this they exist with special, outstanding force. And it is blue, as the colour for shadows, the colour with which it is possible to blend most other colours in harmonious and rich conjunctions (unlike brown, to which it is infinitely superior from the colourist's point of view), which gives definition to this existence based wholly on colour and acquiring its power from coloration. By presenting and exploiting blue as the predominant colour and the basis of all coloration in

conjunction with all the other colours from pure yellow to pure red, Cézanne endowed his colour compositions as a whole with the quality of creating shadow. This is what gives them their special position in the history of painting.

In a representation of the world in which the interrelationships between objects are brought out by blue shadow-paths and all coloration is determined by blue shadow, earth and its creatures are revealed as inapprehensible and inaccessible, because they are from their very nature prisoners of distance. Even what is nearest to everyday is shown as most remote, as something radically cut off from us, on the edge of darkness 'nearest to obscurity' (Goethe's blue!); it is impenetrable to our eyes, however clearly and plastically the details of the objects may stand out.

When one considers the art of Cézanne from the point of view of technique and method, this is the interpretation of it which emerges.

It is in his use of this method that the art of Cézanne exhibits its outstanding greatness, unique in his time, which adds a new phase in the use of blue to the evolution of colorization in European painting. What had earlier taken the entire trend of a period or gradual changes in style to bring about, was now, in a manner characteristic of the nineteenth century, achieved by one individual, who proves himself, when we look back on the evolution of colorization as a whole, to be a star of the first magnitude. (It was precisely in order to demonstrate this that it was necessary for us to trace the history of blue.)

The Middle Ages used blue as the expression of 'the wisdom operating from Heaven, as the miracle of heavenly splendour'; Titian gave it a place in illustrating the 'eternal order of the world'; Poussin used it as a means of establishing the composition of a picture, to hold together nearness and distance, solids with firm limits and space stretching out unlimited—elements of the real world that strained away from one another; the impressionists used it to realize the sensation of the remoteness of the world from their own egos: but Cézanne gave blue a new depth of meaning beyond all these, penetrating to its inmost essence, by making it the basic colour and the foundation of his world of objects 'existing together'. For, when he used blue in this way, he transcended any special connotation which had attached to its former uses. Blue was now recognized as belonging to a deeper level of existence. It expressed the essence and essential being of things and their abiding, inherent permanence and placed them in a position of unattainable remoteness.

# Notes

1. Cézanne adhered to this utilization of pencil strokes throughout his entire life. In a letter written on 9th December, 1904, to Charles Camoin (*Correspondance*, Paris, 1937) he described it very clearly: 'le dessin n'est que la configuration de ce que vous voyez' ('drawing is only configuration', i.e. circumscription of a figure, 'which one has seen', a specification of its position and the amount of space which it occupies). This description is not complete unless we supplement it by saying that drawing is not artistic interpretation and is not the realization of a thing seen.

2. *Exposition Universelle de 1855* in *Curiosités esthétiques*, p. 211, ed. 1900.

3. Quoted by John Rewald, *Cézanne, sa vie, son oeuvre, son amitié pour Zola*, p. 403, Paris, 1939.

4. From a letter to Alfred Sensier, quoted from *Souvenirs sur Théodore Rousseau par Alfred Sensier*, p. 279, Paris, 1872.

5. This explains the peculiar effect of the obvious colour contrasts in Cézanne's pictures. In his book, *Cézanne und das Ende der wissenschaftlichen Perspektive* p. 71, (Vienna, 1938), Novotny remarked very appositely that they (the colour contrasts) 'are not to be regarded as deciding which colours are to be stressed; indeed it seems wrong in Cézanne's case to say that the red of an apple or of a roof, the brightness of a sunlit wall or of a cloud shines out.' Admittedly there are, he continues, 'contrasts between pure colours and broken colour values, or between the values of colours diametrically opposite to one another in the spectrum. Yet no marked artistic effect results in Cézanne's works from the relationships between these colours or between pure and broken colours.'
  'The unifying force which is contained within the majority of colours of different types' was something for which Novotny was incapable of finding a satisfactory explanation. It is produced by the utilization throughout a picture of one persistent scale of colour chromatics. It is by this means too that Cézanne made pure colour appear as an integral part of the series of tones, like a link in the composition as a whole, as in music. Colour has the effect of intensifying stress only when it is shown as a contrast either to another weaker tone or to an overall tonality: but neither of these appears in Cézanne's painting. In his system all colour modulations are of equal value, as in a musical scale, and differ from one another only on account of their 'position' in relation to the keynote, i.e. by the interval between them and the keynote.
  In the same context (p. 72, footnote), Novotny also rightly says: 'no essential significance can be attributed in Cézanne's painting to the differentiation between the values of pure, strong colours set directly next to one another and quite distinct colours. Apparent colourfulness and apparent tonality alike are both only substance in which the superordinated quality of a purely colouristic interrelationship of colours has become effective.' This is equivalent to saying that in these cases Cézanne used colour chromatics of varying breadth (or narrowness) but in both cases the same kind of colour series, namely the chromatic scale.

6. Maurice Denis, *Théories*, 4th edition, p. 258, 1920, reports a conversation in which Cézanne said 'I want . . . to do with colour, what one does with a *tortillon* in black and white work', and as he spoke he traced on his clenched fist the transition from light to shade.

7. Émile Bernard gave a rough description of this procedure, though not a very exact one: 'He started with shadow, in fact with one patch of colour. This he then covered over with a second, larger, one and then a third one, until all the shades together formed a veil and modelled the object with their colourfulness.'

8. These shadow-paths are simply what Novotny described (in *Cézanne und das Ende der wissenschaftlichen Perspektive*, p. 87) as 'the veins of the picture's design, often only faintly visible, though frequently on the contrary extremely plain, but in every case intensely effective' and of which he noted that 'sometimes

# Notes

they seem not to have any direct connexion with the forms of the objects but often on the other hand they are actually covered over by the contours.' The latter is the case when the shadow-paths coincide with the bounding shadows of any object.

9. *Cézanne und das Ende der wissenschaftlichen Perspektive*, p. 73.
10. Ibid., p. 80.
11. Ibid., p. 76.
12. Chevreul, *Loi du contraste simultané des couleurs*, 1839.
13. Maurice Denis, in 'L'Aventure posthume de Cézanne' in *Prométhée*, VI, 1939, writes: 'He emphasizes none of the contrasts so dear to the sun-painters, and does not bother about Chevreul's discoveries.'
14. At different times Cézanne set a different depth of tone for the shadow framework of his pictures, so that the overall impression varies and the effect is sometimes lighter, sometimes darker (and thus more full of colour). He also utilized colour intervals of varying size. These differences do not, however, affect the procedure he normally followed in constructing a picture.
15. Quoted by Rewald, *Cézanne, sa vie, son œuvre, son amitié pour Zola*, p. 404, Paris, 1939.
16. It is not possible to use colour reproductions to illustrate the explanations which follow—present day reproduction techniques have not reached a sufficiently advanced state to illustrate the finer points concerned.
17. Émile Zola, *L'Œuvre*, p. 163, ed. 1909.
18. Ibid., p. 166.
19. Ibid., p. 201.
20. Ibid., p. 331.
21. In *L'Ermitage*, 15th November, 1905, reprinted in *Théories*, p. 204.
22. J. Rewald, *Cézanne, sa vie, son œuvre, son amitié pour Zola*, p. 409, Paris, 1939.
23. 'Cézanne's Technique', *L'Amour de l'Art*, December, 1920.
24. Warm = brown = earth and nearness.
25. Cold = blue = sky and distance.
26. The Greeks expressed this contrast with the words κυάνεος blackish-blue and γλαυκός, light, radiant, brilliant blue, both of which can be found in Sophocles and Euripides.
27. *Farbenlehre*, paragraph 779, Vol. I, 1810.
28. Ibid., paragraphs 780–82.
29. Kandinsky, *Über das Geistige in der Kunst*, 2nd edition, p. 77, Munich, 1912.
30. From *Die Zeit der 'Fröhlichen Wissenschaft'*, 1881-82, Aphorisms 366 and 390.
31. Grete Ring, *A Century of French Painting*, Introduction p. 24, London, 1949.
32. *Farbenlehre*, paragraphs 915 and 916.
33. Diederich's edition, IV, pp. 55-56, Jena, 1907.
34. According to Walter Steinert, *Ludwig Tieck und das Farbenempfinden der romantischen Dichtung*, Dortmund, 1910.
35. Cf. Gottfried Haupt, *Die Farbensymbolik in der Sakralenkunst des abendländischen Mittelalters*, Dresden, 1941.
36. Fritz Haeberlein, 'Grundzüge einer nachantiken Farbenikonographie', *Römisches Jahrbuch für Kunstgeschichte*, III, Vienna, 1939, p. 77 et seq.
37. According to Ernst Berger, *Die Maltechnik des Altertums*, p. 261, Munich, 1904.
38. Cf. Theodor Volbehr, 'Das Rätsel der blauen Farbe,' *Augsburger Neueste Nachrichten*, 1st June, 1931.
39. Ernst Pfuhl, *Malerei und Zeichnung der Griechen*, Munich, 1923.
40. Haupt, *Farbensymbolik*, pp. 100-101.
41. The juxtaposition of the colours chosen for light, i.e. gold and blue, was used as long ago as 3000 B.C., in the bull of Ur of the Chaldees. It is true that it has been suggested that this was due solely to the rarity and costliness of the materials used, but it is more probable that gold and lapis lazuli owed their costliness not to the difficulty of procuring them but to the significance attributed to them; in other words, that people made efforts to acquire these substances solely on account of the symbolical significance which was felt to emanate from their mysterious brilliance.

42. Haupt, *Farbensymbolik*, p. 102.
43. Ibid., p. 106.
44. Ibid., p. 105.
45. See Fritz Haeberlein, pp. 77–126.
46. J. J. Tikkanen, *Farbengebung in der mittelalterlichen Buchmalerei*, published by Tancred Borenius, Helsingfors 1933.
47. Quoted by Tikkanen, according to J. v. Schlosser, *Quellenbuch zur Kunstgeschichte*, p. 234.
48. Schmarsow, in his description of the Jesse window of Chartres Cathedral already made the point: 'The light blue ground (the sky) of the tree, determined the choice of colour for the whole of the rest of the picture'. In *Kompositionsgesetze frühgotischer Glasgemälde*, p. 6, 1918.
49. Theodor Hetzer, *Tizian*, p. 27, Frankfurt am Main, 1935.
50. No one has yet made a historical survey of the exploitation of colour contrasts or even an attempt to indicate the history of changes in the style of using them. It is easy to realize that different colours have been felt at different epochs as being connected with each other just because they are contrasts and one cannot use as a criterion the 'sympathy or antipathy' naturally inherent in colours, or the natural colours of the rainbow, or the colours produced by the palette of any particular epoch. The colour contrasts used in art originate in the 'humours' of races and individuals and their attitudes towards different colours. What determines their juxtaposition in works of art is something pre- and extra-artistic, viz. the fact that they correspond to interests and sentiments which are favoured. For example, it has been possible to demonstrate that the juxtaposition of blue, green and yellow (= gold), predominant in Roman art, was taken over from landscapes of Paradise as portrayed in pre-Christian times; and the conjunction of the contrasting colours red, blue and orange, which was popular right into the height of the Middle Ages, had its origin in the representations of sunrise which occurred as a symbol of Christian redemption as early as the seventh century.

Similarly, to take an example from a quite different era, Goethe called yellow and blue an 'ordinary contrast', which merely evoked excitement, whereas he called the contrast between yellowish-red (orange) and bluish-red (violet) a 'noble' one, because it arose out of 'intensification' or 'enhancement'. In a note dated 2nd October, 1805, he gave the following elucidation: 'Anything which enters into our field of vision must divide itself up merely in order to be seen. The parts divided then seek each other again and can find each other and be reunited; if they do this at a low level they get mixed only with their opposites and come together with them, with the result that what is seen is cancelled out and becomes zero, or at least neutral. Unification can, however, also occur at a higher level, i.e. the divided parts are first intensified and thereafter by means of the conjunction of the intensified degrees they produce a third, new, higher and unexpected thing.' (According to Rupprecht Matthaei, 'Mein Weg zu einer Beurteilung der Farbenlehre Goethes', in the *Hamburger Akademische Rundschau*, 1941, Nos. 8–10.) How certain colour contrasts came to be preferred is explained here as depending on a mixture of philosophical and scientific speculation. And surprisingly enough, though all this is remote from Cézanne in both time and space, one need only think for a moment of some of his later works in order to find that this theory perhaps contains a hint as to how to elucidate and interpret their greatness.

At all events a contrast between colours used by an artist contains within itself not only a natural antithesis, but also a relationship between the colours, a leaning towards one another and a mutual challenging; it is only because this is so that it is possible to use contrasting colours for the purposes of composition and construction of pictures. However, quite apart from the atmospheric values of the different colours used, their lightness (or darkness, as the case may be) and the quantity in which they are used also play an important part for this purpose.

51. Alongside Titian's symbolical colorization we find the allegorical use of colours also still maintained, namely in allegorical figures, of which Cesare Ripa in his *Iconologia*, 1611, gives a list. In this 'painters' dictionary' blue is recommended as the appropriate colour for the robes worn by the figures representing Astrology, Goodness, Poetry, Steadfastness and also Inconstancy. It is usually pointed out that sky-blue is particularly suitable for these personifications; but in the case of the turquoise-blue cloak of Inconstancy alone it is explained that the choice of this shade is motivated by the fact that it resembles the hue of the fluctuating waves of the sea. These cunningly elaborated connotations, however, have nothing to do with the real symbolism of colours, which follows another path.

52. K. von Tolnay, 'Zu Cézannes geschichtlicher Stellung', *Deutsche Vierteljahrsschrift für Literaturwissenschaft und Geistesgeschichte*, IX, Halle, 1933.

# CHAPTER II

# The Cardplayers

On five different occasions Cézanne made a group of cardplayers the subject of a painting and the result of these persistent endeavours is a series of five pictures which are among the most important works of his later years. To quote Dorival: 'Cézanne never produced anything better than these five masterpieces: at all events he never approached the essentially classical more nearly in any other work'.

If for no other reason, these pictures are conspicuous because their composition is identical and unchanging: what distinguishes them from one another is the progressive compression, condensation and concentration of the motif in each one. Such a procedure was not Cézanne's normal way of working. True, he frequently painted the same subject over and over again, but rarely the same composition. He did not repeat his pictorial inventions. If he portrayed any person or landscape twice, he constructed a new pictorial motif for each version. Even when he moved the position of his easel only two paces, as when he was painting the Montagne Sainte-Victoire, he composed a fresh design each time. In a letter dated 8th September, 1906[1], he actually drew attention to this himself: 'Here, on the bank of the river,' he wrote, 'new motifs are forever offering themselves; the same subject seen from a different angle presents (each time) a study of the greatest interest and indeed so different each time that I think I could find enough work to keep me busy for months (here) without moving from the spot, simply by inclining a little to the right one time and to the left another'. It was a different matter when he was pursuing some invention of his imagination—with him this meant some memory—which he wanted to paint. Then he would experiment again and again with individual figures already established by earlier studies, grouping and regrouping them in an effort to discover the ideal way to present some whole which was evidently floating somewhat vaguely before his mind's eye.

# The Cardplayers

This was his procedure in his many pictures of people bathing, paintings in which he was intending to immortalize and transfigure some youthful memory. Letters from his friends in Aix prove that these pictures originated in actual experiences; and studies and sketches still extant demonstrate quite clearly how he gradually transposed an actual experience into an ideal representation—beginning with men in bathing-trunks observed in a roughly naturalistic manner and ending with unclothed bathers; and how, partly under the influence of paintings in the Louvre and partly as a consequence of his own erotic development, he then used naked women to realize this ideal representation. Yet the significance of the motif remained the same throughout: the notion of happiness attained in a Hesperidean existence. Cézanne produced so many variations on the theme that it is easy to trace the transition from the pictures based on memories to the creations of his imagination. We may be absolutely certain that, in any event, the *Baigneusès* was not a portrayal of something actually seen. Cézanne could not possibly have seen naked women bathing in a river; but it is extremely probable that he himself bathed frequently as a boy and as a young man with his friends in the river Arc—beneath the huge tree which also persists as a motif in his pictures and is also a memory-picture, although it appears in a variety of forms[2]. Bathing and lying on the river bank were among the happy experiences of Cézanne's youth.

In the case of *The Cardplayers*, however, the circumstances are quite different. The five versions of this theme are based on one single idea: it does not vary according to the context and there is nothing vague about it. Moreover, these pictures are not five different conceptions of people playing cards—on the contrary all the pictures have one and the same subject which is at first presented in great detail and then gradually reduced until finally only the essentials are left.

Lionello Venturi[3] agrees with Vollard[4], whose statements are often not to be relied upon, in dating the five pictures between 1890 and 1892. It seems more probable, however, that Cézanne worked[5] at them over a longer period of time. For one thing, they differ greatly in their handling of paint and in their construction; then again, they fall into two groups, for each of which different models are used. It is reasonable, therefore, to suppose that after his first attempts Cézanne abandoned the subject for a while, and then took it up a second time when the original models were no longer

available to him. In the three later versions only two figures are portrayed, one of which is Père Alexandre, a gardener employed at the Jas de Bouffan, the country house acquired by Cézanne's father, which appears so frequently in his paintings. This property was not sold till 1899, so it is at least permissible to date *The Cardplayers* between 1890 and 1899, ascribing the first series to the beginning and the second to the end of the decade. On grounds of style, too, the idea of their having been painted over a period of ten rather than two years commends itself, because of the formal differences evident in the pictures. In the earliest versions the figures have that 'classical' clarity which Cézanne evolved in the 'eighties; the later representations of the theme, on the other hand, are akin to the male portraits of Cézanne's late period of which the most outstanding example is the figure of another gardener, old Vallier, who was employed at the studio built in 1902 in the Chemin des Lauves.

It is generally accepted that Cézanne painted the large canvas (V.560, Plate 8), a composition of five figures, one of which is a child (Barnes Foundation, Merion, U.S.A., $52\frac{3}{4}''\times71''$) first and that the version with four persons followed, the child being omitted (V. 559, Plate 9, Collection of Stephen C. Clark, New York, $25\frac{1}{2}''\times32''$).

In the second group (V.556, 557 and 558), the composition is restricted to two men seen in profile sitting on either side of a table. Once again Cézanne seems to have started with a relatively large canvas (J. V. Pellerin, Paris, $38\frac{1}{4}''\times51''$, Plate 10). Later he painted two smaller ones (Courtauld, London, $22\frac{3}{4}''\times27\frac{1}{4}''$, Plate 11; and the Louvre, Paris, $17\frac{3}{4}''\times22\frac{1}{2}''$, Plate 12).

There is a great deal to be said for this chronological order, even though its accuracy cannot be positively proved. It is based on fine distinctions of style in the pictures and also on the visibly increasing withdrawal and alienation of the painter from his models[6]. It is as though he were detaching himself more and more from the tangible reality of their faces and while doing so succeeded in bringing out all the more forcibly a certain mental attitude, a secret and solemn expression; as though he had broken through from their outer appearance to something more essential which arises out of their being together.

For each of these pictures Cézanne made a number of different studies, both drawn and painted. Venturi has recorded eight (V.563, 566, 568, 1085, 1086, 1088, 1482 and 1483). Vollard, in 1914, reproduced a ninth and there was a tenth in a London art-

dealer's in 1950[7]. As can plainly be seen, these preparatory studies belong in part to the earlier and in part to the later groups of cardplayers (Plates 13–16).

So far as I can see, Roger Fry[8] has made a more detailed study of these pictures than any other critic. He describes them as 'the only definitely *genre* pieces of his that exist . . . [a] subject . . . which he evidently studied in some humble café in Aix'. Fry must have believed that Cézanne actually painted *The Cardplayers* in this café, for he continues: 'Here perhaps was the only opportunity possible to so nervous and irritable a man as Cézanne. . . . He could rely no doubt on the fact that these peasants took no notice of him.' Fry goes so far as to assume that Cézanne had found it possible to paint all the various versions of *The Cardplayers* in this inn parlour. Of the effect of these pictures he writes: '[they give] us [an] extraordinary . . . sense of monumental gravity and resistance—of something that has found its centre and can never be moved . . .' Of the second series Fry says: 'The simplicity of disposition is such as might even have made Giotto hesitate to adopt it. For not only is everything seen in strict parallelism to the picture plane, not only are the figures seen in almost as strict a profile as in an Egyptian relief, but they are symmetrically disposed about the central axis. . . . . The feeling of life is no less intense than that of eternal stillness and repose. . . . These figures have indeed the gravity, the reserve and the weighty solemnity of some monument of antiquity.'

That is certainly an extraordinarily good and apposite description. But it tends to make us doubtful about Roger Fry's first hypothesis. Cézanne cannot possibly have painted these pictures in a restaurant or even have lit upon the theme there. Even had he not been as irritable as he in fact was, he could not have executed such detailed pictures in a place of that kind; nor could he have improved from picture to picture in the way he actually did. Such improvement postulates long contemplation and much mental work on the subject. Then again, it is known that Cézanne painted slowly and with long pauses and that he often meditated for a long time even during the actual work of painting. Moreover, he required motionless models. Last of all, he was not an observer of everyday life. He had not the slightest interest in what peasants did or how they behaved: and for that matter it can hardly be claimed that the pictures of the cardplayers do much to enlighten us about the activities or attitudes of peasants.

# The Cardplayers

In addition, Fry's supposition is incompatible with the evidence of Paul Alexis and Georges Rivière, who declare that Cézanne produced *The Cardplayers* (and the portraits of individual peasants) at the Jas de Bouffan[9].

By and large, however, this is not an important point. In his analysis Fry has touched on something much more fundamental. He calls *The Cardplayers* series *genre* pictures. So far as the subject-matter is concerned he has a perfect right to do so: on the other hand he described them—extremely aptly—as 'monumental'. There is obviously a contradiction here: an internal antithesis, apparently inherent in the pictures themselves, is revealed. A *genre* picture is characterized by the unimportance of the subject-matter portrayed. Since the seventeenth century, at least, it has been usual for this type of picture to depict an unimportant moment in the lives of persons who themselves have no claim to universal attention. In the very contrast between such twofold insignificance and the richness of form, colour and lighting exhibited in a *genre* picture lies its essential charm and its real subject. There may in addition be a display of costly stuffs, in the form of clothes and draperies, or a confused array of a number of objects used in everyday life—in brief, picturesque elements which give the artist an opportunity to scatter attractive colours around in a lavish manner. Pictures of this kind call for delicate perception, or a fund of wit and humour, on the part of the painter. Any idea of 'monumental gravity' is out of the question. True, we find Jakob Burckhardt in his guide[10] to Raphael's *Fire in the Borgo* (*Incendio del Borgo*) calling it 'the most tremendously stylish *genre* picture in existence. The portrayal of people in flight, some rescuing others, some helplessly wailing . . .'; and Crowe and Cavalcaselle say of Titian's picture of Emmaus in the Louvre that it is 'a *genre* picture in a monumental setting, a mixture of the most commonplace and the sublime'. Yet in both these cases the incident depicted is in fact far from insignificant and the picture is therefore not a true *genre* picture. In Daumier there are *genre* scenes in which the principal actors are colossal figures and the humorous is liable to change suddenly into the horribly grotesque —acrobats of the stature of Michelangelo figures supping soup. But the fact that they are colossal does not make them monumental.

On the other hand, Cézanne's cardplayers are impressive, and what makes them so is the very manner and way in which they are absorbed in their insignificant occupation. What they are actually

doing, frozen into motionlessness on the canvas, is completely transcended by their seriousness and their dignity.

Is Cézanne being an innovator in this instance as in so many others? Is he opening up new paths here too? Or do *The Cardplayers* gain their monumental quality—so inconsistent with their theme— from the fact that they are only apparently *genre* pictures and that despite the insignificance of their subject they nevertheless portray something significant which is concealed behind the mask of the *genre*[11]? To put the question more precisely and in terms which fit Cézanne's case particularly: are they perhaps in fact reminders of Cézanne's past, memorials of some great experience in his youth as were the monumental *genre* scenes of *Les Baigneurs*, and his represent- ations of the enormous tree which he magnified into something of heroic dimensions?

There is in existence a document written in Cézanne's own hand which suggests this may be so.

This document is a letter which Cézanne wrote to Zola on the 17th January, 1859—two days before his twentieth birthday. It consists of verses and prose, illustrated by a drawing. *Now, this pen sketch bears an astounding resemblance to the earlier versions of* The Card- players, *both as a whole and in certain important details.* The clumsy, childish sketch (Plate 7) is in two parts. In the righthand half we see five persons grouped round an oval table; two, who are seated, are seen in profile, disposed fairly symmetrically about the central vertical axis; three others, of whom it is impossible to say whether they are sitting or standing, are placed between them, behind the table. The figures in profile are clearly more important than the three dwarfs, or children, in the middle. The lefthand half of the picture shows two bearded men who have entered by a door and are looking at the group at the table.

There can be no question of subjecting this drawing by the youthful Cézanne to criticism as a work of art. Nevertheless it is worth while noting various details in it. For example, the figures, the chairs and the table are unfinished; each of the two principal (seated) figures has one leg missing, while the figures at the back have no legs at all. Admittedly the bodies are stiff, the clothes are shapeless and the draughtsman has only an extremely confused idea of perspective, but the movement depicted in the picture is eloquent and a strong feeling for composition asserts itself. The group at the table is disposed in a plane strictly parallel to the surface of the picture: this point and the symmetrical disposition deserve

to be given prominence, for they anticipate features noted by Roger Fry in the later pictures. So it seems at least possible that these characteristics of *The Cardplayers* may be traced back to Cézanne's youthful sketch. This supposition is strengthened by several other points of correspondence. First of all, a very striking and important combination of lines, which recurs in *The Cardplayers,* is to be seen in the lower part of the righthand half of the picture; it is formed by the contrast between the interdependent perpendicular table legs and the lower parts of the legs of the seated men which are stretched out in front of them and together form a V. The antithesis between vertical and diagonal lines is very deeply felt and is explicitly stressed both in the drawing and in *The Cardplayers*; it is used as one of the main patterns of the whole composition in the drawing and also in the first versions of *The Cardplayers* (V.560 and 559). In the paintings the V, framed by the two uprights under the table, serves to give a sort of organization to the particularly difficult part of the composition underneath the table. At the same time the V draws the eye from the side figures to the middle figure. The use of the combination of lines in this way proves that it has become an independent artistic creation, an element of the design, which was indeed originally produced in association with certain figures but has now freed itself and leads its own life in the artist's imagination. In the course of its evolution it persists in asserting itself, despite various changes which take place in other parts of the design; yet it also fits in with other figures to suit the requirements of the artist as his intellectual powers increase.

To anyone not familiar with the mental habits peculiar to painters and draughtsmen (people who think in pictorial lines and shapes), or to anyone who does not realize the importance to a painter of freely created patterns in composition, all this may seem trivial, and merely the result of a realistic disposition of objects. This disposition may even appear to him to be completely natural, simple and without special significance, something everyday and ordinary. In fact, however, it is anything but ordinary for people in real life to take up a position which is completely symmetrical in relation to an axis, still more so that two persons should sit in an exactly symmetrical relationship to one another. It is even more unusual for the symmetry of a position of the legs to be noted as a special pattern and used by a painter; still more, for it to be given an important position in a picture and to be used with such a powerful effect. (One has only to imagine the slanting legs in the drawing or

in the paintings being replaced by two vertical lines or by asymmetrical shapes to see that the whole composition would thereby lose its most important unifying element.) One may search in vain for another picture in which this pattern appears so clearly and emphatically. Thus the occurrence of this arrangement of figures in Cézanne's youthful drawing is in itself striking enough: it indicates that he already had a strong perception of design, a capacity to translate and transform impressions of reality into eloquent compositions, long before the stage when a painter's imitative powers start to develop. And this is so great an achievement that it can remain stamped for the rest of his life on the mind of a man who, being a painter, thinks in pictorial shapes.

### Digression on the Subject of the Picture entitled *Mardi Gras*

In case there are some sceptics who still doubt this explanation let me draw their attention to the fact that the V of *The Cardplayers* is not the only combination of lines preserved in Cézanne's memory and used in the composition of one of his pictures. A glance at the *Mardi Gras* picture (V.552, Plate 19) offers us two further examples. One such line formation underlies the arms of the white pierrot, the second the lower parts of the legs and the feet of the harlequin. These feet and legs have always been a stumbling block for those who have sought to use accuracy as a criterion in judging Cézanne's art; oddly enough the pierrot's arms have not been subject to the same criticisms, though they would deserve them if judged by the same criterion. For they too are completely 'wrong' and their size in particular is not correct in relation to their position in the depth of the picture. This is, however, precisely why together they grow into a free outline in the picture plane and gain enormously in power, just as it is the outsize feet of the harlequin, in line with one another, which lend full weight to his arrogant stride. In both cases it is because two-dimensional shapes are used that they offend against accuracy; but their firm construction and their power of expression were more important to Cézanne than any easily achieved fidelity to nature. And in both cases these patterns or outlines of figures can be traced back to inventions of Cézanne's youth.

Like the V of the cardplayers' legs, the position of the pierrot's arms can be indicated by a Latin capital; they form a rough T, a horizontal beam supported by a vertical one. Now, Cézanne had

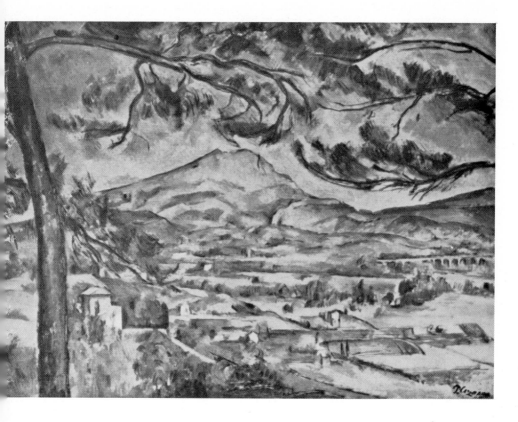

La Montagne Sainte-Victoire, 1885–87 (V. 454) $26^3/_8'' \times 36^1/_4''$,
*National Gallery, London*

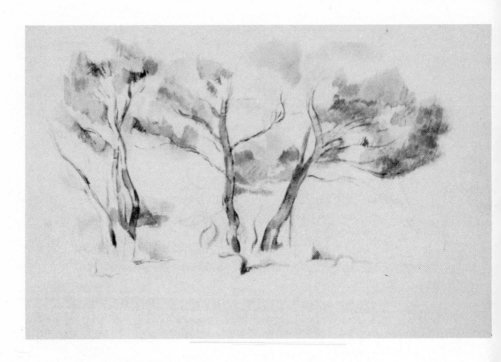

2   Trees agitated by the Wind (water-colour), 1895–1900 (V. 983),
*Swiss private possession*

3　Still-life, 1906 (V. 1154), 18$^1/_2''$ × 24$^1/_2''$,
*Collection of Paul Cézanne (son of the painter), Paris*

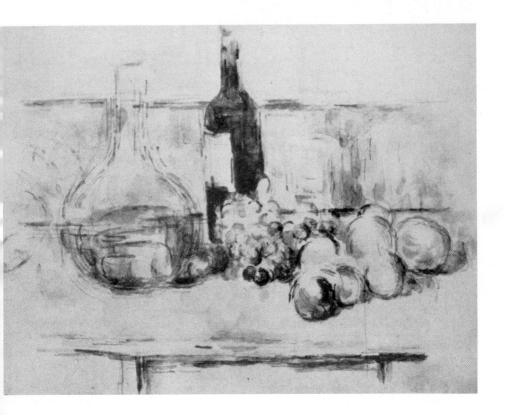

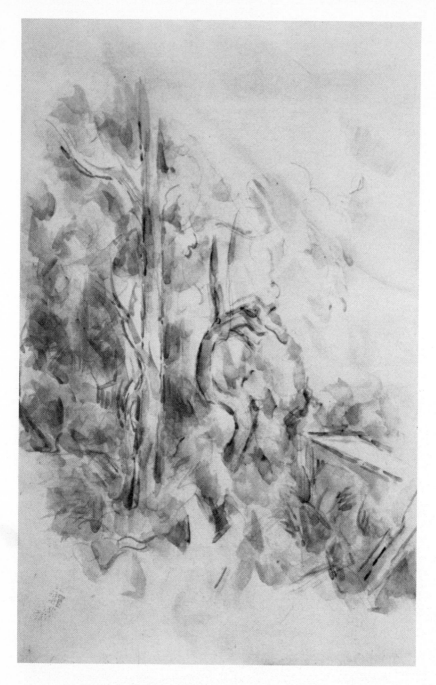

4 In the Park of the Château Noir, 1900–1906 (V. 1038), 18″ × 12″,
*Collection of E. M. Remarque, Ascona*

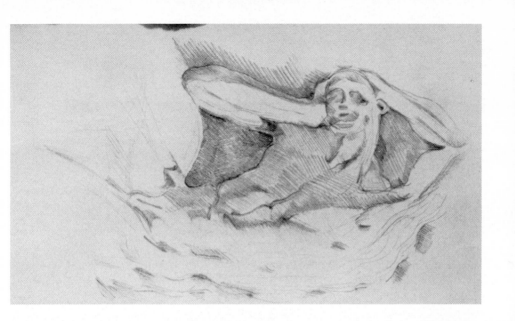

5   Page **XXIII** of a sketchbook (L'Écorché),
*The Art Institute of Chicago*

6   Houses at L'Estaque, 1882–85 (V. 397), $25^1/_2'' \times 32''$,
*Collection of Marius de Zayas, New York*

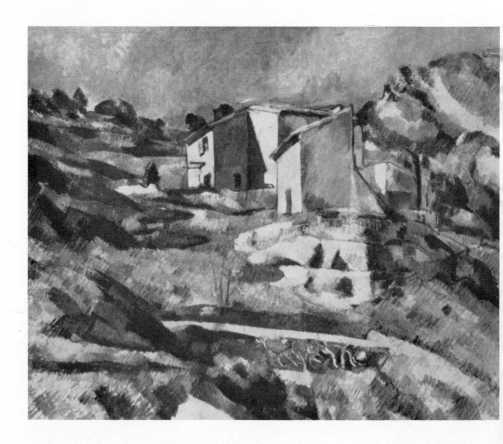

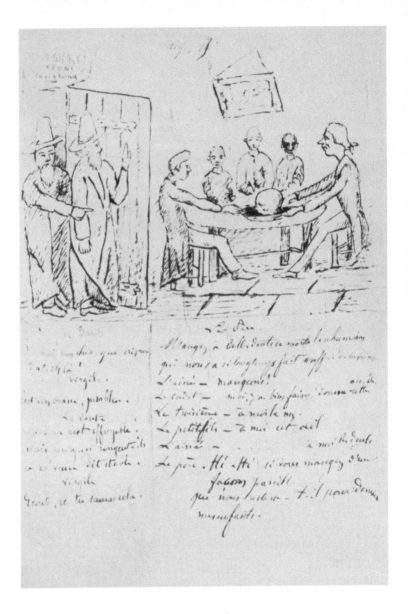

7 Scene in Hell (the 'Ugolino drawing'),
*Collection of J. Leblond, Paris*

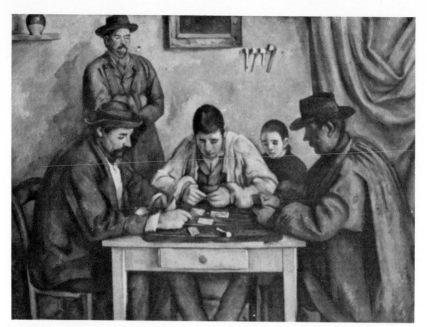

8   The Cardplayers, 1890–92 (V. 560), 52³/₄″•× 71″,
    *Barnes Foundation, Merion, USA*

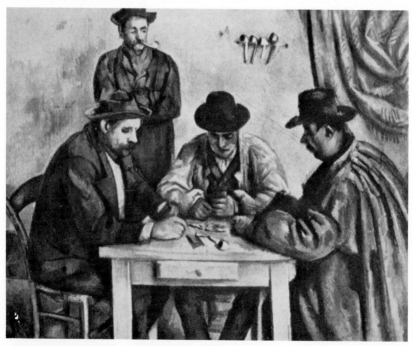

9   The Cardplayers, 1890–92 (V. 559), 25¹/₂″ × 32″,
    *Collection of Stephen C. Clark, New York*

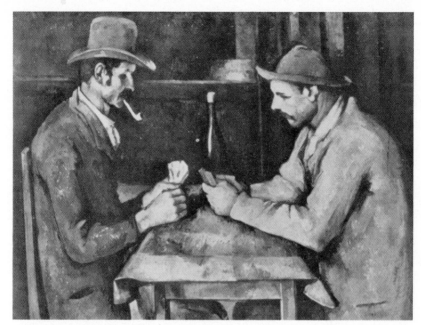

10   The Cardplayers, 1890–92 (V. 556), 38¹/₄″ × 51″,
*Collection of J. V. Pellerin, Paris*

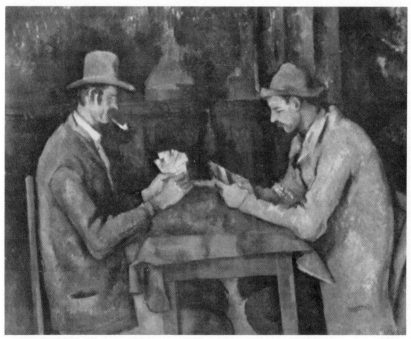

11   The Cardplayers, 1890–92 (V. 557) 22³/₄,″ × 27¹/₄″,
*Courtauld Institute, London*

12   The Cardplayers, 1890–92 (V. 558), 17³/₄″ × 22¹/₂″,
*Louvre, Paris*

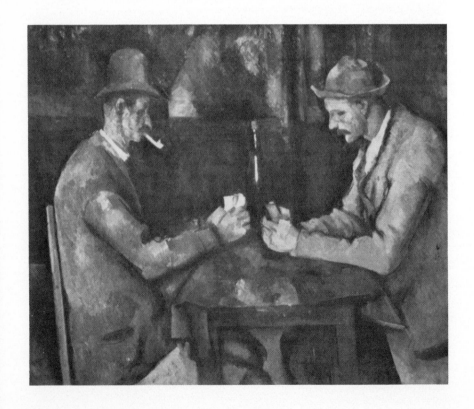

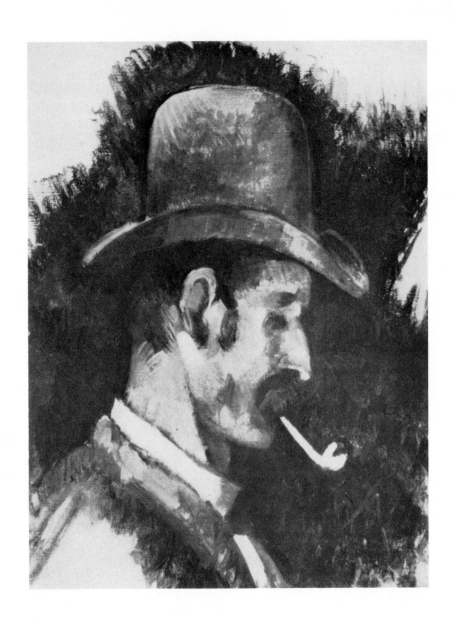

13 Man with Pipe, study for 'The Cardplayers', 1890–92
(V. 566), 10¹/₄″ × 8″,
*Marie Harrigan Gallery, New York*

16  Study for 'The Cardplayers', 1890–92 (V. 1086), 19″ × 14¼″
Museum of Art, School of Design, Providence, R.I., USA

17  French School: attributed to Louis Le Nain, 'The Cardplayer
Musée Granet, Aix-en-Provence

14  Man Smoking, study for 'The Cardplayers',
1890–92 (V. 1483), 10½″ × 10¼″,
Boymans Museum, Rotterdam

15  Study for 'The Cardplayers',
Formerly Matthiesen Ltd., London

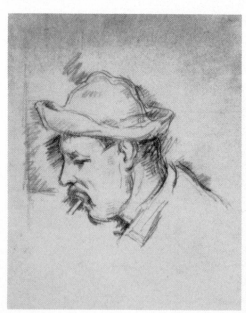
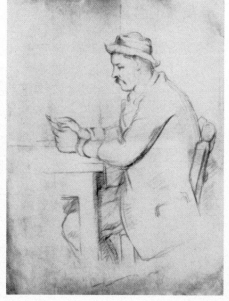

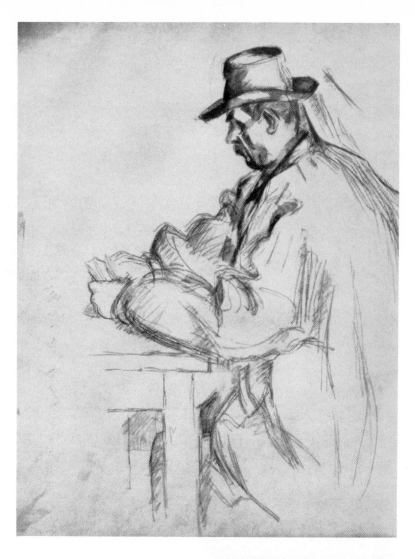

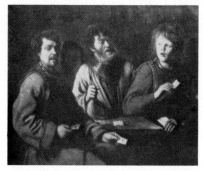

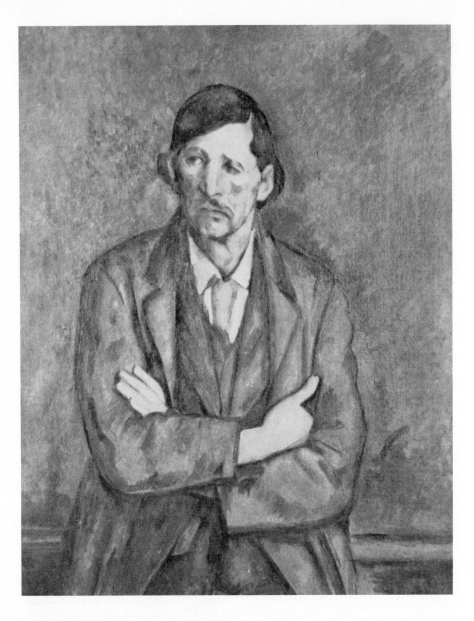

18　Man with his Arms Crossed, 1895–1900 (V. 685), $26^1/_4''\times28^3/_4''$,
*Collection of Carleton Michell, Annapolis, Maryland, USA*

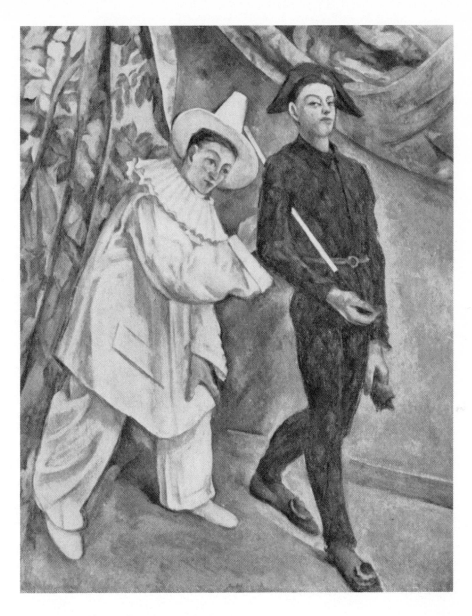

19    Mardi Gras, 1888 (V. 552), 39³/₈″ × 31⁷/₈,
*Museum of Modern Western Art, Moscow*

20    The Conversation, 1872–73 (V. 231), 17³/₄″ × 21¹/₄″,
*Collection of J. V. Pellerin, Paris*

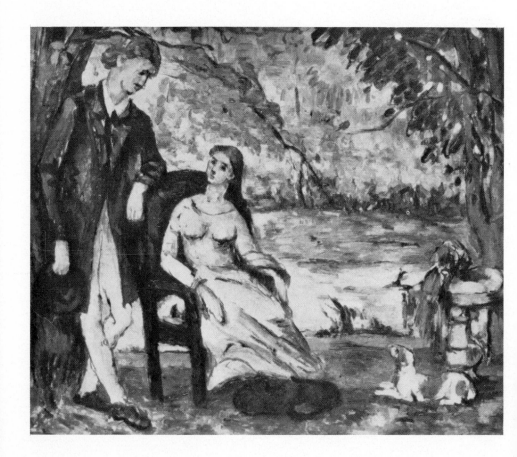

## *Digression on the Subject of the Picture entitled* Mardi Gras

already discovered this outline in the drawing of 1859, of which we have just been speaking: he used it in the arms of the two men standing in the lefthand half of the picture; and just as the V-shape of two figures in that drawing was transferred to *one* person in the paintings of *The Cardplayers*, so the T-outline of the two men in the sketch was transferred to the one figure of Pierrot in the *Mardi Gras* painting. Though contained in one figure, this T-outline nevertheless remains an element of the composition of the picture as a whole, as it was in the drawing too—an eloquent link between two persons. In the drawing it indicates that the second of the two men with pointed hats[12] is pointing out and explaining the group at the table to the first; in the *Mardi Gras* picture it indicates that Pierrot, who is slinking up in a half-bent posture, is probably just about to snatch Harlequin's wooden fool's sword from him.

Cézanne's son has said that this picture was in fact painted in Paris in 1888 when he himself served as a model for the figure of Harlequin, while Louis Guillaume posed for Pierrot. Does this work—a large canvas, 39″ × 32″—owe its origin to some carnival mood of the painter? Does it represent a carnival scene? Or is it something more than that, something quite different, once again the reflection of personal experience or a disguise for it, the expression of some situation which had a special significance for Cézanne? Did he perhaps paint his son here in this proud pose as a substitute for himself? And does the figure slinking up from behind represent someone who was hostile to Cézanne himself and who sought to snatch the symbol of his dignity and thus his dignity itself from him? For the moment let us defer replying to the question whether any such interpretation is admissible. Let us instead simply record at this point that Cézanne had a great affection for the figure of Harlequin—which he portrayed on many occasions.

Now the second of the figure-formulae invented by the youthful Cézanne and found in *Mardi Gras* is contained in this very figure of Harlequin—namely in the feet. The outline which they make can be seen in an earlier painting *La Conversation* and in a sketch which goes with it (V.231, Plate 20 and V.1212), which must have been executed between 1872 and 1875. This particular work is one of the first of Cézanne's 'idylls' and belongs to that group of extremely personal confessions which the artist confided to paint from time to time throughout his life, despite the fact that his was a reserved nature, apparently interested in painting only for painting's sake. These visions of an imaginary happiness, the very opposite of

95

Cézanne's own real life, were sketched in various states of mind, at one time with brutal sensuality, at another, by contrast, with chaste tenderness, but always with a completely transparent symbolism. Other pictures belonging to this group are *L'éternel féminin* (V.247), *L'Après-midi à Naples* (V.224, 112) also 232, 104, 107 and *La Partie de Pêche* (V.230), which shows an angler watched by a dreamy young girl. In the particular picture we are discussing here, *La Conversation*, we see a young couple under trees on a river bank; the lady is sitting on an armchair upholstered in red, the gentleman is standing beside her, his left hand leaning on the arm of the chair. They are chatting to one another in a pose which looks as though it had been arranged by some provincial photographer, commissioned to display the happiness of two newly married people. But—and in our context this is what matters—the lower part of the legs and the feet of the young man are fixed in the same pose as those of Harlequin in *Mardi Gras*, which, like the V and the T, can also be described as a geometrical outline presented in a plane. In this case the outline consists of two intersecting curves which rest on a base, a straight line inclined at an angle and running down from the left towards the right.

Memories of linear and surface patterns like these, first discovered by Cézanne in his youth, can often be traced in his later works: for example, the trees inclining towards one another in the *Grandes Baigneuses* (V.719), on which he worked in the last years of his life, had already appeared with three nude female figures in a small sketch (V.270) which must have been executed in the 'seventies.

## The Cardplayers (continued)

Let us now return to *The Cardplayers*. The heavy table, standing on stout legs, is oval in the drawing, but rectangular in all the painted versions of the subject. Throughout all these pictures, from the earliest drawing onwards, this table is given great prominence—in contrast to the treatment of similar subjects by other painters. There are other points of conformity too, in the various versions, which are significant just because they relate to the less important parts of the composition. For instance, in the middle of both the drawing and the version with five figures, there is a framed picture on the wall of the room, and in both these versions the top lefthand corner is emphasized—in the painting by a vase, and in the drawing by a cartouche with an inscription.

# The Cardplayers (*continued*)

All in all, then, it is true that all the component parts and all the essential linear features of the drawing have been carried forward into the first painted version of *The Cardplayers*. To this we must add the curtain, an item which Cézanne learned how to exploit to the full only later in the course of his artistic development. We must also add one figure which was extended to the top edge of the picture in order to break up its rigid symmetry; this also could only be the result of Cézanne's artistic development. These points of resemblance, to which we have drawn attention above, cannot be either overlooked or dismissed as mere chance; *we are left with the conclusion that all that remains is to regard the original painted version of* The Cardplayers *as a repetition of the sketch which Cézanne executed when he was twenty years old.* In making this statement, however, we are simultaneously drawing attention to another feature: *because Cézanne's youthful drawing has a definite inner meaning, it may be supposed that* The Cardplayers *series of pictures has one too, a hidden meaning of the same type as the drawing which, according to Cézanne's own words, illustrates a personal experience of great importance which deeply influenced his whole life.*

What is this meaning? The five people gathered round the table are not inactive and the rôles they perform are not without effect on each other; on the contrary they are engaged in an extremely unusual activity, chiefly involving the two men in the foreground. The man on the right, whose size proclaims him to be the most important person, is offering to the man sitting opposite him an object on a plate which looks like a badly drawn sphere, or a mediaeval helmet. It is, however, neither the one nor the other, but, as we shall shortly learn, a human skull. This grim performance is being observed by the smaller figures in the background apparently passively or possibly with some expectancy, at any rate without either astonishment or horror. On the other hand, the foremost of the two men with pointed hats who are just entering the door is raising his left hand with horror (or amazement) while his companion is explaining to him by gestures what is going on.

The solution to the puzzle presented by this drawing, which cannot be discovered simply by looking at it, is to be found in what Cézanne has written beneath the drawing. The words scribbled in the cartouche already mentioned, in the top lefthand corner above the door, can serve as a sort of title to the whole thing—like the mottoes which used to adorn the walls of rooms in the houses of *petit bourgeois* families during the last century. These words are: 'La mort règne en ces lieux' ('Death reigns in this place'). The text

97

beneath the drawing is divided into two parts like the picture itself. In each column a conversation is recorded.

Left.

Le Dante:    Dis-moi, mon cher, que grignotent-ils là?
Virgile:     C'est un crâne, parbleu.
Le Dante:    Mon Dieu, c'est effroyable! mais pourquoi rongent-ils ce cerveau détestable?
Virgile:     Écoute, et tu sauras cela.

Right.

Le père:     Mangez à belles dents ce mortel inhumain qui nous a si longtemps fait souffrir de la faim.
L'aîné:      Mangeons!
Le cadet:    Moi, j'ai bien faim, donne cette oreille.
Le troisième: A moi le nez.
Le petit-fils: A moi cet œil.
L'aîné:      A moi les dents.
Le père:     Hé-hé, si vous mangez d'une façon pareille que nous restera-t-il pour demain, mes enfants?

Now the meaning is clear. The picture represents a scene in Hell witnessed by Dante and Virgil. The inscription above the door of this grim room is a reminder of Dante's famous words at the entrance to the *Inferno*:

Per me si va nella città dolente;
Per me si va nell'eterno dolore;
Per me si va tra la perduta gente.

(There is an obvious echo of these words later in Cézanne's letter.) So the door, made of planks nailed together and bound by two iron bands, is the door to Hell, the entrance to that region in which 'Death reigns' and retribution is exacted for sins committed. The following dialogue is exchanged between the two travellers:

Dante: Tell me, friend, what are those people nibbling there?
Virgil: It is a skull, by God!
Dante: My God, how horrible! But why do they consume this revolting skull?

# The Cardplayers (*continued*)

Virgil:  Listen and you will understand.

Now comes the conversation being carried on at the table:

| | |
|---|---|
| The father: | Now eat heartily this inhuman mortal who let us suffer hunger for so long. |
| The eldest son: | Let us eat. |
| The second son: | I am very hungry, give me this ear. |
| The third child: | Give me the nose. |
| The grandchild: | Give me this eye. |
| The eldest son: | Give me the teeth. |
| The father: | Gently, gently, children, if you eat in this way what will be left for tomorrow? |

What Dante and Virgil see and hear in this passage is thus not a scene taken from the *Divina Commedia*. Cézanne's drawing was not in any way an illustration of Dante, but represented something which had its origin in his own imagination. Yet he was at the same time inspired by Dante.

The father who gives his three sons and his grandchild the head of an inhuman person who had for a long time let them starve is a brain-child of Cézanne's own fantasy, yet the idea is also at the same time a cruel and horrible distortion of a famous episode in Dante, the story of Ugolino, which is told in the 32nd and 33rd cantos of the *Inferno*.

Dante and Virgil found Count Ugolino in the ninth circle of Hell, near the sea of Lucifer where traitors are trapped in ice, together with his deadly enemy the Archbishop Ruggeri of Pisa. The two adversaries stood there looking grimly at one another; one held his head above the other in such a way that it seemed as if it were the hat of the other; and the upper head had dug its teeth into the nape of the neck of the other in the very same way as a starving man devours bread (*Inferno* XXXII, 124–29).

At Dante's request Ugolino related his story. Ruggeri had imprisoned him together with his sons and grandchildren, in a tower in his native city of Pisa; he kept them there for many months and ultimately let them starve. The father bore his own fate in silence, but he had to listen to the weeping and pleading of his children without being able to help them. Death came to him only after he had seen them all die. He was condemned to Hell on account of his own sins but the justice of Heaven permitted him to take revenge

for eternity on his inhuman murderer. No sooner had he ended his tale than he sank his teeth once more in the skull of the other dead man. (*Inferno* XXXIII, 76–78).

The similarity between this tragedy and the scene reproduced by Cézanne is obvious[13]. Cézanne has, however, made the affair even grimmer by transposing it to a *bourgeois* setting, to a room where there is even a picture hanging on the wall, and by placing the people who are to eat their fill of a death's head around a table and giving them almost modern clothes. The skull is actually offered on a tray, like the main course of a properly served midday meal. At this point important alterations to the original incident begin to appear. Here it is not the father who is appeasing his hunger— instead he is offering his children the head of their common enemy. For it is not the head of their murderer, but of the man who has let them suffer hunger for a long time. Children and grandchild are very ready to nourish themselves off him; each of them demands as his right a piece for himself, so that the father has to warn them to restrain themselves. If they devour it all at once, what of to-morrow? So much is however clear—that there is no other nourishment for them than the head of the very person who brought them into mortal peril. The dead man can now no longer give them any other kind of nourishment and so must offer himself. That is Cézanne's logic.

What does this story mean? Does it indeed have any meaning which we ought to take seriously, or is it simply the offspring of an uninhibited half-crazy imagination? Of pleasure in horrors? Even if it were so, we should be anxious to make a psychological investigation of the unconscious motives of such an outburst. There is, however, no need to do that, for Cézanne himself gave the answer to all the questions we would ask. He must have felt that his drawing was incomprehensible, even with the two conversations written beneath it, and he was obviously anxious to make it plain to his friend at all costs. For he had something to impart to him which was important, which was torturing him and which mattered very much to him, yet which he could not speak out openly and in everyday language. So he added the following alexandrines:

> *J'ai résolu, mon cher, d'épouvanter ton cœur*
> *D'y jeter une énorme, une atroce frayeur*
> *Par l'aspect monstrueux de cet horrible drâme*
> *Bien fait pour émouvoir la plus dure des âmes.*

# The Cardplayers (continued)

*J'ai pensé que ton cœur sensible à ces maux-là*
*S'écrierait: quel tableau merveilleux que voilà!*
*J'ai pensé, qu'un grand cri d'horreur de ta poitrine*
*Sortirait, en voyant ce que seul imagine*
*L'enfer, où le pécheur, mort dans l'impunité,*
*Souffre terriblement durant l'éternité.*

(*I have resolved, dear friend, to shock your heart,*
*To cast into it a tremendous and atrocious fear*
*By the monstrous sight of this horrid scene*
*Capable of stirring the hardest soul.*
*Your heart, I thought, would cry out at these*
*Evil sights: what a wonderful picture is here!*
*From your breast I thought would issue a great cry*
*Of horror, seeing what only Hell could dream,*
*Where the sinner, dead without undergoing punishment,*
*Suffers terribly for all eternity.*)

(In these words one senses the memory of the words inscribed above the gate of Hell: 'Per me si va nell'eterno dolore'.)

The tone of these lines of Cézanne is ironic but only superficially so. The seriousness can be detected through the irony. They were indeed intended to horrify Zola and to stir his soul. They indicated to him that the drawing must be taken seriously, they sought to expound it to him, and also strove to make him accept the frightful exposition. For the event depicted here as though it had already taken place was an entirely imaginary one: the drawing did not refer to anything which had actually happened—how could it?— but represented a secret desire of Cézanne's. It is clear that he himself regarded this wish as horrible and dangerous, from the fact that after these lines he broke off and then continued in a completely altered tone, consciously superficial and somewhat foolish:

'*Mais j'observe, mon cher, que depuis quinze jours*
*Notre correspondance a relâché son cours. . . .*'

('*But I note, dear friend, that for a fortnight*
*Our correspondence has been discontinued. . . .*')

He then produced a long series of reasons which might have caused this interruption—boredom, a cold, a cough, love or tooth-

ache. It is obvious that he wanted to weaken the effect of the draw-
ing and of his commentary and to make the whole affair out to be a
mere bagatelle. Yet this was all incidental and on the surface only.
He added nothing which could obscure his communication to his
friend. He had spoken plainly enough, at least for anyone who had
an idea what it was all about.

The two men who have entered Hell's gate and become witnesses
of the horrifying drama are Zola, disguised as Dante, and behind
him Cézanne himself, disguised as Virgil, the well-informed person
who is gesturing towards the scene. He is the guide to the spot at
which his own inner vision is laid bare to his friend.

Now it may seem strange that anyone should introduce his own
figure into a drawing. Surely this was a piece of childish behaviour,
surprising in someone who was twenty years old. Perhaps then we
are mistaken in assuming that this is the interpretation to be given
to the drawing? Not at all. In fact it is possible to point to similar
examples of infantilism even in some of Cézanne's genuine works
of art, in paintings which were executed more than ten years after
this drawing, for example in *Une moderne Olympia*. This latter is a
motif which he treated twice (V.106 and 225, painted in 1870 and
1873). These pictures, a simultaneous expression of his admiration
and his envy of Manet (both once again outstanding examples of
self-revelation) were intended to outdo Manet, who had attracted
universal attention to himself for the first time by his painting
*Olympia*. (Cézanne sent the second version of his composition to the
Impressionist Exhibition of 1874 in which Manet refused to take
part!) The pictures show Olympia not as a lean and apparently
apathetic girl, but as a voluptuous woman in a luxurious and
fantastic environment, while the man who was both the creator of
this grandiose work of art and dreams and, characteristically chang-
ing his rôle, also her admirer, lord and master[14], is shown absorbed
in gazing at her.

Another example, *L'éternel féminin* (V. 247), painted between
1875 and 1877, depicts a naked woman surrounded by an admiring
gathering of men among whom is a bishop and also Cézanne himself
at his easel. The idea expressed here is easily grasped; an angry and
disappointed man is speaking, cynically exposing the powerful
motives which govern men, incidentally including himself, and which
are normally concealed.

This work was painted in the same mood as that revealed by
Zola in 1886 in *Mes Haines*, when he wrote (page 2): 'If I am worth

anything today then it is because I stand alone and because I hate.'
Cézanne treated the same subject in two water-colours as well and
in a drawing (V.895, 904, 1207): the composition of the last of these
is reminiscent of Delacroix's *Sardanapale*.

Then there is also the picture *Scène de plein air*, dated 1870 (V.104).
It portrays three naked women with exceptionally sensual figures,
together with three clothed men, one of whom is sitting in a sailing
boat. The first painting in which men were depicted wearing
ordinary clothes in the company of naked girls was Manet's *Déjeuner
sur l'herbe*, executed in 1863; Cézanne also painted another counter-
version of this (V.107). Once again he tried to beat Manet on his
own ground and once again he portrayed himself as well—as hero
of the scenes of pleasure. All these compositions vouchsafe us
glimpses into his secret wishes and dreams, in which the sensual and
the artistic were strangely mixed while the real subject of the work
of art was taken from the deepest levels of the unconscious inner
life of the man who created them.

So in this youthful drawing, which we are now examining, and
which I propose to call the 'Ugolino drawing', this has already
begun to happen—Cézanne's own words demonstrate it. Did he
not want Zola to admire his artistic ability and to exclaim: 'What
a wonderful picture!', and did he not at the same time intend that a
great cry of horror should burst from Zola's breast? Cézanne could
not expect that to happen unless Zola took the drawing seriously
and understood that it referred to Cézanne and himself. Otherwise
it would inevitably appear grotesque and repellent to him.

At that time only Zola, if anyone, could grasp what Cézanne's
obscure phrases were attempting to convey. For he knew best what
was going on in Cézanne's soul. When he looked at the sketch, read
the verses and ultimately came to the words: 'Seeing what only
Hell[15] could dream, where the sinner, dead without undergoing
punishment, suffers terribly for all eternity', he could not fail to
understand to what a point his friend had been brought by hate and
a thirst for revenge against the 'inhuman person who had allowed
him and his children (!) to hunger for so long'. Zola knew this man
well, the only man against whom this accusation could be levelled;
he had participated keenly in the grief, the agony, which that man
had caused to Cézanne. It was the father of the future painter, who
at this very period was preventing his son from dedicating himself
to art[16].

Now for the facts. Cézanne had finished at the Collège Bourbon

in Aix on the 12th November, 1858, i.e. two months before the Ugolino letter was written. Even before that he had had lessons in drawing from Professor Gibert and was painting for pleasure—at least that was how his father understood it. The idea that Cézanne would choose painting as a career seemed impossible to his father, so he compelled his somewhat weak-willed son to study law in Aix. In a letter of 7th December, 1858, the young Cézanne complained: 'Hélas, j'ai pris du Droit la route tortueuse. J'ai pris, n'est pas le mot, de prendre on m'a forcé!' ('Alas, I have taken the crooked path of the law. "Taken" is not the word—I have been forced to take it!')

But in the same letter he asked Zola to find out in Paris the conditions under which one could compete for a prize at the Académie. Thus Cézanne had already at that time a serious desire to become a painter, and the matter had been discussed in his family. With Zola's help he had decided to apply for admission to the Académie. Nothing actually came of this, but on the 20th June, 1859, he wrote that he dreamt of going to Paris. 'There I shall become an artist'— and he already pictured himself sharing 'a fourth floor studio' with Zola. But this, too, remained only a dream, and reality had a different appearance. Cézanne knew of no means by which to turn his dreams into reality, to overcome his father's resistance. He sank into lethargy. 'I am so lazy, I am happy only when I have drunk; I can scarcely do any more, I am a lazy creature, good for nothing.' As with all Cézanne's early letters, people have (quite wrongly) attempted not to take these lines seriously—in fact they reveal what kind of a person Cézanne really was. If at that time he reacted in an exaggerated fashion to all the vicissitudes of life, the fact is that this reflected exactly the style of his youthful letters and pictures. This style was extravagant, vehement, unbalanced and extreme. The brutality which made its appearance in his works and in his written utterances concealed, as Zola had already surmised, a timidity which caused Cézanne suffering, but which was also a protective measure against his own inner violence. His words reveal his fierce, passionate temperament (which he himself later explained as the source of his art); that he was already outstandingly 'artistic' was proved by the completely unrestrained fashion in which he contemplated his state of mind and his circumstances and looked at himself, the fashion in which he reacted vehemently to every stimulus, to every form of opposition, to every opportunity, and was always searching for an appropriate outlet. In his coarse

humour, his biting irony, his uncouth jokes and obscenities—through all this the seriousness of his passionate nature broke through. Most violently of all in the Ugolino letter. Here he revealed how greatly he was suffering not only under his father's control, but also under his own unconscious desires, the other side of his unbalanced character. Simultaneously obstinate and weak, violent in thought and timid in deed, he was outwardly submissive to the stern and impregnable authority of his father, but took refuge in dangerous, extravagant dreams and recorded them with his pen. He wanted to make sure that at least his friend in Paris should know of his ambitions and understand that he had not resigned himself forever, that he still adhered to his high aim, certain he would attain it at some time in the future. For that is the meaning of this picture: fate will overtake the 'sinner', he will go to Hell after his death and will be handed over to him (the son) and in revenge he, Cézanne, will, like Ugolino, consume his head, the very head which thought up the devilish plan to make him die of spiritual starvation. Him and his children: this is an essential point—certainly borrowed from the Ugolino story, yet fundamentally altered. Cézanne at twenty had no real children and was certainly not thinking of the sons and grandsons he might possibly have some time in the future. Using a common metaphor he saw his works as his descendants, he would perhaps have called them his 'true' children then. He lived for them; they would bear his name; he would survive in them. For that reason he could permit neither himself nor them to be dead, in contrast to Ugolino and his sons; only the common enemy could be that; so, at the last moment before hunger carried off the threatened father and his children, divine justice stepped in and sent the head of the sinner to the very place where all hungry people gather together, in accordance with daily custom—the family dining-room table.

But why are Cézanne and his spiritual children also in Hell? First, because such a dreadful act of revenge as Cézanne's could take place only in this imaginary region described by Dante; secondly, however, if C. G. Jung's statement is correct, because in modern times Hell is the unconscious. In actual fact Cézanne was living at that time in the realm of non-materialization of his artistic plans, a realm poisoned by self-torture and given over to (and haunted by) his most hidden impulses and fears. As an artist he had not yet, indeed, found his way up into the world of the conscious.

The chief evidence of the fact that the whole representation

referred mainly to his future works is that, unlike the Ugolino story, the father drawn in Cézanne's sketch is not himself eating but only offering something to his children. In fact, of course, the old banker's opposition did not menace Cézanne himself with starvation, only his spiritual children. It was they, the unborn, not yet brought forth into conscious existence (though necessarily represented in the drawing as actually present), who were the object of concern to Cézanne's unconscious.

These dream pictures and phantoms contain a further very real element. The sustenance which Cézanne needed in order to bring his future children into the world and to maintain them was money—those 'few hundred francs' of which he spoke in a letter of the 20th June, 1859. Had he these he could live as a painter. They could come to him only from his father. But the old man would not give them to him so long as he lived (at least this is how it seemed at the time). If only he were dead, then he could no longer prevent the son's art from receiving and being nourished by what he bequeathed, or figuratively speaking by himself, by what his head had won through work, by his head (naturally, he did not actually think it all out with such subtlety, but he was here following the example of Dante and using the head to symbolize the whole man).

This, then, is how the young Cézanne saw his future—a reprehensible picture and yet one which could not be repressed, if he were to maintain his wavering self-confidence. Apart from his confession, apart from his longing to be free from his nightmares, the drawing and the letter contained still another important feature; they enabled Cézanne to strengthen his own will; by sending them to his friend he was making a vow to himself to stand by the aim he acknowledged in them, namely to concern himself with the future of his unborn spiritual children. Since he knew of no practical way to achieve this aim, he took refuge in depicting how the arm of avenging Nemesis would seize hold of his father on the day of his death. That was the day for which he was unconsciously longing. On that day he would nourish his children with the ear, eye and nose of the 'sinner'.

We know that things fell out differently. After about two years the banker Cézanne allowed his son to go to Paris and become a painter. It had become a matter of indifference to him what his wrong-headed good-for-nothing offspring did. But twenty-seven years were to pass before the painter was freed from the oppressive presence of his father. During the whole of that period the son

remained financially dependent on his father, at times in a most depressing way. Since, moreover, the painter did not achieve what he expected of himself and had no outward successes in his work to point to, his position *vis-à-vis* the person who was supporting him may well have been thoroughly ambivalent, a mixture of admiration and hate.

From what we have said in the preceding pages the following general conclusion can be drawn: youthful memories played a significant rôle in Cézanne's life. Up to his death they provided his art with themes. His father had an overwhelming importance for his entire existence; at the time of the Ugolino drawing the young man was filled with hate towards his father. On the other hand so many purely formal yet important features of this very drawing reappeared in the first version of *The Cardplayers* that one cannot assume that the conformity was purely accidental.

Thus the conclusion emerges that this picture does not contain a simple *genre* theme, such as Cézanne might have lighted upon casually, but a memory of an inner experience which had great significance for him personally. Still more, because the Ugolino drawing, which was the foundation for this series of pictures, was intended to be understood as the expression of a self-confidence won by a hard internal struggle and of a certainty also hard won, *The Cardplayers* must likewise be understood as evidence of a similar, entirely personal inner symbolism. When we understand the pictures in this way we may guess why these simple and unimportant peasant figures can 'have the gravity, the reserve and the weighty solemnity of some monument of antiquity'.

### The *Mardi Gras* Picture Again

Once we have learned with the aid of Cézanne's own explanations to appreciate that certain devices in his compositions may have a meaning and significance for him, we must search for some inner experience as the source of those of his pictures which depict any event. We are now able, therefore, to answer the question whether the *Mardi Gras* composition portrays a situation which had some significance for Cézanne. And the reply to this question must be in the affirmative.

The borrowing of the T-outline from the illustration of the two men with pointed hats in the Ugolino drawing leads us to suppose

that the two figures of the *Mardi Gras* picture are also disguises for Cézanne himself and Zola and that the T-sign, a symbol from the region of the unconscious, represents their close connexion, their inner interdependence. Here, however, this sign is robbed of its original significance in that it is no longer divided between the two figures but is absorbed by the one, the one on the left. The reason for this is that at the time of the *Mardi Gras* picture the bonds between the two young friends had already been destroyed. The very year (1886) in which the painter was freed from the presence of his father, robbed him also of his friend Zola. For many years the painter and the author, the unknown man and the man already famous, had remained close to one another; gradually, however, as Zola's fame and Cézanne's lack of success, and also their views on life and art, clashed more and more with one another, their relationship had become looser. The final break occurred when Zola, in his novel *L'Œuvre*, published in 1886, gave an unmistakable description of Cézanne, depicting him as a man who had failed in both art and life and making him put an end to his life by suicide. Zola was so tactless as to send Cézanne a copy of this book, just as he had always before sent him a copy of every newly published book of his. Cézanne thanked him in a few lines without looking closely at the contents of the book, but from that day he never again wrote to Zola. He was deeply hurt that his former friend, who had once put his pen at the service of modern painting, should pronounce such a destructive judgement on the subject of Cézanne and the impressionists. Yet he could not forget him, he suffered sorely at his loss and probably never really got over it. When Zola died in the year 1902, Cézanne burst into tears and shut himself up in his studio the whole day long[17].

So it was two years after the break that Cézanne was impelled to get over Zola's betrayal by pictorial means, to produce an artistic document which would combat the pronouncements of *L'Œuvre*. For this purpose he turned again to that pictorial outline which he had invented in his youth and employed to express the close bond between the friends. The two men in pointed hats came to the surface of his artistic memory, especially the graphic symbol of their intimate connexion. But now, while retaining the outline, he gave it a new significance; he transformed the hand pointing helpfully into a gesture pointing to a practical joke (Plate 19). Moreover, he gave it wholly to the figure in the rear; this figure had taken back what once bound the friends together, and he must be held guilty

for that. This figure is therefore Zola. The metamorphosis which the two figures have undergone is thus explained. The one in front represents Cézanne, in contrast to the Ugolino drawing. And for this picture of Cézanne his son had to act as model, had to represent the person of his father. But what is happening in the picture? Zola, slinking up from the left, is trying to snatch from the man walking in front of him the sign of his dignity, the wooden fool's sword, which we have to interpret as representing the painter's brush. Nevertheless, the proudly triumphant bearing of Harlequin shows us that this attack will fail. He goes on his way undisturbed, as the frequent later portraits of Harlequin standing alone prove. This was how Cézanne expressed his self-confidence and how he strove to erase the compromising effect made by the misrepresentation in Zola's novel.

Two other important points should perhaps also be stressed in order to support the interpretation we have given to this picture. The choice of a motif depicting people in fancy dress, which is absolutely unique in Cézanne's works, is in itself an indication that in this case he was seeking to 'disguise' a meaning lying beneath the surface; Cézanne had no interest in either the theatre or fancy dress and it is unlikely that he would when nearly fifty years old have been particularly enthusiastic about carnival. Furthermore, the composition of the *Mardi Gras* picture is markedly one-sided and incomplete; it looks almost like one half of a stage scene of the kind seen in engravings of famous actors by Abraham Bosse, but it is impossible to trace any derivation from these. On the other hand it is easy to explain the structure of the picture if one regards it as a resuscitation of the left half of the Ugolino sketch.

### Further Problems of *The Cardplayers*

We do not know what external stimulus induced Cézanne to turn again to the table-top of his youthful imagination and use it in his pictures of cardplayers. It may well be that the chance sight of peasants playing cards revived the memory. Certainly this was not the sole inspiration of the motif—of that we can be sure. He put in so much intensive work on the subject and expended so much pains on it, that it was clearly no chance theme; he was striving to expose and display its special meaning with complete clarity, as in the Ugolino drawing.

Incidentally, it is worth noting that he had never before painted

either peasants or workers and now began to explore the spiritual nature of other men for the first time in his life. The discovery that they suffered from the same unsolved tensions as he himself did helped him to arrive at a solution for these problems. In the first version of this theme, the persons playing cards seemed to lack any inner light and the action lacked concentration and final realization. But while Cézanne went on working to represent ever more clearly the subject which occupied his mind (and his gradual progress towards this goal confirms the chronology of the different versions of *The Cardplayers* which we have already suggested), he was producing numerous portraits of poor and simple men, mainly in connexion with the second, reduced version of the subject. These portraits, which led ultimately to the grandiose fantasy in which the old gardener Vallier was fused into the identity of Cézanne himself, played an important part in the development of the style of Cézanne's old age. In this style all separate objects are idealized into a higher form of relationship which springs from mere endurance of existence. These men appear as poor and hard-working beings, impersonal and supra-personal, each representing the other and each capable of being represented by another in real life; in the last resort any one of them could take the place of another. This was the origin of the wonderful universality of Cézanne's later creations. In fact, not only men but also natural objects received this high distinction, and his later fantasies on the subject of Mont Sainte-Victoire are an outstanding example of nature being subjected to this same fate, characteristic of modern man: the fact that he is no longer a special self but fulfils himself by being representative and thus by being able to be represented in relation to some superior principle which unifies the whole.

One may well object that the portrayal of workers and peasants was nothing out of the ordinary for an artist of the late nineteenth century. Millet and Courbet raised them to monumental greatness. But with Cézanne it was something different. He was indifferent to the *pathos* of work, had no socialist tendencies at all and no sympathy either, and he went far beyond the preacher's attitude characteristic of Millet. His encounter with the poor as a specific phenomenon took place on a very different level. Millet was sensible of the greatness of the simple life, of poverty associated with piety and humility; Courbet felt impelled to paint the 'heroism of modern life' (Baudelaire) as an accusation against society. Cézanne had no feelings of this kind. He was repelled by every aspect of 'modernity'; he felt

no bond with work on the soil and simple people never interested him on account of their simplicity. He only discovered them when he appreciated his own paradoxical position—a creative artist in poverty and loneliness—and the forlornness of the task he had set himself. In order to surmount this paradox he set about painting the series of pictures of *The Cardplayers*. It could be overcome only by being lived out and by being attested through art. This was frequently Cézanne's preoccupation when he was painting.

To this we must add some explanation. When he was young it was passion, sensuality and the search for fame which inspired him to paint certain pictures. Such were the origins of the new *Olympia*, *The Temptation of St. Antony* and *L'Enlèvement* ('The Abduction'). So far as the *St. Antony* (Plate 21) is concerned, it should be noted that the various versions (V.103, 240, 241, 880, 1214) have a spiritual link with Flaubert's *Tentation de St. Antoine*, as Venturi has pointed out. A 'faculté souffrante souterraine et revoltée' (a 'hidden and rebellious capacity for suffering') such as Baudelaire sensed in Flaubert's *Tentation*, permeates the work of the painter too. The complete edition of Flaubert's book was first printed in 1874, whereas Cézanne's first version of the theme seems to have been painted towards the end of the 'sixties (1867–69)—the other versions, according to Venturi, between 1873 and 1875 or possibly 1877. To that we must add that several fragments of Flaubert's (revised) first version had already appeared in the year 1857 in the periodical *L'Artiste* at that time edited by Théophile Gautier[18]. Possibly, therefore, Cézanne drew his inspiration from them. As for the subject of self-portrayal by artists in works of art in the nineteenth century, it is interesting to note that Flaubert said of himself: 'In *St. Antony* I was myself the saint'[19]. Moreover, in the first version of the *Tentation* one finds the cry: 'Oh, fancy, oh, fancy! Carry me off on your wings,' that my grief may be dissipated!', which is also a sentence which could have been written from the heart of the Cézanne of the 'sixties and 'seventies. In order to fulfil this desire, both poet and painter let their imagination stray in the same direction. What Louis Bertrand said about Flaubert would probably be equally applicable to the Cézanne who painted these pictures: 'He sought for consolation and a strange sort of voluptuousness, to surrender in imagination to those temptations which he himself condemned as deceptions and as culpable' and 'the hallucinations which he ascribes to the hermit are the apparitions he himself used to see, which bewitched him and brought him to despair' (but there was a

meticulous erudition in Flaubert's representation which is lacking in Cézanne's).

The subject was also treated by other painters of the period. In the Salon of 1869 there was a *Temptation of St. Antony* by Isabey, which Gautier has described[20]. Nevertheless, Isabey did not understand the heart of the problem; he had not himself experienced loneliness. On these grounds Gautier criticized him, for Gautier grasped the significance of the subject. He found too much display of female devils, nymphs, bacchantes and angels in Isabey's picture. 'The whole essence of the "Temptation" is loneliness,' he wrote. Cézanne depicted it thus, with only a few figures, emerging in ghostly fashion from a blackish background.

Later, sensuality inspired yet another remarkable and tremendous composition of Cézanne's, *La lutte d'amour*, ('The Contest of Love'), which Vollard has ascribed to about the year 1886. It exists in two versions (V.379 and 380). As a dramatic-pathetic invention this subject stands quite alone in his work. In a landscape shadowed by trees, one sees four couples at different stages of the battle of love. If Vollard's estimation of the date is correct (and there is more in its favour than in the suggestion of Venturi and Dorival that the pictures belong to 1875–76) then these paintings may well be connected with a passion which overwhelmed Cézanne at this time[21] (though it did not go beyond a kiss), and of which there is otherwise no trace in his work. The pictures would then be a heroic dramatization of his love affair, going far beyond the reality (if Baudelaire's estimation of its scale is correct). The appearance of a dog[22] in a conspicuous position in this painting proves that it could have a symbolical meaning, for, according to Cézanne's own explanation of his *Apothéose de Delacroix* (V.245), a dog was for him the embodiment of envy and ill will.

Now to get back to the paintings of *The Cardplayers*; the inner impulse effective in them is understandable when they are related to the Ugolino drawing, which served essentially to provide a basic design for them. They were—unconsciously—destined by Cézanne (and for Cézanne) as a sign to be given to his friend who, in real life, had become inaccessible, a sign visible from far off that Cézanne's conflict with his father had been victoriously surmounted. Simultaneously, he thereby put an end to and resolved the problem of his antagonism towards his father.

The real theme of the pictures is the victory of Cézanne's art over his father as a result of his bringing it slowly to maturity

through hard work. Yet at the same time it is more than that. Cézanne's art had overcome not only the resistance of the elder Cézanne but also that of Zola (and of all the other critics), simply by virtue of the fact that the work which had been pronounced dead continued to exist and to grow. Because the Ugolino drawing contained this message as a prophecy Cézanne unconsciously reached back into the past towards it. As, however, the situation had in the meantime altered radically, the series of pictures now produced was bound to reveal fundamental divergencies.

At the time of the Ugolino drawing the scene was related to the future, it expressed hope and confidence and at the same time sought to reinforce these feelings. With the evolution of the various versions of *The Cardplayers* a great *œuvre* is set before us. These pictures draw our attention to the antecedent creative period and collate its results. That is why the scene in Hell has been transferred to daylight and the people round the table are no longer occupied in demolishing a skull but in playing cards—a peaceful, harmless and perfectly lawful activity which has no need to shun daylight; and this activity is taking place undisturbed, with gravity and at the same time with enjoyment, among people who are self-assured and pleased with themselves.

In the Ugolino drawing those who have been rescued from death by starvation appear to be almost separated from the onlookers. There are indeed two independent inventions in this composition, which are only very loosely linked. We have demonstrated that the execution of the lefthand half (Zola and Cézanne disguised as Dante and Virgil) was perfected in the two figures of the *Mardi Gras* picture in Cézanne's classical style. Since, however, the artist at this stage still required the onlooker for the righthand half of the drawing, for the group at the table—because in this picture it was essential that Zola and no other should be shown as witness of the artistic activity—he was compelled to include the spectators in the composition along with the cardplayers themselves. This was in fact what he did in the first version. Two onlookers appear in it, a man and a child, the first taking over the lefthand half of the drawing, the other retained from the group round the table in the drawing. If then the man represents the spiritual figure of Zola we may well ask whether the child has also a symbolic meaning. I have not succeeded in obtaining any answer to this question by studying Cézanne's life. I therefore put forward a theory which occurred to me when I was reading what C. G. Jung has written about *anima*

and *animus* and leave the psychologists to pronounce on its reliability. If I apply Jung's explanations to this figure of Cézanne's then it is possible that the girl looking on is the portrait of Cézanne's *anima*, the 'childish' part of his nature. Day-dreaming and 'gazing unconsciously', she is contemplating the conscious activity of the artist, taking place in the outside world, an activity which after all has always 'protected itself against the dangers arising from the depths of his own soul'. According to Jung, the *anima* has magical power and magical knowledge, and is, according to him, what 'poets often call their artistic temperament', and thus exactly what was in Cézanne's eyes the most important ingredient of a truly creative personality.

Now comes the question why Cézanne used a party of cardplayers as a symbol of his artistic activity. It may well be that in the first instance the mere chance observation of a group of cardplayers in a café (or during the midday break of the workers on his own property) aroused Cézanne's interest through their symmetrical arrangement. Since it led him to find, through painting, a solution to an inner problem which was weighing on his mind, this interest was not really an artistic one, but one which arose because a tendency towards this symmetry already existed deep within him, because the symmetry which he saw in the players awoke in him a memory of the symmetrical design of that youthful composition of his which had been so full of significance and so eloquent. If, therefore, he noticed the symmetrically arranged figures engaged in playing cards, then, because his mind had already entered the realms of symbolical meanings, he was bound to feel that cardplaying also represented something symbolical. For in Cézanne's lifetime the playing-card and a preoccupation with it had already acquired a symbolical value and taken on a meaning closely connected with painting.

Here is how it came about. When Cézanne first came to Paris in the 'sixties, he used to frequent the Café Guerbois, which Manet, Monet, Degas and other young painters also patronized. There they used to tell a tale of a conversation which was supposed to have taken place between Courbet and Manet. Courbet had compared Manet's *Olympia* with the Queen of Spades in a pack of cards, coming out of a bath, whereupon Manet is said to have retorted that Courbet's ideal was a billiard ball[23]. Vollard attributes a similar saying to Daumier[24]. When visiting an exhibition of Manet's paintings Daumier is supposed to have said: 'I do not care at all for Manet's painting but I do think it has one outstanding quality, it brings us

back to Lancelot'—Lancelot being the name given in France to the Knave of Clubs. Renoir is reputed to have been of the same opinion.

According to John Rewald[25] the critic Castagnary, friend of Courbet, was the first (in 1865) to compare Manet's *Olympia* with a playing-card. J.-E. Blanche was perhaps influenced by him when he wrote in his book on Manet[26]: 'The modern young painters were all in love with *Japonaiserie*. They strove to paint in the flat, flat as playing-cards, to quote Degas, that stiff-necked follower of Ingres, who forbade himself to and prohibited his friends from "making a figure three-dimensional". To make a thing three-dimensional is the same as taking refuge in modelling by means of lighting; light, half-tones and shadows distributed in such a way that they accentuated the relief by means of a ray of light falling from above, or by letting light brush objects gently or fall across objects'. Zola was also familiar with this matter. 'It has been said jokingly', he wrote[27], 'that Manet's pictures recall Épinal's engravings and there is a good deal of truth in this sneer which is really praise; the process is the same in the one as in the other, the shades of paint are applied flatly, with this difference that Épinal's workers used pure colours without troubling about light values, and Édouard Manet produces a multitude of tones and places them in the proper relationship to each other. It would be far more interesting to compare this simpli-fied painting with Japanese woodcuts which in fact bear a resem-blance to it because of their exotic elegance, their magnificent splashes of colour.' (Épinal's engravings are picture sheets, printed like playing-cards.)

There is no doubt that we are here confronted with an important characteristic of modern painting. The battle of words between Courbet and Manet is, therefore, more than a mere casual anecdote; it marks the clash of two styles, two ages, the old and the modern schools, a break in development visible from afar and at once strongly sensed by painters. The antithesis between three-dimen-sional painting and painting in the manner of playing-cards may, therefore, easily have imprinted itself deeply on Cézanne's memory. As we have seen, it was widely recognized. In Cézanne's own painting, too, this contrast played a similar part. For a short time, before and around 1870, Cézanne also tried to paint three-dimen-sionally and to extrude plastic volumes by means of crude contrasts of light and shade and by curving brush strokes 'like billiard balls' (see V.83, 100, 103-8, 120). By 1872, however, he had already

given up this method and had gone over to 'flat' painting. Even then he kept aloof from the Japanese technique of composing figures and objects out of lines (which created an impression of space) and flattish spots of colour; instead he asserted his own highly individual style. All the same, Cézanne did paint in a 'modern' style in the sense in which the word is used here. He preserved the flatness of a picture as it is preserved in Manet's pictures and in playing-cards.

This leads to the surmise that Cézanne was unconsciously associating playing-cards with modern painting, in contrast to the older schools (inclusive of the Académie) which modelled by means of light and shade. And thus for him cardplaying may in his own unconscious mind vicariously represent his own painting. This is all the more possible because, after all, at a very early date, before the short-term deviation mentioned above, he did begin by painting flat in his own fashion, in that he used the palette knife instead of the brush, then later changed over to employing the method of colour modulation, the direct opposite of any kind of modelling with light and shade.

If we accept this theory, cardplaying would be a symbol of Cézanne's for the activity of the modern painter; and in relation to Zola it would mean that Cézanne had won his place in the modern movement and was holding it with complete confidence. It is no argument against this interpretation to admit that Cézanne was generally not satisfied with the results of his own work; for despite this discontent he remained convinced of his vocation, and had on occasion even expressed this conviction in so many words. The theory we have just advanced finds still further support in the fact that Cézanne himself once compared his painting with playing-cards. On the 2nd July, 1876, he wrote to Camille Pissarro from L'Estaque on the Mediterranean: 'I have begun two little pictures in which there is sea, for Mr. Chocquet, who spoke to me about something of this kind. They are like playing-cards, red roofs in front of the blue sea. . . .' Then, going on to talk of other themes to be painted, he continued: 'The sun is so frightful here that it seems to me as though things were turned into silhouettes, not only in black and white, but also in blue, red, brown and violet. I may be wrong but it seems to me that this is the extreme opposite ('l'antipode') of modelling'[28]. What he was probably trying to say was: Nature herself, in the strong sunlight of the south, dictates the road for modern painters to follow; and thus many an artist who

has decided on a particular method of interpretation finds it already plainly indicated in the real world which he sees there.

One important difference between the Ugolino drawing and all the versions of *The Cardplayers* is the fact that in the original drawing the figures were portrayed full length, but later they were reduced to three-quarter length. In itself there is nothing remarkable about this, since three-quarter figures are better fitted to focus attention on the activity going on around the table and this particular change is only evidence of the fact that Cézanne had in the course of practising painting gained some perfectly ordinary experience of composition. Nevertheless the use in this composition of three-quarter length figures when Cézanne was dealing with this particular theme has led people to link *The Cardplayers* (among other things) with a picture in the Aix Museum, also called *The Cardplayers*, by a pupil of Louis Le Nain (Plate 17). The theory that Cézanne was inspired by this composition to paint his own *Cardplayers* was first advanced by Tristan Klingsor[29] and thereafter frequently repeated by others without further investigation. There is no doubt that Cézanne knew the picture; whether he had a high opinion of it, we do not know; the statements he is alleged to have made about it seem to be inventions which originated after people had made up their minds that there was a connexion between *The Cardplayers* and the Le Nain picture. When we bear in mind all we otherwise know about Cézanne's judgement of art it is scarcely thinkable that he could have overlooked the weaknesses of this mediocre picture.

The hypothesis of this derivation, moreover, appears to rest on a failure to appreciate what can serve a modern artist as inspiration in the work of another, which is—either the design (whether of the composition as a whole or of single inventions) or the 'spirit' (the philosophy on which the whole thing is based); the merely graphic means absolutely nothing. What is more, a close scrutiny of the two pictures in question reduces the resemblance between them to the fact that in both there are three persons gathered round a table playing cards while a child looks on. And even this is not an exact observation, for in the Le Nain picture the child is standing in the background in such a way that it cannot see what is going on at the table. In design and in spirit, however, the two pictures are entirely different. In contrast to Cézanne's composition the arrangement in the Le Nain is asymmetrical and constructed out of diagonal intersections and contrasts of light and shade; it also contains no figure in profile. In spirit the older work (Plate 17) is a genuine *genre*

picture; the young soldier at the right is hesitating as to which card to play, the older one on the left (the figure in the foreground) on the other hand is, in the meantime, turning to the person looking at the picture and is betraying to him, by showing him his card, what the outcome of the game will be: he has the winning ace. The central figure is looking expectantly at the young man who does not know what he should play; and so the ephemeral nature of the proceeding, of the whole subject of the picture, is still further stressed. But such an effect was very far from Cézanne's intention.

In fact, of course, the inspiration for his pictures, in consequence of the inner significance of his intention, lay elsewhere, indeed where one would scarcely expect to find it unless one recognized that Cézanne's art portrayed his personal inner experiences.

Unconsciously in *The Cardplayers* he was referring back to the Ugolino drawing. This is proved not only by the various points of correspondence between them already mentioned, but also by small details. Take, for instance, the background. In both the drawing and the paintings, a framed picture hangs on the wall, although it is given a special position in the painting only, so as to accentuate the strict symmetry of the composition about its axis. Corresponding to the cartouche containing the inscription over Hell's gate in the drawing, we find in the painting a vase, a piece of half-glazed pottery, recognizable as one which appears in some still-lifes; to preserve the balance of the design as a whole, a heavy curtain with rich folds is introduced at the right. Like the table and the pottery, this curtain is a stock item from Cézanne's studio in the Jas de Bouffan.

In the second version we can see the beginning of that process of concentration on the essential (in the sense of the inner significance of the thing portrayed) which characterizes the development which took place in this series of pictures, bringing out that inner significance more and more clearly in each succeeding one. Indeed, this is the principal means by which the chronological order of the paintings can be determined and is even more reliable than the stylistic indications. The girl, the picture and the pottery on the wall shelf have all been eliminated; only the cardplayers remain and the onlooker with arms crossed, standing wrapped in his thoughts. The central player has acquired a hat, while the hand of the one on the right has been suppressed; the distances between the figures have been diminished and the lines which unite them in one plane have been strengthened. The solemn and monumental

rigidity has thus been reinforced and any lingering memory of an ordinary scene of cardplaying has vanished. A heavy silence lies over the figures portrayed; they are sunk deep in thought.

Five studies for the first two versions have been preserved. For each of the two figures in profile there is a detailed preliminary drawing (V.1085 and 1086, Plate 16). These are on sheets of paper of the same size, used horizontally in the case of the lefthand player and vertically for the righthand one. Both have been partially gone over with water-colour paints, each in a different manner; the left-hand player with violet and sky blue plus a little yellow at the chair, the righthand one with only a few dabs of violet colour. As the man seated on the left is dressed in brown in both the first versions of the picture and as a very detailed linear execution can be traced in the drawings under the water colours, it must be assumed that these two sheets were not originally intended to be in colour and that when the paintings were begun they were actually not coloured. Both demonstrate Cézanne's working methods very clearly as they have been described in Chapter I—solids emerge from a network of shadow-paths and patches of shadow, sketched in different nuances and shades of blue. The design of both drawings is most closely followed in the five-figure version of *The Cardplayers*, although even here there are some modifications; compare for instance the hat of the man seated at the left. On the other hand some details of the water-colour suggest that it was not executed until after the production of the four-figure version of the paintings; for example the shape of the moustache and the fresh arrangement of the way the folds of the coat of the man on the left hang together. As for the study of the man sitting at the right, Cézanne carried out some very marked simplifications of outline here, particularly in the arm at the back. The detail of these drawings proves that they were not drawn from actual cardplayers but from models who had to sit still with cards in their hands. At all events, these two drawings are part of the preparatory work for *The Cardplayers*.

The same cannot be said of the picture of the standing onlooker (V.563). This is a small (12″ × 15½″), indistinct oil study, the original condition of which can scarcely be traced in some sections[30]. At best this is a recapitulation, given up by Cézanne when only in its initial stages, of the relevant figure in the first version (V.560).

Venturi has put forward another study said to represent the central figure (V.568) and to have been made explicitly for the second version of the picture (the man is wearing a hat). I doubt

whether it was painted by Cézanne. For it is more naturalistic, more ordinary in its representation and in the vulgar sense more correctly drawn than was Cézanne's custom; on the other hand, the arrangement of the dark areas lacks rhythmic organization; they are not developed as constructive shadow-paths but as delimiting lines, forming contours around masses, or as shadows in depth, introduced into constructive light areas. Compare, at the left (the man's right arm) the outline above the hand, which leads to the elbow. Observe at the right shoulder the shadow fraying, flying off into space, the indication of the outline of the left arm from shoulder to elbow. This neither models the solid nor unites it to space, but simply forms a contour, at the same time both disconnected and lacking in repose. The forearms, resting on the table top, are partly concealed in *The Cardplayers*, but in this study they appear with the undersides completed in a remarkably feeble way. The dark patch in the background at the left, obviously indicating the standing figure, likewise suggests a free copy and not a study.

Five further works of Cézanne's have a connexion with the second series of *The Cardplayers*. Cézanne first drew the head of the man with the high stiff hat who sits at the left, the gardener Père Alexandre, alone (V.1482), then on the back of the same sheet of paper he sketched his head and the upper part of his body in water colours (posed in front of the background which he also used in the pictures) (V.1088). Something very similar in form to these preparatory sketches appears in the largest version of the painting (V.556, Plate 10), the one which is regarded as the earliest of the two-figure compositions. Finally, he painted the head and a small piece of the upper part of the body in oils in front of a dark blue ground (V.566, Plate 13). The bright patch projecting into the background in this sketch just in front of the front edge of the brim of the hat makes it evident that this study preceded the second and third versions of the picture; perhaps Cézanne was seeking here to find a new link between the shape of the hat and the background, stronger than that seen in the larger pictures. For the figure sitting at the right there are two preliminary drawings; V.1483 (Plate 14) is only the head with a very light indication of the background, but a pencil study not indexed by Venturi takes in the whole figure at the table (Plate 15). This is probably the earliest extant drawing of a cardplayer by Cézanne but during the actual execution of the pictures he nevertheless rejected it in favour of the others already mentioned.

## Further problems of The Cardplayers

Can the connexion with the Ugolino drawing be used to throw light on the meaning of the second group of *The Cardplayers* paintings as well as that of earlier versions? The motif now seems to be reduced to its core—the two principal actors, Ugolino and his elder son, whom we recognize as disguises for Cézanne and his works, the elder son now representing all the other children together. These two formed the nucleus of the youthful drawing—the other sons and a grandchild were added in order to follow the Ugolino story, but from Cézanne's point of view were not necessary—and now they alone are the protagonists of the picture's theme. In these paintings they appear more completely absorbed than ever before in their occupation, which symbolizes Cézanne's artistic activity[31]. But we observe that they are now in a different room; they are no longer seated in front of a bare wall, but at a window which opens on to a view of the countryside—trees throwing dark shadows and the day itself looking in at them. Nature is accompanying the work of Cézanne.

Now too, this group of two players has been given a new form; now, in addition to the psychological significance which it held for Cézanne, it has been turned into an intensely interesting problem of design for the artist. This does not, of course, mean that it has become detached from its content—on the contrary. Cézanne was concentrating his efforts on anchoring his figures more firmly in space, binding them more closely to one another and establishing them more securely in their surroundings, in order to give them a more universal and supra-personal eloquence. They express passivity, surrender, absorption, engagement, inner qualities which genius must possess before it can produce any outward creations. The highly simplified forms, impassive faces and restful poses of these figures are all exterior manifestations of this inner aspect; the unity of the subject-matter serves to make it a dominating motif, in that it seizes on all the things portrayed, uniting those near and those far, those important and those unimportant, and at the same time interpreting them all with equal care.

A further word must still be said about the third player in the first version. In the Ugolino drawing he was, after all, merely a brother of the man sitting on the left. Now, since he contributed nothing to the significant content of the picture and possessed no special meaning on his own, he has vanished not only from *The Cardplayers*, but also from Cézanne's entire work. On the other hand, the onlooker with his arms folded, a likeness of Zola, was retained

because of his inner significance. What is more, this figure reappears in other, quite independent paintings though each time painted from different models, and always with slight alterations in his pose; as a whole figure in V.563, a half-figure in V.685 and 689—this last a portrait of a man with a penetrating glance and a powerfully expressive face (Plate 18).

There are certain further differences between the three versions of the second group of pictures. The most important is that the figures are steadily reduced in size in relation to the space surrounding them. It is as though from picture to picture they were moved a little further away from the spectator. To the painter they thus became step by step more completely visible. And the further back they went the richer the artistic texture became, the more completely it absorbed the details of the scene. The colour became deeper and stronger. A blue-grey film was cast over the whole, giving it unity and shadow. The final stage is reached in the picture in the Courtauld Collection (V.557, Plate 11)[32], in which only a shadow of the bottle of wine survives. This bottle had been introduced by Cézanne in order to form a link between the flat surface of the table in the foreground and the vertically divided wall in the background. This is a familiar device used by painters and as such entirely valid, but he now sacrificed it as being a too independent detail which would spoil the composition as a whole, would detract from and interfere with the predominant theme. For it must be remembered that though these pictures may appear to be far removed from the Ugolino drawing and to owe their greatness and solemn dignity to Cézanne's skill, nevertheless they did have their origin in important and painful events of his youth (which determined their design and content) and in his early experiences of life (to which they gave expression).

If the foregoing psychological interpretation of the pictures of *The Cardplayers* is, by and large, correct, then it may even be possible to determine a more exact date for the second series—with the two players. For if all these pictures do in fact contain an inner reference to Zola, we may assume that Cézanne was impelled to take up the theme afresh in 1896. It was in that year that Zola accepted an invitation from Numa Coste to come to Aix, where he stayed a few days but did not visit Cézanne, with whom indeed he had not been in touch for ten years. Cézanne learned of Zola's visit only after he had left and was deeply distressed to hear that the friend of his youth had stayed in the same city as himself, in the district which was

home to both of them, without shaking hands with him. He had 'forgotten' that it was he who had broken off the relations between the two of them. It is quite possible that in these pictures he was conducting a conversation between the two of them which never actually took place. The stylistic indications as to date would fit in perfectly with the period 'after 1896' for all three pictures.

The psychological interpretation which we have given here of Cézanne's pictures is moreover not so outrageous as it might seem to be at first glance. There is historical justification for it: Cézanne would not be unique if it were correct.

To take one's own destiny as the theme of one's works was characteristic of creative minds in the nineteenth century. If we consider only the philosophy of the age, how extraordinarily personal, even private it is; Fichte, Kierkegaard, Schopenhauer, Nietzsche! The romantic poets too, Goethe, Schlegel, Tieck and even Stendhal, made their own inmost problems the subject of their works; similarly the musicians Beethoven, Schubert, Schumann. In this respect the visual arts were backward. In certain landscapes portrayed in the works of Caspar David Friedrich we seem to perceive for the first time the throbbing of an unmistakable undertone, which suggests the inner problems, the loneliness and forlornness of the painter. Then a novelty unheard-of in the world of painting appeared in Courbet's studio: an enormous picture of the size of a great historical scene, dedicated to the artist's destiny, though at this stage still only to the external circumstances of his life, the people he met and the things he did. In this 'realistic allegory' the painter sought to present a social picture, as in *The Stonebreakers*, an appeal to the conscience of mankind as well as a document of self-confession and self-glorification. Courbet would have been the last person to want to display his inner problems in his art, but he was the first to show that the life of the artist was a possible subject for a painting. This he did because he considered that representations of historical themes were finished: subjects hitherto taken up by painters and abstractions esteemed worthy of representation such as the sublime, the great, the touching, the noble, all meant nothing to him any longer and he had the courage to admit this. Because progressive and honest artists of talent now followed his lead, the choice of motifs for painting was suddenly greatly restricted; it seemed that only portraits, landscapes and still-lifes were left. In fact, however, another subject was added: self-portrayal, putting the inner problems of the creative self into paintings. This was not so with all artists but it was certainly

the case with the outstanding ones: *now indeed works of art became in many instances documents portraying an inner situation, regardless of the outward appearance which they depicted.* The emergence of self-portrayal in pictures explained the subjectivity now visible but previously unknown, the distortion of the real world emerging as a completely new style. The artist painted in order to give expression to his own inner attitudes, to his unresolved problems, to his suffering at the hands of life; beneath the surface of his representations a 'motive force'[33] lay hidden, which compelled him and stimulated him at the same time to make violent alterations to the normal forms of real things as they are usually apprehended. The most outstanding example of this is, of course, Van Gogh; after him come Gauguin, Toulouse-Lautrec, Seurat, Munch, later Kokoschka and also Klee.

In the works of Manet, Monet, Sisley, Renoir and Pissarro an opposite tendency developed, the painting of pure sense impressions. Now, Cézanne had hitherto been reckoned as one of this group of artists and the obvious difference between his art and theirs was explained by assuming that Cézanne had surpassed their devotion to nature, to sense impressions alone, by his 'pure' painting, by excluding his self from his art even more positively than they did. But Cézanne was not one of those who naïvely glorified the beautiful external appearance of the real world. What many writers have already admitted to be true of Cézanne's romantic early period can now be seen to hold good for his later work too. What was unique about Cézanne's art was that, under the appearance of an intense objectivity, he portrayed the inner state of his ego as being the overall and basic situation of his own self in the world of his time, even on particular occasions (as in the case of *The Cardplayers, Baigneurs* and *Mardi Gras*). He was unique, too, in that in his works he overcame the pathological and rose above the suffering which was the origin of the impulse: the ultimate significance of his art, the development of his creative powers, which he sensed even in his old age, consisted in the fact that with ever increasing purity and power he portrayed the universality of what elevated his nature (as a whole) beyond the suffering of the world. On this point more details will be found in later pages of this book.

The inner state of his ego, the problems and experiences of his own self, were the theme of countless works of Cézanne's; over and above this, his destiny as a whole, and with it the particular view of the world which emerged therefrom, became the basic prerequisite of his art. Yet in his work he did not depict his ego only in a state of

distress, but also as possessing a positive virtue, indeed as being itself a creative force. During his whole career from youth to old age Cézanne's conviction was that the real source of his and all genuine artistic creation was not to be found in talent, genius and craftmanship, but in *tempérament*. But *tempérament* was not only a prerequisite of art, it actually was also the artist's vocation. The world of a work of art could come to life only in a completely successful portrayal of the artist's personality, if this was expressed clearly and strongly. And so, in Cézanne's work, to portray the artist's ego seemed to be a theoretical challenge, just as this aim obviously determined his practical artistic activity from the beginning. To be original, 'to tell the story of body and soul', that is what mattered most of all.

The word, the term, *tempérament*, as used by Cézanne his whole life through, originated in his conversations with the friends of his youth in Aix. It became famous in Zola's frequently quoted formula: 'A work of art is a corner of creation, seen through a temperament.'[34]. This formula may have been the literary property of Zola, but its content was probably inspired by Cézanne. It fits the character of Cézanne's earlier work far better than Zola's: and the expression *tempérament* was to continue to predominate among the aesthetic terms Cézanne used for far longer than it did with Zola: for him *tempérament* was more important, signified more than for Zola. But Zola was strongly influenced by Cézanne in artistic matters; his own insight was limited and he certainly depended on Cézanne for ideas.

In Zola's *Salon* criticisms of the year 1866[35], *tempérament* played a significant rôle. These reports were dedicated to Cézanne and in the foreword to them Zola made reference to 'the grand talks we have had with one another for ten years', which he wanted people to see as duologues between 'two old friends who know each other's hearts and who can speak to one another with a simple glance'. Then he went on: 'We tested and rejected all systems and after this tedious work we said to ourselves that apart from a powerful and personal life all is but lies and stupidity. . . . We looked for humanity everywhere, we wanted to find a personal accent in every work, whether picture or poem.' As we can see, Zola himself stated that Cézanne played an important rôle in the formation of his convictions. In what follows, therefore, we can be certain that at the least we are hearing Cézanne's ideas too. There he wrote: 'There is one eternal truth . . . temperaments alone are alive and rule their age'

and 'art lives only through fanaticism, through personal accents, through the particular flavour of the work.' 'For me . . . a work of art is . . . a personality, something individual. What I require from an artist is not that he should give me tender visions or terrifying nightmares; but that he should surrender himself, body and soul, and demonstrate plainly that he has a powerful and individual mind, a nature which seizes nature with a mighty hand and sets her before us exactly as it sees her.' Notice that this is not Pissarro's reproduction of nature, with which both Zola and Cézanne were at that time already familiar and of which they thought highly, but a conception in which the artistic temperament is credited with a much more forceful intervention in the real world. 'The point is' —so he continues—'that one should be one's self, lay bare one's heart, shape an individuality with energy . . . my wish is that one should be alive, should create something new outside of all conventions, by following one's own ideas and one's own temperament'. Temperament is the decisive thing; without it all pictures would of necessity be ordinary photographs; the real world as seen by the artist must be subordinated to temperament. 'The word "realist" means nothing to me for I consider that the real is subordinate to temperament.' Then again, 'more or less accurate observation' means nothing 'if a forceful individuality is lacking to awaken the picture to life'. 'Every great artist has achieved the goal of giving us a new personal translation of nature.' 'Reality is the constant element which is present and different temperaments are the creative factors, which endow works with differing characters.' For Cézanne and Zola the good, indeed the only real artists are those very 'temperaments which do not crop up in the *Salon*'.

This attitude, however, was born of the conviction that 'no rule of any kind can be laid down and no directions given: each one must rely boldly on his own nature and not try to deny it. He must set himself outside the damned rules which are taught in the schools.' And then, entirely in tune with the young Cézanne, 'I have no traditions. . . . Happy are those whom the masters do not recognize as their pupils! They belong to a special race; they are destined to be masters themselves, egoists, clearcut and plainly detached personalities.'

Once it is accepted that *tempérament* alone opens the way to truth and life, every genius has a right to create his own world; these different worlds exist side by side, all contrasting sharply with the idea of the one and only true world of beauty as taught by the art

schools of the classical tradition; thus each newly emerging genius has a free hand to develop his originality and to vindicate his individuality. 'So, every artist will give us a different world,' writes Zola, 'and I shall gladly acknowledge all these different worlds on condition that each of them is the living expression of the artist's heart', and then, in terms which are unambiguously Cézanne's: 'I admire the worlds of Delacroix and Courbet'.

The menace presented by the most extreme, completely unrestrained form of subjectivity, which can so easily turn into a depraved 'originality at any price' (just as it did with Cézanne in his first years in Paris) was here not in evidence at all; indeed, subjectivity had become the foundation stone of genuine artistic creation. On the other hand *tempérament* had already acquired a more extended significance as the way to truth and life. It determined more than the *form* of the world-picture; it became, with all its problems, the *content* of art, not merely a medium, but the most profound concern of the person creating the work of art and in particular of the truly creative man.

In seeing things this way, however, Cézanne cut himself off from Zola, perhaps, indeed, he differed from Zola in this from the very beginning (though probably unconsciously). Zola gave the term a psychological import: for him the qualities of the *tempérament* lay in eye and hand; which is why he never understood Manet. It was only in the course of the long years during which his estrangement from Zola gradually took place that Cézanne realized clearly that for him *tempérament* meant something other than this; and had done so from the very beginning. For it was characteristic of the early days of Cézanne's art that he had not yet found a clearly recognized 'corner of creation' which he could seize with eye and hand, but only a world which was distorted again and again by the demands and needs of the ego. He progressed only gradually to the vision of nature seen without restraint, and right up to his death his extremely individual method of setting about the production of every single one of his pictures remained as follows: he started with a subjective representation of the interrelationships of the whole, with their poetical and so to speak intellectual significance, and then he moved on to portray objects.

But in the 'seventies Cézanne's *tempérament,* as a part of his development as a whole, underwent a fundamental change without surrendering any of its importance. Its nature was transformed both because it could, and in order that it should, open up the way

leading to the truth of the real world. Thus *tempérament* no longer led to the creation of a subjectively interesting impression, as Zola understood this process, but to a revelation of universal truth, which unites all artists and which, despite their individual differences, recurs in the work of each of them, essentially the same. In the late works of Cézanne, it is his *tempérament*—the gift of candour, of openness and of receptivity towards truth of observation—which in the striking phrase of Delacroix is his *vis poetica* (*Diary*, 8th June, 1850).

<div align="center">NOTES (CHAPTER II)</div>

1. *Correspondance*, edited by John Rewald, p. 288, Paris, 1937.
2. The first version was sketched in a letter to Zola as early as 20th June, 1859; cf. also Cézanne's letter of 9th April 1858, *Correspondance*, p. 21.
3. Lionello Venturi, *Cézanne, son art, son œuvre*, Paris, 1936.
4. Ambroiše Vollard, *Paul Cézanne*, Paris, 1914.
5. Lawrence Gowing is of the same opinion: see the text of the catalogue for the Cézanne Exhibition, Edinburgh and London, organized by the Arts Council of Great Britain, 1954.
6. See Charles Sterling, 'Cézanne', *Catalogue of the Musée de l'Orangerie*, 2nd edition, Paris, 1936.
7. By kind permission of Matthiesen Ltd., London.
8. Roger Fry, *Cézanne, a Study of his Development*, 1st impression London, 1927, 2nd impression 1952.
9. According to Fritz Novotny, *Cézanne*, Vienna, 1937, index of the reproductions, No. 58.
10. Reprint of the 1st impression, p. 922.
11. Meyer Schapiro, *Cézanne*, New York, 1952, gave a positive reply to this question. He said that these pictures showed 'none of (the) familiar aspects of the card game'. He also said that they were not typical of the peasants of Provence.
12. For a discussion of the symbolism of the pointed and tall hats which recur so frequently in Cézanne's youthful phantasies—they are symbols of creative power—cf. C. G. Jung, *Psychology of the Unconscious*, p. 73, London, 1922.
13. It is probable that the source of Cézanne's knowledge of Dante was the French version by Louis Ratisbonne, secretary and friend of Alfred de Vigny, who began to translate the *Inferno* in 1852. Delacroix mentioned this translation in his diary on the 4th August, 1954. There was, however, another French translation of Dante, written by a Mr. Mesnard and criticized by Sainte-Beuve, *Causeries du Lundi*, XI, pp. 198 et seq., in that same year, 1854 (cf. Louis Gillet, *Dante*, 1941).
14. Venturi held a different opinion on this point. He wrote: ' "A Modern Olympia", in which Cézanne portrays himself sunk in contemplation, was intended to transform a romantic mystery-play into a light comedy scene, and to offer a challenge to everything that Manet's coy gentility represented. Thus this picture reveals another side of Cézanne's soul to us, not his violent passion, but his scorn for certain moments when he cherished illusions.' This explanation is not convincing. By contrast with Manet's these pictures by Cézanne are extremely 'pathetic'. Only his attitude towards Manet can explain why Cézanne picked on the Olympia theme. His hatred of the older painter is well-known; he was furious about his *culte de soi-meme*, his elegance, his gentility, his skill in painting and in conversation, even his *soigné* appearance. How the clumsy Cézanne must have detested him—with his awkward movements, his huge head framed in a black beard, Cézanne the unkempt,

<div align="center">128</div>

# Notes

the dirty, isolated man who had no visible accomplishments to show; how he must have loathed him for his success!

15. Hell is here used with a double meaning. The fact that Cézanne regarded his own work as an invention of Hell, proves that the drawing and the thoughts which inspired it were products of the unconscious. According to C. G. Jung, Hell is the modern expression for the unconscious.

16. Zola's characterization of Cézanne's father, in the preliminary notes for *L'Œuvre* runs as follows: a joker, a republican, a *bourgeois*, cold, petty and mean.

17. Cf. John Rewald, *Cézanne, sa vie, son œuvre, son amitié pour Zola*, pp. 327 and 384.

18. See *La première tentation de St. Antoine, publiée par Louis Bertrand*, Charpentier, Paris, 1908.

19. *Correspondance*, II, p. 73, letter to Madame Colet.

20. Th. Gautier, 'Le Salon de 1869' in *L'Illustration*, May-June 1869, reprinted in *Tableaux à la plume*, Charpentier, Paris, 1880.

21. Cf. Rewald, *Cézanne, sa vie, son œuvre, son amitié pour Zola*, pp. 276 et seq.

22. The catalogue of the Cézanne Exhibition in the Musée de l'Orangerie, 1936, suggests that the attacking animal is not a dog but a panther; but this can hardly be right.

23. Albert Wolff, *La Capitale de l'art*, quoted by Meier-Graefe in *Entwicklungsgeschichte der modernen Kunst*, Munich, 1915.

24. Vollard, *Cézanne*, p. 35.

25. *History of Impressionism*, p. 107.

26. Quoted by A. Basler, *Le dessin et la gravure moderne en France*, p. 26.

27. In 'Édouard Manet', 1866, published in *Mes Haines*.

28. We must bear in mind that when he made this comment Cézanne was not thinking of dispensing with degrees of colour modulations or of plastic representation in space. What he had in mind was the modelling of separate objects by means of sharp contrasts of light and dark, with full light shining on the plastic high points and shadow in the depths. Cézanne stressed flatness while elaborating plastic volumes to the full. This was how he understood the doctrine of the *'plans'*, a doctrine which Gauguin, according to one of his remarks to Émile Bernard, never understood. According to Émile Bernard, *Sur Cézanne*, Paris, 1925, Cézanne wrote as follows about Gauguin: 'He did not understand me. I never wished for the absence of modelling or of gradation, ('le manque de modelé ou de gradation') and will never tolerate it. That is all nonsense. Gauguin was no painter, all he did was make Chinese pictures.'

29. Tristan Klingsor, *Cézanne*, Paris, 1923.

30. See the pipe, the lower part of the body, the contour of the body at the left.

31. See also Meyer Schapiro, *Cézanne*, New York, 1952: 'He created a model of his own activity as artist.'

32. In the catalogue of the Cézanne Exhibition, Edinburgh and London, 1954, No. 52, Professor Lawrence Gowing propounded the theory that this version was the first of the second series ('perhaps the first of the smaller versions of the subject').

33. 'Motive' = what moves the artist.

34. 'Temperament' was a word which Delacroix, Baudelaire and even Champfleury were already employing to describe artistic genius, but they used it only from time to time and for them it did not represent the basic prerequisite or the origin of artistic creativity. On 24th May, 1865, Baudelaire wrote in a letter to Madame Paul Meurice, on the subject of Manet: 'He will never be able completely to fill in the gaps in his temperament. But he does have a temperament and that is the important thing.' To Baudelaire the term 'temperament' was equivalent to talent, to the ability to make an object interesting and alive in the execution of his painting. Gautier also used the word in the same sense when in his *Études sur les musées* (1849) he called Gros a painter who had 'more temperament than taste and a great gift for selection'. He wrote even more plainly in a criticism of the work of Peter Cornelius (in *L'Art moderne*, p. 238, Paris, 1856): 'These painters do not lack intellect,

or knowledge or talent, not even genius, but they do lack temperament, a quality for which, in our opinion, there is no substitute and which one senses in the smallest brush stroke.' What he is really indicating here is a gift for the artistic representation of a wealth of sensuality, of that opulence without which works of art give no satisfaction to the eye ('mécontentent l'œil'): i.e. something quite different from what Cézanne had in mind.

35. Reprinted in *Mes Haines* under the title 'Mon Salon'.

# CHAPTER III

## Cézanne's Symbolism and the Human Element in his Art

Cézanne himself has given sufficient indication that a number of his pictures can be understood as symbolical representations of some of the events of his own life to induce me to interpret them thus and to feel justified in doing so. In developing this interpretation I became convinced beyond a shadow of doubt that a great deal of his art had a meaning for him, even if he were at times himself unconscious of it. Moreover, the study of those works of his which can be so interpreted revealed the means he adopted of coming to terms with certain problems in his life.

In Cézanne's works there is not only a 'symbolism of events' but also, parallel to that, a 'symbolism of artistic design'. This was based on an insight into the significance of visible phenomena, an insight which in turn had its origin in his experience and his understanding of the way in which his own life fitted into the world in which he lived.

The mere fact that he took his own person and destiny as subject-matter for his art marked Cézanne out as a modern painter; his modernity was further demonstrated by the fact (not unconnected) that loneliness played a great and significant rôle in his art. This modernity, which had such tremendous consequences for art as a whole, was one of the effects of the shock administered to European society by the French revolution and the industrial revolution which followed in England: both of these isolated the artist. Of course a tendency in the direction of isolation was in itself nothing novel. Genius inclines towards solitariness and this tendency, which lies deep within every creative artist, had made itself felt much earlier. Nevertheless, there are fundamental differences between the lonely people of earlier centuries and those of the nineteenth century. A brief historical survey is essential at this point

for a better understanding of Cézanne's loneliness and the rôle it played in his art—a review which I shall restrict to painters, though the problem of loneliness is really more far-reaching and has perhaps been even more obvious among poets and philosophers.

### Degrees of Loneliness

Generally speaking, we are so used to accepting the figure created by the nineteenth century as being a true picture of the artist, that the isolation into which artists were plunged in that period is regarded as a basic characteristic of the artist's life in general. Nevertheless, sculptors and painters were not solitary men in ancient times or in the Middle Ages—on the contrary, they were associated with artisans in the service of the state and the church. In late antiquity and in the Middle Ages too, solitude was the privilege of religious thinkers, with whom artists had not the slightest connexion. On the contrary they lived and worked in communities, whether craftsmen's unions, monasteries or courts of princes, corporations or guilds.

Perhaps the first person to put forward the conception of solitude as an ideal condition for artistic creation was Leone Battista Alberti, in the first third of the fifteenth century, a time when the artist was beginning to be placed in the same intellectual class as the learned man. It was, indeed, one of the signs that artists were starting to rise in the social scale, to lead distinguished lives and to attain the same intellectual level as thinkers. The idea reappeared in Leonardo da Vinci's writings, but in slightly altered form; for although he wrote in his notebooks that 'you really belong entirely to yourself when you are alone', this only proved how very much of his life was still lived in society and how deeply he was involved in its interests. He did not regard solitude as being by any means an indispensable condition for creative work, which, indeed, he carried on successfully at all times in complete harmony with life at Court, and largely in the service of religious practices binding on all. To Leonardo solitude seemed to be the ideal condition for contemplation of nature, the works and manifestations of the Creator; and because he thought of the inner nature of man in relation to the outer nature of the world it was natural that his own nature appeared to him to be most perfectly revealed in this very state of solitude. To be alone assured him freedom and happiness.

By the time we come to Michelangelo, on the other hand, it is quite another story. To quote Carl Justi[1]: 'For him all encounters in

life and all the gifts of fate were but sources of disappointment and mistrust, fear and hate', and so he took refuge in solitude. It was his melancholy temperament which caused him to adopt this attitude. Yet if his works betray only too clearly the suffering life brought him, his misanthropy, his violence and his longing for deliverance, they are not the fruits of his solitariness: or only in so far as it was in this solitariness that his communion with what is divine and great and his vision of perfect beauty and nobility reached its height. These creations of his are, in consequence, characterized by a certain 'being alone with one's self, which finds perfection in an absolute inner equilibrium of all the component parts'[2]. Justi says[3]: 'Michelangelo was by nature a lonely creature who neither had need of nor indeed was capable of relationships with his equals. He knew this himself, stated it, and scarcely ever regretted it'. It is true that he surpassed all his contemporaries in creative power to such a degree that he could find no 'equals', so that, if only for that reason, he was bound to have a lonely life. Nevertheless he did not find the inspiration for his work in the consciousness of this. For his Catholic faith and his familiarity with Greek philosophy and Roman mythology together ranged him in the most highly cultured stratum of the society of his time and gave him a place in it. To him the divine creation of the world, the sinfulness of mankind, the fact of Christ becoming man, His sacrifice for our redemption, the authority of the church and the Papacy as a mandate from God, the testimony of the Old Testament and also of the philosophers of antiquity, were all realities through which his spiritual existence was sustained. Lonely because of his melancholy, he was nevertheless not made forlorn in his solitude by scepticism. Moreover, his creative activity assured him his own special place 'in the world', acknowledged as a genius without equal, the counterpart in his own sphere of strong-willed popes and cultured princes who genuinely shared his conception of the world, received, employed, given commissions by them, yet always treated with a consideration which demonstrated their admiration. His very fame, which he enjoyed universally from early youth to extreme old age, made him irrefutably a man of his era, for in his time as in ancient times fame was a living divinity who assembled all men of intellect in her temple.

In pictures (particularly portraits) by other artists painting in the Florentine style, such as Pontormo, Rosso and Bronzino, loneliness made its appearance as a reflection of the chilly ceremonial of the court, which penetrated deeply into their lives. Even in groups of

figures, though people were often shown crowded closely together, yet they were all portrayed behaving as individuals and rejecting the world around them by bearing and gesture: it is as though they were no longer able to come together in harmony or to fit into a whole. These painters were still bound to the society they lived in, but inwardly they were beginning to break away and, what is more, to move off in a hitherto unfamiliar direction. What Michelangelo and other great men of the High Renaissance had accomplished was so stupendous that it made it impossible for others to carry on the tradition. That is why a man like Pontormo, consumed by boundless ambition and full of dissatisfaction with himself, gradually avoided mankind more and more until he ended up as a victim of hallucinations and ghosts. In his case solitariness was not so much a source of artistic creativity as to a large extent a consequence of it—the consequence of living, in the shadow of Michelangelo, Raphael and Correggio, haunted by the delusion that he had to be equal to them or even surpass them[4].

Rembrandt's loneliness was in a completely different sense a consequence of his artistic powers. As soon as he began to display his special qualities to the full extent, he was excluded from the very society whose favourite painter he had been when he was a beginner. Admittedly this was not unwarranted. For in the style he adopted from about the time of *The Night Watch*, he sought to force the patrons who commissioned paintings from him to accept a representation of the human figure which was absolutely and completely a-social and which aimed at portraying the lonely existence lived by individuals, each face to face with his destiny. All the same, the fact that Rembrandt suffered the experience of 'being thrown back upon his own resources', afforded him new insight into life, and actually revealed to him the ultimate bond of faith between the solitary man and God, that is to say the most secure and safe bond of all. No one is less forlorn than the solitary figures of his late period.

Watteau presents a more complicated problem. He must have known the feeling of being lost in loneliness. This painter of the world of fairies and of the theatre had obviously some weighty reason for creating the melancholy spectator of his courtly scenes and parties, who stands out in contrast to their glitter like a strange spirit cut off from conversation and music, dancing and love. This impression is often so strong that it arouses the feeling that all the décor being unfolded around him consists of nothing more than a figment of his imagination or his longings. Yet it is not total loneli-

ness which reigns here; for the world still exists and is bound up with 'society', those groups of highly cultivated minds attached to the Court who made a creative contribution to life through their own enjoyment of it. Life may indeed be a dream, a passing moment, but the glitter of happiness has a certain value, even when it is seen from afar, and nature, not reluctant to let men tame her, weaves a protective web around all this kind of life. In the world of grottoes and groves, intellect and physical nature complement one another in alternating challenges—the one refreshing, the other ennobling. In such surroundings the melancholy man can even enjoy his solitude—as did all those romantic natures who came after him and created for themselves gardens with alleys and box hedges, fountains and marble gods, little temples and ruins.

Throughout the eighteenth century, a sort of painful pleasure—the pain and happiness of being alone indissolubly combined—was an important feature of the romantic artist's existence, for it was at that period that nature was revealed to him in all her greatness untouched by the hand of man. The French revolution put an end to this feeling and made the artist once again feel much more closely integrated in society: indeed he now even became a political figure, engaged in the service of the state and interested in the fate of the masses, which actually provided him with inspiration. It was only when Europe's social structure disintegrated after Napoleon's fall and when science gradually undermined man's belief in the possibility that life and the world had a coherent meaning—only then did solitude begin to emerge as the fearful fate of all mankind. From about 1830 onwards this fact was slowly grasped by one class of the population after another—the disinherited, the displaced, the enlightened and the newly created masses. Among painters, too, the notion of loneliness began to prevail, with twofold effect—on the artist's vocation and on his view of nature. It is to be found in the Barbizon painters, in Constable and, particularly clearly, in the landscapes of Caspar David Friedrich, each with their lonely spectator. Following belatedly in the wake of the generally developing consciousness, these artists once more attached a positive value to the state of solitariness. The soul selected for higher flights flees from mankind. In its loneliness it surrenders the advantages of pursuing society in exchange for an insight into nature silently carrying out her own laws. Nature vibrates in harmony with the soul and inspires it; or the soul in enjoyment of itself loses itself in nature.

Yet this attitude could not be maintained for long. The hopeless-

ness of solitude came too forcibly to the fore everywhere. It became the distinguishing mark of the new intellectual predicament of all classes. Artists evinced this by appearing for the first time released from every restraint, complete 'outsiders' in the eyes of society, and without any real objectives: a few of them, such as Ingres for example, at that time still Director of the Academy in Rome and later in Paris, were maintained in fictitious honorary posts (for the Academy had now at last lost its significance): some were appreciated by particular connoisseurs yet were not supported by them and even had no personal contact with their patrons; all were without a clearly defined field of activity and by no means all were firmly convinced of the significance of what they were doing; but all were at the mercy of a public without judgement, which had ceased to have any idea of the purpose or the potentialities which lay behind great artistic endeavour.

The most authentic representative of this moment in the history of ideas is Delacroix and because of his inherently passionate temperament he succeeded in making a new virtue out of necessity. He too suffered from loneliness, from the 'unavoidable loneliness to which the heart is condemned'[5]. But delving deep into the great works of the past—both literature and art—and encouraged by a select number of distinguished minds who kept themselves at an extreme distance from the crowd, he created a passionate and gloomy style of painting in which the richness of the artistic values offered to the eye surpassed anything hitherto known and which made everyone overlook how completely insignificant for his time his themes were. Delacroix's works owe their strength, their emotional impact and the compactness of their artistic construction exclusively to his personal conception of art, which set him entirely apart from his time and indeed placed him in opposition to it; they had an atmosphere of loneliness because they were created in a state of complete aloofness and it was because of this circumstance, too, that they were condemned to suffer their particular sentence: the crowd failed to understand them because it still sought in art the glorification of society (in one form or another), and they were lauded only by the few, in particular by those strong-minded artists who appreciated the constructive imagination and expressive power of realization of their creator[6].

About the middle of the nineteenth century a radical and general transformation took place which plunged the artist's whole existence into a still deeper, hitherto unknown degree of isolation. The

classical school was dying and romantic painting had proved incapable of forming a school, with the result that the artist's last conceivable anchorage was crumbling away; the mission of every artist and its realization had become the responsibility of the single individual. Art was thus robbed of any form of general support and became equivocal even to itself. It was an incredible position: no one knew any longer whether he was dealing with an original artist or a madman.

As long ago as 1846 Baudelaire had summed up the situation and seen clearly what was wrong. In his report on the *Salon* he said: 'We lack a school, that is to say a faith and therewith the impossibility of doubt', meaning that there was no longer any general conviction as to what art should be and everything seemed to be permissible. The result was that nearly every newly emerging artist of merit was exposed to the gravest doubts about his vocation and his talent, not on the part of the public but in his own eyes. He was menaced by despair, or, reacting in the opposite direction, was seized by megalomania.

The contrast between the nature of Delacroix's art and that of the generation of painters which followed him is further illustrated by the alteration which took place in the choice of themes adopted by these artists. 'Universal' subjects taken from history and literature lost their artistic significance; in their place we find motifs which owed their choice simply and solely to the personal interest of the individual artists. However, painters like Millet, Courbet[7] and Daumier strove, by their method of representation, to transcend in these private themes the now inevitable separation and isolation of the individual. They sought sympathy for themselves at the same time as they sought it for their subjects. (This explains the peculiar violence of their pictures, which often creates an effect of importunity.) At all events, loneliness became for them a driving force behind their artistic production: what is more, it proved to have such an important and fundamental rôle in the determination of the whole artistic personality that it provided them with purpose and significance. From now on every single artist took his direction from loneliness. Painters of the late nineteenth century frequently asserted that they worked for themselves alone, but this was in fact a way of proudly concealing their anxious concern to overcome their loneliness by attracting friends and an audience. For, like all the other arts, painting is in form and construction a means of communication.

## Cézanne's Symbolism and the Human Element in his Art

After the brief interlude of realism in France, the generation of the impressionists followed Delacroix. Like the symbolists, they too appeared to be in flight from loneliness. Because they had no definite place in society and tradition, because they were no longer bound by any contract, they took refuge, each according to his own fancy, in many remote corners of the world; in the tinsel of the ballet, the theatre and the race course (Degas), in the *demi-monde* of music hall and chorus girls (Toulouse-Lautrec), in the 'blessèd isles' of the Far East (Gauguin) or in the mere contemplation (but no more in any sense the understanding) of nature (Monet, Sisley). Yet not one of them became integrated with the world he depicted, or found a home there: everywhere they remained mere spectators. Monet, for example, devoted himself exclusively to the appearance of light, to its power to deceive by transforming, to blur and to destroy outlines, and not to its creative or illuminating powers. The power of light to disintegrate the visible appearance of objects seemed to him to reflect, as though in a mirror, his own instability, his aimless drifting in time. In nature, in the quivering outlines of things seen, in the isolation of a single moment, his eye, extolled by Cézanne, discovered fragments of the harmony of being in most minutely graduated colour harmonies. Pissarro and Sisley, too, were content with similar results. For all of them solitude now had the effect of reducing their artistic aim to a minimum: their relationship with things was restricted to what they saw at a moment when those things were illuminated by light and they held aloof from any significance the things seen might have. Moreover, their isolated situation stamped their work with another of their characteristic features: they had, in the words of Émile Bernard, 'adopted the cold colour scale in exchange for the warm one' which had previously been usual. This exchange was a symbolic action of first importance which had its origin in the artists' spiritual state. The overall tone of the world as they saw it and as their works depicted it reflected only the feeling which their own position evoked in them, the chill of isolation.

Manet and Renoir, on the other hand, appeared not to be conscious of the modern artist's problem of loneliness. Despite some resistance to their art at first, the *bourgeois* society of the Second Empire seemed to give them an objective and afforded them some inner security. But Manet's dandyism, expressed in the refined elegance and nonchalance of his art rather than in his appearance, was another proof of his isolation. A dandy is an extravagant man,

an outsider in the mask of a society-man, a casual person, one whose heart is not involved, who is without ties, and who, although he plays the game along with the others, really only looks on at the lively bustle. And two other characteristics betray Manet's inner isolation. Like Monet's his art was based entirely on the eye, on his extraordinary and unique gift for observation, which would not and indeed could not grasp anything more than the charms of colours and shapes. Furthermore, even Manet's art grew up without a tradition; a free and by no means inevitable decision sent him to Velazquez and Frans Hals seeking an anchor for his art. This choice may have been a stroke of genius, may have turned out to bear rich fruit, but it reveals the fundamental loneliness which Manet felt.

The position of Renoir was different. He lived and worked in the circle of his family, protected and cherished, never failing to be stimulated by joy, throughout all the cares of life. He is the only example of this kind of artistic existence which so many have striven in vain to achieve. He was indeed a primitive man, for whom the family represented the world: wife and children, nursemaids and friends were not only his models—they practically determined the circumference of his world. This was true to such a degree that Renoir even conceived and carried out his landscapes and still-lifes in relation to his family, transfiguring them thereby. It is this sense of security which makes Renoir's work so infinitely charming, serene in itself. Yet for the very same reason it is limited and somehow trivial, too facile, not mature enough to reveal full awareness of the very serious position of the modern artist, because, himself untroubled, he was unable to perceive, to sense, to realize the problem of solitariness.

Van Gogh was exactly the opposite case. Of all the artists of his time he can probably be said to be the one whose fate was to suffer the greatest neglect, a fate fundamentally opposed to his nature. From early youth he sought some bond with the world, a feeling of brotherhood among men. He hoped to find it among the poor by going to meet them with compassion, but he discovered that this was impossible; he was forced to give up his compassion in order to recognize and to appreciate the deeper agony of the loneliness of all mankind in his time, something more than the social misery of the miners and of all poor people. The insuperable abyss which surrounds each of us makes the aid of man to man impossible. All that is possible in man's forlornness is to 'concentrate attention on

objects which are unchangeable, that is, on what is eternally beautiful in nature' (letter to the painter Rappard), and out of one's own loneliness to give to other lonely people an indication of joy as well as of common need, and to erect monuments to forlornness itself. During the last years of his life, Van Gogh remained absorbed by this task and died overwhelmed by loneliness, without suspecting that he had attained his goal.

Now at last we come to Cézanne. He too was a great man neglected, but in comparison with all the artists we have mentioned up to this point, his attitude to loneliness was basically different, in two respects—because his experience of it was so profound and because of the position he took up in relation to that experience. He too became a lonely man as soon as his artistic career was even hinted at, that is, soon after his arrival in Paris. He had hoped to live in close and friendly relationship with Zola and to share accommodation with him, but this did not come to pass. Nor did he ever reach any sort of friendship with the painters in the circle of the later impressionists, whom he very quickly got to know; as early as 1870 Achille Empéraire wrote that Cézanne had no longer any friends in Paris[8]. And when he shared any of their exhibitions he at once appeared completely isolated. He cut himself off more and more from frequenting other people until he disappeared from their sight. He buried himself in himself, withdrew from every kind of joint undertaking, began at the same time to hate and to fear mankind. All this was due to the experience of insuperable solitude into which his art cast him—first his colossal intentions and his dreams of huge works, later his quite peculiar conception of the meaning of his aims. He, who as a boy had been a great boaster and from whose pen facile verses had flowed by the hundred, began —because of the shame and the pride of the lonely man—to lose the power of speaking and writing. We see evidence of this in his letters, in which he tended to use stiffer and stiffer expressions and ever more involved circumlocutions. Even the few admirers of his art who approached him towards the end of his life found it impossible to break through this solitariness, for it had now become the only satisfactory way of life for Cézanne. We have his own written statement for this. On the 21st January, 1901 he wrote: 'Loneliness may steel the strong, but for the waverer it is a stumbling block'; and on another occasion: 'Loneliness—that is what I am fit for' (*voilà ce dont je suis digne*).

Both consciously and unconsciously he now felt that solitude was

essential; that his art could not flourish except in loneliness. That is why, fully aware of what he was doing, he became an untouchable, no one might come near him; that is why he feared most especially those who might 'get at him' and would let no one watch him while he was at work.

The *unconscious* feeling is revealed in several incidents. In the year 1885 there was a moment when Cézanne's solitude, which he had by then for a long time considered to be a prerequisite of artistic creation, was threatened by the sudden bursting forth of passion. A deep psychological force protected him from the catastrophic consequences which such an upheaval might have caused. Here is what happened. Cézanne had declared his love for a lady in Aix, as we know from a draft letter which has been preserved on the reverse of a drawing[9]. The letter in question was sent off and Cézanne awaited an answer with the greatest impatience. This we learn from three letters of the 14th May, and 15th and 27th June, 1885, in which he begged Zola to send on to the Poste Restante at La Roche Guyon, where he was staying, any letters which might arrive addressed to him from Aix. Cézanne waited in vain, because, as he informed Zola on the 6th July, he had not thought of going to the Post Office to collect any letters which might have arrived for him! He had 'forgotten' that he had not given Zola his private address. For this unusual 'forgetfulness' of Cézanne's a psychological explanation can easily be given—his art did not leave the necessary room for his passion to blossom fully. The higher principles which guided his existence kept his lower impulses within bounds and the way they influenced him indicated plainly that loneliness was Cézanne's artistic destiny. He himself appreciated this very soon afterwards. No later than the 25th August, 1885, he wrote to Zola: 'For me there is only the uttermost loneliness'[10].

This incident shows that Cézanne's attitude to loneliness did undergo a fundamental change once during his life, if only a temporary one. It was not merely, as one often reads, that serenity set in, a growing indifference with increasing age: on the contrary, the suffering caused by his solitude persisted undiminished. This is evident from his later pictures with their profound understanding of loneliness and their visions of the happiness of friendly companionship. In his early days, on the other hand, Cézanne countered loneliness with resistance, rage and violence. He maltreated earthly phenomena when he represented them—people, objects, even nature —because they seemed to confront him with coolness. He strove to

snatch them to himself with violence; to bend them to his own will in the exuberance of his own feeling; to impose his own sensations on them. Because of the suffering, restlessness and distress caused by his own feeling of being lost amongst them, he attempted to 'interpret them angrily with his own thoughts' to use an expression of Hölderlin's. About 1870 this attitude changed. It is true that at that time Cézanne was also still evading a general obligation, that of military service, and obviously without any hesitation, without feeling he had to justify his action or having any doubt as to his right to act in this way. But, by dedicating himself wholly to his art, he now accepted the fate of loneliness as an essential prerequisite of his work, surrendered to it, and thereby gained that new view of the world which was expressed in all his work from now on. In place of the 'angry interpretation' there came a quiet, relaxed and solemn contemplation and understanding of people and things. This was the moment when Cézanne's art underwent that fundamental and final change of style which determined all his later work. Up till then his painting had in its 'anger' oscillated among a variety of different ideals, because it possessed no sure stronghold, no anchor, no foundation; from now on, on the other hand, it developed along a straight line, ceased to change and search, because it had found a firm anchorage in the new attitude of the artist.

Probably Cézanne's 'conversion' took place quite undramatically; perhaps it was the result of a long inner struggle. In any case its significance for him was revolutionary: it meant a true renunciation of his former ego, a release from hate and rage. The new attitude towards objects, which his pictures tell us he now achieved, could never have been acquired save through submission to that very loneliness which he had hitherto so greatly hated, and under which he had suffered so deeply. Here, indeed, we are not dealing simply with a change of technique or a new style. On the contrary—the warping, rigidity and distortion formerly seen in his works are no longer present, the objects depicted no longer show opposition towards one another; they are no longer subjected to an uneasy, melancholy pressure, heavy with gloom and despair, which seeks violently to force them together. They are now shown 'standing together and existing together' in a way that is unforced and dignified, at first, it is true, somewhat uncertain and muddled, but becoming later ever more clear and unambiguous. Cézanne's world attained quiet, peace, harmony and unity; loneliness, which

had hitherto created a feeling of intolerable suffering, now formed a foundation for a new and peaceful existence.

We are dealing here with a genuine 'conversion', indeed one of a religious nature; not merely a rational conclusion that loneliness was inevitable and resistance senseless, but an inspired insight which was later to appear in his works. All this coincides with the period (the years 1870–72) when Cézanne was turning away from his 'black' style and his *couillarde* method with all its violent features and was turning towards impressionism—note that this was *before* his years of apprenticeship with Pissarro. Cézanne's so-called impressionism is only the appropriate contemporary expression of his already complete surrender to loneliness. (Hence the extraordinary, almost self-contradictory element in Cézanne 'the impressionist', for which so many different explanations have been given.) For his acceptance of loneliness had given Cézanne a very unimpressionistic view of the significance of things as revealed in their relationships to one another, which was already glimmering beneath and underlying this impressionism.

## The 'Conversion'

The transformation in Cézanne's attitude towards loneliness must be understood as an event brought about by faith. It had to be thus because of the depth and violence of his nature, the tremendous vigour with which he experienced life and which shook his whole being. Here was a man who had suffered so greatly from solitude that he was driven to revolt against the world and was thus brought to the brink of self-destruction. The ultimate result of his experience was that he came to find security in the very emptiness of solitariness and was able to discover there a new meaning for the world. When this happens to a man, when he finds all values turned upside down, when he comes to the conclusion that to rebel is proof of weakness while to submit humbly is a form of strength and a source of power; when he is able to recognize the outward appearance of things as the structure which sustains the world and to represent it thus; then this event can only be understood in all its awe-inspiring gravity as arising out of the experience of every degree of loneliness, down to its lowest depth, which is the modern malady analysed by Dostoevsky and Nietzsche, the state of being abandoned by God. In contrast to most of mankind, Cézanne successfully accomplished the transition from rage and dejection to resignation, to acceptance

of suffering and so from the state of being abandoned by God to that of being protected by God.

There are two special points to note about this: Cézanne was the only modern artist who experienced loneliness to the ultimate depth and tasted it to the full and so, by virtue of his 'conversion', he attained a new insight into the nature of the appearance of objects such as can emanate only from *acceptance* of loneliness.

It was not that he had gained any intimacy with things outside himself or any confidence in dealing with them, nor had he let himself be tempted into any sort of illusion as to the possible condition of mankind; he remained apart from them all, and he accepted the solitude of man as the inescapable fate of his time. But behind this apartness, which cannot be penetrated by human curiosity, by any interest in life, by any mood, in brief by any kind of human importunity, he glimpsed in the complete silence and inviolable remoteness of things an analogy, an earthly symbol of the eternal existence and 'self-preservation' of the divine. The indivisible unity of the divine seemed to him to be visible here in the formal relationships of things to one another. This was their real nature, to represent which became the aim of his painting.

How was it possible for awareness of the existence of things to evolve out of the darkness of loneliness and the very fact that they are completely abandoned by God and totally apart from men? How did it happen that this was actually the result of a conversion? The answer is that in experiencing utter solitude one becomes aware of time, of perishing through time and of the fear of so perishing. As he becomes aware of himself and his situation, the man who has been freed from all ties falls a victim to the relentless passing of time because he is no longer able to give it any meaning, and is instead dragged along by it like an object without will power, even to his annihilation. This, he vaguely senses, is the situation of modern man, from which he necessarily and naturally tries to escape, either into 'business' or into 'society', where time passes for him without his noticing it, where he can linger unmolested while time ceases to exist for him. But the artist can seldom take this way out into an unending and unbroken round of activity. If his work is to be true to the epoch in which he lives, loneliness and its effects are a prerequisite for him and there is no means by which he can kill it within himself without endangering the vitality of his work. In order not to get lost in another direction he must therefore somehow come to terms with loneliness and the sense of time bound up with

it, which is a threat to his ego. In the face of such necessity the impressionists escaped into the shortest period of time that could be experienced, into the moment, which they illuminated and immortalized. They tried to disguise the true nature of time with their cry: 'How beautiful is the shortest moment!' Already Van Gogh could no longer bring himself to do this. His ardent nature pictures, his glowing colours show the world on fire with its own transience and at the same time give voice to his cry of fear at the thought of solitariness. Once Cézanne had successfully passed this most critical stage without either fleeing or being afraid and had submitted with resignation, he was no longer filled with fear at the thought of time rolling away, he was liberated from the influence of time and he perceived the timelessness of the world, its deeper independence of all association with time (the very thing which meant so much to Courbet, Manet and Daumier). He had a revelation of the world in a state of timelessness and unchangeability, forever existing and preserving itself in existence, and paradoxically enough, he saw it in phenomena which reason had no difficulty in proving to have come into existence and be destined to perish. In this paradox, however, we come to the heart of the matter, to what it is that Cézanne's works offer us, beyond the mere likeness of comprehensible natural things.

Incidentally it is worth noting that the fact that Cézanne's art was independent of time is very plainly demonstrated by the clothes of his models, which never have anything about them to distinguish them as costumes of the age; although they follow the fashions of their day, they seem timeless, and become even more so the further Cézanne advanced in his development. But even early pictures of his sisters and the one which he painted in 1870 of two ladies walking, which was based on a fashion engraving in the *Illustrateur des Dames*, have this remarkable characteristic.

What happened to make Cézanne's 'conversion' possible? Like many of his contemporaries he first experienced the feeling of loneliness when he lost God, without at the time realizing its significance. Born and brought up a Catholic, he nevertheless grew out of his faith at his grammar school. What was left was unrest and overweening ambition, doubt, lack of simplicity, taking pleasure in not conforming. These were expressed as plainly in the blasphemies of his early letters as in the themes of many of his early works. Naturally the friend of Zola was a confirmed anti-cleric, but, in strict contrast to 'the modern unbeliever whose godlessness consists of indifference',

as Zola described[11] him—the man who believes only in himself, his will and his knowledge—Cézanne still possessed some consciousness of his transcendental nature, which for the moment was expressed only in a passionate striving towards the production of pictures with overwhelming persuasive power and a self-evident finality. Although his representations of the *Temptation of St. Antony* and *Don Quixote* were painted under literary inspiration, they have religious depths in them. Here he was not concerned with mere pictorial solutions to his own problems, nor with psychology, nor with material accuracy, but with the ultimate fate of his own ego which appears disguised as the tempted saint and as the erring yet noble-minded fool. But in other pictures of his 'dark' phase too—for example those portraying pairs of lovers and his 'idylls'—Cézanne was searching for something which he could venerate, which could offer him security in the night of his separation from God, despite the fact that he was at variance with his subjects and was abusing them. He had already ceased to look out for links with society or tradition—quite the contrary, these were the very things which he despised because he knew that what still remained of them was full of lies. He was searching much deeper, near and far, for something which could hold him completely, in life and art—indeed for something which would give him a foundation and a meaning for life and the world. Hence the grotesque distortions of his sensual motifs.

The large copy he made of a Christ in the anteroom to Hell[12] also points to Cézanne's original religious leanings. This cannot be regarded solely as an experiment in colour and form; the content of the picture is also important.

While all these struggles were going on within his unconscious and pressing him sorely, Cézanne felt he was abandoned by the very men whom he respected as the only true artists; on the one hand by Zola, on the other hand by the group who were later to be called the impressionists. What attracted him about these people was their honesty and sincerity. They were not like the mass of the academic painters, pretentious and conventional, they portrayed only what they saw and exactly as they saw it. They subordinated themselves to the real world which seemed to speak to them. Admittedly their view of the real world differed widely from Cézanne's. Yet there was something idealistic about their behaviour both as men and as artists.

It is not impossible that the cleavage between himself and these men, which made him feel that he was being banished once more

into loneliness and thus inevitably cast out into the night of solitude, opened Cézanne's eyes. Indeed, there does not seem to have been any other decisive event in his life which might have caused his 'conversion'. It was in any case undoubtedly the consequence of his extreme isolation and it showed itself in an attitude similar to that of the impressionists—by his subordinating himself to the real world. All the same, Cézanne, in contrast to those other painters of his time, did not take refuge in a vision of nature as something friendly, enlivened by the changing seasons, something which charmed and pleased the senses. Confronted with nature he did not forget his loneliness. Whereas other artists worked in an atmosphere of self-enjoyment, in a subjective and intimate relationship with the subjects which they were painting, which was intensified as they worked, Cézanne on the other hand painted in a state of self-oblivion, dedicating himself wholly to the objects into whose essential nature he sought to penetrate and preserving a permanently impregnable detachment. So his manner of recording nature in his works, in contrast to that of Pissarro, Monet, Renoir and Sisley, was still further demonstration of his innate religious attitude.

Inner submission was followed by outward submission. After some time, during which he was experimenting on his own with this new way of painting, he went to Camille Pissarro and worked beside him, taking lessons from him. He even copied some of the pictures of his older fellow artist. He was then already thirty-three years old. And he applied to Pissarro the words which fitted himself to an even greater degree and with greater justification, 'humble et colossal' ('modest and a giant').

*Sacrifice* was the keynote of Cézanne's 'conversion' and what he sacrificed was the uninhibited self-affirmation of his ego and his revolt against higher authority. These are matters of which neither Zola nor Cézanne's fellow painters were aware. Even Pissarro did not suspect, had not experienced or even dreamed of anything like what was going on in the inmost heart of the young man who was portraying nature by his side.

Yet this element of sacrifice in Cézanne's conversion is precisely what entitles him to be regarded as one of the great minds of his century—one of those who, regardless of the consequences and without reserve, accepted a state of loneliness as being the real and true condition of man, and who then set out from this 'lost stronghold' to seek a way to reunite man with the transcendental. Like

them, Cézanne set about sacrificing and transforming himself under the compulsion of a longing, a deep yearning for some faith.

It is a characteristic and a very remarkable fact about the history of thought in the nineteenth century, that in an epoch when social upheavals, natural science and historical research were causing a disintegration of faith, the greatest thinkers nevertheless insisted with all their might that religion must be preserved or restored as the basis on which to construct a scale of values. This is true of Goethe and Hölderlin, Kierkegaard, Stifter and Nietzsche and in France particularly of Baudelaire. In the visual arts this tendency showed itself, at most, in the work of Van Gogh. Otherwise painting was 'humanist', at first narrative and romantically pantheistic, then later sensualistic and rationalistic. It was here that the work of Cézanne differed from that of other painters. It therefore acted as a link between painting and other greater intellectual achievements.

What this group of outstanding men had in common was a fundamentally religious disposition, a profound psychological need for religion. Only because he too possessed this could Cézanne penetrate to the depths at which an authentic 'conversion' was possible, authentic in that it took complete possession of the man and re-shaped him, his life and his work. For that was precisely what happened to him. Undergoing this experience of an inner conversion changed his style, the basic attitude of his art towards the world and also his exterior mode of life. He returned to the religion, to the church, in which he was born. It has been usual to see only the external circumstances which led to this return; it has been said that Cézanne became a practising Catholic again under the influence of his pious sister. But the content of his work refutes this hypothesis—which indeed does no particular honour to Cézanne and does not accord with his intellectual stature. In any case, one can acquire a deeper understanding of Cézanne's return to Catholicism by a study of the spiritual attitude expressed in his work, and the inner meaning of his creations; he approached the church through a conception of the world that was both mystical and Christian, which he had reached in his own way. Conversion through self-surrender and victory over self was, of course, not by any means a particular attitude of mind discovered by him, but something which he learned from Christianity. Moreover, his attitude can only be properly described in the language of mysticism. The humility which he took upon himself, the passive self-abandonment to creative work, the complete exclusion of his own feelings, of his

own vanity (in contrast, as it were, to Manet and Delacroix), of his personal will (in contrast to Van Gogh and all the later artists)— all these are qualities which have been extolled by those who have had mystical experiences, as ways leading to the understanding of the truth. Indeed, Cézanne's very lack of will power, about which he complained so much and in which he felt the church was his only protection, becomes intelligible as a means to fulfilment when given a mystical interpretation: this weakness was in fact only the exteriorization of the reverse side of his unresisting inner submission, his surrender of all his strength. Just as virtue, according to St. Paul, finds fulfilment in weakness so also did Cézanne's work.

We see then that Cézanne's 'conversion' was a unique experience, peculiar to himself, which explains why he, in contrast to most others of his century who went seeking after God, returned to the existing church. He was compelled to do so and it was possible for him to do so without being untrue to himself, because in the deep night of loneliness in which everything disintegrates he became convinced that there was a divine value and significance in the very fact of being in existence, and that the essence of the reality of things lay in this 'existing'. In real everyday life the church, persisting and unshakeable because based on unshakeable foundations, represents the eternal existence of the Divine. According to his own words he felt that the strength of the church was the proof of its truth.

None the less, Cézanne was by no means a religious figure: his attitude to religion was intellectually immature. His faith did not contribute anything of importance to his way of living—only to his art. His effective return to Catholicism did not produce any religious intensity in his art. In his later years he painted only one picture with a religious theme—the *Old Woman with a Rosary* (V.702, Plate 22). Of this Venturi wrote: 'The whole offers a tragic impression of a life in dissolution.' But in fact this alleged 'dissolution' turns out to be a unique firmness; the old woman's attitude expresses imperturbable repose; she is indeed bowed, but that is on account of the burden of her years, and is therefore something permanent. She is not oppressed by the feeling that bodily and mental powers are failing, she is also not just a good old woman who is upheld by faith alone and babbles the rosary without meaning or understanding; that is not how Cézanne saw her. We may rather say that her essential attribute is that she too is a lonely person, yet one who demonstrates that she has a bond with the transcendental, quite

candidly yet at the same time with the deadly seriousness of an infinite detachment. How differently she holds her rosary from the men and women who were painted in the fifteenth and sixteenth centuries holding this token of their faith! She is clutching it with all her strength and all her hope. In this attitude the old woman is a timeless character, unmoved, unchangeable as the idea that man is dependent on and turns towards God—an idea which she represents. Is she in fact praying at all? Cézanne does not give us the answer to this question. In this figure he has painted an image of 'existence' in the purest sense. Seen thus, the woman evokes an impression of something profound and full of meaning—she is presented to us with such earnestness. This impression is created by the composition of the picture, based on parallel lines and on setting the upper part of her body in a cube standing on one edge, from which head and arms are suspended like pieces loosely attached. But these formal devices are only effective in conjunction with and in contrast to the nature and reality of what is shown, which is given an enduring transcendental significance by our knowledge that it is forfeit to death. The physical appearance of this woman was turned by Cézanne into a self-supporting composition—one in which the different elements are transcended into a whole, so completely at one with itself that there seems neither the necessity nor the possibility of alteration—and thus transformed into a symbol, a sign, an emblem. Completely prisoner of her solitude, this woman represents what is permanent and eternal; a human being who is more than a human being because, believing in her loneliness, she experiences her ultimate union with God. This woman is not obsessed by the dissolution of her life; she obsesses us by the mystical withdrawal which is snatching her away from all that is temporal[13].

In general, however, the religious aspect of Cézanne's art was quite independent of the subject matter and was not specifically Christian[14]. It was revealed rather in the way he tracked down the absolute, the ultimate and the timeless. In order to understand this, one must bear in mind that it is possible to have a religious work of art of which the theme is absolutely and completely non-religious. Georg Simmel[15] has drawn attention to this: 'It is important to recognize the basic principle', he wrote, 'that there are religious works of art whose theme need not be religious at all, just as (and this is much more readily recognized) there are some completely irreligious works whose theme is religious. The representation itself, the artistic function of the picture, what I might call the manual

direction of needle, pen or brush, is permeated by the religious spirit; the dynamic of creation itself has the particular accent which we call religious. There is therefore no need for religious details in such pictures; the whole picture is religious, because the primary force which produced it is religious.' The words of Meister Eckhart may be applied to Cézanne: 'The outward appearance of pictures is to an experienced observer not a purely exterior matter; for to the man who looks inward all things are an inner divine melody.' Cézanne's religious 'primary force', the 'inner divine melody' which he discovered in all things, consisted of that which is permanent and is preserved in permanency, the irremovable, the unmoving. Through this quality of irremovableness, the constant interrelationship of things in Cézanne's pictures, something sacred is manifested, which reaffirms the eternity of the Divine Being yet is not bound to any historical religion but rather harks back to more ancient intuitions. Cézanne reveals the deep, religious significance of the fact that life exists by his manner of representing and transfiguring secular and ephemeral things.

This is what sets the tone for his work, determines his position in relation to other artists and explains his originality. An old substratum of faith comes to the surface in a new way and acquires a visible form in his painting. Seen in this way, the real world and nature become the reflection of an attribute of God.

All this enables us to understand that if Cézanne at the age of fifty had once more become a good Catholic who seldom missed a Sunday Mass, and if he ultimately died fortified by the rites of the church, such matters were not mere outward forms but something which Cézanne himself took extremely seriously. The circumstance, too, that he did not use Catholic themes as such in his art may not be explained away by saying that his religion meant nothing vital to him. Neither was his faith detached from his art. On the contrary, his Catholicism was completely genuine and sprang from a profound faith which had all the more power to determine the 'unthematic religious spirit'[16] of his art.

Let us now consider his painting from the two angles combined, that of loneliness and that of religious feeling; let us see how far his artistic compositions actually portray these two phenomena of life.

In Cézanne's works the unmistakable signs of solitariness appeared for the first time at a very early date. Men and women painted by him give the impression of being cut off from one another and even where people are portrayed in groups there is no unrestrained

association nor any conversation between them. Each individual leads a separate existence. The natural surroundings in which they are placed make no response to them; yet in those pictures it is evident that the painter has not achieved what he set out to do; there is an inner conflict between his convictions and what he has painted, as though he were striving after the precise opposite of what he actually saw in the appearance of the world around him. Something in these individual figures is still pressing for unification, for the elimination of solitude; they are therefore in conflict with each other, contorted, rigid. None of his early landscapes contains any human beings or animals[17]. The fact that human beings are excluded is accentuated by certain motifs of which he was particularly fond. For example, already in V.34—which it is estimated was painted between 1865 and 1867—we can see a certain road which was later to appear again and again in his paintings. It begins at the lower edge of the picture, continues straight into the centre, leading the beholder on into the scene, then after quite a short stretch it breaks off abruptly. In *The Railway Cutting* (V.50, Plate 37) the spectator is separated from the view portrayed by a high wall in the foreground which stretches right across the picture. The same wall motif, symbolic of the impregnable detachment of nature, reappears in another landscape in V.158 (Plate 23).

During his impressionistic period nature as Cézanne saw it became more friendly—probably the influence of Pissarro played its part here. The countryside in his paintings of that time seems opener, more approachable, sometimes even cheerful, almost as seen by the other impressionists. Yet in none of his paintings is there any real familiarity, nowhere does the heart of the observer beat in time with the pulse of living nature. When he returned to the south this peculiarity of Cézanne's emerged even more strongly; he slowly developed a solemn style in his landscapes, which began to create an impression of inaccessibility, and ultimately this became true even of the scenes which he painted from nature in the north (V.311, 312, 313, et seq.). And now a new feature, symbolic of the exclusion of the beholder, made its appearance in his compositions, namely the falling away and sloping away of the foreground, 'the diminution of the powers of objects in the foreground to displace space' (Novotny's expression). The earth lost in density and weight, quite often it seemed to be practically disintegrating. It withdrew into a vagueness which inevitably appeared nonsensical when compared with actual space, but which, when looked at independently,

revealed the symbolic meaning all the more plainly; the areas touching the lower edge of Cézanne's pictures bring out clearly the insuperable gap between the painter and the world of the object painted, the practical unattainability of the things seen, which can often be observed in his still-lifes too, particularly if one compares them with the tangibility of the objects in Dutch still-lifes. This style of presentation is especially marked in the landscapes, making it impossible for the imagination to enter into them, because they sink away so unnaturally into the bottomless space in front of the beholder who steps towards them[18].

To illustrate the loneliness of Cézanne's portraits let us first draw attention to one particular characteristic: the way in which his figures sit lost in space—a feature which recurs frequently. Early examples are *The Artist's Father* (V.25 and 91, Plate 33), *Empéraire* (V.88), and *Reading aloud at Zola's* (V.118, Plate 25); examples of his mature period are *Chocquet* (V.373) and *Madame Cézanne* (V.570). In later pictures, however, we cannot fail to notice the more explicit banishment of people into empty rooms which seem to lie far from the cheerful, noisy activity of the crowd. Cézanne painted his own wife thus, also Gustave Geffroy (V.692, Plate 26), lost and at the same time spellbound in the midst of the lifeless rigidity of his books and papers. With increasing age, from the time of *The Cardplayers* onwards, Cézanne stressed this conception more and more. Lonely people are seen in lonely rooms. Their lifeless glance, their sightless eyes, expose their isolation in the world, they have no influence on other people and are blind to any effect other people may have on themselves.

Nevertheless there can be no more superficial idea of Cézanne's portrayal of people from about 1880 onwards, than Dorival's assertion[19] that his portraits 'exhibit an almost complete indifference towards his drab or uninteresting models'. Cézanne did not feel that the people portrayed were 'completely indifferent' in the sense of being without significance, rather they were 'without differences' in so far as they were examples of men forlorn in their own loneliness. In fact, 'Cézanne makes not the slightest attempt to record outstanding people with a strong inner life'[20]. For he felt that in an epoch when the masses were beginning to organize and to become the ruling powers, it was no longer important to 'record' physiognomies. His art at this period was part and parcel of the contemporary history of thought: the 'strong inner life' had fallen victim to isolation and was shut off from all influences; features were

frozen into sealed masks; and fame, both present and posthumous, had lost its significance (because both kinds implied a belief in a continuing community of men). The merely representative portrait had played itself out and become a caricature because its symbolism had lost all connexion with reality. The portrait painter had to seek another field; yet he could no longer restrict himself to the painting of private persons as Rembrandt and certain of the portrait painters of the early nineteenth century had done. In those days even an insignificant man counted as someone of worth because of his position in his family and his membership of a community that still believed, either in the divine origin of a living faith, or at least in the virtue of a profession of faith binding on all. Even the humblest man still meant something to his brother men, who recognized that he had his own secrets and his own depths. But that era, too, had passed. That was why Dorival could say: 'The secret of the individual leaves Cézanne completely cold.'[21] It was a proof of Cézanne's greatness that he understood that the individual no longer had any secrets and this is made plain by his solitariness—he is driven inside his outward appearance and is therefore expressionless or dumb in his attitude. This was the very attitude which, as portrayed by Cézanne, suited his own inner nature so well[22]. And by surrendering himself to this solitude and apartness, Cézanne succeeded in painting men without criticism or blame as types, as pictures representing this inescapable submission. Their 'banal facial expressions' (that is to say, the expressions of their time, which Renoir too, otherwise so different from Cézanne, knew how to reproduce in his portraits) must not lead us to the conclusion that he was indifferent to the sitters; it is the true expression of those people—'not really an expression at all', as Dorival rightly remarked[23]; but to an artist the expressionlessness of their features became striking and intelligible if only because it was something with permanent validity. Hence the portraits of these people thrust by fate into loneliness already held something more than a merely negative identification and they lacked nothing, even if 'no accessories permit us to come to any conclusions about their lives, their characters or their professions'[24]. They rise far above such details and represent the inner state of a whole man, which for most people remains hidden under external conventions which still persist.

Finally, the free compositions of bathers: Dorival was wrong when he saw in them a substitute for Cézanne's 'suppressed libido'.

The earlier, realistic versions are memory pictures, the later ones, which really count (Plates 27 and 45), are documents of a victory over self; in them an attempt is made to illustrate the loneliness of the people painted by Cézanne as something which had already been conquered spiritually in the light of his newly discovered view of nature, and to celebrate this victory[25]. How great, important, full of symbolic meaning and permanent they are intended to be is most quickly appreciated by glancing for comparison at Renoir's *Baigneuses*. For these charming creatures appear trivial, unimportant and ephemeral in their play, and the lightness of their movements seems merely incidental. They have to play in order to pass the time and their temporal transience, their youthful freedom from care, reveal their whole nature. In this, indeed, lies their infinite charm. On the other hand, Cézanne's bathers—sitting, standing or lying—exist solely for the sake of their being together, for the compositional relationships between them. All personal or temporal features about them, such as their faces, are absorbed into a superior entity. Their gestures reveal nothing about them; they have been transcended into something universal, distant, impersonal, almost faceless and they stand for the idea and the unity of the picture in which they feature, which are what is permanent about it.

It is well known that the pictorial elements used in the composition of these pictures of a somewhat halcyon existence were taken by Cézanne from events of his youth—a time when he was still far from being clear about his own spiritual condition. However, after he had undergone the experience of loneliness (during the period which began in Paris about 1863), and from the time when he realized that he was fated to remain a lonely man, he felt impelled to record pictures from memory, the idyllic representations of an irretrievably lost human association. He attempted to carry out this aim, painting numerous versions of the pictures each of which concentrated increasingly on the permanent elements which achieve mutual self-preservation through the harmony of their existence. In doing this he was asserting that he had broken through the deadly menacing circle of his isolation and had gained a new understanding of the existence of the world by virtue of accepting his loneliness.

The memory pictures which served him for this purpose were a record of the friendships of his boyhood, a noble sort of love which had nothing sensual about it; they were exclusively friendships between boys. The *farouche* shyness and timidity which were funda-

mental features of the first versions of this motif are still evident in the latest ones—the last surviving form of loneliness persisting in the midst of an otherwise perfect harmony between man and man, between man and nature: the sexes are always depicted separate. This separation took on a new significance in the later versions of the *Bathers*. Of course women were also represented side by side in joy and peace; they were also transposed to the 'blessèd isles' where life is dreamed away in the happiness of an idle society and where nature has no other purpose than to provide a haven for this happiness. But the essential condition for such an existence here and elsewhere, for men and women alike, was the absence of love. Cézanne, like other great minds of his time, regarded love as the cause of the most terrible kind of solitude, what Baudelaire called the state of being abandoned while being embraced. In other ways, too, the individuals constituting these groups bear the signs of isolation. They illustrate how the lives of lonely people turn values upside down: when they lie down they become a heavy burden on the earth; when they rush forward they are frozen into rigidity; when they sit down it is an agonizing torture; their features lose all personality and are extinguished.

After these brief indications of the way in which loneliness is illustrated in Cézanne's pictures, let us study how he portrays religious feeling in artistic form. Many writers on Cézanne have suggested that there is something like a religious solemnity in Cézanne's pictures. Yet these observations generally amount only to this: the writers seek to put into words the effect of his pictures in terms of their atmosphere, but are neither taken completely seriously nor do they really want to be understood in the true sense of their words[26]. In this chapter, on the other hand, I intend to show that the spiritual content of Cézanne's art was something which was in effect if not in subject religious; it was a belief in the eternity of 'being', an eternity which he once *believed* was 'in God', which he then later *observed* in the realness of the world and *portrayed* in his works as a new type of interrelationship between things and as their 'existing together'. This 'organization' of the world was what Cézanne was most generally concerned to express through his art; in order to portray it he gave up imitative methods and thus sacrificed certain attributes of things which would otherwise have been made visible; he also sacrificed the shapes of individual objects (this can already be observed in Plate 28). His treatment of space, perspective and objects was determined by this 'organization'; for

its sake he developed a particular arrangement of planes in his pictures; under its compulsion he selected and observed his motifs and models. Only this 'organization', seen as a religious symbol, can provide a coherent explanation of the many singular features of Cézanne's art and explain their connexion with life as he lived it. Only in this way are we at last able to contemplate Cézanne's work from the same standpoint as that from which we already view other great artists—Giotto, Leonardo, Raphael, Michelangelo and Rembrandt, for example. In fact, we can no longer be content to seek to express the meaning of Cézanne's work in the language of the studio, though he used it himself. When he spoke of his artistic aims he talked of reproducing his *sensations*, portraying objects in relief, showing clearly the depth of space, and finding the precise equivalent for every shade of colour and every deviation of shape which he observed. These indications of his own views are indeed important: yet they are only indications, for they mention the means, but still not the goal and the ultimate aim of the artist. A picture containing nothing but solutions of those tasks and problems would not arouse universal interest; indeed such a picture could not even be painted, for such solutions presuppose an underlying aim, an idea directing them. This does not mean some notion invented by the imagination, such as is the necessary prelude to every single work of art, but the artist's ideology, on which his entire work depends. In order to appreciate this fully we need only think of Raphael, Michelangelo and Rembrandt: each of them in portraying something actual also revealed a universal truth. Cézanne frequently stressed that an artist's success was determined by the extent of his revelation of such universal truths. Truth is, however, first and foremost transcendent; so Cézanne's aim was to represent the real world in his pictures as an expression, a symbol, a bearer of such transcendence (Plate 29).

No one word is adequate to describe the relationships between objects in Cézanne's pictures; for is it not true that the insoluble bonds between them, their anchorage and the stays which support them, endow them first and foremost with a place in the composition, but also with their shape, the sensation of togetherness, pure and unmixed with any other attribute, and a permanent 'being'? Are they not painted in such a fashion as to evoke an impression that their special purpose, their 'nature' is to be permanent, in consequence of one determining characteristic running through them?

Let us look at a particular illustration of this point. It is well

known that Cézanne painted the sea as an unbroken surface, indeed a congealed mass, houses as boxes without joints, rocks as blocks, trees with smoothly closed outlines, men and fruits as persistently motionless. In his pictures a mountain is not depicted as made of stone, a meadow does not consist of grass, fruit has no flesh, the human body has neither soft nor hard in it, is neither flexible nor taut. The leaves of his trees would not feel either rough or smooth if one took hold of them. All matter is *one* and is comprehended as one: when once all that grows and dies, all that is half-finished and vague, has been set aside, we perceive those qualities which in the last resort exist permanently, lying beneath all the other evanescent ones. And it must be so. For just as it is essential to have a conception of 'being' as composed of an infinite variety of things and materials, in order to grasp the variability of the real world, so a conception of homogeneity, of qualitative undifferentiatedness, is necessary to comprehend unvarying existence. This enduring element takes a special form of its own. From one point of view it is seen as an uninterrupted, unbroken mass of colour put together with mysterious complexity; from the other it appears to consist of simple and regular stereometrical pictures, of which all tangible, perishable objects are only vague combinations or approximations. Just as space is the universal medium in which objects are disposed and become intelligible to men, so cylinders, spheres, cones and cubes are basic shapes by means of which the diversity of matter can be reduced to simple terms and therefore unified. In other words, clear-cut solids with simple regular outlines can be fitted to one another with the same exactitude and firmness as the accurately finished parts of a piece of furniture, edge to edge, joint to joint, dove-tailed together. Cézanne used to trace his way back to fundamentals through the vague outlines of real things made complicated by many irregularities, when he wanted to portray the enduring element in outward appearances, the permanence of their 'being'. This was not the same thing as the former custom of using regularly shaped solids in art classes to interpret complicated shapes in nature, tracing them back to simpler ones. In that case the forms were a means to an end, but for Cézanne they were the essence, the essential core of the outward appearance of the thing seen. On the other hand, Cézanne's method was not 'cubist'; it did not serve to introduce a special arrangement of picture planes and spatial organization so as to ensure the artistic quality of a picture; it did not serve art, but the *meaning* of art; not the produc-

tion of works of art, but their significance and, moreover, their transcendental significance—a fundamental difference. Stereometric basic shapes caused Cézanne special problems. Because his aim was to portray the permanent element in real things, which were not dead but alive, he had to use curved outlines. For rectilinear, flat, regularly shaped bodies do not exist in nature as we see it with the naked eye, except in the form of crystals, inorganic and lifeless matter: everything that grows and lives evolves from a nucleus and tends to develop into spheres and other bodies bounded by curves. This experience is so universal that we have the feeling that even a lifeless snail shell is a living structure. Solids defined by curves make us think we actually feel the forces suggested to us by the sight of the outlines of such formations. Solids bounded by straight lines do not give us this feeling. We call them rigid, for at best they may show a tension between their extremities: this, however, does not appear to be a living force, but the emanation of some extinct power, something which has come to a standstill and is thus the reverse of power.

Cézanne was also compelled to prefer curved shapes because only solids bounded by curves can be plastic in the full meaning of the word; a cube, even when illuminated by the most favourable distribution of light and shade, is 'un-plastic', if we use this term in its full and artistic sense as the antithesis of 'solid'. But Cézanne was interested in plasticity: indeed the more he disregarded the superficial charms and material differences of solids as irrelevant and evanescent, the more intensely he interested himself in plasticity.

In a much quoted letter of 15th April, 1904, to Émile Bernard, Cézanne recommended the use of spheres, cylinders and cones—not cubes!—as the foundation of all formal representation, for the sake of the impression of life which they gave and their plasticity. In his own pictures it is not the houses but the rounded natural formations which most powerfully suggest a state of stable 'being'.

On the other hand, solids bounded by curves, and in particular by regular curves, do also suggest movement to the human mind—the very thing in which Cézanne had not the slightest interest. This was the greatest difficulty he encountered when he was using stereometric basic forms. He devoted all his efforts to bringing the movement of curves (and of straight lines too) to a standstill in his pictures; and because he succeeded, he derived great profit from this difficulty, for he actually illustrated this process (of bringing movement to a standstill) and so created a doubly strong impression that

things bounded by curves were standing still, permanent, persisting.

The methods employed by Cézanne for this purpose were: interruption, shading off and the interaction of two or more curves on one another (particularly obvious in the still-lifes with fruits) in such a way that a junction was formed between them which had almost the effect of a right-angle on their tendency towards movement and so cancelled it out. All this can be seen to particular advantage in the still-lifes, the distorted nature of which can indeed be explained by this procedure. The openings in circular pots, soup plates and cups, abnormal from the point of view of perspective, are not oval but are drawn with the long sides parallel and the corners turned almost in the shape of a right angle; the edges of tables do not continue in the expected position in the picture plane (e.g. V.196, 210, 341). These 'faults' are not, as others have said, to be attributed to the adoption of different horizons; rather does all serve to bring to a standstill those outlines which suggest movement, to discourage the eye from sliding along them and thus to prevent it from apprehending the things themselves as having been moved, that is to say, being found in a state of change.

The desire to paint what was immobile, what was permanent and had achieved 'mutual self-preservation' through indissoluble interrelationships, guided Cézanne also in his choice of motifs and models. He favoured definite forms, clear-cut images, established things: apples and pears, pots and cups, bare mountains, rocks, tree trunks and houses (Plate 29). The unemotional clarity of southern landscapes, endowed by nature with a structure inviting plastic portrayal, set a standard for his entire conception of nature. This made him look at the northern countryside also as if it were a Mediterranean landscape, and so when painting nature in the marshes of the Seine he ignored all the atmospheric changes which accompany clouds and wind and damp mists in that region. Of course Cézanne did not find his style ready-made in the Provençal landscape: he looked at it, recognized its inherent individuality and exploited its peculiar characteristics to develop his own style; but there is no doubt that the natural conditions were more favourable there than in the north.

Wherever Cézanne could not avoid the soft, the vague, the mobile, e.g. in cloth, in leaves or in clouds, he now did all he could to eliminate these qualities in them. So he treated the cloth of his table napkins, tablecloths and curtains as though it had been poured

into rigid moulds like lead, so to speak; and the foliage of trees and clouds, which incidentally meant little to him, he lumped together into large, heavy, motionless masses.

Because Cézanne's inner purpose as an artist was to portray 'that-which-is-preserved-unchanged', things to him were neither individual, unique in the sense of exceptional, nor typical of the general character of their kind, as Novotny has observed[27]. They were both less so and more so, not wholly individual yet much more than merely typical. They were representative of something which did not allow them to be complete as single objects and at the same time transcended them into something absolutely universal outside themselves. Hence, although displaying the signs of permanence and of unalterability, they were, as individual objects, liable to constantly renewed changes in shape, as is illustrated very clearly in the pictures of the Mont Ste. Victoire (Plate 29). The same is true, too, of other objects which frequently recur in Cézanne's paintings, his fruits and utensils, and is also exemplified in the portraits of his wife. The outlines of all these individual subjects undergo alterations to make them fit into a composition depicting an unshakable, fixed interrelationship between the various forms, a picture in which—in Cézanne's interpretation—their true nature comes to light for the first time.

Cézanne's peculiar and personal conception of space can also be explained by the fact that he wanted to show objects as unalterably linked to one another but unconnected with human beings. This was the origin of the most impressive quality of space in his pictures, its perfect stillness and immobility. The tendency of spatial perspective to develop into movement is halted. What he portrayed was not the impression of measured distances, but a permanent and harmonious disposition of objects in space governed by their being together. Cézanne did not plan space as an empty shell into which he later imported objects and placed them in a certain relationship to each other, expressed through diminishing size, diminishing clarity and changing colour; on the contrary, his essential method of reproducing space was to show solids as convex, as detached and separate from each other or as partially covering each other, in other words by making the plasticity of things manifest everywhere and by making them overlap. Solids are more important than space, fullness than emptiness; what possesses weight and the quality of forming a centre is more important than the wavering outline which has no weight; and the fact of filling counts for more

than the fact of being a recipient: what can be seen of space seems to be filled. This last characteristic is especially plain in the atmosphere, which does not appear as a medium floating high above the earth, drifting away into infinite heavenly space, but is represented as something solid reaching right down to the ground. Since the quality of emptiness in space or space as such is not stressed, the possibility of movement (which of course includes the possibility of things changing) is eliminated. In Cézanne's pictures there is no emptiness, no space in which anything could move; every object is linked to another and here even the air is only one such object among others. By developing this characteristic, Cézanne in fact made a radical break with 'scientific perspective'[28], the whole point of which is to construct a continuous *empty* space, and which painters employ for the very reason that it lets them create a picture containing freely moving figures[29]. It is understandable that Cézanne, who aimed at doing the very opposite of this, was compelled to use 'wrong' perspectives, though of course 'wrong' only in the traditional meaning of the expression. Yet it is not correct to say, as Novotny does, that 'what he painted was no longer, practically speaking, perspective at all'. In Cézanne's pictures space is seen just as much in perspective as in those of any other artist and he used both the device of tapering and the convergence of lines of perspective; yet he employed neither of these devices as the foundation of a composition, only as something subordinate to and serving the relationships continuously produced between objects themselves.

All the same, space as seen by Cézanne is certainly 'not a space in which objects can *live*',[30] not an 'illusory space', offering a false picture of the everyday world to man; it is the space in which things have their being, in which they exist together, which they themselves actually create in the first instance merely by their being together: it is both the possibility and the result of their existing together. Thus it is no longer something special in itself but is inextricably a part of the objects depicted in the picture. It acquires its special qualities from this characteristic.

This is true first and foremost of nearness and distance. Taking the spot where the beholder stands as a base, the world represented by Cézanne begins at a point further away than a close view, precisely where small details can no longer be picked out, even in the foreground, and where things in the distance are just as visible as those near at hand. By comparison with landscapes by Claude Lorrain, Corot or Monet, which stretch out from the closest proxi-

mity to 'who knows how far', the whole of a nature scene painted by Cézanne is set in the distance; it is of limited depth, without the charm of contrasts, the familiarity of the near and the allure of the far; yet it is firmly put together, clearly defined, unified and restful. The contrast between near and far seems in Cézanne's works to be cancelled out by some overriding unity and his landscapes, especially in his old age, are successful when painted according to the methods he used for figure compositions, with the principal subject large and imminent in the middle of the picture while it is at the same time distant in space, at the horizon of real space (V.665–66, 763–766, 798–804, Plate 29). And while the central motif which comprises the core of the whole formal structure lies in the distance, the impression not infrequently given in Cézanne's pictures (quite the opposite from that usually given in the works of other artists) is that space is pushing forward into the foreground. Although it is immobile it yet seems to have been projected from the distance, indeed even to have stepped out of it. It is as though the object which is the motif and which is depicted in the distance determined space, as though this motif conveyed its own powers to other nearer objects and by the extension of these things actually created space. To put this yet another way: Cézanne merges the contrasting visual appearances of nearness and distance in space into the form of distance (in which things have revealed their meaning to the man who is alone) by assembling the outlines of individual objects in all parts of a composition in such a way that they are seen as the eye could in everyday reality see them only if it were focused on the middle distance. In ordinary life the impression of things seen very near is confused and restricted while things in the remote distance are rendered indistinct and exaggeratedly simplified, only the middle distance appears to comprehend them as clearly distinguishable objects.

Similarly the homogeneity of what appears in the section of the world portrayed is furthered by presenting all objects with the same degree of distinctness (which is by no means realistic or to be assessed in realistic terms), enabling space to be apprehended as the space in which things have their being, regardless of what the human eye sees. This unreal clarity is produced in two ways in Cézanne's work. First, one solid is divided from another by bands and patches of colour which form shadows and hold the composition together; the arrangement of these, which is due in each case to the particular character of that part of the world being shown,

separates them from one another. Secondly, this clarity is assured by reducing objects to simple, definite stereometric forms, easily grasped as units, and by the unbroken modulation of the modelling colours. The uniform distinctness thus achieved depends not on a faithful and clear rendering of detail but on the general application of the method of reducing shapes to simplified units[31].

A symbolical *one*-ness can be traced running through the 'facture' of Cézanne's paintings, representing something permanent, which is preserved eternally unchanged in 'being', the fundamental characteristic shared, despite their great diversity, by all things seen. An example of this is the way in which all things seen are indicated by colours and every colour is seen as shadow, is made use of for shading so that the representation of 'being' seems to be subjected to a uniformly solemn darkness which has a subduing effect on even the most intense tones of colour and actually dims the fire of Cézanne's most colourful late works. Rather than give a list of examples let me name only V.794, the great picture of the *Château Noir* where the building smoulders in an intense red. The effect of that painting can be described thus: it is the stillness of a shadowy existence, in which the joyful harmonies created by things existing together are held fast by the solemnity of destiny; here there is no light, no cheerful brightness and also no enlivening movement which might create life.

Then there is a second unifying feature of the 'facture', namely, the detached patches of colour frequently but not invariably applied in one direction. They evoke the carpet-like character (Plate 24) of the mature works, that special quality which differentiates Cézanne's painting from the other types of 'free' ('broken colour') painting with which we are familiar. In a woven carpet an impression of a positive remoteness from nature predominates; a distortion of the natural forms is caused by the technique and by the rigidity of the web itself. The tension thus created between the real thing and its artificial representation and the exploitation of this tension can be an asset endowing the carpet with a certain indefinable charm; a further advantage is the exceptional evenness of a picture woven into a carpet, accentuated by the fact that the qualities of the material of which the carpet is made prevail over the very different visual qualities of the substances of which the things portrayed are made, whether they are clothes, flesh, flowers, fruits or utensils. In contrast to mosaic, for example, this technique is characterized by extremely close-set dividing lines running through the material quite independently of the shapes of the objects depicted. These

threads of different colours, whose differences do actually dissolve, when viewed from an appropriate distance, into homogeneous representation of objects, yet at the same time preserve something of their real incompatibility. This is the procedure Cézanne adopted in his own technique: for each shade of colour in the shaping of any object he would apply a special brush stroke, or if necessary even several closely adjacent to one another, as no painter before him had ever done. True, free brush strokes and blobs of colour were known long before his day—in Pompeii, in the paintings of Rembrandt and of Frans Hals, in those of the Dutch landscape painters and, shortly before Cézanne's time, again in those of Géricault and Delacroix, and even also in those of Daumier. Yet these painters did not use such brush strokes and spots of colour to form a homogeneous groundwork for their painting: they employed them with the utmost superficiality in order to break up what they saw into entirely new artistic forms or to show off the inspiration, the temperament, the inner excitement of the creative hand. With Cézanne it was exactly the opposite; he had a method, a systematic technique for spots of colour (even when the spots were of different sizes and applied in different directions), a way of weaving together a picture from start to finish out of single touches of colour, an unvarying technique, which might be described by saying that the started with the coarser threads and gradually introduced finer and finer ones into the web he was weaving. In so doing he introduced great variety into the arrangement of the brush strokes—sometimes they were parallel and of equal length, sometimes short and broad, sometimes again long and narrow. In certain pictures they ran vertically from top to bottom; in others from right to left or the other way round; often they ran in several different directions at once. But all these different ways of directing the brush had one thing in common—the fact that they evoked an impression of an independent, close, unbroken texture which remained visible beneath the picture and was not merged into it. The texture of Cézanne's pictures bears a certain resemblance to that of Titian's later works, differing from them only by its firm rigidity.

Of course a picture by Cézanne contains both large and small shapes, but on the whole it is the 'small structure' which predominates (Novotny's words)—taking all the different methods of achieving an effect into consideration, there is no doubt that 'small structures' are more effective than larger shapes, if only because they can be sustained throughout.

The 'small structure', the 'carpet effect', in the unity of Cézanne's 'facture' did, however, accentuate flatness. His brush strokes and spots of colour served, like the threads of a Gobelin tapestry, to establish the surface unity of a picture, to impress it on the eye as an essential quality of the picture, and thus once more to assure the complete and motionless repose of the whole appearance of the picture within the space which it portrayed. They are a painter's device for making the spectator aware that there is something firm and impenetrable here, an anchorage which resists the evanescence of space. And in this respect they are very much more effective than the texture of a carpet, because, unlike the web of threads, they do not actually lie under the picture, do not restrict it from behind, but on the contrary, being woven into the stuff of the picture, occupy no place at all in real space. These paint strokes of Cézanne's, regarded as creating flatness, had their origin in his mind and coincided with the development of space as determined by the mind.

Deliberately to accentuate the flatness of a picture, 'to remind one's self that a painting is essentially a plane surface, which one has covered with paints arranged in a certain way' ('se rappeler qu'un tableau est essentiellement une surface plane recouverte de couleurs en un certain ordre assemblées'), as Maurice Denis put it[32]—an idea forgotten for hundreds of years, but already in 1890 the first point in the programme of the symbolists and of Gauguin— is a thought which had already occurred to Cézanne at a much earlier date. Even in the portraits which he painted before 1870 (Plate 42), he took pains to do this, laying on the paint roughly with a spatula. This technique had less to do with the mason's than writers on Cézanne have frequently suggested, but can be compared rather with that of the plasterer, who lays plaster flat on walls with a trowel, in order to achieve a smooth, unbroken surface. What is common to and essential in both techniques is that a substance is laid on to a flat surface in such a way that the flatness strikes the eye. The paints which Cézanne laid on with a broad spatula also '*stayed*' in the flat surface, they did not emerge from it or create solids. In other words, they were not merged in the representation of something which was three-dimensionally visible. For the rest, they remained to a considerable extent quite patently matter plastered on to a flat surface and so arranged that (like certain shapes used in experimental psychology) the eye could apprehend them in two different ways and, while observing them, would

oscillate between a conception of the spatial (three-dimensional) and of the flat (two-dimensional). This is what Cézanne aimed at achieving. And his whole life long he remained true to this aim. Later he was able to realize it with his brush.

The difficulties which he had to overcome in doing this are plainly demonstrated by the constant alteration of his manner of applying paint, at least in so far as the size and the direction of the brush strokes he employed were concerned. Even the most minute variations could result in very different effects being produced. After a short while, however, he overcame one clumsy fault, which had tended to call the whole process in question, namely that of identifying the spots of paint applied by his brush with single objects, such as the leaves of trees. V.264, 265 and 269, not to mention numerous other pictures, are good examples of this. In these pictures the unity of the flatness is broken here and there by his using one single stroke to represent one single object and so turning it into the portrait of a plastic object. Single leaves so painted stand out from the flat surface and are much too starkly detached from the other cohesive masses rendered by strokes. Leaves painted in this way also suggest a near view, thus conflicting with the other parts of these pictures, which are, like the rest of his paintings, conceived as though at a distance.

The *Portrait of Victor Chocquet* (V.283), reproduced on the jacket, dates from 1876–77 and formed a milestone in the progress of these struggles. In this, a work executed with the highest degree of perfection, Cézanne achieved a uniformity of surface for the first time with complete success, by the employment of separate spots of paint which produced a tapestry effect. From then on, he was in full control of this highly personal method, although he continued by various means to make it more and more perfect.

Novotny regarded the connexion between the plane surface and the depth of space in a picture as 'the real cause of the distinctive vitality of space in Cézanne's pictures'[33]. According to him, not only does the composition of the surface endow space with intensity, but 'the omnipresent changing relationship between the surface of the picture and the space in the picture, projected as a pure expression of form (without any bearing on the subject itself) unconsciously on to the world of the subject, results in things *becoming* and *growing*'[34]. Novotny pointed out that this could be found elsewhere in Cézanne's pictures too.

Further observation and careful consideration of the circumstances

in which Cézanne worked must, however, lead us to a contrary view. Cézanne's world was not in a state of 'becoming and growing', for these processes had lost all intrinsic significance for an artist like Cézanne living at this period in the history of thought. They had become meaningless to him. The world to which his mind alone still had entry was in a state of 'being'; in that world the actual forms which things had evolved were taken to be permanent, motionless and final, and their real significance lay in their *relationship to each other*; his world was thus entirely one of symbol, not of likeness (which is what it would still be if it portrayed 'growing and becoming'). It was a symbol, as Cézanne himself knew and stated, 'parallel to nature', to quote his well-known words once more, that is to say: in the strictest sense separated from the real world by an insuperable gap, like two lines which never meet.

Here it must be stressed that even his last paintings continued to express this idea of permanence and 'being' and that they did not contain any tendency towards a 'baroque' style as has often been suggested. The difference between them and his earlier paintings is that in the later ones the forms which go to make up a universal harmony are even more independent than ever of the objects portrayed and are still richer than before. This has given rise to a slightly erroneous impression, especially among people who immediately take it for granted that the lavish use of curved shapes has something baroque about it, the feeling of which flows away in movement.

The divergence revealed here between the works of Cézanne's latest and earliest years is not synonymous with the contrast between movement and repose. Something different emerges. In his so-called classical period, between 1883 and 1895, Cézanne used a general arrangement of surface and space to evolve individual objects which were fixed in the surface of the picture as in space and were held together as *opposing* units by means of colour links. These compositions were developed almost without a break outwards from their centres (the centre of the picture and the centre of space) and a decreasing density in the paint frequently became evident towards the edges of the pictures, regardless of whether the subject depicted was far away or near (Plate 30). Pictures grew misty towards the corners in vague indications of space and at the same time the texture of the surface ceased to be sufficiently firm (in, for example, the views of Gardanne). This was caused by the fact that the contrasts were not yet perfectly balanced, were not yet firmly enough

interwoven. Cézanne's power to reconcile them by the free creation of forms was in these pictures not yet adequate to sustain this balance over the whole field of vision. Towards the end of the 'eighties his compositions began to show signs of a greater co-ordination in this respect: all parts of a picture became of equal density, the subject was apprehended from the edge of the picture inwards and thus the whole surface of the picture was filled or at any rate the centre was no longer given prominence (for example V.626–628, 1888). This tendency later fell off again if the dates given by Venturi are accurate, but re-emerged more strongly in landscapes containing reflections in water, a motif which Cézanne favoured for a while (V.637–641, Plate 30). Success in achieving his purpose is seen in such pictures as V.661–666, which are thought to have been painted between 1890 or 1894 and 1900. In them objects were interwoven in a unity of space and surface in such a fashion that both spatiality and flatness surrendered much of their independent appearance and permeated each other more than ever before. Evidence of this was the opening up of a new depth of space at this stage in the artist's evolution (V.712–13, 1900–04), though figures no longer stood out from this depth. Fullness and emptiness, nearness and distance (or solids and space, foreground and background) were blended into one continuous whole by the immaterial substance of freely created patches of colour (V.714, 715, 718, Vallier). This free-floating substance in a picture did not, however, at any stage take on an independent existence; on the contrary it was destined to be the bearer of the particular meaning of the picture, as expressed in things actually seen, of which the picture was still, after all, a portrayal. This substance of a picture had now acquired such an enormous wealth of shades and relationships that it appeared to vibrate in the interplay of these combinations, or to undulate gently. Yet—and this is the decisive point—the world of objects which was being evolved out of this substance was still; things painted thus were seen to be in a state which gradually became comprehensible and was not movement, but repose, a lingering and a remaining. Even the 'crystalline' material of Cézanne's last pictures, for example, the agitation which is, as it were, thrown inwards in the *La Montagne Sainte-Victoire* and in the *Rocks at Bibémus*, betrays no trace of any 'growing and becoming' of the earth which artists of other ages took a special pleasure in perceiving in stones just like those.

## Cézanne's Symbolism and the Human Element in his Art

We have seen how Cézanne discovered a symbolism in the world of real things. There is a question which we can now no longer defer, namely, how is this symbolism related to life and death? Can the state of mere 'self-preservation-in-being', the absence of feeling, the existence of a world without light, atmosphere and movement, portrayed in his art, be interpreted in the last resort as representing quite simply—death? Some have said that Cézanne's world is remote from life, have felt that it is cold and stiff. Yet if we stand before a picture by Cézanne is it not true to say that all thought of death is extinguished, even though the picture exhibits no joy in living? His world, though fettered and frail, seems to possess no earthly characteristics, such as the liability to fade, to grow dull or to perish. For the thoughtful spectator this is a world very much more enduring than the ripe figures, pulsating with energy, which Rubens painted, or the ghostly visions, burning with a flame fanned by passion, which Delacroix portrayed. Though he was not, indeed, given to such intensification of life, Cézanne's world appears just as certainly to be remote from death.

But even apart from such comparisons, it surely cannot be said that Cézanne's art is remote from life. What is true is that it offers a completely new conception of life, as we can learn by comparing it with that of the neo-impressionists, which came into existence during Cézanne's lifetime. If we let our eye wander from a picture by Cézanne to works by Seurat, Signac or Cross, we note at once that these artists painted a stiff form of life, even in such a lively composition as Seurat's picture of the circus. By means of this comparison we can immediately proceed from effects to causes and so discover what emerges from the dissimilarity between Cézanne and the neo-impressionists. Let us consider pointillism once again, for it was a method of painting common to all these artists including Cézanne, and it is precisely here that the difference between them lies: the correspondence of technique is only superficial. When they used this method, Seurat, Signac and Cross were attempting to carry out a visual experiment, to adapt a scientific theory to their artistic ends. The neo-impressionists had learned that a picture seen by the human eye is composed of numerous separate spots, so they analysed what they saw and painted it as a number of distinct dots of colour harmoniously disposed in a variety of ways, shading off into one another, and thus actually did succeed in making anyone who looks at them from the correct distance see the dots merge again into smooth unbroken pictures. However, because they never them-

selves *actually saw* scenes composed of dots, their art remained a mere experiment to reinforce what the physiological eye had already perceived. And because, like all demonstrators of experiments, they painted their dots in a most simple arrangement, 'in a geometrical solidification of the shapes of things' (Novotny's expression)—it was in fact quite simply impossible for them to accomplish anything more by this process—the finished product was mere shapes of things: they were incapable of penetrating the meaning of life or the world at all. The scenes they painted remained largely 'on the surface', robbed of life and rigid, because they resulted in fact from a superficial arrangement of things, given an independent existence so that they might be looked at, but devoid of all meaning. The highest state they attained was a rigidity of death out of which a despairing cry of longing for life went forth.

Cézanne on the other hand did not base his pointillism on any scientific theory—it was a means invented by himself to interpret the significance of 'being'; and he was able to elaborate it only because he set himself the goal of making just such an interpretation. It is true that Cézanne believed that these spots were set before him in nature and that he could observe them in front of the motif; in reality, however, they became visible to him in the model only because he looked at it in the light of his feeling that things were maintained in being by their 'standing together'.

Therefore, whereas the divisionism of the neo-impressionists was lifeless because it applied to art a scientific theory which could not be proved by experience, Cézanne's apparently similar method of painting rested on his fundamental belief in the symbolical character of the actual world; this gave vitality to his paintings and so proved that his technique was by its very nature different from that of the neo-impressionists. There was also material evidence of this inner divergence in that the neo-impressionists' dots of paint were of pedantically uniform size, while those of Cézanne on the contrary showed the greatest diversity in dimension (even where he aimed at making them regular) and were actually full of contrasts. This in turn results from the fact that Cézanne did not use these spots merely to compose pictures but made them subordinate to the general contrasts which filled his compositions, or, looked at in another way, that the spots of colour served to construct these contrasts out of the arrangements of colour and form which they created. At the same time we must bear in mind that these contrasts were entirely static in nature: they did not, as in architecture,

express the forces which interact as opposites on one another, but solely those which illustrate how objects are related to one another in the world (and to a world). They were contrasts which supported and intensified one another. It was possible for them to do this because they came on the scene solely in order to play a part in the sphere of artistic design and did not, as it were, represent things 'which clash violently with one another in space'. Indeed, in his painting Cézanne did not take contrasts of the latter type—those which are known or felt in the real world—into account at all.

These contrasts between forms (as distinct from actual antitheses depending on the theme of the work) are the source of harmonies similarly independent, composed of chords which contain nothing abstract, precious, artificial or remote from life but in which, by virtue of their symbolic character, which they impose on the real world as Cézanne depicted it, 'life of life'—*spirit*—can be perceived. The full symbolic significance of things 'standing together' and 'existing together' is made plain in Cézanne's art by the chords which combine to form the ultimate overall harmony of each picture; how very emphatically, how essentially these chords are, indeed, *life itself* when understood in this way! For (to generalize) harmony is the *living* combination of opposites. Ultimately the harmony in Cézanne's pictures revealed the concord of objects (concord in the sense of strings tuned to the same key), their 'mutual self-preservation' in the togetherness imposed on them from above, their 'being' in a relationship out of which alone they first came into existence at all as individual objects.

This ultimate overall harmony is found in every one of Cézanne's works; it is built up out of mere form and colour contrasts and chords (which ignore both the contrasts and the relationships of the real world); it makes itself so strongly felt that many a beholder in contemplating it forgets—wrongly—the subjects always clearly present in the pictures. In this 'musical' configuration of colour and form the art of Cézanne may be misunderstood as 'pure', as created merely for art's sake, and Cézanne himself as an *artiste pur*. This, indeed, is the root of that widespread error which was publicly contradicted only a few years ago for the first time by the French painter, Paul Rebeyrolle. But from what has just been said, properly understood, the true position emerges. Cézanne's art is not 'pure'— purified of life—because of the fact that it is without emotion, atmosphere or participation in the destiny of individuals: on the contrary, because it is detached from the joys and sorrows of the

individual, *it sees life as a whole in a 'pure' way* (that is to say, as free from its accidental and transient features) in its essential 'being'.

Therefore Cézanne's art, far from being remote from life, is also far from being 'remote from mankind', to quote again from Novotny, the author who devoted particular attention to the study of the problem we are now discussing[35]. Cézanne's art in no way rejects humanity; it is not 'ultra-human', it is not without 'any intellectual and emotional participation of man in the life of the things represented'[36]. Absent are only all those conceptions of the real world which spring from man's capacity for desire, from his appetite in the widest sense of the word. Present, on the other hand, is an 'intellectual and emotional participation', such as springs from considering things passively and merely acknowledging them, a form of vision which, as we have already seen, subdued the egoistical will of the artist so that, by recognizing and accepting his loneliness as the fate of mankind in the age in which he was living, he was able to struggle through to the point where he could abstain from apprehending objects singly since this no longer enabled him as an artist to capture a world view, but only the phenomenon of impenetrable loneliness. It had become an intuitive procedure: the awesome nature of what he apprehended intuitively, however, affected the emotions too, as is plain from the solemn gravity of Cézanne's pictures.

The human element is displayed in two ways in Cézanne's art— in the wholly unemotional *ethos* of the artist himself and in the portrayal of the *ethos* of objects and men, whose state of being is its exclusive theme.

Novotny has contrasted Cézanne with Rembrandt; saying that Rembrandt as an old man subjugated the human element in an entirely personal struggle, while Cézanne on the other hand had dispensed with the human element from the beginning, his art being 'the product of a final step in the history of an evolution' and an 'exclusion of the human element'. There are two things to be said against this theory. First, a genuine and wholly personal victory was involved in Cézanne's case too, though admittedly it occurred, as we have seen, in his youth. Secondly, the consequences of this victory were bound to differ completely in Cézanne's case from those which followed in the case of Rembrandt, if only because these two artists lived at such different periods in the history of thought. In an age still closely bound by and based on religion, Rembrandt carried submission to God's will to the extreme (as his

late works indicate), he felt the proximity of God and communion with God in the silence of solitude and, seeing all things in the real world in this light, he was able to depict them as having universal validity. Cézanne on the other hand broke new ground by turning away from the will to the true condition of mankind in his time, in which faith itself no longer had any unifying force. True, his loneliness excluded human '*pathos*' from his art, but not human '*ethos*'. He accepted loneliness, and recognized that it was only through the maintenance of an impregnable detachment from objects and men that he could find the way to penetrate to their essence and their humanity: he therefore eliminated from his artistic programme the 'sentimental and atmospheric values which *objects* have for creative subjects'. This did not, however, mean either that things were 'deprived of souls' or that 'the creative artist retired into the background'. Things are not 'deprived of souls'; it is only that one can no longer sense their 'souls' in the subjective states of mood of the creative artist; one can, however, apprehend them in the mysterious 'being together' of the objects, now revealed for the first time, looking right through them into loneliness out of a position of loneliness; a process of step by step progress of understanding, whose last stage and highest degree lies before us in the complex texture of Cézanne's late works. And the creative artist did not 'retire into the background'. It was only as a *non*-creator, as a private person, quite apart from his artistic activity, as a '*citizen*' who had his preferences and his dislikes towards objects evaluated 'with regard to sentiment and atmosphere', that Cézanne became in the course of his life more and more insignificant, ordinary and impersonal: he became a *bourgeois*, a *rentier*, indeed in his old age his private existence was almost completely extinguished. But, as a creative artist, he now became really dominating for the first time, he became himself entirely, from picture to picture he was actually more clearly visible, appeared more stylish and more consequential in his style, 'poïetic' as no other painter of his time. His art was not *determined* by objects, not naturalistic, not fulfilled through objects in any ordinary everyday view. Rather was it in the highest degree personal and indeed particularly so in his *creation* of a world in relation to nature. Yet one can understand how Novotny came to have the feeling that in Cézanne's art 'the creative artist . . . retires into the background'. For Novotny saw the creative artist as someone who expressly reproduced his personal sensations, what he experienced in relation to nature. That admittedly Cézanne did not do. But there is another kind of creative

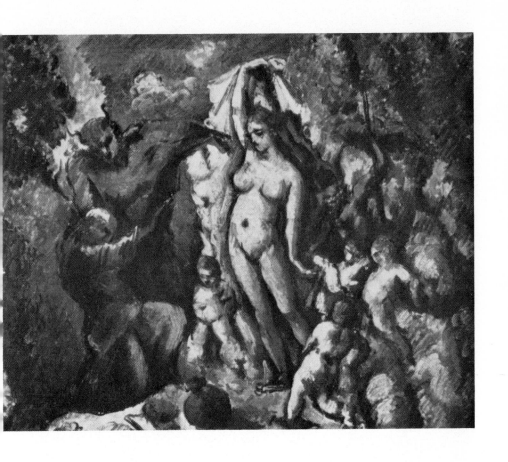

21    The Temptation of Saint Antony, ('La Tentation de Saint Antoine'),
(V. 241), 18$^{1}/_{2}''$ × 22'',
*Collection of J. V. Pellerin, Paris*

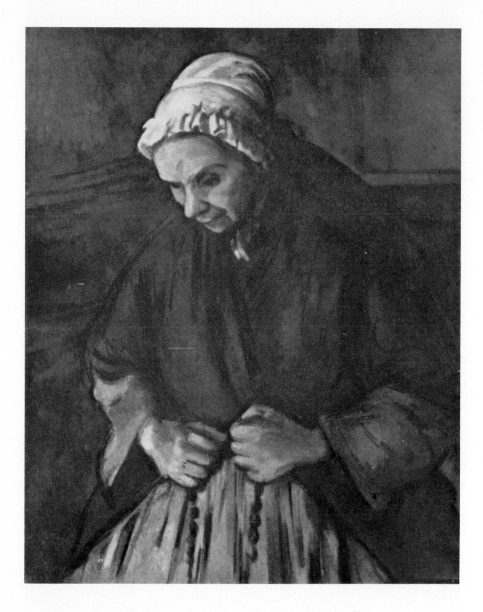

22 Old Woman with a Rosary, 1900–1904 (V. 702), 33$^1$/$_2$″ × 25$^1$/$_2$″, *National Gallery, London*

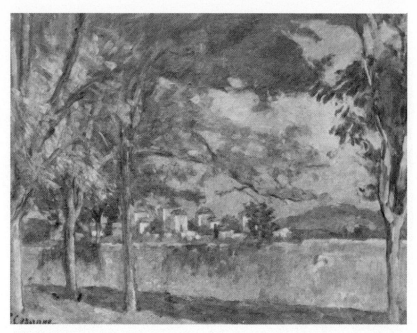

23　The Path, 1875–76 (V. 158), 19³/₄″ × 25¹/₂″, *Durand-Ruel Collection, Paris*

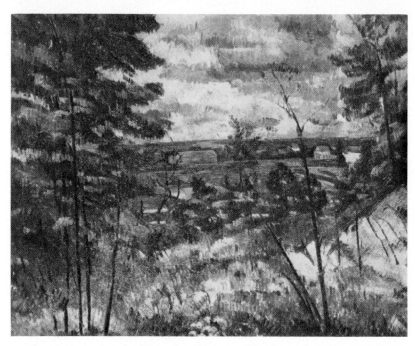

24　Landscape, 1879–82 (V. 311), 28¹/₄″ × 35³/₄″,
　　*Formerly Collection of Paul Signac, Paris*

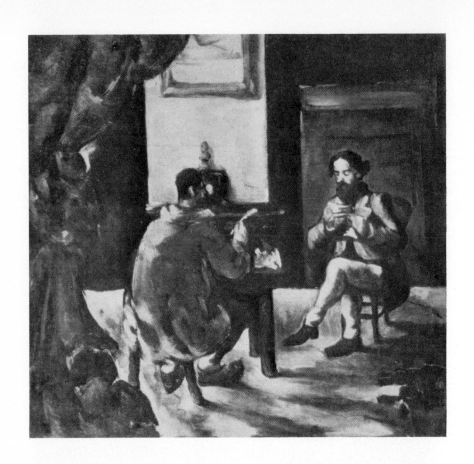

25 Reading aloud at Zola's, 1869–70 (V. 118), 20¹/₂″ × 22″,
*Collection of J. V. Pellerin, Paris*

26  Portrait of Gustave Geffroy, 1895 (V. 692), 45³/₄″ × 35″, *Lecomte Collection, Paris*

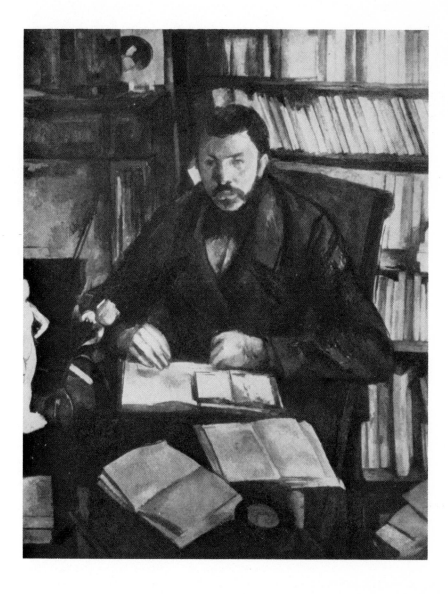

27   Bathers, 1879–82 (V. 390), $23^3/_4''$ × $28^3/_4''$,
    *Lecomte Collection, Paris*

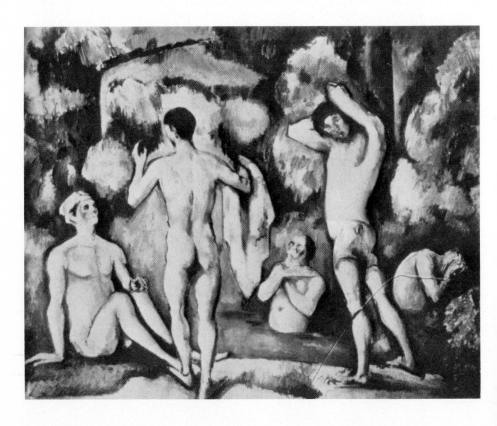

28    The Fishing Village of L'Estaque, about 1870 (V. 55), 16½″ × 21¾″,
*Collection of J. V. Pellerin, Paris*

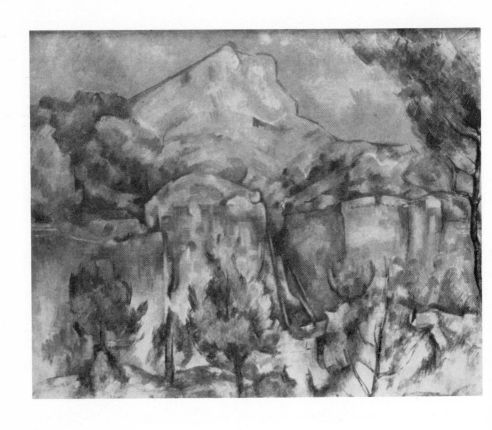

29   La Montagne Sainte-Victoire, 1898–1900 (V. 766), 25$^1$/$_2$″ × 31$^7$/$_8$″,
*Collection of Miss Etta Cone, Museum of Art, Baltimore*

artist—the one who lays his personality open to a basic conception of the world so that it becomes the vehicle of artistic activity and who therefore puts into form much more than feelings, 'atmospheric values', likes or dislikes. Because this kind of artist gives his whole existence to his art, without revealing personal details about himself in his works, he seems to make the creative artist disappear. In fact, the opposite is the case. Only such total self-surrender to the process of creation enables the creative artist to attain the highest possible degree of effectiveness or, to adhere to Novotny's metaphor, brings him into the 'foreground'. But of course the foreground of this creativity is transparent, in order to let the real essence of things shine through. The artist here becomes entirely 'immanent' in his artistic production. Therefore, to the person who has not deliberately focused his eye so as to perceive him, it is possible for him apparently to withdraw into the darkening distance of the 'background'.

To eliminate one's own will and all subjective feelings, moods and judgements—first, in order to further creative activity, and then, in the act of creation itself, in order that one may capture the true essence of a whole—that is the attitude of a true mystic. And indeed the essence of Cézanne as an artist can be seen to be just that: he has the humanity of the great mystics, which attains complete and perfect self-realization only in self-effacement and self-elimination, and which progresses from that point to the practical activity of the truly human.

Novotny says that in Cézanne's art all that 'can be assembled, from the subjective point of view, in the term ultra-human' (which I have rejected) can be 'if considered from the objective point of view, summed up in the term "un-aliveness" as a central characteristic'. This term I also reject and I have already demonstrated that it is inaccurate to apply it to Cézanne's work. The examples cited by Novotny show that he wrongly takes for 'un-aliveness' the 'being' of things which is revealed in the state of 'self-preservation'. This is all the more remarkable an error as he ascribes a 'foundational' quality to Cézanne's art. But Cézanne's art could not possess that quality if it were essentially 'un-alive' in its nature, since what is 'un-alive' or to put it more plainly, what is dead, is not capable of providing any foundation for an understanding of the world and life.

Novotny next sought to categorize and interpret the *repose* of

Cézanne's work. He saw that 'the repose in a composition of Cézanne's is not the repose of an "existential" picture'—that is, a painting by him does not possess the kind of repose which emanates for example from one like Bellini's *Santa Conversazione* in which a number of holy personages standing quietly side by side produce an effect by means of the dignity of their 'existence' and establish the significance of the picture by the mere fact of their 'existing'. Accordingly, Novotny conceded 'only apparent repose' to Cézanne's compositions. But though the repose of Cézanne's pictures may indeed be radically different from that of existential paintings, it is still anything but 'apparent'. Cézanne portrays *repose* as integrally bound up with his conception of the 'being' of things, not merely as the bearing appropriate to certain unusual people; and just as repose is inseparably linked with dignity in such persons, so it is simultaneously both quiet and solemn in Cézanne's *world* too.

Furthermore, because he failed to take account of Cézanne's position in the history of thought, Novotny believed that his art presented a paradox, that it was an art 'close to nature' yet constructed in accordance with the principles of an 'abstract' art; and he now advanced his own theory, evolved in the course of his investigations, as follows: 'Anyone who makes an analytical study of this art discovers a world of men and things from which natural life, as human feeling and understanding see it, appears to be withdrawn; he is therefore tempted to see in this picture-world the projection of a world of ideas which surpasses and transcends reality; and yet he seeks such ideas in vain for he looks too hard and in the wrong direction; and finally he recognizes that this art is a copy of nature in the form of a world seen, as it were (and merely "seen"), for the first time, a world less thought out and felt than in any other type of painting before this age'. This interpretation of the work of Cézanne, brilliantly formulated and yet at the same time so unsatisfying, takes on its proper meaning as soon as one realizes that Cézanne's 'seeing' is an intelligent perception of the world as a whole 'preserving itself in the standing together' of things and that separate objects evolve their individual form only out of this world as a whole. Then one grasps the 'idea' for which Novotny looked around in vain; and one understands why, for the sake of this 'idea', 'natural life, as human feeling and understanding see it, appears to be withdrawn' from the world of Cézanne. For 'feeling and understanding' are inevitably in conflict with the concept of 'being preserved unchanged'—a metaphysical concept.

To extract this concept from the apprehension of nature and to portray it in apprehended reality, as Cézanne has done, is something which can only be done by expounding symbols. For this particular concept cannot be apprehended directly in the real world, as an idea ought properly to be. Nor is it directly accessible through a pictorial representation of real objects. Rather is it true to say that in this concept reality is expounded in symbols as a metaphor and a sign; whereby the whole of what is unique in Cézanne's art, the general impression of something 'seen-for-the-first time', in turn finds a foundation in that concept.

If we accept this hypothesis we can agree with Novotny's statement that it was Cézanne's 'great deed in the history of thought' that through his efforts 'the creation of a world of pure artistic perception independent of and equal in status to the world of reason' became 'the really decisive artistic purport of art'. To my mind, however, this sentence contains another significance than that intended by Novotny, since Cézanne's 'pure artistic perception' cannot be conceived as having been acquired through self-sufficiency or through being remote from life and indifferent to man's destiny.

On the contrary, Cézanne's 'autonomy of artistic formation' was the outcome of an ineffable necessity, it was the fruit wrung with difficulty from this necessity, an ultimate, truth-revealing, rational view of 'the whole in its context'. What is more, it originated in an era when men were no longer capable of imagining a whole or of portraying it symbolically because they were under the sway of calculating and analytical reason and their feelings were no longer involved in any way.

Cézanne's 'autonomy of artistic formation' then did not even represent the highest pinnacle which the art of painting has ever been capable of reaching, as has often been believed; it did not even represent painting at its 'most free', as Novotny suggested. Cézanne's art was restricted in a terrible way by the spiritual necessity of his time and in consequence of this appears even more narrowly circumscribed than, say, the work of Raphael and Titian or that of Rubens and Poussin.

Yet, on the other hand, Cézanne's art was anything but—indeed it was exactly the opposite of—what another (much more discussed) author has said about it. In order that the interpretation given to Cézanne's work by Hans Sedlmayr in his book *Verlust der Mitte* ('Loss of the Centre')[37] may not be spread abroad uncontradicted,

I propose to say here what is essential about and against his analysis.

Like Novotny, Sedlmayr sees Cézanne's painting as 'ultra-human and remote from life' and characterizes it as a 'borderline case'; in his opinion its unnatural stillness is a preparatory state for a *break through of the ultra-human* (that is, the loss of the centre). For it leads to man's being placed on the same level as 'things', a contradiction of natural experience. Here, he concludes, 'the behaviour of this supposedly "pure" painter (Cézanne) borders on the pathological, on those symptoms of disease which consist of *a denial of empathy*[38]. In such circumstances all is dead and strange, human beings now see only exteriors and they are no longer conscious of the spiritual life of others.'

Agreeing with Novotny, Sedlmayr says that Cézanne's painting is 'in accordance with its inner aim, the representation of what "pure" seeing, cleansed of all spiritual and sentimental ingredients, finds present in the visible world', but he adds that its results correspond to the experiences of a 'state of extreme non-participation of the mind and the soul in the experiences of the eye, a state between waking and being fully awake, in which, so to say, the eye is awake, while the mind is still sleeping. Then the world with which we are familiar appears as an assembly of spots and outlines of different forms, colour, size and "consistency"; similarly the things with which we are familiar wait behind this colourful fabric, in order to arise out of it. . . . The charm of this procedure consists in the fact that everything looks *new*, the commonplace takes on an unusual primitive freshness, something "elemental". Above all, colour, freed from its task of making things recognizable, gains an intensity never known before. The moment our intelligence intervenes, this phenomenon is dissolved and the magic fades away. The pictures of Cézanne are evidence of this or a similar state of seeing.'

These sentences might perhaps suffice as a description of the impressionistic methods and technique of Claude Monet. Yet even he painted a composition (as did all the impressionists), created an arrangement and exercised restraint in the use of the dots of colour on the surface. Even Monet's eye did not operate without the participation of his mind and his soul; for he painted out of joy in the phenomena of light and full of admiration for the richness of nature. If it is true that he reproduced 'the world with which we are familiar as an assembly of spots and outlines of different forms, colour, size and "consistency" ', it is also true that he created in

'full wakefulness', for he was constantly evaluating the dots of colour which he observed. There is no painter, whosoever he may be, to whom the world *appears* as an assembly of spots of colour, who sees *these* gay blobs thus in nature and then merely repeats them on his canvas. The painter invents, creates and produces these spots of paint with his imagination, as a means of expressing his own view of nature; in a purely material sense it is in this that the originality of the process of creation is revealed most plainly. It is only in this creative process itself that the spots of paint appear disposed in a logical arrangement.

But now for Cézanne! It is surely insulting to say of him that his pictures 'record' a state of seeing such as one experiences 'between waking and being fully awake'. That implies something which is still lying *below* the level of average perception—as though the magic of Cézanne's compositions would disappear if we were to compare them with the everyday picture seen by our ordinary intelligence; as though they did not leave such comparisons behind them as completely unimportant (as indeed does all great art); and as if they had no existence in their own right. Only someone who is blind to the truth expressed in Cézanne's art, its rational intelligence, could dare bring '*our* intelligence' into the field against it. Only such a person could confuse his own staring at things, drunk with sleep, with the poetical vision produced in Cézanne's works which opens up new associations and meanings. For someone who is drunk with sleep, colour is 'freed from its task of making things recognizable'. For Cézanne, on the other hand, colour is the very opposite—it is what really invests things absolutely and completely with the quality of 'being' most characteristic of them, gives them a hitherto undreamed-of plasticity and firmness, and displays them in an unshakeable state of 'existing side by side'. As Rilke saw it when he wrote: 'The production of something which carried conviction, the process of making a thing "become" a thing, the reality which, by his own experience of an object, was intensified until it became indestructible—that is what appeared to him (Cézanne) to be the purpose of his inmost labours'.

The 'free' colour patches by means of which Cézanne evolved his solids plastically and portrayed them in association with one another, were (if possible) even less frequently in his case than in that of any other painter the result of reproducing impressions acquired by staring blankly at nature. These colour patches were not inspired by any pathological tendencies in his manner of

observation, but resulted from an intense mental process; through using them Cézanne arrived at that skilful technique in the use of media which he tormented himself throughout his life to discover[39]. His colour combinations in fact contain 'théorie développée et appliquée au contact de la nature'[40] ('theory developed and applied to contact with nature'), or the 'construction which one must oneself acquire through working'[41], as Cézanne wrote on another occasion. At the same time, on the other hand, he did not regard these vigorous and effective patches of paint as a goal and an end in themselves: they served to express his *sensations*. For him *sensations* or *sensations colorantes* were, however, no mere visual statements which he could repeat on canvas, but complex experiences[42], *sensations d'art* as he once said[43], of things in their 'existence together' and in the interplay of their 'existence together'.

Sharply defined patches of colour are particularly well suited to depicting these 'complex experiences' as inextricably linked, because one can manufacture a homogeneous medium, a uniform texture out of them—unlike lines which break up planes and suggest movement, whether within the plane or in space; or in contrast to a smoothly painted surface in a picture.

Cézanne's *sensations d'art*, his artistic sensibility (that is, in his sense of fitness in design) which is now seen as what it really is and as what—going far beyond Rilke—first explains the sense, the meaning and the value of this 'process of making a thing "become" a thing', and 'reality intensified . . . until it became indestructible', which dominate his art, ought in future to prevent such a misunderstanding as Sedlmayr's statement that 'the extraordinary vegetative quietness of the pictures' of Cézanne is equivalent to 'a stillness *without* life'. This sentence if taken seriously would mean that the stillness of death prevails in Cézanne's art: after what I have written above about this problem I venture to say with some confidence that here, where the 'idea' of motionless endurance is symbolically portrayed, it is the stillness of immortality with which we are dealing, the stillness of Kant's three principles of reason.

Sedlmayr has pointed out that in the work of Caspar David Friedrich death plays an important rôle opposite to man, abandoned in nature. In his paintings sea, mountains, mist and ice stand contrasted with the sentient aliveness of man as something quite different, namely as something dead, and even the things which surround man and have been manufactured by him, such as rooms, furniture and so on, are frozen stiff and lifeless. With Cézanne

it is quite different. Loneliness and quietness never have a frightening effect in his works, but seem self-sufficient, solemn and liberating; although not in need of human beings, nature never seems abandoned in his works (as, say, in those of Seurat and Cross); the human beings themselves are not, on the other hand, threatened by death or stamped with death, as so often in Rembrandt. Cézanne does not give us a view of the world seen by night, but the mysterious experience of a serene harmony of all things seen in the unvarying light of day.

There never can be a 'break through of the ultra-human' except where one's link with God has been broken. It was therefore impossible for Cézanne ever to have 'prepared' any such thing, for his whole way of life was founded on a *credo*. How greatly Cézanne the artist surpassed in faith Cézanne the man has already been clearly demonstrated above.

To infer from his alleged striving after 'pure' painting, that he lowered mankind to the level of inanimate objects is to misunderstand Cézanne fundamentally. Instead, this painter, who was a 'believer' (one now understands the meaning of this expression) his whole life through, and not just in his old age, elevated men and things alike into a secret state of a life within, and arising out of, the harmony of total 'being', in which they seem to exist and to be immortal. To recognize that and appreciate it, one must, it is true, rely on the completed or almost completed portraits. For example, the portraits of Chocquet, Gasquet, Vollard and some of Madame Cézanne, and finally the various self-portraits, provide a criterion for a just judgement on this point.

I disagree with Sedlmayr's analysis and consider that Cézanne's art ought, on the contrary, to be regarded as a last great attempt to oppose the general tendency towards 'unbridled chaos' with a sane and purposefully ordered conception of the world of human beings supporting and maintaining each other in a common fate. In him, in fact, painting 'emerges as the last metaphysical activity within European nihilism'—Nietzsche's view of the great art of his time in general.

## Cézanne's Portrayal of People

Like all artists, Cézanne measured other human beings by the standard of his own humanity; and like other great men before him he found that his humanity smoothed the way to a conception and knowledge of men, yet at the same time impeded him.

This inner contradiction is particularly clear in the portraits painted in his youth (between 1865 and 1872). Though they represent people whom Cézanne knew well—friends or relatives—something deeply reserved, inaccessible and alien adheres to them all. This is the reflection of the painter's own nature in their faces, just as their monumentality mirrors the basic attitude of his grimly serious nature. Their gloom too reflects only Cézanne's own mood, not his psychological conception of the person portrayed. The difficulties created for him by his own genius in conjunction with his character kept people at a distance from him and locked them away from him, just as he himself, on account of his uniqueness, was set apart and reserved.

Yet despite this attitude of mind he penetrated to a realization of the human element in other men and did not merely make use of them in order to portray his own spiritual physiognomy. These people, painted by Cézanne, are all unmistakably different in character, yet are controlled by one common destiny: a terrifying and metaphysical loneliness which leaves them rigid, partly at a loss, partly angry, partly suffering in bitter mood what cannot be avoided.

The question is this: what spiritual vision of a general kind beyond the conventional, real world could be offered by mankind, by man, to an artist like Cézanne in the years of his youth? The answer sounds pitiful enough: every man was either a reactionary and believing Christian, or a progressive and enlightened atheist, in either case embodied in the outward form of a civilized *bourgeois* citizen. Cézanne wasted no time with the portrayal of such mask-like features (which sufficed for Manet), nor with any kind of psychology—he went right to the heart of the stuff of humanity. That is why these early portraits stand out as so radically different from all contemporary portraits; they appear to be portraying a band of smugglers or a secret society of political conspirators (V.88). There was something rebellious even in the miserable figure of the poor crippled Achille Empéraire and the expression of suffering on his face. Behind this (and not only in his case) lurks impotence, the lost feeling of those who see no way out. The same is true again even in the portrait of Cézanne's father, which does not so much as hint at the self-made man or the tyrannical head of a household (V.25 and 91, Plate 33). Not one of those who are thus mentally stigmatized has an open face, not one a hint of a liberated personality; they tend rather to look inwards, are spiritless, intimidated,

as though the way into freedom was barred to them, as though 'nothing in life were allowed' to them. And yet they nearly all belong to the *bourgeoisie* of the city of Aix-en-Provence, which in the 'seventies of last century was certainly still leading a comfortable life, conservative, yet at the same time full of expectations of progress. But even these provincial *bourgeois* and in particular the intelligentsia, were already infected with the malady of the century, 'la profonde séparation et la grande solitude de l'homme', and so was Cézanne. Hence his conception of their faces and their bearing.

This conception was already far beyond Manet's, which Baudelaire had branded as symptomatic of decadence. Manet's *décadence* consisted essentially in a narrowing of background, as opposed to Delacroix's cosmopolitan eye, his urbanity and the richness born of his creative imagination. Regarded on its own, Manet's painting was secure in its self-control, civilized, pleasure-loving and in the highest degree personal, an art which was contented and unassailed. Of this there was no longer any trace in Cézanne. In the painter and in his models too, confidence in life had dwindled. With it the elegance and the assurance of the representation faded; that of the clothing and bearing of the persons represented went with it too. While, however, life in the atmosphere of society kept Manet and those of his contemporaries whom he painted remote from one another in their inmost hearts, and concealed their inmost thoughts, Cézanne, as he grew lonely, gained an insight into the inner hearts of those around him who had already grown lonely. Because he understood their alienation and their reserve and portrayed it, he was able to approach their spirit which put its stamp on the era, the epoch. In so doing he became 'the pioneer of a new art'—to which, be it noted, no other artist ever provided a sequel.

On the other hand, Cézanne himself soon drew new conclusions from the fate of mankind in his century. This is visible in portraits after 1876–77. These are the years in which the portraits of Chocquet (V.283) and of Madame Cézanne (V.291 and 292, Plate 31) were executed, while the self-portrait (V.286) represents the transitional period. What is new is the quietness and restraint, and the way in which existence, attitude and determination are bound together to form an integral whole, which opens up a new approach to the world around the persons portrayed. Admittedly the spectator still remains conscious of a feeling of alienation in relation to these men and women and of their inherent inaccessibility: they still keep to themselves, but now they do so with resolution, resigned to loneliness,

easy and relaxed, because they are in accord with the inevitable. Compare for example the difference in posture of Madame Cézanne sitting in her chair and the painter's father in the picture mentioned above (V.91, Plate 33); and it is not that the act of sitting is more correctly painted in the later picture. It is not a question of correctness. It is a question of what the manner of sitting as variously depicted says about the person sitting, what it makes known about him. And in both cases what it tells is the spiritual position, the 'attitude', for in both cases the portrayal of the physical is a direct expression of the spiritual.

Cézanne's new type of human being has confidence and poise, a quiet determination. In his resolutely accepted solitude he succeeds in becoming wholly himself as an existing being. He is portrayed as free from all convention, from all compulsion, such as a public or social appearance might demand of him—in a homely suit which permits him the utmost relaxation. So he reveals himself totally. In this connexion the portrait of Chocquet with the open shirt-collar must also have been something of a novelty even when compared with Courbet's portraits (in which the artistic and romantic charm of the negligé had already been exploited). This is indeed a striking example of how differently two artists can interpret identical subject-matter.

In Cézanne's early portraits the figures are in conflict with the space and the objects around them; now they are depicted in harmony with it. It is not just that Madame Cézanne sits comfortably in her chair; it is rather that the chair has an eloquent relationship to her, it surrounds her, it protects her like a shrine, and its shape at the same time sounds an echo of the female figure which endows it with dignity. Never before was this ugly, old-fashioned piece of furniture painted with such greatness as here by Cézanne.

While man in Cézanne's first conception did not even seem to be protected by his own clothes—they did not fit him, they hung on him like something alien—the clothing of the woman of the period (from which Renoir was able to extract such incomparable charm) now developed—with all its stripes, bows and ruffles—a solemnity not derived from the clothing as such; simultaneously however, it evolved a pleasingness and candour which frankly appealed to the world. The transience of fashion was overcome and fashion acquired style, in that it was appropriate to the spiritual attitude of the wearer and gave her a means of self-expression. Suddenly it seemed capable of carrying in a most fitting way the *universal* destiny of

mankind of those years. Each of those portraits seems to say: so it was in those days, this is how things were with mankind. This is true not only of women but inevitably of men as well. In both cases the meaning is: our common destiny weighed too heavily; it was so demanding that it was not a question of the fate of just one individual. Here for the first time is the anonymous man who emerges only occasionally from the masses; he is pictured within the limitations and the (still potential) greatness of his unknown existence. Think for the sake of example of the difference in significance of Madame Cézanne sewing, as compared with a woman doing handwork, painted by a Dutch painter of the seventeenth century. Madame Cézanne is 'working', while for those other women sewing, embroidering and lace-making possessed the charm of an aristocratic pastime—something enjoyed in the shelter of one's home which increased the womanly dignity of the ladies engaged in this delicate occupation.

In those years Cézanne portrayed himself also as an unknown and unremarkable person in whose external appearance there was nothing to characterize him as a painter; yet at the same time he did show himself explicitly as someone in strict agreement with the world around him, using formally pictorial equivalents of primitive striking power and overwhelming frankness (for example in V.287). On the other hand he also used other means, such as large outlines and a free arrangement of masses in space, as in both V.286 and 290, to express in the person portrayed the open attitude in relation to the world and the determined attitude towards living, which he had evolved through accepting his fate. In particular the last portrait, one of Cézanne's greatest achievements, shows a man who has acquired a seeing eye through resignation, through *humilitas*, with features grown calm, with penetrating glance, i.e. a glance which sees beneath the surface, and is directed in relaxed fashion towards the world of earthly things which unveils itself to him in its true significance. As always with Cézanne, the eye is not actually *looking*, it is not gleaming with the energy of observation, but is *beholding* and is aware of the inner heart of things beneath the surface which deceives most people. What this glance embraces is evident in the picture itself; it is the 'existing together' of forms, their mutual illumination in discovered harmonies, which transcends them above the mortal and the ephemeral. Both the features of this prematurely aged man (Cézanne was not yet forty years old) and the lapels and folds of his everyday jacket have here lost all trace of the way in

which time has affected them and made them its victim. The whole person is apprehended as an architectural structure, the parts of which—related to, supporting and carrying one another—seem to assure a spiritual existence or, more correctly, to signify its preservation. Here the features have actually become completely spirit and soul.

While portraits from Cézanne's 'rebellious' phase show people whose minds opposed the forces shaping the fate of their time, whose inner souls were therefore in conflict with the outer world, and while this conflict in its turn made a homogeneous construction of the figure impossible, the portraits from the end of the 'seventies onwards possessed unity, because the forces of destiny no longer met with resistance from the minds of the individuals. They could therefore permeate the figures completely and shape them without hindrance. If before there were two opposing forces which made it impossible to represent a human being as one unbroken unit, everything was now harmonious and meaningful, since only one formative force was at work. As a result of this, however, man came to be regarded as a piece of nature, as a purely natural being, who, submitting to this law, served his own preservation and maintenance, because only his universal, not his particular, destiny was important.

Cézanne then progressed further along this expository path, in that he devoted ever more attention to what was general and *universal* in nature and positively suppressed the individual. This can be seen in his style from the end of the 'eighties onwards. In contrast to his landscapes in which a rich and entirely new style of design—the fruit of this conception—was just then being developed, the portraits of that time became more empty and exteriorized, for this same conception simply did not suffice when it came to portraying the human nature of men and women. Compare the two portraits of Chocquet (V.373 and 375), painted at that time, with the portrait of Chocquet which we have earlier discussed, then also the portraits of Madame Cézanne and the self-portraits. The differences are always of the same kind; by comparison with the earlier versions the later ones are impersonal and general, indeed one might say immature and inferior in conception. For it is only in the lower levels of nature that regular and universal shapes are produced, as for instance in crystals and the honeycomb cells of bees, and in buds and seeds at an early stage of development.

But the inner firmness of the comportment of these people has increased, the unity in their structure has become even more

positively evident. Face and body are apprehended as quite simple, regular shapes; indeed they are seen so exclusively as stable forms of solids rendered motionless by being fixed in the surface of the picture, that an impression of *pure space* emerges and all thought of the dangerous power of time has disappeared from them. In these portraits Cézanne evolved the patterns which were to serve him to express more and more conclusively what is permanent; he found the graphic symbols for that idea which he 'beheld' as underlying all the varied multiplicity of things of the real world which grow and then fade away.

An outstanding example of this phase of Cézanne's style is the *Mardi Gras* picture which was painted in 1888 (Plate 19).

Shortly afterwards, however, Cézanne's manner of portraying people took a new turn. This change was connected with the experiences which were, artistically speaking, suppressed in *The Cardplayers* (Cf. Chapter II). They are of two types. First, stress was once more laid emphatically on the mundane, which had been undeveloped in the earlier period because the relationship between a figure and its surroundings had generally been regarded as un-important—now man appeared linked to the world around him. Simultaneously individuality again emerged. These two new features were signs of a step towards greater fulfilment and deeper truth made by the matured man. For it is only by making clear the stamp of his personal destiny and letting it be known that he has a fixed place in the space in which men live that the individual man is seen to be both whole and true in the way in which he stands for what is universal in mankind: whole in that he embodies the *fatum* of his existence, the fact that it must fall victim to death, in that he is marked by age (time) and by his struggle for existence; and true because he is only now understood in the midst of all his human problems with complete gravity, with utter seriousness.

Hitherto regarded by Cézanne as a natural object which merely existed, man now appears as a suffering creature, or rather he now *re*appears; however, he is no longer struggling against his fate but is resigned to it and represents it in all its momentousness.

This conception is illustrated in the portrait of *Madame Cézanne in the Hothouse* (V.569) which Venturi dates about 1890; it shows itself in the paintings of workers which were executed in conjunction with *The Cardplayers*; equally in various pictures of boys and finally in *Geffroy* painted in 1895 (V.692, Plate 26) and in *Vollard*, dated 1899 (V.696, Plate 32). The people in these pictures are no longer

portrayed in front of an empty background but in the midst of objects and in explicit relationship to them; and yet not 'at home' among them, but rather suspicious of and even oppressed by them. Those famous curtains, which now crop up again and again, weigh down on the persons portrayed, to whom they do not belong, and the same is true of the books and tables which surround Geffroy in his workroom. The atmosphere of the rooms is stuffy and oppressive; in them people live in fetters. When discussing the pictures of workers playing cards I drew attention to the fact that their game had become a heavy and solemn affair, indeed it was almost as though they were held fast in this state and suffered it. They embody a universal human destiny—self-preservation while one is in bonds and under compulsion. Not that they utter any murmur of complaint. There is no question of that. On the contrary, they accept their destiny, but they now look through it with the utmost gravity to ultimate darkness and give visible form to it in all its seriousness.

It was this gravity which also produced the portrait of Vollard, which deviated so far from the picture of him portrayed by other artists. Cézanne saw more in him than did Renoir, who painted Vollard as an art lover and connoisseur. He also saw something more in Vollard than the enterprising and smooth trader who found it amusing to shock the *bourgeois* citizen and to spin a yarn for him, and who tried by recounting doubtful anecdotes to render impossible the serious consideration of just such works as his own portrait by Cézanne. If we were to give credence to him (Vollard) this creation would be the work of a whimsical sleepwalker—yet we have already known for an appreciable time from what other eyewitnesses have told us that Cézanne was in fact quite the opposite, even outwardly, and was not even remotely inclined to do anything peculiar in his art or to speak peculiarly about it. From the portrait itself, however, we learn that Cézanne here, as also in his other portraits, did not enquire after the exterior, for in his opinion mere reproduction of an exterior resulted in pictures of 'horrible ressemblance'. He searched for those forms which expressed the essence of mankind as an entity and sought persistently the exterior form of the special, unique appearance for the sole purpose of finding something indicating destiny. This was the procedure Cézanne adopted even with such a natural actor, so difficult to see through, as Vollard, and he set himself the task of penetrating to the universal human core. That is what we have before us in this portrait, a portrait which, like and unlike at the same time, goes far beyond the doubt-

ful character of the man portrayed and shows him as a representative
of a whole generation, of an epoch, as the man of the great city,
withdrawn into a corner of a room, closed up, rigid, empty-eyed,
because 'blind from too much light', shapeless and yet embarrassed
in his attitude[44].

The portraits painted by Cézanne in his old age, say between
1900 and 1906, show that his conception of mankind altered once
again. Not long ago it used to be said that these works were lyrical
and baroque; lyrical because they were more personal than the
earlier portraits and baroque on account of certain agitated lines
and crooked planes which appeared in them. But those who say
this have, as is frequently the case nowadays, allowed themselves
to be deceived by generalized and superficial observations. Things
have now come to the point that a critic who traces a personal note
of the creator in a work of art believes he is entitled to speak of its
'lyrical nature'. As though one generalized statement establishing
one such fact were sufficient! And a similar irrelevance prevails in
the field of determination of style. In fact Cézanne's later works are
neither lyrical nor baroque. Their very quality as 'works of old age'
makes it impossible to class them in these categories. 'Lyrical' and
'baroque' are styles which belong in a significant sense to youth
and to middle age; towards the end of the life and creative activity
of an artist, everything is determined by the eye of old age, the
mature and mellow eye which observes things from a great spiritual
distance and out of a great quietness. We recognize this in Titian
and Michelangelo, Poussin and Rembrandt and in the writings of
Shakespeare and Goethe.

Now, from the time of his 'conversion', we can find a general
tendency towards remoteness and calm in Cézanne's work; his work
as a *whole* acquired the characteristics of his late period through the
maturity of an ageing mind. In the last years of his life his work
took on in addition the special marks of a 'style of old age'; the
things depicted seemed actually to retreat from their outward
appearances, the edges of things became fluid and space surrendered
something of its clear identity. All contrasts lost some of their
sharpness. Simultaneously things began to be evaluated in a new
way; in relation to the world around him man lost some of his
individuality; he began to blend into the world, to become one with
it in the fullness and sweetness of extreme perfect maturity. Simul-
taneously, however, his 'existing', which it had ever been Cézanne's
wish to portray, reached the final stage of its evolution. The figure

of man now emerged as something permanent beyond all possibility of alteration, no longer held fast by force or subjected to strict design and outline, but something left standing after the current had carried away all that was perishable, because it was incapable of action, tender and fragile yet made all the more enduring by its very feebleness and impotence, with hands no longer capable of gripping, powerless limbs and joints incapable of exertion. For these powerless bodies are built up into an indissoluble framework of interplay of colours and forms, which carry, support and maintain each other mutually in equilibrium, which are no longer taken from the appearance of real things, but are acquired from an insight into the 'being' which lies behind them. In the figures of old Vallier (V.716–718, Plate 36), of the peasant (V.713) and of the old woman with the rosary (V.702, Plate 22) their expiring, wavering 'creatureness' reveals what is above and beyond nature in mankind . . .

### NOTES (CHAPTER III)

1. *Michelangelo, Neue Beiträge*, p. 372, Berlin, 1909.
2. Georg Simmel, *Philosophische Kultur*, p. 167, 1911.
3. *Michelangelo, Neue Beiträge*, p. 390.
4. Vasari calls Pontormo 'malinconico, bellissimo, solitario'.—At the end of his life he was living alone in a room to which access was gained by ascending a ladder, which the unhappy man pulled up after him so that no one could reach him against his will.
5. *Journal*, 9th June, 1823.
6. The most convincing proof that this was so is afforded by a passage in Delacroix's diary for the 14th May, 1850. Someone had read out to him the passage from Benjamin Constant's novel *Adolphe* which runs as follows: 'L'indépendance a pour compagnon l'isolement' ('The companion of independence is isolation'). Delacroix changed the wording (unconsciously) into: 'The result of independence is isolation,' and was of the opinion that the phrase was a statement of what was absolutely 'inevitable'.
7. The popular picture of Courbet is of a man who enjoyed life and was a materialist securely rooted in his rusticity; the leader of a group of men of similar outlook, all quite immune from the malady of loneliness: yet there is a passage in a letter which he wrote in November, 1854, to the collector A. Bruyas which reads: 'Beneath the laughing mask which you see me wear, I conceal grief, bitterness and a sorrow which sucks the blood from my innermost heart like a vampire. In the society in which we live one need not make a great effort to find emptiness. There are in truth so many stupid people that it makes one feel most discouraged and afraid to develop one's intelligence lest one should find one's self completely isolated.'
   In their diary (on 19th October, 1856) the brothers Goncourt write of the draughtsman Charles Méryon: '. . . madness and wretched poverty seated side by side . . . no commissions, no bread . . . his poor sick brain filled with imaginary terrors . . .' and (on 25th December, 1856) of Paul Gavarni: 'Gavarni is living an even lonelier life than ever. He is no longer a human being, only a spirit . . . He sees no one in his tiled attic.'
8. John Rewald, *Cézanne, sa vie, son œuvre, son amitié pour Zola*, p. 327.
9. See Cézanne, *Correspondance*, edited by John Rewald, Paris, 1937, No. 100.
10. Cf. John Rewald, *Cézanne, sa vie, son œuvre, son amitié pour Zola*, pp. 276–280.

# Notes

11. *Mes Haines*, p. 48.
12. V.84, *Le Christ aux Limbes*, painted between 1868 and 1870—after Sebastiano del Piombo.
13. The extreme contrast is illustrated by Leibl's *Women praying in church*, where the act of praying is looked at from an entirely external point of view.
14. Émile Bernard (*Souvenirs sur Paul Cézanne*, p. 70, Paris, 1924) reports that he asked Cézanne: 'Why do you not paint a Christ?' 'I would never dare,' he replied, 'first, because it has already been done better than any one of us could do it and also because it would be too difficult.'
15. *Rembrandt, ein kunstphilosophischer Versuch*, p. 170, Leipzig, 1917.
16. To illustrate this still further let me quote Simmel who on p. 153 of his *Rembrandt* writes: 'There are many still-lifes and landscapes, which demonstrate an attitude of devotion towards the existence portrayed in them, a presentment of universal interrelationships . . ., intertwined with timidity before their secret depths—all of which does not necessarily arise from a religious basis but is either absolutely identical with the religious spirit or is evolving towards it.' This was exactly the position of Cézanne. From the time of his 'conversion' it was 'devotion and presentiment' which led him on to fulfilment as an artist; and starting out from them he found his way back to the church. That is the reason why Catholicism did not influence his art at all. With him it was a question of a religious portrayal—in contrast to a portrayal of religious themes.
17. The same comment was made by Meyer Schapiro, *Cézanne*, New York, 1952. There are a few exceptions: the *Banks of the Seine* and V.243, 249 and 251.
18. From a historical point of view this conception of a picture brings to a logical conclusion a tendency which had already set in earlier. Baudelaire had already perceived in 1859 that landscape painters were on the road which led to Cézanne (*Curiosités esthétiques*, p. 325). In Corot, Rousseau, Daubigny and Boudin he was already finding 'Nature without man' and he spoke with disapproval of the 'artists who want to portray nature without the feelings which nature awakes.' Those landscapists were preparing the way for Cézanne's conception of nature, even though their works appear to us today to be conspicuously full of feeling, in contrast to those of Cézanne. It was he who took the first decisive step and applied his imagination exclusively to the interrelationship between natural objects and its significance, instead of 'explaining' nature by means of his imagination, which is what Baudelaire required of a landscape painter. It was inevitable that there should be this difference, for the painters of the Barbizon school still had a sort of familiarity with nature which permitted them to savour her manifestations to the full (atmospherically speaking), even though their melancholy (which sprang from their incipient isolation) and their yearning (to return to an overall unity) influenced their choice of 'atmosphere'. Cézanne, on the contrary, understood himself, and looked at man in general, with a relaxed vision, seeing man as something set apart from natural things. Therefore he could regard landscape also as something detached, as a simple arrangement of 'being', as an independent existence.
19. Dorival, *Cézanne*, p. 69.
20. Ibid., p. 69.
21. Ibid., p. 69.
22. Far more than, for example, the feeling of being pushed around in space which one senses in Degas's portraits.
23. Dorival, *Cézanne*, p. 69.
24. Ibid., p. 70.
25. The fatal confusion which has arisen since the pictures produced by neurotics and madmen have been hailed as works of art can be cleared up by means of this distinction: 'substitute for and evidence of self-control.'
26. All the same, I should like to recall to mind the splendid passage which Friedrich Rintelen wrote on this subject. He says: 'His finest portrait is that of a farm worker who is sitting at a table, leaning on his elbow and smoking a

little pipe. It is natural that Cézanne understood this typical representative of our times best of all; it is the simplest thing to do and he is striving after the simplest. Yet that is something more than understanding: it is religion, and I do not hesitate to say that this is the most thrilling of all pictures of recent times in its greatness. There is the same piety in it as that which . . . Le Nain painted in his rustic *Supper* where we feel that we are witnesses of an early Christian Agape.' (Friedrich Rintelen, 'Paul Cézannes geschichtliche Stellung', *Reden und Aufsätze*, p. 157, Basle, 1927.

27. 'Das Problem des Menschen Cézanne im Verhältnis zu seiner Kunst', in *Zeitschrift für Ästhetik und allgemeine Kunstwissenschaft* XXVI, 2, 1932.

28. Fritz Novotny, *Cézanne und das Ende der wissenschaftlichen Perspektive*, Vienna, 1938.

29. The scientific perspective used in painting up to the time of Cézanne was something discovered by the architectural engineer Brunelleschi of Florence at the beginning of the fifteenth century. It conceived space under the image of the pyramid of vision, as the view into the inside of a pyramid into which a spectator is looking from the apex of the pyramid—an entirely artificial structure which has nothing to do with pictorial space as we really experience it, but is on the other hand very appropriate if one wants to rationalize space mathematically i.e. to measure the proportion between the degree to which things diminish in size and their distance from the beholder. This kind of perspective construction made it possible to portray depth in painting in a new way; but too little emphasis has hitherto been placed on the fact that it also had a most upsetting effect on artistic realization (from a given set of themes). Throughout the whole of the fifteenth century, perspective simultaneously supported and confused painting. Raphael in his later years was the first to turn it to good use in his compositions and to incorporate it perfectly in them. Artists like Tintoretto, El Greco, Rubens or Poussin—who knew something about the way to illustrate space as they experienced it—made the most violent changes in this scientifically correct method of representation and broke it up, if indeed they did not actually replace it, by introducing solids which created space and were capable of expressing something quite different. Yet even they could not eliminate the circumstance that the representation of space by means of central perspective draws attention in a marked way to the spectator standing in front of the picture, that it links him to the space portrayed in the work of art and suggests to him that the space in which he finds himself and the space in the picture are one and the same. That was something which Cézanne, however, neither would nor could affirm since his aim was, as we know, to portray a world infinitely remote from all human beings, unattainable by mankind and invulnerable to human intervention (however feelingly the intervention might be made). Hence the compulsive inevitability of his break with 'scientific perspective'.

30. Novotny, *Cézanne und das Ende der wissenschaftlichen Perspektive*, p. 81.

31. It is possible that many observers are not immediately conscious of this clarity; yet we can learn from a comparison of his painted landscapes with the numerous photographs taken of his motifs that Cézanne excluded from his paintings everything whose shape he could not represent unambiguously, decisively, simply and completely. In nature, all landscapes contain an enormous number of elements which are not clearly distinguishable or are confusing to the eye, such as bushes, twigs, haze or objects which do not stand out sharply from one another. As the eye contemplates the real world, such vagueness can act as a bridge between clearly distinguishable objects, linking them up, or it may be contrasted with them; it usually predominates in what we see. By eliminating all such vagueness Cézanne gave his landscapes coherence, constructing them exclusively out of firmly traced units, i.e. single images such as plots of land, undulating ground, flat fields, single trees, bushes, hills, boulders, houses etc., to all of which he gave outlines of a uniform degree of clarity in his pictures. He achieved this, as he himself pointed out on occasion, by means of an exceptionally difficult method of

observation. As he contemplated the motif which he was painting he had to free himself from the procedure ordinarily used for the purpose of orientation, whereby the painter's eye takes up a perpetually changing point of view, adapts itself constantly to the greatest variety of distances and then distinguishes the details of each object as accurately as possible, whether it lies in his immediate vicinity or at a considerable distance from him. Instead, he had to contemplate the objects which were at varying distances from him without altering the viewpoint of his eye so that when, for example, he looked at a tree whose trunk appeared to him as one unified mass, he had to see the foliage as mass too, so that single leaves were not distinguishable. The logical consequence of this was that, because he always started out from his view of such objects, he then also distinguished objects which appeared as clearly comprehended shapes in the middle distance—i.e. one does not see single blades of grass or single stones in the foreground of his landscapes, nor single objects on the horizon, but in both alike flat coloured areas or plastic solids (as the case may be) as though 'in the middle distance'. In his still-lifes he gave a similar interpretation to the objects which in the real world were lying quite close in front of him. That is why, to add a further example, he did not show the crossbars of the windows when he painted a house as one unified block; he inserted them only in those cases where he worked at a picture for such a very lengthy spell that he arrived at a unit of observation of masses which differentiated items of dimensions as small as window crossbars.

Cézanne had an innate gift for this way of seeing things from one single standpoint at an unvarying distance; but it must not be assumed that this was the fount and source of his art. On the contrary, the tasks he set himself in his art compelled him to cultivate this talent most rigorously; and he may well have undertaken his experimental compositions containing only a few items, such as still-lifes with two fruits and so on, with the purpose of developing and establishing this style of observation. Certainly it is already perceptible in the pictures of the 'sixties; in these works of his youth it led to the omission of all detail and a harsh reduction of all that he saw to a very few concentrated elements of colour and form. Then about 1870 there appeared those landscapes whose originality (which was due to this type of 'vision') represents something absolutely new in painting (V.50, 51, 54, 55), among them being the *The Railway Cutting* and *Melting Snow at L'Estaque*, which are extremely violent both in structure and in expression. In them Cézanne seized on the scene which lay before him in nature, re-moulded it radically and eliminated all save a few of the main items it contained, cutting out everything indefinite or vague in form. It is true that at that period he depicted isolated objects quite clearly, and even with a uniform degree of detail, but he always gave them the forms in which they appear if one sees them from a point close at hand. This is particularly obvious in V.55, if one compares the fishing boats with the roof-tiles of the houses near at hand. Later, when his mature style was evolving, Cézanne adopted a different basic point from which to make his observations, at a greater distance from his pictures, that is to say 'further away'. But he retained the uniform clarity of objects in their detachment from one another and in their distance from the painter—this was indispensable to his art.

32. *Théories, 1890–1910. Du symbolisme et de Gauguin vers un nouvel ordre classique*, Paris, 1913, and frequent later editions.

33. Fritz Novotny, *Cézanne und das Ende der wissenschaftlichen Perspektive*, p. 84, Vienna, 1938.

34. Ibid., p. 89.

35. What follows is a brief exposition of my inability to accept the views Novotny gives in his essay 'Das Problem des Menschen Cézanne im Verhältnis zu seiner Kunst' (*Zeitschrift für Ästhetik und allgemeine Kunstwissenschaft*, XXVI, 2, 1932), an important and profound work the significance of which I should like to emphasize all the more because I disagree with its findings.

36. Cf. Novotny, *Cézanne und das Ende der wissenschaftlichen Perspektive*, p. 83.

37. Op. cit., Salzburg, 2nd impression, 1948.
38. The italics are in the original.
39. *Correspondance*, pp. 257 and 266.
40. Ibid., p. 253.
41. 'La construction qu'il faut arriver à posséder'. *Correspondance* pp. 268 and 297.
42. Ibid., pp. 165, 257, 261 etc.
43. Ibid., p. 255.
44. Let no one interpose that all this is simply the consequence of the rigid motionlessness to which Cézanne notoriously condemned every one of his models. The exact opposite is the case. Cézanne required his models to sit still and keep quiet because it was only thus that he could succeed in observing and extracting from the real world of nature the inner picture which he himself had formed of the person he was to portray.

# CHAPTER IV

# The Problem of 'Realization'

When Cézanne himself mused about his art his thoughts revolved around the concept of '*réalisation*'. This he regarded as an omnipresent problem and his highest aim, and the best contemporary critics of his work agreed with him that his most important task, and at the same time also the aspect of his creative work which caused him the greatest difficulty, was the achievement of what was represented by this word. Yet in later literature about Cézanne the word ceased to be given such prominence; what is more, its meaning changed to the more vague conception of 'succeeding' or 'bringing to a successful conclusion', with the result that the word *réaliser* also lost its very specific significance, above all in connexion with Cézanne. For example, let me quote from Lionello Venturi[1], who wrote: 'Whereas he said of himself, that he could "realize" only with difficulty and allowed people to reproach him for not knowing how to "realize", in fact Cézanne "realized" to perfection in his good moments and then with only a few pencil strokes.' In another passage[2] Venturi indicated that the aim of *réalisation* (which he had not mentioned in the sentence I have quoted) was 'order'. He maintained that as it is impossible to attain absolute order in art, Cézanne did not in fact 'realize', 'parce qu'il continuait d'être artiste'. 'Everyone', continued Venturi, 'confused the common understanding of the term *réalisation*, i.e. the completion of some work by a simpleton (an expression of Cézanne's) with *réalisation* of order, as Cézanne understood it. And everyone believed that he did not understand how to "realize" because he had not learned what all the schools teach'. To quote another example, this is what Adrien Chappuis[3] had to say on the subject: 'A word about the expression *réaliser*. Within a composition as a whole Cézanne gave each natural image its special character by emphasizing the ways in which it affected

his sensibility. He took pains to paint the vision produced by a combination of his visual impressions and the logic of his imagination. Complete success in the reproduction of this vision was the meaning of the word *réaliser*[4]. Dare I confess that these explanations of the problem do not appear to me to be very enlightening?

The danger of rendering the problem even more obscure has now been increased still further in English-speaking countries because we have become used to translating the words *réaliser* and *réalisation* with 'realize' and 'realization', which at best express only part of what Cézanne wanted to say, so making it hard for people to understand why this particular matter should have caused him such special difficulty. Only a study of the history of the subject can help us to make any progress on this point.

When we use the expressions 'realized' or 'unrealized' aims of a work of art, as though they were normal and commonplace, we are apt to forget that such terms appeared in art criticism for the first time in the nineteenth century, when painting had entered a new stage and arrived at a crucial point of development. Bearing that in mind it is fair to assume that these terms and the opportunities of employing them are in themselves a stylistic landmark and that they were by no means in general use. When we read what Alfred Sensier wrote in 1872[5] of the romantic landscape painter Paul Huet: 'il était un artiste d'intention plutôt qu'un réalisateur' ('he was an artist of intention rather than of fulfilment'), these words throw positive light on the new and previously inconceivable position in which art now found itself: works of art were now being produced in which a purpose *could* be perceived, distinct from the completion of the work presented to the eye of the beholder, whereas up till now it had always been taken for granted that in art —to use a phrase of Delacroix's[6]—'execution adheres closely to invention' and 'in painting as in poetry form and conception are indistinguishable ('se confond')'. True and original art was simply regarded as '*réalisation*'. Thus Baudelaire[7] could write: 'Toys give children their first initiation into art, or rather form the first *réalisation* of art for a child, and when the child reaches maturity more perfect *réalisations* will not afford his spirit the same satisfaction ('les mêmes chaleurs'), nor the same enthusiasm, nor even inspire in him the same trust ('croyance') as those playthings'. It had always before seemed unthinkable to infer a second, concealed and unfulfilled intention behind what an artist presented to the beholder in his works—except of course in the case of insignificant artists, in

particular those who were imitating a great model, for in the works of an imitator it was possible to discover details of technique, of composition, of drawing, or of coloration, of which better executed examples were to be seen in the works of others, where, moreover, they were employed to produce better results.

There were admittedly a few important exceptions to this rule. The attention of art critics had already been attracted by the *unfinished* works of Leonardo da Vinci and Michelangelo. It was obvious that unfavourable circumstances alone could not have been enough to prevent both these masters from completing so many of their works, and that some special problem of 'realization' must have troubled them; in other words they must have come up against some inherent obstacle, the reasons for which were to be sought in each case in the nature of the artist himself. It was evident that Leonardo's universality and his extensive interests were themselves among the causes of his difficulties: his research and architectural work, for example, absorbed much of the energy needed for realization, if only because they actually occupied his whole time for long periods. In addition his inspiration was crippled by the fact that he constantly pondered over his work, repeatedly testing the images of his imagination and applying ever fresh criteria to them. He always required that every painting should have a considerable human thought-content and insisted that the composition of each as a whole should be perfectly clear to the eye. At the same time, he had to be able to execute it with the utmost refinement of detail; the figures had to combine beauty and nobility, charm and dignity, poise and passion, to be accurate from the point of view of natural science, and artistically eloquent, individual and universal (typical); their gestures strong yet restrained, the expressions on their faces ideal and yet also psychologically differentiated. Almost inevitably, it would appear, these innumerable self-contradictory requirements made the completion of any work extremely difficult; the uniform realization of all these purposes required enormous mental exertion, one so great that even an extremely powerful mind could succeed in summoning it up but rarely in a lifetime. That is why Leonardo has bequeathed to us only a few completely finished works, why he gave up many unfinished— such as the *Adoration of the Magi*, the *Hieronymus* and the *Battle of Anghiari*—and was able to finish others again, such as the *Mona Lisa* and *The Last Supper*, only as a result of taking great pains and by working on them over an extended period of time. Yet, whatever

inherent difficulties Leonardo's working methods may have caused him, they applied, strictly speaking, only to the finishing, not to the *réalisation* of his artistic creations. His competing interests tended to dam up his creative powers and so to increase their force, and his projects did not really give rise to any genuine problem of *réalisation* because there was nothing inherently impossible of solution about them.

On the other hand, that was exactly what troubled Michelangelo. In his case, as in Leonardo's, there was no gap between being willing and being able; but with Michelangelo there was an irreconcilable contradiction between the 'willing' of the creative individual and the potentialities which are the pre-conditions of art itself. His goal was even more difficult of attainment than that of Leonardo. The world which he wanted to create surpassed human experience, the creatures in it represented perfection in a world of giants, in which normal appearances were transformed into something supernatural by a combination of beauty, size and expression. Besides, something in Michelangelo's nature urged him on towards the impossible. The gigantic works which he brought to completion were only a fragment of what he dreamed of doing. 'He belonged', says Carl Justi[8], 'to those few select human beings who hate anything easy. He needed work which stimulated his physical forces, which transported him into that aggressive state which is actually akin to demolition and destruction.' His *vis poetica* was therefore by nature as much opposed to completion as were the creatures of his imagination which it visualized. Moreover, his imagination created ideas with such force that it never permitted accurate preparatory work nor could it be satisfied with its first conceptions. While he was actually engaged in the process of artistic production it continued to operate and develop, refining and enriching what he was creating. Since Michelangelo himself knew this, he could not even adhere strictly to his clay models, for they gave only one main view of a figure—the motif from which he started out but not the final form. That is why he was doomed so often to find his projects wrecked through misjudgement of the dimensions of a block of marble. The unyielding material itself prevented the realization of many of his ideas; sometimes the dimensions insisted on their greater right to set bounds to the boundless and so clipped his wings; technical limitations took revenge for the scorn with which—in certain respects—he treated them.

'We find'—Justi[9] speaking again—'flat parts which could not

possibly have been intended to lie just so; sections in relief, opposite which pronounced hollows had to be placed; dents which are detrimental to repose and harmony. Such faults, which pursued him during his work, could spoil his pleasure in it. Hence so many marbles which remain unfinished'. Delacroix had already made the same observation[10]: 'The effect produced by Michelangelo's statues depends to some extent on certain disproportions or uncompleted parts which enhance the significance of the finished pieces. . . . It is possible that his original idea was indefinite and that he relied too much on the inspiration of the moment for the development of his thoughts, so that if he frequently lost heart and gave up a work it was because he really could do no more to it'.

Besides, he loved to portray ideas by means of a large number of figures—such as apostles, slaves, ancestors, prophets and sibyls— which were intrinsically identical. These had, of course, to be individually distinguishable from one another and yet were supposed to show an interrelationship by means of contrasting harmonies and variations in certain of their points of correspondence. In such variations on a prototype, repetitions and discords inevitably appeared, as a rule as soon as the figures began to emerge from the marble and to take on the shape of real appearances. Finally, the clear unambiguity of anything complete was incompatible with Michelangelo's *ethos* of forms. It was as though each of them possessed unlimited potentialities of development over and above its mere gigantic size, but in the final state of the work of art only *one* of these was preserved and had a voice. Therefore the final realization turned out to be a restricted and a diminished vision of the original conception—this is very obvious in the slaves on the Julius tomb. Thus in the second half of his life Michelangelo was unable, to wish for the complete realization of his ideas; he undertook it only reluctantly and carried it out in truly antinomic images: we need only recall the architectural components of the entrance hall to the Biblioteca Laurentiana, the downflowing stair and the supporting pillars which split up the wall.

We may well think we have thus been able to discover the reason why these two great and exceptionally gifted artists failed to achieve 'realization', and in so doing we may even have taken an important step towards understanding their manifestations as a whole; but let us now look at Rembrandt. For a long time the art-loving public, like the critics, failed to understand what were his artistic aims in the later years of his life and accordingly supposed they saw

in his works a lack of *réalisation* which did not in fact exist. It has been proved that no such problem ever existed for Rembrandt; and the works he produced carried out his real intentions wholly and completely. But those who misunderstood him presumably found it hard to believe that such a great artist could ever be incapable of expressing fully what he had in his mind. They thought that in his old age Rembrandt's aims had diminished in clarity along with his representational capacity.

In general however, so far as the old masters are concerned, it is still a valid axiom that their artistic intentions coincided with what they 'realized' in their works, and that these intentions can be deduced only through what they 'realized'.

In the course of the nineteenth century this axiom ceased to be valid for the artists of that time. And along with all the other important changes which painting was then undergoing, we find the 'realization' of a work of art, of an artistic idea or of certain difficult aspects of form and of spirit, beginning to emerge as a problem. The word *réaliser* started to invade art criticism, where it soon occupied a prominent place.

In Castagnary's *Philosophie du Salon de 1857*[11] we find a definition of the new expression: 'A *realized* work is, on the basis of the idea contained in it and its outward form, not a copy and also not a partial imitation of nature but a quite extraordinarily subjective production, the outcome and the expression of a purely personal conception'. And he adds, as elucidation: 'The artist materializes and concretizes his personal conception of beauty to correspond to the particular forms (laws of form) of his art'. Therefore the realization of a work is based on the power of the artist to conceive beauty (and not, be it noted, on the power of his inventive imagination) and on his capacity to give to this concept (of a universal inherent notion of what is beautiful) a concrete form in accordance with the laws of form pertaining to his particular art. Thus it is not through the artist's execution that realization is achieved but through his intuitive appreciation of what is universally beautiful (whether it be the beauty of his own inventions or of the motif which nature has given to him) and by his grasp of the eternal laws of his art, that is to say by the metaphysical conditions which make his artistic existence possible. Castagnary re-stated this theory when he said: 'Art is simply the realization of individual expression under the supreme control of a conception of beauty and by means of the infinite number of differing basic forms (types) which nature offers'.

# The Problem of 'Realization'

If this be so, then he who would be an artist must possess a subjectivity, a personal talent, strong enough to recognize beauty as an idea and to render it really, truly and convincingly visible in the typical objects presented to his eyes by nature. He who can do this 'realizes', makes real, a work of art and at the same time the universal task of art; he fulfils 'une véritable création seconde'[12], and brings art into *real* and actual existence and so also 'beauty . . . as a pure form of truth'[13]. The term *réalisation* obviously means a joint creation, a confluence-point where creative personality, beauty as an idea, the laws of art and nature all meet: its central importance cannot therefore be disputed.

Possibly no one at that period understood the term so clearly, profoundly and comprehensively as Castagnary, who was one of the most important critics of his time. It did nevertheless occur in the works of other writers on art.

So far as I have been able to discover, Delacroix used it in his diary notes only towards the end of his life, on the 21st October, 1860. In this passage he was speaking of Rubens and said: 'his greatest strength . . . lies in his wonderful plasticity ('saillie'), that is to say in the wonderful life of his pictures. Without this gift there can be no great artist; only the very greatest artists successfully achieved a realization of the problem of mass ('épaisseur') and of a plasticity which gives the effect of being alive.' A few lines further on he then wrote: 'Puget . . . realizes life through plasticity as no other artist has been able to do; so far as painters are concerned this is also true of Rubens'. Thus Delacroix used the world *réaliser* in a double sense, first in the meaning of 'become aware of, understand and solve' (a problem), then as substitute for 'portray convincingly' (viz. life). Without doubt these two meanings are connected: the term *réalisation* can be spread, as we see here, over a series of mental activities, of which each is an augmentation of an earlier one while those preceding it serve as prerequisites for it. The *réalisation* of anything depends on one's first becoming aware of that thing as a problem, then understanding the problem, and finally solving it; in solving it one arrives at a convincing portrayal of the task presented by the problem. Because this is so, however, the word *réalisation* contains a certain vagueness; which is exactly the impression made here by Delacroix. Later the vagueness occurs again and again, and it is created by the remarkable circumstance that the objective of the *réalisation* often enough remains in the dark or is unexpectedly altered in the very act of realization.

## The Problem of 'Realization'

With other writers of the same period the word *réaliser* soon under-
went that vulgarization and watering down which tends so easily
and quickly to afflict all terms which become fashionable. For
instance, Ernest Chesneau[14] wrote (*à propos* of Rubens) of the
'realization of his natural instinct by the hand of a master' and
Sensier[15] (*à propos* of Rousseau): 'Too excited to realize his visions
(in the course of a stroll through the forest), he was able only to
sketch a few studies and to note down some charming, fleeting
outlines with his pen'. In both these cases 'realization' means the
clear, complete and convincing portrayal of something, the creation
of a 'tangible reality', as Sensier once called finished works of art
in contrast to sketches which he defined as 'the promise and the
prologue of a great mind'[16].

As a consequence of all this it is understandable that people
began to glimpse the difficulties which underlie or can arise in the
course of fulfilment of *réalisation*. It became obvious that the academic
painters of the time were persisting in a state of complete misunder-
standing and blindness about the problem of *réalisation*; and now
their antithesis, the independent artist, came on the scene—one
without traditions, who understood the problem but who encoun-
tered enormous difficulties in solving it, because he did not possess
the means to do so.

In a poet's imagination a figure was now born, a painter, full of
high aims, who was not capable of putting convincingly on canvas
what was in his mind and—still more important—what he actually
'saw'. This painter was Frenhofer, a figure wrapped in mystery,
hero of Balzac's short story 'Le chef d'œuvre inconnu', written as
early as 1832. Frenhofer lived in a dangerous state of delusion about
the degree of his *réalisation*. His main artistic problem was plasticity
of solids and what Leonardo da Vinci called *sfumato*, i.e. surround-
ing objects with a soft misty atmosphere. His whole life long he had
struggled to portray this; now a grey-haired man, he had collated
all his experience and after ten years' labour created the work
which he himself regarded as the pinnacle of perfection in painting:
his efforts had, he believed, borne fruit. When after long hesitation
he showed the picture to two other, younger painters, they could at
first see only 'colours placed together in chaotic confusion, held
together by a mass of strange lines and forming an impenetrable
wall of painting'. Only after looking at it for a long time did one of
them remark in a corner of the picture 'a piece of foot which emerges
from this chaos of colours, shades, undifferentiated hues, a kind of

mist without shape'. Then he exclaimed: 'There is a woman underneath!' and started to explain to his friend the layers of colour 'which the old painter, thinking to improve his picture, had brushed on, one on top of the other'.

How could things have come to such a pass? How had such a state of discrepancy in perception, in recognition arisen? Frenhofer had not gone about his task in an unreasonable way. He had studied nature most intently and given deep thought to painting. He had discovered that solids are not in reality separated by lines, and had 'laid a cloud of bright, warm half-tones' over his contours 'which had the effect of making it no longer possible to point to any spot where the contours meet the background'. The painting did indeed seem 'woolly' when seen close, but if one withdrew a few steps then, Frenhofer fancied, the things depicted acquired a firm shape and stood out from one another. To *his* eyes the solids displayed complete plasticity and he believed that one could at the same time sense the atmosphere which surrounded them.

But what Frenhofer saw, or thought he saw, in his masterpiece remained invisible to others, and even to people of his own profession, who tried extremely hard to see it. Frenhofer had after all not realized the integration of solids and atmosphere in his picture. Far from achieving a 'convincing' representation, he had not even produced a recognizable one.

Here, then, Balzac, with the penetration of genius, had seized on the problem of 'realization', on its very first appearance, at its roots and at its most critical point. It was the problem of a new, completely subjective way of 'seeing' (of which Castagnary had also spoken), thought out to its conclusion, indeed taken so far that there was no longer any clearcut kind of perception common to the artist and the world around him. The new artist was forced to fall back on subjectivity in his interpretation of beauty and of form; the possibility of any sort of artistic realization depended on this subjectivity; he relied on it, had to do so. This could, however, lead to a point, as Balzac had seen, where the artist simply lost all contact with the people who looked at his works, indeed even with his own colleagues; all contact with the world's way of understanding pictorial representation. Whereas the critics of the time recognized the problems involved in achieving *réalisation*, Balzac had actually called in question its aims and object, had demonstrated that where the artist's technique was fundamentally subjective (which he represented as being the secret which Frenhofer had anxiously concealed

from everyone his whole life through) even the foundation on which to rest the *possibility* of fulfilment no longer existed; or at least, that this foundation had been greatly shaken and that it would have to be established anew under new conditions, namely by the artists themselves who would teach the public to see in their own way (something for which there was no precedent).

Balzac's Frenhofer, the first artist to undergo this terrible experience, could not survive the failure of 'realization' in his *chef d'œuvre*. The criticism of his colleagues roused him for a moment from his self-deception, but he then sank back into the delusion which had for long been haunting him, that it was envy which made other painters decide to slander his achievements. He therefore ordered them to leave his studio. When someone called there the next morning, he found the pictures destroyed and the painter dead. Balzac is silent as to how he had come to his death. Had the old man killed himself after it had finally dawned on him that he had failed? Or had death struck him while he was still unconvinced and only deeply disappointed about the recognition which had been refused to him?

The inspiration for this gloomy tale must have come to Balzac from the painters of his time. The whole story exhibits an intimate knowledge of the problems affecting the romantic painters and of their views on such points as the depiction of solids, the function of lines, and the question of light. It may be that he had been inspired by Delacroix's tragic loneliness as an artist, although as a matter of fact these two, in spite of being contemporaries, had no contact with each other. Certainly Delacroix was at that time the most obvious French artist to think of as one whose intentions might be understood and equally well misunderstood in the manner described in the story. However differently from Balzac's hero Delacroix the man had behaved, he was certainly the first painter to battle consistently with the problem of *réalisation*: the entries in his diary are evidence of this. On the other hand, Delacroix was not the only one; as he himself learned from Baudelaire, Daumier was beset by the same uncertainties and doubts[17]. But Delacroix was not yet using the expression *réalisation* for the problem in question. He used instead such words as *exécution* ('execution'), *fini* ('finished', 'concluded') and *rendu* ('rendered', 'completely fashioned'), or the verbs *achever* ('complete', 'finish') and *compléter* ('make complete', 'fulfil')[18]. While he was pondering over the difficulties which lay in these terms, or rather in the artistic processes which they denoted, all he was really doing was ventilating his problems of realization.

He was concerned to bring a composition to completion in such a way that every single item portrayed in it should possess the appropriate and necessary recognizability and detail, without losing the fire of the original inspiration and the spirit of the representation. Or, in other words, the factual details depicted should and must retain their full rôle in the construction of the picture—as patches of colour, light areas, dark areas, line formations. That is the meaning of the sentence recorded by Delacroix on the 26th October, 1853: 'A work is finished when the author has taken the necessary pains to remove from the path which he makes me follow, or from the perspective which he opens up to me, all impediments which might cause me trouble or irritate me'. Put in yet another way: a work is completed when everything which is seen in it has become *form* and has been absorbed into the *interrelationship of forms*. The difficulty of achieving this has been described once more by Delacroix[19] as follows: 'The first inspiration, the sketch, which so to speak represents the egg or the embryo of the idea, is generally far removed from perfection; you may say it contains everything, but this "everything" must first be released, unveiled ('dégagé'), which simply means that every part must be linked up (with the whole). Just what makes such a sketch the most exquisite expression of an idea is not the suppression of details but their perfect subordination to the broad outlines which are intended in the first instance to capture it (the idea). The greatest problem is then to succeed in effacing in the (finished) picture the details which, notwithstanding, actually create the composition, indeed the texture of the picture itself.' To achieve this is the 'most serious difficulty of all', even for the greatest artist: it is a task which 'demands long experience'[20], which requires 'a heart of steel', a resolution in the face of difficulties which can never be foreseen. Even at the end of his life Delacroix felt that he had not reached this goal. He lived 'in the hope of completing' and thus, he felt, he would die. It was on the 15th January, 1861, two and a half years before his death, that he recorded these thoughts, and added: 'At this moment I appreciate my own weakness and realize how many uncompleted sections, or sections which cannot be completed, are contained in the thing which a man calls a finished or completed work'.

According to Delacroix these difficulties arose from several causes. The completion of a picture was first and foremost menaced by the routine handwork entailed, but secondly by the demand for exaggerated fidelity to nature in detail.

## The Problem of 'Realization'

So far as routine was concerned, it was brush strokes which caused the trouble. Titian[21] first revealed the inimitable value of these '*touches*' for giving vitality to a picture, but later painters fell into the error of using them to create a uniform perfection and finish and a harmonious balance pleasing to the eye, for the sake of which they spoiled[22] the original idea and destroyed the air of spontaneity or 'sweet disorder' ('heureuses négligences'). Here everything depended on the placing of the patches of colour—this must not be elevated to an aim in itself, not used as an opportunity to display cleverness, not allowed to deteriorate into boring repetition. A great artist will always let us sense the warmth of his execution ('la chaleur de son exécution'), a sort of improvisation and spontaneity, but he will never let his skill intrude, or offer displays of mere show. Both elegance and pedantry impede artistic realization.

So far as fidelity to nature is concerned, on the other hand, realization can equally well be endangered by too slavish adherence to detail. 'Those who exhibit too many objects and display them all uniformly distract attention from the idea of the picture'[23]. Such artists 'do not concern themselves sufficiently with the effect made on the power of imagination by a multiplicity of details too circumstantially presented, which, even when they are true, deflect the mind from the main point, that is from the immensity or the depth, some conception of which can be given by a certain art'[24].

A decisive rôle is played here by an important yet frequently unrecognized distinction, namely that between accuracy and truth. On this point Delacroix wrote (17th October, 1853): 'Accuracy, which most men take to be the truth'. What is 'accurate' reflects what is 'real' in the mind of the ordinary man and corresponds to what is 'right' (in the judgement of the uncomprehending); truth however lies in 'the striking and the poetical aspect' of reality which the artist reveals through his imagination, whether creative or figurative (but it is always both). The 'abuse of faithfulness to detail' creates a danger to which—according to Delacroix—even the greatest artists are exposed, even Rubens whom he admired so greatly. Yet because of his outstanding power of imagination Rubens could permit himself some exaggeration in detail, without endangering the realization of the theme of his picture. As a general rule, however, it can be said that artistic truth, which is the main concern of realization, demands a sacrifice from the imitator of the real world. In order to save the spirit of artistic truth from being

206

suffocated, actual appearances must be dealt with in degrees of fulness of detail and the most important thing being depicted, that is, the one which has the most to say to the mind, must be given in exhaustive detail, while everything else must simply be indicated, each with the degree of thoroughness which corresponds to its function and its importance. Here we see a remarkable contradiction between the real world and the artist's realization, between the real thing as it is beheld and its realization through representation by the artist.

Nevertheless, even this examination does not embrace the whole compass of the problem. Rather can we say with Delacroix that realization with its potentialities and its limitations postulates two essentially different types of artistic personality, which Delacroix saw embodied in such contrasting phenomena as Shakespeare-Racine, Michelangelo-Raphael, Rubens-Poussin, Beethoven-Mozart. Those who belong to the series Shakespeare, Michelangelo, Rubens, Beethoven, with their extreme idealization and great freedom and richness of execution, are impelled to take faults, slipshodness, unevenness, indeed abnormalities, in their stride, when they want to attain the realization of their ideas in their works; those who act thus are the 'impetuous, undisciplined geniuses', 'those who obey only their instinct; . . . the people who do not guide their genius but are guided by it'. The cheerful, relaxed men, brought up in secure conventions and under lucky stars, such as Virgil, Racine, Mozart etc., 'the divine geniuses who follow only their own nature, but who also command it . . . never fall into abnormalities . . . contradictions and offensive errors'[25]. 'The beauty of their work is never accentuated by being contrasted with effects which have not succeeded in their aim'[26]. Both types of genius achieve realization, but two different kinds of it, two basic sorts which cannot be combined. One is plainly and simply perfect realization ('la forme achevée'); it is so perfect that it even presents a form of exaggeration. 'The lack of flaws and incongruities eliminates from it the spicy element ('le piquant') which one finds in those works which are full of both faults and beauties at once[27], which possess in these contrasts the perfection of a successful trial of strength.' In Delacroix's eyes, this certainly held good of modern times only, that is of art since the Renaissance. In modern art there is a great cleavage between beauty and expression. 'Antiquity is always regular, serene, perfect in its details, and its whole is virtually sublime and above all criticism,' he wrote on 24th February, 1858. It had

'restrained power and simplicity', perfect knowledge, unity and proportion, innocence and consciousness, perfected technique without exhibitionism, and it combined nobility of appearance with *pathos* in such a manner that it combined the charm of the perfect with that of the partly imperfect.

Among the 'modern' masters those who came nearest to this ideal were Titian—'whose modelling ('le rendu') is so miraculous'[28] —and after him Veronese, who attained 'the non-plus-ultra, the acme of modelling everywhere'[29]. Both possessed 'that *sangfroid*, that repose and the relaxed temperament which distinguishes those spirits who have themselves under control'[30].

These statements by Delacroix show that his view was that realization was restricted by the nature of the artist and determined by the idea of the picture, the basic elements of the first sketch; the difficulties of realization were caused by the antithesis between mind and nature, which a work of art must reconcile and which ancient art was able to eliminate entirely because in those days nature and mind were in harmony with one another, whereas in modern times such reconciliation presented almost insuperable difficulties because, in modern art, the mind had set itself the task of decomposing the natural image and of creating an abstract conception of its essence. The consequence was that the mind gained supremacy over nature and even Delacroix yielded to this supremacy. This explains why he saw realization as the antithesis of the mental asphyxiation which was produced by a slavish imitation of the real world[31].

Delacroix's ideal and model for his method of realization was the art of Rubens, rather than that of the famous Titian or the artists of antiquity who were so greatly admired and respected. The Flemish master, in contrast to other baroque painters who also worked with drafts from their imagination, revealed his design as a whole and the full *pathos* of the representation in his first sketches, but did not at that stage give his figures the lucidity of expression which is essential throughout, nor their material form, nor their objectiveness. Only in the completed picture did Rubens's mind seize hold of and transform the material to the maximum extent possible, both extensively and intensively; only then, by means of gradually developing the plasticity, the sharpness of the outline and the lighting, did he create solids possessing unity and uniformity.

There was, however, a fundamental difference between realization by Rubens and by Delacroix. Thanks to assured tradition Rubens

was quite certain what was intended by realization and what it had to achieve, for, so far as visibility, clarity and perfection of portrayal were concerned, ideas about pictures and works of art as such were still fixed in his day. For Delacroix, however, this presented a problem which he had to solve, quite alone and for himself, on the basis of his own conception of the aims of his art. And a critic writing on Delacroix's last *Salon* gives us evidence of how the solutions which he adopted were endangered, and of the serious way in which they were exposed to total misunderstanding on the part of the public. It was Jean Rousseau who wrote in *Le Figaro* of 10th May, 1859, that the pictures submitted by Delacroix showed signs of old age. 'The time is near', he said, 'when, if Delacroix does not get cured, he will wear himself out linking up shades of colour without worrying about what they may portray; he will paint bouquets in which one can no longer find flowers'[32].

The problem we now see emerging gained greatly in importance with the birth of impressionism and intruded into many passages of art criticism, chiefly as a result of the advent of *plein air* painting. This new style possessed the peculiarity that, for the first time in the history of art, artists ceased to discriminate between sketches and pictures: works which they declared were finished bore all the signs of improvisation hitherto regarded as characteristic of sketches —transient showiness, allusion and unevenness in realization.

Émile Zola, for long the protagonist of the new trend and in particular of Manet, now started to concentrate his observations on *réalisation*. The notion of realization became the touchstone of the modern movement for him and later occasioned his keenest criticism. Zola's objections are more easily understood when we remember that the style which prevailed in modern painting immediately before the emergence of impressionism was a new sort of realism and, although both subject-matter and composition were frequently of a revolutionary nature, it was at that time still usual for pictures to be filled with details true to nature. Courbet, Millet and Théodore Rousseau had reproduced their subjects with all the clarity and force that could be wished.

It was the works of Manet and of the *plein air* group around Monet which showed the sharpest cleavage with the downright kind of realization attained by this romantic realism and, in Zola's view, suffered the greatest disadvantage thereby. In 1867, it is true, he wrote of Manet's *Déjeuner sur l'herbe*[33]: '[in this picture the artist] has realized every painter's dream of placing lifesize figures in a

landscape. And we know how effectively he solved this difficult problem.' But ten years later Zola's judgement sounded a very different note. Then such pictures seemed to him entirely inadequate, precisely in their realization. They appeared to him like mere experiments, 'incomplete, illogical, exaggerated and ineffective'.

This *volte-face* arose from the fact that Zola had waited with longing for the master 'who would "realize" the *formula* of painting in light colours, boldly and powerfully, throwing caution to the winds; who would establish it firmly as it ought to be and would give it its proper position, in order that it might interpret the truth of the last phase of this century'[34]. Now he wrote: 'The great misfortune is that no painter of this group has realized the new formula with power and finality, though they all apply it, scattered throughout their works'[35]. The 'formula of painting in light colours' is actually the *style* of the impressionists, not just their technique or the fact that they restricted themselves to the phenomena of light and the light shades of colour. It is more than that, it is their artistic talent, it is their way of comprehending the real world by merely continuing to observe it, it is their abandonment of any attempt to picture what is universal. But a picture of what is universal was just what Zola felt was missing in the works of all those who made use of the new technique of light colours. That was why he criticized Manet, saying he 'realized'[36] nothing owing to his hastiness, his approximations and his lack of passion in observing nature, indeed on account of his lack of reflection. One notes the inherent contradiction between what the impressionists wanted and what Zola required in a work of art. By means of their technique they also revolutionized the construction of a picture, the concept as well as its realization; to be exact, they used and exploited this technique only because they possessed a new conception of a finished work of art. But he held fast to the traditional conceptions.

Now, among those at whom Zola was aiming when he wrote these criticisms, was Cézanne. In the very same notes for the draft of the novel called *L'Œuvre* from which the above quotations are taken, we find the assertion that Cézanne was 'un génie incomplet, sans la réalisation entière' ('an incomplete genius who does not achieve full realization'). Moreover, the hero of this book, the painter Claude, 'this tortured and incomplete genius' who committed suicide in front of his *œuvre irréalisée*, is, in Zola's own words 'a Manet, a Cézanne, more nearly Cézanne'. His most essential

characteristic is this very deficiency common to both artists. To this we must, however, add another surprising circumstance: Cézanne himself shared Zola's opinion! First, with respect to the impressionists—in his eyes they did not paint 'final', complete pictures which could satisfy themselves and all the demands of art, that is, fully 'realized' pictures. Secondly, with respect to his own art—however far Cézanne otherwise gradually dissociated himself from Zola's pronouncements on art, he did agree with him on this one point to the end of his life, with the exception of a few moments, namely that he too achieved *réalisation* only in his mind; that, like Claude in *L'Œuvre*, 'he did not succeed in bringing out the remainder, in making it stand out' ('faire sortir le reste'), he did not know how to conclude or finish ('finir')[37]. In his frequent attacks of depression he would have confirmed Zola's words about Claude, that is about his own likeness: 'Good beginnings, then suddenly a standstill, never carrying a thing to its conclusion, no perseverance, no remarkable strength'. In short, 'aucune réalisation'.

Several passages in letters reveal that Cézanne was distressed by his incapacity to 'realize'. This makes it possible to believe Émile Bernard's statement[38] that even when he was an old man Cézanne continued to identify himself with the figure of Frenhofer (Plate 34) in Balzac's short story; and that, contrary to what has hitherto been assumed, his reason for doing so was not that he agreed with his opinions on the use of lines which do not appear in nature, but that Frenhofer, like himself, failed to realize his intentions. In this respect they do in fact have a striking amount in common[39].

In spite of this there is still one radical and important difference between the two painters. If it is true that Frenhofer blurred the contours of objects until they finally ran together in a vague confusion and mist, he did start out from specific individual objects when composing a picture. But Cézanne did not do this. As he himself has said, his 'starting point was too far removed from the goal to be attained, that is to say, the portrayal of nature'[40]. So far as pictorial *completion* of the subjects depicted was concerned it was only at a fairly advanced stage that a picture by Cézanne achieved the degree of *réalisation* which is present in a mere sketch by an old master, or even by Delacroix, though it is true that at such a stage a painting by Cézanne was vastly superior to a sketch by Delacroix in its wealth of nuances and in the means used to make effects. Whereas in the work of an older master the whole concept of a picture is revealed to us from an early stage and later work on it

only serves further to enrich and refine its appearance, Cézanne introduced the concept of his pictures fully into the natural outlines there depicted only when his work was completed, and so established it firmly right in the world of nature.

Thus Cézanne's problem of *réalisation* originated in an 'ideal' (as we have shown above: genuinely metaphysical) starting point and persisted right up to the portrayal of nature. The peculiar difficulties of the task he set himself arose from this peculiarity in his methods. These difficulties were now even increased because he insisted on restricting himself to natural data as the vehicle for realizing pictorially his concepts about the existence of visible objects.

Cézanne has given us some elucidation on this point in his letters, though admittedly only in his later years. From his very incompletely preserved correspondence it appears that it was about 1896, i.e. at the stage of his development which is marked by *The Card-players*, that he first used the expression *réalisation* which Zola had brought so forcefully to the forefront in his novel *L' Œuvre*, published in 1886. From 1903 to 1906 Cézanne used the term very frequently. The problem, however, occupied him throughout his entire artistic career.

If we set aside the unreliable statements of Gasquet—which he indeed alleged came from Cézanne's letters but which deviate considerably from extant originals in their mode of expression[41]—we ultimately find that Cézanne used the term *réalisation* in three different ways. First, he employed it in accordance with normal linguistic usage when he wrote: 'J'ai réalisé quelque progrès', 'I have aimed at progress and have achieved something better than before'. Next, the word *réalisation* occurred with an 'absolute' meaning: 'ma réalisation en art'[42]: 'I believe I come nearer to it every day, even though it costs me some pains.' Thirdly: 'I am so slow in my *réalisation* and am very sorrowful about it'. In this last sentence he indicated what *réalisation* really meant without actually defining it.

We get a hint of what this is when we read in Cézanne's letters that for him the conception of *réalisation* (what was to be 'realized' in his art) was bound up with *nature*. Speaking of his efforts to overcome the difficulties of 'réalisation sur nature[43]', he said: 'in order to realize any progress there is only nature' [44], and went on: 'the obstinacy with which I pursue the *réalisation* of that part of nature which comes under our eyes and gives us the picture'[45]. Finally,

shortly before his death: 'I must therefore "realize" in the presence of nature.' And in the following words, as though he felt he must once and for all give complete expression to the thoughts of which he had already so often spoken, Cézanne described the full scope of what he intended to 'realize' in his art: 'Les esquisses, les toiles, si j'en faisais, ne seraient que des constructions d'après (nature), basées sur les moyens, les sensations et les développements suggérés par le modèle'[46] ('my sketches, my canvases, if I made any, would be merely things constructed "after" nature, based on the means, the feelings and the developments suggested (inspired) by the model'). In this not easily understood sentence I would underline the words 'constructions' ('after' nature) and 'développements' (which the model inspires in the painter). By using these expressions, Cézanne made it plain that his aim as an artist was not to reproduce the appearance of nature as perceived by the observer: it was his intention to make nature thus seen only a starting point in order to arrive at 'constructions', the architecture of pictures, in which he could 'develop' what was only suggested or hinted at in the model (nature again, as ordinarily understood).

We see that the 'realization of some progress' consisted for Cézanne in a 'realization' of nature or 'after' nature right up to the point of erecting a 'construction' which had for its part in turn to follow nature.

But, as we shall see, he expressly drew attention also to the rôle of nature in the process of 'realization'. The fundamental prerequisite for 'realization' was 'intelligent observation'[47], 'comprehension of nature through a personal temperament'[48], which entailed discovering her character, her spirit, her state of 'being' and her riches ('dégager l'esprit de la nature')[49]. Cézanne possessed this capacity in extraordinarily high degree and was moreover well aware of this. His 'sensation forte de la nature'[50] (which is far more than a mere feeling for nature) served him as criterion in comparing his own talent with that of those artists who lacked the temperament necessary to capture the essential in nature. The *sensation forte* inspired a sort of second sight in his *développements* from the model, which enabled him to perceive meaningful interrelationships between things seen, whose spiritual content he never mentioned in actual words. The *sensation forte* assured him the metaphysical vision described above. Through it, all that exists in the world was stripped of its liability to be changed by the passing of time and was elevated into a higher state of permanency, of harmony, of

maintenance and preservation, a state in which things (imprisoned in certain forms) were transformed and in which they overcame and survived their transience in uneventfulness. This view of the world acquired by Cézanne through the 'emotion of nature'[51] furnished him with the plans, the designs, for the architecture of his pictures.

After these, the next stage was *réalisation* of individual forms, of trees and mountains, hills and houses, water and clouds, of fruits and the limbs of human beings, by selecting from the changing appearances which they offered to the eye those impressions which fitted in with the plastic values and colour scales, shadow-paths and distribution of mass in the structure as a whole. The shapes of separate objects had to evolve *within* these basic patterns. In other words the painter wanted to illustrate the permanent, unalterable relationships which persist in the world through loneliness and timelessness, and to demonstrate the stability of their existence: to do this he had to relate them in a recognizable way to the real world as ordinarily understood, to the shapes of objects which are perishable and subject to change. For what Cézanne aimed to do was to state a truth about that world which lies always around man, and not just about his own subjective feelings or experiences. In order to do this, therefore, he had to include representations of the real world within his portrayal of the truth. Let me stress once more that this did not mean that he had to add to his conception as a whole by painting in details as true to nature as possible or reproducing objects exactly as they strike the eye of the ordinary person looking at them in the everyday world. 'Realization' did not depend on precise reproduction of things but on bringing out their significance. This Cézanne could do only if he made the objects which he was depicting stand out from the outlines which indicated their mere presence and develop into manifestations of functional existence within the picture which he had previously established as a whole. So he had to make objects evolve out of the general framework of a picture up to a point where they were recognizable in the normal way, to build them up from fragments of objects emerging from the overall structure, until they were nearly enough complete to be—even as separate items—endowed with the power of creating an effect within the conception as a whole.

To that extent Cézanne used nature both to draft a 'study' (his own expression) as an 'idea' and to 'realize' it, in one and the same process. Because of the fundamental conception of the world on

which he based his art, it was essential for him not only to portray the unshakeable structural harmony of the whole in his completed pictures, but also to make the individual objects depicted in them appear to signify something 'lasting' and 'indestructible'.

Rilke correctly perceived this remarkable characteristic of Cézanne's art when he wrote as early as 1907 that in Cézanne's paintings the main purpose was 'the production of something which carried conviction, the process of making a thing "become" a thing, the reality which, by his own experience of an object, was intensified until it became indestructible'. But this was not the ultimate aim of Cézanne's art, it was only one among other things which served the object of expressing his metaphysical conception of nature as a symbol of permanence, of harmony, of victory over transience. That is why the truth of the real world as portrayed by Cézanne, 'intensified into something indestructible', surpasses by an infinite amount the everyday real world.

But there is still a third way in which nature played a part in Cézanne's method of creating pictures: it was from nature that he acquired the *means* of realization; that is, from the colours of natural phenomena. These follow certain rules, and in Cézanne's view a painter should realize his aims simply and solely by means of the changing interrelationships of colours in solids. These are the means which the model offers the painter, and they are the underlying cause of the fact that 'reading and its realization often come very slowly to the artist'[52].

Now we come up against the point out of which Cézanne's own particular difficulties in realization arose. He was forever complaining about how difficult he found it to capture those media which had to be observed in nature herself. It seemed as though nature had deliberately opposed his mode of action: how could it be otherwise? It was only during and through the execution of his pictures that the concept of true nature, which was Cézanne's point of departure, was visualized: it could therefore provide him only with the principle but not the means in detail for his representations (unlike for example Michelangelo and all artists who worked towards an *ideal* and who found the formal means for portraying nature ready-made in their conception of the *pathos*, greatness, beauty and tragedy of the human form—the idealized physiognomy of nature). Ideas came to Cézanne 'in the presence of nature' and 'from nature' according to the circumstances, but at the precise moment when they entered his head they were not

contained in any distinct forms—they consisted only of the general principle of representing 'existing together', mutual obligation and mutual support. Once more there was no other medium than nature through which to 'realize' this conception of 'being' in nature in a particular motif in a picture. 'For progress in realization there is only nature and the eye develops in contact with her.'[53]

Nature, however, offered the painter nothing save *shades of colour*, neither lines nor pure black and white effects, nor dark and light effects, but only the repeatedly quoted *sensations colorantes*. Cézanne felt himself most strictly bound by this fact.

Yet certain of his pictures do undeniably contain lines and a considerable number of drawings by his hand are in existence. True, the function of these lines is first and foremost to create dark areas. We must therefore first be clear about the relation of line to colour in Cézanne's works before we can properly understand the third aspect of nature's rôle in his process of realization.

From a historical point of view, the origin of Cézanne's assumption that coloration is all that our eyes are capable of seeing in the real world lies in the generation of romantics who preceded him. Burger-Thoré wrote in 1847[54]: 'Lines or drawings serve no other purpose than that of holding colours together, enclosing their harmonies. One might even say that the line in painting is only an abstraction; it does not exist; one assumes it between two different colours as one assumes it between two solids in nature'. Gautier[55] said: 'At the outset in painting there stands a lie, for in nature there are no lines. Contours dissolve into one another, the line does not exist'. Delacroix noted that lines do not occur in nature and exist only in the minds of men. Vasari too had already made this last point[56]. And all the impressionists denied the existence of the line in nature as seen by man. Baudelaire[57] went deeper than all of these when he said: 'In nature there is neither line nor colour. Both are abstractions, which owe their nobility to the same source. In both cases nature is only the stimulus'. This conception is all the truer because it embraces both the classical and the romantic method of representing the real world, and asserts the relativity of both conceptions, namely their dependence on the universal and metaphysical analysis of what is real. Whether an artist sees lines or colours or both in nature and uses them in his creations, depends entirely on his attitude to the real world, on the significance which he attributes to it. If Burger-Thoré, Gautier and Delacroix regarded only colours as real, and the line as an abstraction, this arose from

the fact that they had a romantic attitude towards the world and perceived the interrelationship of things seen in an atmosphere of colour (though not the isolation of objects in plastic distinctness), yet at the same time felt that life and movement, expressed directly by lines, were something entirely intellectual. If on the other hand Vasari extolled the intellectual origin of the line before these three did so then it was because he insisted that works of art should be regarded as intellectual creations (and not as imitations of nature), and considered that drawing was the core, the source and the pattern for all the visual arts, in which ideal proportions—for figures, for space and for planes alike—could be represented. Balzac's Frenhofer was of course also seen as a romantic artist, though he wore a costume of the seventeenth century. Like Gautier he stood for the view that outlines are blurred in nature; in his pictures he would suffer no lines, on the grounds that the sun disintegrates the outlines of objects.

Cézanne had, however, his own reasons for his views. These did not originate in a conception of nature which was romantic or impressionistic (interested only in shades of colour) but sprang from his personal notion of *the One which is permanent in the changing world*, which he saw in every object of the real world and its relationship to the world around it. In order to represent this pictorially he needed one single and uniform means of expression, one which would not have a tendency towards separation and movement as a line does, but the very opposite—the one most able to combine things and immobilize them. Only colour could provide this, for all its variations could be presented as degrees of *one single* coloration[58].

If then Cézanne was to continue to dispense with the line as a means of realization in his work, this did not in any way mean that he excluded the effect which is obtained in other painters' works by lines sharply defining objects in a finished picture. The logical use of colour, according to a frequently quoted statement of the master, ought to emphasize the drawing, that is to say, produce a form as exact as other painters achieve with lines. Actually Cézanne does accomplish this through his use of colours[59]. If one takes a number of Cézanne's pictures which have been carried to different stages of completion and sets them side by side, it becomes evident that both the distinctness of the plastic forms and the firmness of the picture increase in proportion to the painter's increasing skill. Starting out from being merely spotty and undefined, the surface gradually becomes more and more covered

with colours and thereby consolidated into a picture; then objects become distinguishable and recognizable by being more and more closely and firmly linked to one another and so by this process there is a progressive development towards complete modelling and clear definition; the beholder is finally presented with the alternatives which nature herself offers: he can either fix his eye on one small section of the picture, in which case he will see merely spots of colour; or he can let his eye rove over larger sections of the canvas when he receives in addition an impression of lines on the bounding limits of the object—created by means of a series of particles of colour placed very close to one another (close in the chromatic sense). Since these lines are created only by the beholder's process of perception and are not introduced by the artist as a particular method of achieving his design, they dispense with the expressiveness which can normally be observed in the work of artists who use actual lines; they are, to use Fritz Novotny's words, 'without tension, dead' (in the electrical sense). It is wrong, however, to evaluate these images by the standards of ordinary lines; they are not afflicted by any such deficiency as the expression 'without tension' might lead one to assume. They are perfectly adequate for the rôle allotted to them and their so-called 'absence of tension' is a positive quality, the consequence of an inevitability to which they have been submitted. Indeed, if they did possess tension they would immediately suggest isolation and movement, which would be contrary to what Cézanne intended in his pictures.

In the same way, Cézanne's artistic intentions explain his 'jerky and frequently fragmentary handling of lines' or, to put it more accurately, the impression that there is such a handling of lines. In order to avoid the effect of movement given by flowing, continuous lines, Cézanne permitted the patches of colour in the areas at the edges of objects to amalgamate only here and there so as to create the effect of a closed line.

However, those fragments of lines which one does find in his pictures—drawn then in an absolutely normal manner in *one* movement—do not belong to the completely realized picture, but are merely the painter's notes, needed in the course of his work. They are intended to disappear in the final realization. But they do not even pertain to the fulfilment of the realization itself; they are not a part of the building, but of the framework and at that of an internal framework which, when the building is completed, will be covered up.

Countless auxiliary lines of this sort can be found in Cézanne's numerous unfinished pictures, and they greatly detract from their effect, as one can see by comparing these pictures with any of his completely realized works. But there are even instances where one and the same painting contains parts in which both subject and form have been worked on until they have attained the utmost richness of appearance and the fullest resonance, while side by side with these there are lines, the temporary character of which is thereby all the more plainly revealed. Wherever such lines still survive, the degree of realization is always less, i.e. the continuity of volume, space and plane is not developed to its conclusion. This defect becomes noticeable in a specially insistent way in the very complex late works, as for example in the portrait of old Vallier (V.718, Plate 36). In that picture Cézanne added lines at various points where layers of paint already existed. This proves, as can indeed be observed in other pictures, that he did not start out from some scaffolding of lines established in advance, but only reached the point of drawing in strokes when he was in the midst of the work. Yet, what is still more important is that here (as also elsewhere) none of these strokes forms a part of the design (= 'realization'): each single one is simply a pointer to some special problem of colour and form, the solution of which Cézanne did not ever reveal to us and which is therefore fully intelligible only to the master himself; for us, however, it is actually a pointer to some weakness in the composition as a whole.

'Le dessin n'est que la configuration de ce que vous voyez', Cézanne once wrote[60] ('A drawing is *only* the outer figuration of what one sees'). This remark, of which little note has been taken, is a declaration that he did not regard the linear structure as a part of the realization of the image of the real world in a work of art, because he held that realization aimed directly at the inner structure, the metaphysical meaning of the outward appearances of things seen.

But what, after all that, is then the significance of those pencil drawings of Cézanne's which were not intended as preparatory sketches for paintings? What of those reproductions of sculptures in the Louvre (and more rarely of single figures from paintings) to which Cézanne is alleged by Vollard to have attributed very great importance and which remind us in such a startling way of the exercises of Academy pupils copying examples of the plastic art of

the ancients? Of course, so far as form is concerned, they have nothing in common with such copy drawings of ideal examples. How then did they serve Cézanne? For what purpose did he undertake them? The explanation for these curious studies is surely to be found in the fact that, according to Cézanne's theory, the colourlessness of sculpture was in keeping with the potentialities of black and white drawing. Larguier has recorded the following statement by Cézanne: 'Drawing is' (by this he means presents or signifies) 'a relationship of opposites or simply the relationship between two shades, namely white and black'. Such a vague statement certainly sounds like Cézanne and it is probably a genuine quotation. In saying this Cézanne was declaring that drawing was capable only of reproducing the relationship between lightness and darkness, and between light and shadow on solids. Therefore properly speaking a colourless or a monochrome solid was the only subject suited to the medium and the potentialities of the art of drawing. With such a solid the draughtsman does not need to leave colour out, to occupy himself with any abstractions. However, as we have shown earlier, Cézanne's primary interest as a painter was now directed towards shadows, not only towards the shadows of solids which emphasized the plasticity of appearances, but also towards the associations between different solids through shadows, on which he constructed his compositions. He made drawings of plastics in the Louvre therefore, because he wanted to make an intensive study of the shadows cast by solid bodies, and he studied the shadows introduced by other artists into their compositions in their relationship to the bright areas on objects, because he wanted to record them for himself and to learn from them. The technique of his drawings confirms that he really proceeded in the manner he had described. He drew shadows (blackness), and placed lines, only where their blackness corresponded to something dark in real things. That is why he did not trouble about contours at all, but instead interrupted his strokes whenever he came to a light part in the outline of a solid (Plate 35); he had therefore not the slightest interest either in creating a beautiful flowing line or in preserving its integrity—on the contrary, he treated lines as if they had no right to an existence (i.e. their own linear existence) at all, broadening them and narrowing them in order to make them correspond with the way in which the shaded areas extended. He also distinguished carefully between hard and soft, sharply defined and softly blurred dark areas. But that was all. The material aspect of matter

did not exist for him; no more did the constituent elements of physical formations set in front of his very eyes. In lighter parts, where the gradations of shadow are gradually extinguished, he left the white paper as it was, bare, not caring whether some further image was formed here to be looked at or not. Any other artist would have inserted the necessary strokes at this point from memory or imagination; Cézanne did not do so. On the other hand he always 'composed' with dark areas, even when he was merely drawing. He applied his strokes and gave them direction in a visible relationship to the surface of the paper.

Cézanne used exactly the same procedure in his drawings from nature; in them he made use of strokes as un-linear (and also as un-pictorial) as possible, employing them as a means of representing dark forms, as a substitute for the shadow-colours in their 'existing together', immobile, expressionless and regardless of the actual potentialities of the lines. This can be seen exceptionally well in the sketch books recently* published[61] in facsimile, for example in the many landscape studies of L'Estaque (Plate 35). Here we can trace how in drafting a picture motif Cézanne composed on a foundation of shadows, starting out from shadows which either were formed at the edges of objects or themselves created isolated dark patches. In the first case the shadow-paths (the black areas) do indeed resemble what is usually called contour, but it is evident from their changing breadth and the breaks in them that they are not to be seen as bounding lines but as planes indicating forms. In the second case, where it is a question of isolated formations of patches scattered over the surface of the picture (these are particularly easy to see in the sections with trees), the meaning is still more readily recognizable; these patches are simply nothing but darkness and often actually formless. There no part of a line has a value of its own and no line as such has any function; only to the extent that it stands for darkness or represents a plane, is it a substitute for colour.

The very construction of Cézanne's drawings, the manner in which he drew strokes from which all the character and beauty of individual lines was eliminated, is further confirmation of the theory that colour was the only medium he took into consideration for the 'realization' of his paintings. It is true that he found it difficult to 'observe' in the real world colour phenomena which

* 1951.

would simultaneously make forms clear, but that was because of the need to select from his observations what would serve his general idea of representation of nature. He had to discover colour sequences in the objects before his eyes, which would enable him to 'compose' these objects as an indissoluble unit 'standing together'. For this purpose colour impressions picked up haphazardly could serve no purpose at all; equally useless were those, for example, which embodied the most attractive aspects of different objects. Instead he had to take certain (deep) shades of colour in the motif as the basis for his observations; he had to find their equivalents on his palette; and once he had set down these basic shades of colour he had to contemplate the objects of the real world in relation to them until they yielded a foundation, a starting point from which he could settle further shades of colour to be used to depict further facts of the real world. Between the areas of colour originally fixed and all later ones however, there must reign that rightness of relationship which Cézanne has called 'logic' of colour; an association had to be produced which corresponded to that of a musical scale. It required the greatest pains to discover those shades of colour in nature which would fit in to a series of tones in a picture without endangering their stability as a whole, once the keynote which laid the foundation had been given. What a great influence this principle had on Cézanne's observations of his *sensations colorantes* is proved by the colour juxtapositions in his pictures, 'unnatural' in relation to the normal external appearance of objects. For Cézanne was creative and entirely original even in the manner in which he 'observed' and in this particular field he surpassed all the painters of his time.

The whole of what Cézanne aimed to accomplish through his artistic endeavours is contained in the term *réalisation*, as he understood it, and in it nature played a triple rôle—constituting the source (something absolutely true), setting the aim (something existing objectively), and affording the means for the representation (something seen in colour). This can be expressed in another way thus: Cézanne directed his efforts towards extracting from the real world as his eyes saw it all the means for representation needed to make a lively pictorial reproduction of those chosen objects in which (each in its own way) the interrelationship, the 'existing together' of a world had been revealed to him. He sought to make a complete revelation of this overall interrelationship itself, the essence of nature;

side by side with this he wanted at the same time to portray each of the single objects seen in nature, illustrating the striking objectivity which they necessarily possess within this interrelationship to the exclusion of all other attributes.

In this analysis of his art we have now established clearly all the factors in Cézanne's technique of realization. But one thing still remains indefinite, namely the relationship to truth brought about by such a (successful) realization, since this whole thing is inseparable from and depends on the experience of this man with his personal, lonely, individualistic temperament, who was no longer sustained by any general feeling that the world understood him. Did *réalisation* actually take place with Cézanne? Did something 'become' real, something which exists in truth and which is true, simply because it conforms to reality? To put this another way, do Cézanne's 'realized' pictures give expression to an understanding of the world which corresponds to reality? And do we see him on the path towards such a correspondence in those of his works which are not completely 'realized'? To pose the question in still another form: was his personality, his nature, such that it put him directly on to the trail of truth? And do his conceptions of the 'standing together' and 'existing together' of objects in relation to a world give expression to an understanding of the true condition of the world?

We shall not find the reply to these questions by looking at them from the standpoint of commonplace and utilitarian experience, for that is the very viewpoint from which the reality of the world is concealed. The artist must, Cézanne himself declared[62], actually penetrate the outward appearance of ordinary reality. 'One cannot be too scrupulous, too sincere or too humble before nature; but one is more or less master of one's model and above all of one's means of expression. One must penetrate what is in front of one and persevere in expressing one's self as logically as possible.' What he meant by 'penetration' of objects in painting (which is, after all, *portraying* these objects) we can infer from a note of Delacroix's[63]. He says: 'One enjoys the actual representation of objects . . . and at the same time one is animated and exalted by the significance which the representations contain for the spirit. These figures, these objects, which seem to a part of our spiritual being to be the heart of the matter itself, seem (simultaneously) like a firm bridge on which imagination relies in order to *penetrate* to that mysterious and deep sensation of which the forms are in a certain sense the

symbol (hieroglyph), but a symbol which speaks quite differently from a cold representation', that is to say, a mere reproduction of commonplace reality. For truth is never attained through rightness (accuracy), the kind of correspondence between an artist's statement, a configuration, and an isolated fact of experience, which can be verified by non-artistic means. Truth is here simply wholeness itself, what is universally valid in the most comprehensive sense, what brings details to view in a hitherto unknown manner. When an artist is working he must, as Delacroix continually stressed, consider reality—and the meticulous detail appropriate to it and the fact that everything real has equal finality—only as a frontier in relation to truth, which one does not cross because one wishes to be certain of not bringing forth monstrosities; but, apart from that, reality is sacrificed in order that the truth may become apparent.

Inadequate as ordinary experience may be, a purely *aesthetic* standpoint is no more helpful here: enjoyment of nature and self-enjoyment, the outward appearance of beautiful nature living in harmony with itself, in which the impressionists were absorbed; none of these leads to the real essence of nature. On the contrary, as they deal exclusively with the outward appearances of transitory nature, which perishes in the atmosphere and the sun, they explicitly ignore *things* as they really are. Impressionism is therefore not the point from which to start to form a judgement of the truth of Cézanne's art.

On the other hand it is equally impossible to utilize *typical* nature for this purpose, as most artists prefer to do, for it defines every being as an unchangeable once-and-for-all thing and mirrors what has been shaped by fate, the natural forms which have emerged from the struggle for existence.

To sum up: in seeking to judge how much truth is contained in Cézanne's portrayal of nature, it is wrong to examine how far his vision corresponds to nature regarded as something commonplace and utilitarian or seen as something beautiful or typical. Does it then correspond to nothing at all? What is to be the criterion for our judgement?

It is the fact that with Cézanne realization is revealed through beauty, that in every single picture nature is projected ('constructed', says Cézanne) as something whole, that out of this whole the parts are evolved, that this whole dissolves harmoniously into its parts and yet itself continues to exist in the harmony between the initial

whole, and the end, i.e. the objects evolved to the point of perfect objectiveness. The naturally beautiful plays a small enough rôle in Cézanne's art, yet the artistic beauty of his work—the harmony and melody evolved through the medium of configuration alone— is strong; that is to say, in terms appropriate to painting, the beauty of the organization of solids and space and the beauty of ornamentation of the surface. With Cézanne these two forms of beauty are fully integrated and permeate one another; they are, however, at one and the same time the covering up and the uncovering of the triple aspects of 'realized' nature. Indeed, they are so to such an extent that nothing of them survives separately with an independent existence.

There are two statements which throw further light on this point. First, one by Renoir who said something like this: if Cézanne just places two spots of colour on a piece of paper this may be merely a beginning but it is already to some extent a work of art. Then there is Cézanne's own statement, that he had to make use of every expedient in order not to lose a harmony in the course of his work once the keynote had been given. From both these statements we can deduce that the artistic and the beautiful were merged for Cézanne respectively in a vision of nature 'existing' and nature 'being preserved by the standing together of things'. The first spots of colour (misunderstood as abstract) which he placed on a canvas or a piece of paper concern nature alone and emphatically not the formation of single objects. That artistic, harmonious beginning which Renoir noted is simply and solely the foundation for the 'standing together' of things, not the reproduction of any parts of the things themselves. In that this beginning turned out to be beautiful every time without exception, Renoir's statement about its beauty being already contained in it at its origin is proved to be true. As, however, this same beauty is preserved in Cézanne's pictures throughout the whole process of creation, in all the phases of realization right to its fulfilment, the fully realized work has also the quality of being true. As for the separate objects depicted in Cézanne's paintings, one can say that in the process of giving truth a form their everyday outlines are, as it were, burned in fire, and out of the fire of truth the objects emerge in new form, which, though recognizable, yet at the same time bears witness to this truth, and therefore appears 'deformed, distorted' to the ordinary mind. In a great part of the process of realization Cézanne's concern is to preserve the recognizability of objects while at the same time

the act of creating them serves in representing true nature; that is, serves what *remains* permanently behind the becoming, expiring and resurrection, the 'being' which Goethe has said is eternal.

It is this truth-content of Cézanne's pictures which has the effect of challenging us with such enormous force as the works of only a few other (very great) masters exhibit. Quite inexorably Cézanne's works elude all attempts to use them for decoration or ornament, indeed they withdraw from the very room in which they are housed, by reducing to vanishing point the effect of the space which surrounds them. They demand the right to dominate and they do dominate absolutely, merely in order that they may speak out. The voice in which they speak out, its revealing quietness, is, however, so strong that it forces the observer into silence. This can be illustrated in a moment simply by considering the very different effect created by, for example, the pictures of Van Gogh and again in a different way those of Renoir and Monet; their works are useful to a room, because they enliven it and fill it with their vitality, their lamentations or their outbursts of joy. Even Corot portrays a quietness in his pictures which is quite different from that of Cézanne—the former charms, the latter reveals—but we must not overlook the fact that this phenomenon of quietness creates a bond running from Corot to Cézanne and that indeed a formal expression of this link between them can actually be found here and there in a sort of kinship between their ways of constructing pictures.

### NOTES (CHAPTER IV)

1. *Cézanne, son art—son œuvre*, Introduction, p. 49. Paris, 1936.
2. Ibid., p. 43.
3. In the Introduction to *Dessins de Paul Cézanne*, p. 6, Paris, 1938.
4. 'Un mot sur le terme "réaliser". Dans l'ensemble d'une composition Cézanne laissait son caractère particulier à chaque aspect de la nature, tout en soulignant la façon dont sa sensibilité s'en trouvait affectée. Il s'efforçait de peindre la vision qui résultait à la fois de ses impressions visuelles et de la logique de son imagination. Réussir à rendre pleinement cette vision c'était le sens du mot réaliser.'
5. *Souvenirs sur Théodore Rousseau*, Paris, 1872.
6. *Journal*, 13th January, 1857.
7. *Morale du joujou* in *L'Art romantique*, p. 143.
8. *Michelangelo, Beiträge*, p. 382, Leipzig, 1900.
9. Ibid., p. 393.
10. *Journal*, 9th May, 1853.
11. Op. cit., pp. 8–9, Paris, 1858.
12. Ibid.
13. Ibid.
14. *La Peinture française au 19e siècle, Les Chefs d'École*, p. 142, Paris, 1862.
15. *Souvenirs sur Théodore Rousseau*, p. 52, Paris, 1872.
16. Ibid., p. 79.

# Notes

17. *Journal*, 5th February, 1849.
18. Another example of the same problem can be found in a letter from Jules Dupré to Théodore Rousseau, dated 14th July, 1842: 'I find it impossible to finish my pictures, however hard I try to bring them to an end. What a hard thing an ending is!' ('Les tableaux sont interminables, quelque acharné que je sois à vouloir les finir. Quelle dure chose que la fin!'). Quoted by Alfred Sensier in *Souvenirs sur Th. Rousseau*, p. 138, Paris, 1872.
19. *Journal*, 23rd April, 1854.
20. Ibid., 1st March, 1859.
21. Ibid., 1st January, 1857. 'Titian introduced that breadth of execution which he applied equally to figures and to robes—it is the acme of painting.'
22. *Journal*, 18th April, 1853.
23. Ibid., 13th January, 1857. *Notes pour un Dictionnaire des Beaux-Arts*, article on: 'Mer, Marines'.
24. Ibid.
25. Ibid., 10th June, 1856.
26. Ibid., 20th April, 1853.
27. Ibid., 24th December, 1853.
28. Ibid., 1st January, 1857.
29. 28th April, 1853.
30. Ibid., 23rd January, 1857. *Notes pour un Dictionnaire des Beaux-Arts*, article on: 'Antique'.
31. The fact that he recognized this problem and mastered it is what made Delacroix as an artist so vastly superior to Géricault and historically so far 'in advance' of his time, for Géricault, as Gautier very rightly remarked ('Études sur les musées', 1850, reprinted in *Tableaux à la plume*, p. 45, Paris 1880) was still devoted to 'le culte du morceau rendu', which often 'carried him away beyond expression and propriety.'
32. According to Maurice Tourneux, *Eugène Delacroix devant ses contemporains*, p. 102, Paris, 1866.
33. In 'Édouard Manet', reprinted in *Mes Haines*.
34. Zola, *L'Œuvre*, p. 269, Calman-Levy edition.
35. Preliminary notes to *L'Œuvre*, 1879.
36. Ibid.
37. *L'Œuvre*.
38. Émile Bernard, *Souvenirs sur Paul Cézanne*, p. 44, Paris, 1924.
39. It would seem that Cézanne's great interest in the history of the unfortunate Frenhofer can be confirmed by a hitherto unexplained drawing. It is probable that V.1575 (Basle Museum) depicts the scene where Frenhofer shows the picture with the female figure to the boy Poussin.
40. Cf. John Rewald, *Correspondance*, p. 140 (the year 1878).
41. *Correspondance de Cézanne*, p. 306.
42. *Correspondance*, pp. 257 and 295.
43. Ibid., p. 258.
44. Ibid., p. 265.
45. Ibid., p. 276.
46. Ibid., p. 297.
47. Ibid., p. 261.
48. Ibid., p. 275.
49. Ibid., p. 288.
50. Ibid., p. 258.
51. Ibid., p. 289.
52. 'La lecture et sa réalisation est quelquefois très lente à venir pour l'artiste.' *Correspondance*, p. 267.
53. Ibid., p. 265.
54. *Salon de 1847*, p. 119.
55. *L'Art moderne*, p. 140, Paris, 1865.
56. *Della Pittura*, Cap. I: Il disegno, padre delle tre arti nostre, Architettura, Scultura e Pittura, procedendo dall' intelletto . . .

# *Notes*

57. *L'Œuvre et la vie d'Eugène Delacroix*, 1863, in *L'Art romantique*, pp. 17/18.
58. In the spectrum, from yellow to green, blue, violet, red, orange and back to yellow.
59. Rather surprisingly, we find that Gautier had already described this method (in *L'Art moderne*, p. 143, Paris, 1856): 'Even if one develops solids from the centres outwards' (in accordance with the procedure of Gros, Géricault and Delacroix) and 'even if one avoids using any kind of line at all, one yet achieves a concealed drawing which is not any the less real.'
60. *Correspondance*, p. 268.
61. *Paul Cézanne, Carnets de Dessins*, by John Rewald, Paris, 1951 and *Paul Cézanne, Sketch Book*, owned by the Art Institute of Chicago, published by Curt Valentin, New York, 1951.
62. Letter to Émile Bernard dated 26th May, 1904.
63. *Journal*, 20th October, 1853.

# CHAPTER V

# Cézanne's Historical Position and Significance

*'Y a-t-il encore quelque chose à dire sur Cézanne? Tout le monde connaît . . . et malgré tout, Cézanne reste un auteur difficile . . . Peut-être qu'au lieu de le considérer comme un phénomène unique dans l'histoire, il est possible de le mieux situer dans son temps, et même de le rattacher au passé.'*

*Maurice Denis, 'L'Aventure posthume de Cézanne' in: Prométhée (L'Amour de l'Art, Nouvelle Série) VI, 1939.*

No appreciation of Cézanne's historical position and significance is possible unless one first establishes what are the problems involved and the factors which have to be taken into account. For this purpose one must see how his art fits into the framework of the artistic aspirations of his time and how it is linked with the past. The *influence* which his art had on others is already part of the history of another period—that which followed him and to which he led up; only those who have been subjected to it have the right to pass historical judgement on that influence.

However, we cannot form an appreciation of the relevance of Cézanne's art to its historical setting merely by examining what he derived from, or how he reacted to, the influence which contemporary trends in painting or the practices of individual painters had on him; this is something which goes deeper than that, embracing, based on, and meaning the status and individuality of his art in relation to his time as a whole and to the intellectual attitudes of his time, which in turn must be seen as being determined by history and significant for history.

To categorize his work as partly romantic, partly classical, or to explain that it is either impressionist or post-impressionist, is com-

pletely to miss the point, because this fails to bring out what is historical about Cézanne's art. Labels of this kind, used for purposes of history, are misleading, because such terms are superficial and do not probe the deeper level of influence exercised by the intellectual trends of his period in history on Cézanne's art. It is, however, precisely the historical position and significance of these intellectual trends which matters here. Closely bound up with the main stream of development in French painting, they fit into the grand context which spans so many centuries. For the art of Cézanne was not a simple continuation of what had been created before him; it reacted towards earlier art and reacted against many contemporary tendencies: that is what made it revolutionary.

Cézanne's own writings serve as a guide to our historical investigations. From them it is clear that Delacroix and Poussin were the two masters whose lead he chiefly followed and whom he regarded as determinative models. We deduce from Cézanne's paintings that what he regarded as important in these artists was not so much their personal style as the attitude of mind, with its historical significance, revealed in the general structure of their work. His works do not on superficial examination resemble those of either Delacroix or Poussin. It is true that some reflection quickly establishes a link between Cézanne's colour modulations and Delacroix's colorization and between Cézanne's method of organizing a composition out of solids 'standing together and giving each other mutual support' and Poussin's 'orderly art' (Carl Justi) with its unshakeable interrelationships. But this is not indeed enough to make any detailed connexion between him and the two masters at all clear nor to explain how it was possible for him to owe an obligation to both of these models who were so diametrically opposed to one another.

It is a striking, indeed curious fact, that in this conception of his art there is no mention of three other artists who patently and without a shadow of doubt strongly influenced the form of Cézanne's work, namely Courbet, Manet and Pissarro. Moreover, it does not seem to be a simple matter to see how their influence fits into a historical field which ranged from Poussin to Delacroix, since they in turn have each quite different historical associations.

There are, therefore, two types of questions to be asked. First: what is the relationship of Cézanne's art to realism and impressionism? Secondly: what is its position in relation to the principles and methods represented by Poussin and Delacroix, which are

arbitrarily referred to under the titles 'classicism' and 'romanticism' and are yet by no means so radically opposed as these two descriptions imply? Finally: since the art of Cézanne obviously represents a synthesis of these two tendencies, how and in what way is it to be differentiated from all other combinations of these two conceptions of art already attempted before his time?

Now it is true that something is said about these problems in every book of any size written about Cézanne. Yet nowhere have they been thoroughly examined in all their ramifications. Only Friedrich Rintelen and Karl von Tolnay have made Cézanne's historical position the subject of an independent study[1].

In the case of Rintelen the study consists of a lecture given in the period before the first world war. It is therefore worth pondering over because it shows how this keen observer, who did so much research 'into the mind of man which seeks knowledge and puts things into artistic form', was already, only ten years after Cézanne's death, busy trying to range the artist's work into its historical context, and so to understand it, though he had only just experienced its revelation. Yet the historical sketch which this author gave occupied no more than a mere ten printed quarto sheets. He started by drawing attention to the loneliness and isolation which Cézanne needed in order to create his work, then he placed Cézanne, who in his youth was a friend of Émile Zola, among the impressionists, naturalists and colourists, whose aims are usually 'stamped with the name of Manet'. Yet it was already plain to Rintelen that 'Cézanne kept at a distance from Manet', 'seems to have feared and avoided him'. Then follows a brief description of the impressionists and their aims: 'an understanding of the colour of light, the purity of colour, the clearness of the relationship between colours, the multiplicity of shades of colour in light and in shadow, the uninhibited vision of nature, with no appearance of striving after atmosphere', which had become important for Cézanne. Yet, he continues, Cézanne took up an attitude of opposition towards the impressionists' ideas, their lack of style, of seriousness, of energy, of 'what is significant for mankind'. In his striving after higher things Cézanne was assisted by the romantics, particularly Delacroix and Daumier, but ultimately he turned to the classicism of Poussin as well.

So Rintelen actually touched on almost all the essential historical factors which determined the development of Cézanne's art, yet he left them high and dry and failed to link them up. The excellent

general analysis of the style of Cézanne's art with which his lecture ended contained scarcely any indication of the historical influences surrounding his painting. He gave no explanation for the change in his manner of painting which was the result of inner experiences, nor did he make a correct assessment of the rôle which external influences played in Cézanne's development. All he stated was that the impressionists' colour and their exploitation of tones of colour laid the foundation for Cézanne's representation of space from which he then changed over to something absolutely new, leading to his use of tones of colour as a means of creating plastic figures 'of a truly cubic illusion'.

Tolnay's treatise, which in important passages corroborates Novotny's essay *Das Problem des Menschen Cézanne im Verhältnis zu seiner Kunst* ('The problem of Cézanne the man in relation to his art') (1932), is concerned only with the relationship of Cézanne's art to impressionism—his formulation of the question goes no further. The conclusion at which he arrives is paradoxical and at the same time unsatisfactory. Tolnay says: 'Cézanne emerged as an opponent of impressionism from the very outset. Yet his artistic victory over impressionism does not signify the expression of some new phase of intellectual evolution, but simply the incarnation of the intellectuality of the last quarter of the nineteenth century'. Further: 'Cézanne's historical significance does not lie in the fact that he won a victory over his generation but in the fact that he extracted the utmost from the slumbering potentialities of his generation'.

Pronouncements of this sort signify little in the context of serious and scientific historical research. Cézanne, who was neither a 'victor' over impressionism nor an impressionist, was also not, as Tolnay opines, a link in the chain of painters who produced 'polychrome atmospheric colorization', those artists from the eighteenth century onwards whose works were 'based on an enhanced sensibility for colour values' and who 'combined Veneto-Flemish polychromatism with Dutch atmospheric tonality'. Admittedly Cézanne had a greatly enhanced sensibility for colour values, yet this served him, as I have shown, in solving an intellectual problem of which neither the Venetian nor the Flemish polychromists nor the Dutch tone-painters had an inkling; nor indeed the colourists of the eighteenth century either. From a historical point of view Cézanne had no connexion with these artists—a fact due largely in the first instance to the influence of Delacroix, whose interest in

and use of colour had its basis in the much more comprehensive aims and methods of Rubens. In the genealogy of Cézanne's art, however, Poussin also had a dominant place, next in importance to Delacroix, with the result that Cézanne's *œuvre* did not in any way fit into the historical line of French colorization, but presented 'a new phase of spiritual evolution', in that it united the inheritance of the baroque and the romantic with that of the classic. That has long been recognized by other critics. Even at the time of his death Cézanne was regarded by the young painters who admired him as a representative of classicism, because, as Maurice Denis wrote in 1907, he 'took trouble about style'[2]. In comparison with impressionism his art seemed akin to and affiliated to 'old pictures in museums'[3]. From the pictures exhibited by Cézanne in the *Salon d'Automne* of 1905, Maurice Denis gained the following impression: 'Cézanne appeared like a stern old master with a carefully cultivated style, the Poussin of still-lifes and green landscapes'[4]. But even that too was a one-sided and inadequate categorization which Maurice Denis himself tried to amend. For he also considered that Cézanne's art presented 'an effort to achieve a proper combination of style and feeling'[5]. 'Style' here may mean the structure of classical French picture composition[6], but the expression 'feeling' contains the meaning of a spiritual inspiration which issues from increased susceptibility and tension of the senses. 'Feeling' ('sensibilité') is that higher sensitivity towards reality which at the time 'was almost unanimously accepted as the sole motive for a work of art'[7], that is, its *raison d'être* and proof that its existence was justified—in effect, in the eyes of the romantics, the foundation on which all creative art was based. From this we see that Maurice Denis felt that Cézanne's work was a synthesis of two art tendencies which were opposed to one another, even if he did not pursue further the problems to which this theory gives rise.

Yet the most important point of all, historically speaking, lies buried in these very problems, because Cézanne's chief preoccupation was to get to grips with the realism which prevailed in the world of art at the beginning of his career, and it is only his insistence on his own artistic ideas in opposition to this realism, this fidelity of representation, which explains and makes us understand why he chose to adopt Poussin and Delacroix as his two 'ancestors'. Poussin and Delacroix, as he testified explicitly on several occasions in his letters, showed him the way to control the artistic media which were so important to him in this conflict. These media had, more-

over, a decisive influence on the historical significance of Cézanne's art and its place in the evolution of French painting as a whole.

For a description of the historical position of French painting at the time when Cézanne was beginning his studies in Paris, we can turn to Zola, who sent one in a letter addressed to Antony Vala-brègue on 18th August, 1864. It is contained in a long essay with the title 'L'Écran' (the screen, the film, the transparent web), in which Zola assembled his thoughts on art. This essay is particularly revealing for our context because, although it was meant to sum up the literary tendencies of the time and was addressed by one writer to another (future one), Zola employed the language of painting throughout. It confirms the fact which emerges from other sources too, that at that time Zola frequented artists almost exclusively and had as yet come little in contact with men of letters; further, how-ever, that his aesthetic views were still strongly influenced by his painter friends. His thoughts moved rather among the exhibitions being held in the studios than along the highways and byways of literary controversies. The beginning makes this clear without doubt. It runs as follows: 'Every work of art is a window opening out on to creation; stretched taut in the window frame there is a sort of transparent screen ('une sorte d'écran transparent') through which one can perceive objects which seem more or less distorted ('déformés') because they suffer more or less palpable alterations to their lines and colours. These alterations have their origin in the nature of the screen. . . .'

The whole conception, the simile chosen, and the mention of the 'alterations to lines and colours'—all these obviously sprang from the discussions of the young painters who had formed Zola's circle of acquaintances since 1863[8]. Furthermore, in this simile there is an echo of a memory of an aid to painting about which Zola could have known only through a painter, and of an explanation of the nature of painting by Leone Battista Alberti, which likewise could only have become known to him in the same way. In order to demonstrate the central-perspective construction of the space which was to be depicted in a picture, Alberti had said that a painter ought to regard a painting as a view through a window. He also recommended the use of a veil ('velo'), a piece of loosely woven material, as a practical aid to establishing the position of shortened lines of depth on the surface of the painting. The painter ought, when executing the principal part of his work, i.e. the drawing, to look through this veil, which must be placed in front of the window[9].

Zola took over the simile of the window but transformed the veil into a transparent screen, although he probably had the same thing in mind, even if he described it in slightly different terms.

But with him this screen now acquired a new significance. It was no longer a mechanical aid to the draughtsman; it became a symbol for the mind of the artist, for his personality, his temperament. 'We see Creation (i.e. nature) in a work of art through a man, through a temperament, through a personality.' That is why —according to Zola—an objective reality was impossible in a work of art; merely to represent something as real was to see it as though through a veil, its outlines and colours distorted; for there could be no undistorted view through windows. 'The window is not free'.

As to the nature of the permeable screen there was no certainty; some said it was intellectual, others that it was material in construction, determined by man's physical make-up. Zola did not want to express an opinion on these opposing interpretations; all he wanted was to make realistic statements. Thus he dealt first with the 'écrans de génie' and explained that 'the leader of a school puts a very powerful film (or filter) in front of pictures which gives them great intensity', whereas the pupils use the *écran* of their master because they do not possess a strong enough one of their own[10]. Now, most artists are only pupils, but society needs even the works of schools, if they are created in the mind of some genius who has made a success, so there are also 'écrans des écoles', those distortions of reality common to a school.

At this point Zola, speaking of the position as it was in his time, differentiated between three types of screen: the classical, the romantic and the realistic. In itself this was nothing special, nothing worthy of special mention. But the description which Zola gave of them, composed exclusively in the terminology of painting, was such that one must assume once more that he was here giving the opinions of young painters and also of Cézanne—in fact quite particularly of Cézanne (the Cézanne we know from his earliest pictures)— who at that time exercised the greatest influence on Zola. Indeed, *there can be no doubt that we have in this description nothing more nor less than Cézanne's appreciation of current trends in art.* Therefore let us reproduce these sentences in some detail. Here is what Zola says: 'The classical screen is a beautiful sheet of very pure talc, of fine and dense grain and a milky white. On it the shapes of things are clearly drawn with simple black strokes. The colours of things are dimmed by passing through the veiled clarity ('limpidité'), often

they are even completely extinguished in doing so. The lines undergo a perceptible distortion, all tend to become (evenly) curved or straight lines, to flatten out, stretch into length, with greatly extended undulations. In this cold and scarcely permeable crystal, Creation (nature) loses all its hardness, all its life and glowing force; only its shadows are retained and they appear on the smooth surface as a bas-relief. In a word, the classical filter is a magnifying glass which promotes lines and makes it difficult for colours to pass through it.

'The romantic screen is a sheet of unsilvered mirror glass, pure, yet a little dull in certain areas and tinted with the seven colours of the rainbow. It not only lets colours through, but gives them more strength; frequently it transforms and mixes them. Outlines, too, undergo alterations here; the straight lines bend to breaking point, the circles turn into triangles. Nature shown to us through this screen is restless and exciting. Shapes are strongly marked, by means of great patches of shadow and light. The illusion of naturalness is stronger here and more seductive; there is no peace, but life itself; a life which is more intense than ours; no pure development of lines nor yet a sober restraint of colours, but instead the whole passion of movement and the whole sparkling brilliance of imaginary suns. In brief, the romantic screen is a prism with immense refraction, which bends every ray of light and splits it up into a dazzling spectrum of sunlight.

'The realistic screen is a simple window pane, very thin, very clear, which is claimed to be so completely transparent that things seem to pass right through it and are therefore presented with complete realism. So there is no alteration here in either lines or colours, but an exact, free and artless reproduction. The realistic filter denies its own existence. However, that is being too conceited. Whatever it may say, it exists, and therefore cannot boast of giving us Creation in the radiant beauty of truth. However pure or thin it may be, even if it is only window glass, it still has its own colour and a certain thickness; it tints things, it reflects their shapes like every other (filter). For the rest, I willingly admit that the pictures which it gives us are more real; it attains a high degree of exact reproduction. It is certainly hard to describe a filter the main quality of which is that it is almost non-existent; I believe, however, that I am judging it fairly when I say that a fine grey dust diminishes its transparency ('limpidité'). Everything which penetrates this material loses its splendour or, rather, is slightly dimmed. On the

other hand lines become more voluptuous, to some degree exaggerated in breadth. Life is unfolded with greater opulence, a material life, slightly ponderous. To sum up, the realistic screen, the latest to be seen in contemporary art, is a smooth window glass, very transparent, without being clear ('très limpide'), which gives pictures as true as any filter ever can'[11].

A *criticism* of the prevailing basic tendencies of contemporary painting is unmistakably incorporated in this description. The classicism of Ingres and his pupils is rejected as lifeless, colourless and lacking force. Romanticism, which sees the world through a rainbow-coloured veil, comes out of it better; it gives enhanced strength to the colours of the real world, it depicts life and its contrasts with heightened force, passionate movement and sunlike brilliance. It possesses passion and freedom, no clear-cut divisions, but movement and luminosity. That was how Delacroix painted. Realism comes nearest to the radiant beauty of the truth, but even it darkens and dims things. Its lines are voluptuous and broad; life as portrayed by it is opulent, material and ponderous. But that, says Zola, is the truest picture of the real world which artists are capable of giving. What he was here describing was the real world as discovered by the landscape painters Théodore Rousseau, Troyon and Daubigny and by Courbet. Then Manet also came to join them and Zola at that time took up the cudgels on his behalf with the greatest energy, positively identifying himself with his art. Nevertheless Courbet remained the most outstanding figure of the whole group at that time and, when certain critics cast the name of 'realism' at his art, he first accepted it and then deliberately defended it.

There is no doubt that Zola's and Cézanne's sympathies were wholly and completely on the side of the 'écran réaliste'; but for Zola, as radical opponent of all schools, it was not enough that realistic art should continue to develop along the lines now accepted as normal; he wanted to see it re-created and given fresh life in an original and personal manner. His idea was that this should be done by means of those bold distortions ('déformations') on which all works of art are based and at which the disciples of realism are also proficient, in spite of their fidelity to nature. When Zola uttered these thoughts he was certainly thinking of his friend Paul. Himself a realist, he felt a deep and intimate bond with the artist who at that time was already painting works in which nature was distorted with a greater ruthlessness than in those of any other artist.

## Cézanne's Historical Position and Significance

It may well be that the two friends from Aix had discussed and formed their views on the future of realism together in the quietness and seclusion of the provinces, but even so they were not by any means alone in them. No later than 1857 the critic Castagnary (1830–88) had uttered similar and even more radical views[12]. In the 'intellectual trends of his time' he saw an infinite confusion, an 'anarchy of ideas' which had begun as long ago as 1820 and from which realism now stood out plainly as the only living trend. Historical and religious painting were dead, although they were still practised; so also were classicism and romanticism. Their 'exaggerated subjectivism' had become intolerable and had exhausted itself. The evidence of this state of affairs was indisputable and was a threat to Delacroix, but he surmounted it and out of the need to do so extracted quite new values, as is shown by the pictorial freedom and richness, the composure and the 'rusticity' of the works of his old age. Art itself yearned for a new security which only reality, nature and the living ego within it were able to offer: 'Art is above all an expression of the human ego, which is stimulated by the outer world'[13].

Castagnary perceived a historical connexion between the disappearance of art with a universal import and the emergence of the ego as an artistic theme and he was already pointing out as a universal phenomenon of the time something which was later to come to fruition more perfectly in Cézanne than anywhere else in the field of painting. This novel element appeared to him, again in terms of the contemporary tendency, to be 'progress' and not, as we see it, a break with historical evolution.

Castagnary again spoke out quite clearly on the subject of the ego as the central problem and pre-condition, the content and the theme of modern art, when he said that in order to portray itself the ego made use of the most varied subjects taken from the real world. 'The extinction of religious and historical painting makes way for the absolute predominance of the *genre*, of landscape and portrait, which depend on individualism'[14]. . . . 'It is no longer gods and goddesses, heroes and epic songs which your fortunate art will realize and make visible, but you yourselves, the scenes of your life and nature which surround you. In these things lies the whole truth, in them the whole of poetry'[15]. With these words Castagnary was describing the foundation on which the art of the second half of the nineteenth century, the themes of Courbet and Manet as well as those of Cézanne, were built up. The art of all of them was

concerned exclusively with their own ego, even though it was disguised under many different forms. But of course each expressed the truth and the poetry of his ego in a different manner.

So far as the young Cézanne was concerned he certainly agreed with Zola in regarding himself in the year 1864 as a realist, as one whose aim it was to capture the full actuality and whole richness of life, just as he found it in his immediate surroundings. But what this life was, what it signified, in what way it was manifested or revealed, or in other words what in the real world around him was nature, he did not at that time yet know. Nor did he know what medium he could and should utilize for the purpose of portraying this life. He attempted much without arriving at any satisfying results; and before 1865 Cézanne could not be reckoned as an independent artist. However, in one respect the views of Cézanne and Zola were already obviously diverging: whereas the writer believed that the nature of realism was primarily determined by the choice of subject-matter (social and human problems taken from the life of the great city), Cézanne felt from the outset that for him the problem of realism was one of form and not of content.

This is shown by the extremely personal decision which Cézanne made in the circumstances of the time. In the middle of the nineteenth century in France there were two kinds of realism: first, the *trompe l'œil* cultivated just as much by Ingres and his pupils as in the free ateliers of Gleyre, Couture, Cabanel, Gérôme, Cabanier etc.; secondly, realism of the material, of the contemporary *sujets* chosen by Courbet—who did not reproduce them with cold exactitude but intensified their aliveness. Cézanne now rejected both the exact imitation of actual details and the representation of motifs taken from ordinary life.

He had two reasons for spurning the *trompe l'œil* style. It was the kingdom and the heritage of the 'schools', towards which he had an innate antipathy which he shared with Courbet and Manet, Gautier, Champfleury and Zola—a factor of extreme importance in the overall historical picture. In the eyes of these men the schools were the cause of the downfall of art[16]. The skill taught in the schools—for example the methods of Ingres, which as early as 1848 Champfleury branded as 'the precise imitation of irrelevant detail'[17] or the reproduction of things 'in a commonplace, prosaically real style'[18]—repelled Cézanne too. Even in his most unskilful experiments it is obvious that he was conscious from the outset of an order of significance in the appearance of things, that certain

features of the real world appeared to him to be important, others on the contrary unimportant. He never strove for that uniform clarity which leads to optical illusions. The leaders of the schools on the other hand regarded extreme exactitude as the sign of perfection itself and on this they based their theory that, with this ideal goal in front of them, art could be taught according to fixed rules. That, then, was the second reason why Cézanne and his friends scorned the schools, as is confirmed by the testimony of Zola, who conveyed Cézanne's views on this point too in the letter to Valabrègue already mentioned. In that passage in which he speaks of the 'écran puissant' of geniuses in contrast to the 'petits écrans opaques' of the schools, Zola says that the method of imitating a master produces 'hideous results'. 'Every school', he continues, 'has this horrible feature, that it makes artists falsify nature through following certain rules. The rules are tools of mendacity, which are passed on from hand to hand, in that one reproduces in an artificial and petty manner the great, sublime or attractive figures which the *écran* of the genius has presented with all the simplicity and force of his nature.'

Rules were justified only for the genius on whose works they have been founded; but for that genius they were not rules at all, they were a personal way of seeing things, a natural effect of the 'screen'.

So Cézanne found entirely unacceptable the notion of unalterable perfection as an art ideal, seen as the antithesis of the personal form created by the artist himself; this was the doctrine of all the classicists and all the eclectics alike. In the history of ideas this is important. For, although antipathy towards classicism and eclecticism was fairly widespread among the important artists of Cézanne's generation, he alone countered the false and spurned ideal, not by turning back to nature as the sole teacher (in spite of some remarks he made which could be and often were misinterpreted in this sense), but by re-establishing the identity of idea and form, so essential to art. As Vasari once wrote (in his introduction to the life stories of famous painters): 'idea sive forma' ('idea *or* form' (as such)); as Baudelaire[19] said: 'idea and form are two things in one;' so for Cézanne ideas always existed in his art only in so far as they were forms. This leads us back again to the problem of reproduction of the real world. If one examines an isolated artistic idea, such as fidelity to nature, the perfection of natural forms or of means of portrayal, that is, an idea which did not issue from the subject-matter of a picture through its realization but was absorbed into

art as being important in itself (because it contained an ultimate and original truth), one can understand why such an idea would make form less important and lead to its neglect. And so the way was open for the 'optical illusion', the imitation of the insipid everyday real world; and this was precisely the stupid procedure against which Cézanne turned instinctively and with all his force.

In doing so he leaned on Delacroix, whose art had come on the scene as an out and out challenge to the commonplace insipidity of the 'schools' and which was understood as such and respected by the then young generation. As an example of this let me quote a judgement of Gautier. He compared Delaroche and Delacroix, saying of the art of the former that it was cold and precise, clumsy and real, the outcome of great pains, desperate study and a prosaic conscience; the art of the latter on the contrary grew in an intelligent manner, was lyrical and thrilling, like an improvisation by some great poet. Delacroix's figures, 'his bold genius, new style, of extreme delicacy and spontaneity, the youthfully impetuous, glowing artist with the flying hair' (all expressions of Gautier's) stood lifelike before the eyes of the young generation of painters. His example now gave Cézanne a second reason for rejecting realism as being mere imitation of detail.

Delacroix 'shook off the yoke of the schools in order to follow his genius alone'[20], and it was his very originality, his self-sufficiency and independence, and of course the inevitable consequence that he was unable to found a school, which won the attachment of the young Cézanne, whose rebellious disposition sensed a kindred spirit in him. The man who remained alone in and with his art, just because he was inimitable, seemed to Cézanne to be the right model to follow on account of this very quality, since only an irreproducible and hence unteachable art was the outcome of a truly creative process and so had a meaning for him as an example to follow. But in what way did this relationship between the beginner and the (newly dead) master manifest itself? Not in stylistic influence, and not in (unimportant) inspiration for motifs: Cézanne owed nothing of this kind to Delacroix. What he did owe him was rather, in Cézanne's own words 'appui moral' ('moral support'), i.e. courage and inflexible confidence in himself. In practice this meant relying on his own ideas, starting off from a general view born of the imagination, and rejecting slavish imitation of the real world in all its detail. It was this very freedom which was the distinguishing mark of Delacroix's art; and one of his greatest admirers, Gautier

again, voiced the following opinion: 'The truest pictures have never deceived anyone and deception is not the aim of art. If it were otherwise, then the greatest work of the masters would be *trompe l'œil*, but *trompe l'œil* with its mathematical exactitude is always achieved only by mediocre painters. . . . Painting is thus not an art of imitation; . . . the painter carries his pictures in himself . . . the canvas serves only as a vehicle. . . . With a view of forest, of lake or mountains he is painting his soul'[21].

Cézanne adopted the same attitude towards the realism of detail. Yet, just as he rejected this, so he also opposed the realism of topicality ('actualité'), i.e. the use of contemporary subject-matter, which Courbet had introduced into painting with the argumentativeness of one criticizing his own times. Courbet's programme was: 'one must bring art into contact with disreputable people' ('encanailler'), and this politico-social undertone and preference for the common people and things in the real world was not at all to Cézanne's liking. Even though Cézanne also swept aside the unpolished provincial in those years and, so to speak, played the proletarian (in order to conceal his inner tenderness and vulnerability), yet the world of the common man—poverty, misery, ugliness and sheer need in daily life—was never subject-matter for his art[22] and he had no sympathy whatsoever for the notion that he ought to employ motifs of that kind in order to express the modern and realistic aspects of his art; nor was it ever a problem for him to be contemporary.

In this he differed, however, not only from Courbet, but also from Zola. The latter once wrote[23]: 'Through realism one achieves an exact, complete and honest portrayal of the social *milieu* of the age in which one lives: the view adopted by the realist is indicated by reason, the demands of the intelligence and participation of the public, and his studies are free from any mendacity or deceit. Reproduction ought to be as simple as possible, so that everyone understands it.' He then advised the modern painter, 'le peintre de la vie quotidienne', to seek his subject-matter in the *bourgeoisie* and among 'little men'. This was certainly not what Cézanne had in mind when he used the term realism; and the idea of establishing aims of this kind for his art could not possibly have had the slightest appeal for him. Now Zola in his work actually did follow the advice he gave others and so an antagonism between the points of view of the two friends, which had begun to make itself felt in their works as early as 1865, was now established. Now we see we are getting at

the roots of their later estrangement, which finally led to the break between them.

In general it cannot be gainsaid that Cézanne also favoured contemporary material laid before him in the real world, and selected realistic subjects, but the motives for his selection were entirely different from those of Zola, and so his choice had a completely different significance. He had taken up a determined position against the schools and the themes they had sanctified by tradition, yet at the same time he found it impossible to be satisfied with the mere outward appearance of nature as a subject for his work. His individual personality was in fact beginning to force its way into the forefront of his existence and to make itself the central point and theme of his art—and, moreover, in an entirely original way. He was therefore bound to depict subjects which had some special significance for his personality (as a being who stood upright, stood firm, stood alone), his family and friends, sections of familiar countryside which held associations of memories and hopes for him, and fruits and utensils which were part of his own home. To put it the other way round, we can see that when he depicted trivial objects of this kind he always did so in a special manner because he looked at them in relation to his own self, and to what lay deepest and closest to his heart[24].

If we now compare him once more with Courbet, we might perhaps be inclined to assume that Cézanne differed from Courbet only by having a narrower field of vision. For indeed Courbet also desired only to paint himself and his world (the only thing that he knew thoroughly); he even hesitated to make portraits of people with whom he had no close relationship. In the peasants and workers of his homeland he discovered or recovered his own ego. But this, of course, was exactly how Cézanne did *not* look at the objects he was contemplating painting. He wanted no underlying bond of sympathy with his subjects—on the contrary he sought the most extreme alienation and the preservation of a mystery about the existence and persistence of his own ego and that of the subject. What Cézanne strove to do in his art was to make this existence visible in all its mysteriousness (in himself and around him) and to 'transcend' it in (by means of) the construction of the picture.

We can express the antithesis between Courbet and Cézanne in still another way. With Courbet the purpose of 'investigating mankind' was to reproduce human life and nature without falsification and with the greatest possible vigour; the essential point of

this 'humanitarian art' (Castagnary) lay in an interpretation which was at the same time both human and social. From the point of view of 'society, which has shown curiosity about the real world and which is anxious to see and recognize itself', and as the representative of that society, the artist had a duty to comprehend and portray the 'phenomena of communal life'[25]. And in the course of doing so his ego (in that it was social and socially participating, compassionate) should manifest itself. This is what Courbet did, or at least how he saw himself. Cézanne on the other hand painted absolutely without regard to society—for himself alone, just as though there were no society at all, in complete isolation and loneliness. His creative ego evinced itself therefore only in the comprehension and depiction of such objects as were important for the existence of this ego in the world to which it belonged, eloquent and expressive of his inner self. When Cézanne portrayed people, they testified to the existence of his own ego, were a-social figures and, as is of course well known, not even the fashion of their clothing could give them a secure position in society. They wore the fashions of their time, but it was as though their garments were free from every limitation of fashion. These people were, like all other objects painted by Cézanne, merely instances of his absolutely personal problem of 'being' and 'existence', and thus they deputized for the artist himself. People portrayed in Cézanne's way grew out of an assembly of external data into objects illustrating the most intimate problems of the painter himself.

Despite all these points of difference, however, there still remained a link between Courbet and Cézanne. This was the fact that Cézanne adopted some of the essential elements of Courbet's technique and stolid, heavy style, namely those which were designed to represent real things. In order to portray real things in all their persistent actuality, Courbet avoided the use of lines and brush strokes, movement and expression, and so any suggestion of coming and going. That prevented him from making meaningful distortions of individual objects and also precluded the possibility of self-sufficient and firmly constructed compositions. This has always been felt as a defect in Courbet's art, yet, in the light of his basic aims, it was unavoidable. What, however, gave rise to a defect in one respect resulted in hitherto unknown richness in another, namely in coloration. In order to depict the present-day as fully and firmly as possible Courbet created a new technique for himself, which relied exclusively on the use of colour. This consisted in making use of 'covering'

colours as a rule for reproducing both light and shade, distance and nearness, things clearly recognizable and indistinct things. For the whole surface of his pictures Courbet used the dense, opaque enamel-type, viscous pigment which reflected all light. Ever since the emergence of style in painting, since the days of the Venetians and Rubens, this type of paint had indeed been used for portraying solids on which light shone, while shadows and half-shadows were painted transparently and by applying one translucent hue over another lying below it. This process was not merely incidental, for by means of it he was able to give an intense materiality to things, which was entirely new by comparison with all earlier representations[26], and to strengthen the force of their 'existence' by giving it uniform significance in every part of the picture. Courbet's method did not compete with images of the real world, which naturally surpassed it, but with the art which existed before his day; it is by comparison with this art that his made such a tremendous impression of objectiveness and materiality.

All those critics who had any sympathy at all for Courbet's art were full of praise for his use of colour, ('the vigour of the hues, the enamel-like homogeneity of the substance of the paint ('pâte'), the opulence and freedom of its handling') and for the masterliness of his execution. 'The century has not seen two practitioners of this breed', wrote Théophile Silvestre—no two masters who could have reproduced both the plasticity of objects and the differences between things seen at varying distances by means of different grades of colour and colour values, and thereby maintained such a clear distinction between the values peculiar to the different colours.

From a study of the path along which Cézanne's art developed it is not difficult to discern how much this feature of Courbet's art served him as an example. And though even in the 'sixties he still could not feel certain in his own mind as to exactly what it was about Courbet's art which was important for him, he did immediately adopt his vigorous manner of laying on paint with uniform strength and density in every section of the picture, the rich enamel-type substance produced by applying paint in thick layers with a well-loaded brush or with the aid of the palette knife.

So the young Cézanne took over from Courbet the technique of colour gradations which was of course a first step on the road to the colour modulations which Cézanne later evolved. In addition, he adopted Courbet's method of juxtaposing violently contrasted colours and exploiting the potentialities of natural coloration to the

utmost degree possible with the pigments at his disposal, intensifying black, green, grey etc. to the ultimate degree of realization attainable[27]. Moreover, this technique developed by Courbet retained its importance for Cézanne's art even in the final stage of his development. When Cézanne was attempting to represent in a painting his own special insight into the essence of the natural world, in which he most surpassed the ordinary man's comprehension of the manifestations of the real world, this method became and remained of the greatest assistance to him.

Nevertheless, Courbet used intensified local colours worked up into strong contrasts in order to produce representations of objects which emphasized their separation from one another. Or, to put it the opposite way round, the method of painting whereby Courbet arrived at these widely differing colour values was the outcome and the consequence of applying his human talent to producing isolation and of restricting it to isolation. Fundamentally, he never got beyond the stage of development which he achieved as a young man in Père Lapin's *atelier*, where it was remarked that he never painted a whole figure—'he studied only the parts'. But Cézanne, whose artistic nature drove him from the outset to produce whole things, compact and closely set, immediately took up Courbet's method of interpreting the real world with strong colours and used them for entirely other purposes—to form the highlights and nodal points of colour-form compositions. Historically then, 'the brilliance of Courbet's colorization' did indeed in this way play an important rôle in the art of Cézanne and it was this too which induced him to employ the palette knife for a while in his painting, as Courbet had done with predilection and great skill.

This has a further special significance, arising from the fact that this instrument could be used for only a special kind of painting. It could not possibly have been used before painters began to favour an open and 'free' (or 'broken') style of painting, which aimed at giving an absolutely unique liveliness and a unique wealth of shades to the substance of paint. That, again, only became necessary when painters had turned to employing colour as the sole medium for the creation of forms, for composition and for expression. So the palette knife probably first appeared as a painter's tool when the ageing Rembrandt used it in his paintings, shortly before the appearance of the free, imaginative and open brush technique used by Frans Hals in his old age. In both cases the objective was to enliven a self-contained work with colour in a very special way, to use the

paint not as a means of imitating nature, but for spiritual and artistic ends, in order to detach the creation of the painter from the ordinary real world in a material way, to distinguish it and actually to impose an outward spiritual structure on it. A freely handled brush was capable of doing this just as well as a knife. Yet there was still a difference between them. When he used a brush the painter was forced to rely on the guidance of his hand, and inevitably had to represent the entire paint substance as being in motion. The palette knife, however, had the effect of spiritualizing the material of the picture in a less subjective, less personal, more universally valid way. One did not depend on the clever manipulation of the brush in order to create a wealth of colour nuances, but could produce outstandingly clear, blended tones of intense effect and of the greatest variety, not by mixing paints vigorously with one another on the palette but by spreading them only lightly mingled with one another on the canvas. Particles of the pure colours then survived side by side. Isolated, they created an effect of their own, and yet when seen from a certain distance they dissolved into very fine and rich, blended tones: indeed in a mysterious manner they oscillated between these two effects. Despite this, the wealth of colour so obtained was motionless; and the more gently the palette knife was applied to individual sections of a picture the more motionless they seemed. To this, however, still a third effect was added. Masses of paint applied with a spatula, which always cover a surface uniformly or harmoniously, gave the coherence of the picture's surface and of the priming their value as a supporting unity and thereby accentuated the figurative, the artificial, the anti-naturalistic element of the work. This effect was formerly achieved with the aid of drawing, by fitting together linear images and by applying paint almost as though it were varnish. But with the development of colorization objects began to be represented with a plasticity and fidelity to nature which almost produced an optical illusion and the superficial cohesion of pictorial compositions steadily diminished. This lack of cohesion threatened to destroy the unity of pictures. Some antidote had therefore to be found, and what is more it had to be produced through paint. Rembrandt introduced it but remained almost unique in his use of it.

Then, on a lower level, there was John Constable, who also used the palette knife, roughly in the period 1810–37. It enabled him to represent nature as unified in colour, as coherent and filled with air, as life beneath the wind which moves and the light which is

moved. He had a partiality for using it in order to break up largish surfaces of apparently similar colour (in nature) into a rich and lively juxtaposition of tones contiguous in the colour scale, e.g. the green of an area of lawn or of a group of trees, into numerous, interweaving, rippling greens from his palette. He used the sweep of the spatula in a new manner in order to create movement in the substance of his paints; he did not actually apply the paint with a knife, but 'stroked' it on to the canvas, so obtaining the effect of movement in the brushwork, an effect increased and enriched by the clear effect of the 'free' (or 'broken') particles of paint.

Théodore Rousseau, who knew Constable's pictures, employed the spatula in a similar manner[28].

Finally Courbet, who may well have been familiar with the pictures of both Constable and Rousseau, made use of the spatula for the sake of preserving the purity of the colour tones and the beauty and richness of the material substance, yet the manner in which he did so could almost be called timid in comparison with that of his predecessors.

Cézanne was quite different. True, he learned the technique from Courbet, but he used it in the most brutal way imaginable, as no man had ever done before him (not even Rembrandt in his later years, though he was violent enough, for example in the Brunswick family picture). And he immediately achieved two things: an intense, gleaming, enamel-like shining pigment and that consolidation of his figure units in the picture plane, which has remained for ever one of the principal characteristics of his art[29]. His passionate temperament, which seems to have been responsible for this brutal technique, forced him compulsively to adopt one of the fundamental principles of construction to be seen in his art. His psychology proved to be something directly present and vitally important; and a process for obtaining material beauty in a picture, such as Cézanne took over from Courbet, became in his hands a means of illustrating a significance which was disclosed in the things seen.

One further link between the art of Cézanne and that of Courbet remains to be mentioned: the aim common to both of depicting solids with quite special insistence and with a feeling for the impenetrability of their mass. Here, too, Courbet was absolutely original. We have to go back to J. L. David in order to discover another example of such firmness and plasticity of bodies and of things. David, however, achieved this quality by means of lines. Courbet achieved it exclusively by means of colour. Ultimately,

## Cézanne's Historical Position and Significance

Cézanne imitated Courbet's method of modelling in the round for only a short period—that process which I mentioned in Chapter II and which the artistic circles of the Café Guerbois (V.103, 104, 106) christened the 'method of the billiard balls'. Shortly afterwards he invented his own process for this purpose. He used Courbet's plasticity also with a violence, impatience and passion which would certainly have gone entirely against the phlegmatic and easy-going nature of the master from Ornans. But through Courbet's example he did obtain an important approach to one of his own problems; indeed he was here presented with both the problem and one (for him temporary) solution to it. The problem, as seen by Courbet, was how to portray the objectivity of objects in all their impenetrable firmness and self-concentration. Cézanne accepted this as being his problem too, but with the sureness of genius he very soon showed how he and Courbet differed, by rejecting the latter's solution to the problem and showing a complete lack of interest in the distinctive appearances of different substances and materials—which Courbet regarded as very important—that is to say: the optically equivalent values, refraction of light and types of reflection, which are characteristic of stone, moss, water, satin, silk and so on. It would be more correct to say that Cézanne noted Courbet's method of emphasizing the uniform weight of matter and took from it his conception that all objects possess a potent *unity* through the fact that they are material, and then painted in such a way that he disregarded the incidental qualities of the common primary material. So we see that although there was a relationship between the problems faced by Courbet and Cézanne, there was a divergence between their methods of posing them. This divergence plays a decisive rôle in helping us to recognize the historical position of Cézanne's art. The characteristics of matter became a central problem for both artists and they both gave very different answers to it. And this was the cause of a crucial revolution in the artist's interpretation of the everyday real world. It is essentially by reproducing material things, the hard and the soft, the shining, the shimmering or the dull, that a painter creates an atmosphere for the beholder who, by yielding to these material charms of matter, shows that he is willing and inclined to be and is even already being seduced into accepting the atmosphere which results from savouring the differences between those qualities. Cézanne, however, renounced all this and so gave an exposition of the real world which was completely lacking in atmosphere. This is recognized to be the

case in his later works, but even in the early ones he was already representing the real world as mere 'existence'; at first, admittedly, he portrayed its constituent parts still in a state of confusion, held together only with the utmost difficulty. Examples of this phase are the 'black' still-lifes and the pictures of orgiastic scenes with a pair of naked lovers on a sofa to whom a negress is serving coffee. These latter scenes owe their powerful and unpleasant effect to the very absence of any kind of atmosphere. By adopting this type of portrayal Cézanne unquestionably deprived himself of many opportunities to create an effect through his painting, but it also enabled him to overcome one of the great dangers of realism, for when the realists visualized the real world as being full of atmosphere, they always ran the risk of converting it into a '*milieu*' and thus being prevented from giving it any deeper interpretation[30].

There is still one further way in which a relationship between Cézanne and Courbet (as realists) can be demonstrated: both of them painted figures, living beings and objects, which (according to a remark of Delacroix's[31]) 'neither meant anything nor were intended to mean anything'. For Cézanne the entirely meaningless, unlyrical and unpsychological nature of Courbet's art opened up the way to contemplating things in their 'existence together', by showing him that in art things (both dead and living) were worthy and capable of being portrayed through themselves and for themselves as mere formations of the real world. In the words of Lemonnier, there was no place in Courbet's painting 'for either a longing or a complaint'. He never 'painted a head which thinks or a soul which suffers'. It was just because of this that he opened up a new avenue of approach to objects, making it possible to observe them in their undisturbed selfhood, and Cézanne then went along this road in order to find and discover not just the facts which Courbet saw in every single thing, but instead a hidden relationship of meaning between them which far surpassed the significance of the individual or even of the group—that significance to which artists used always to prefer to devote their attention. The very restriction of the painter's field to what was visible alone, which is what Courbet undertook, his 'breaking out into nature' (Lemonnier) and the fact that he was thereby 'cleaning up painting', was for Cézanne an uncommonly challenging stimulus; it directed his serious mind to a road along which one could walk to find what was true and strong in a work itself, which drew none of its value from the subject-matter; it directed him towards concentration and

solidity of construction and also towards the study of nature, it encouraged him to engage his creative artistic powers not in inventing but in constructing.

Courbet had had his first great success as early as 1849 and by the time Cézanne arrived in Paris had adopted a somewhat restrained line in order to meet the public taste. Whereas he was thus attracting less attention to himself and had become less 'intéressant', Manet had by this time drawn all eyes to himself and thus to a new form of realism. Even Zola[32] had seen that 'there is not the slightest resemblance between Courbet and M. Manet and, if they are logical, these artists must be mutually exclusive'. This was in fact so and the contrasts between them became increasingly fundamental. Manet knew no humanitarian or socialistic purpose in his art; *his* realism was a matter of style, of unvarying intelligence, but above all of sparkling 'esprit'. He had, too, a different conception of nature.

Were it not usual to regard the expressions 'realism' and 'naturalism' as synonymous and to treat them as virtually interchangeable; and were it not my purpose to distinguish them once more from one another according to the proper meaning of these words, then one could label Manet as a *naturalist* as compared with Courbet the *realist*. We should thus be able to express the difference between them quite plainly. On historical grounds, moreover, this distribution of the terms would be particularly easy to justify for it would be attributing to Courbet the only label he ever claimed for himself and his art. In fact he never called himself anything else but a 'realist' and he always referred to his art as 'realism'. True, he did not patent the expression—it came from Champfleury or Geffroy— yet he did adopt it, after some hesitation, and on many occasions he explained and defined it in his own way.

There had, of course, been other realistic currents in European art long before Courbet—in Flanders, Spain, Italy and France, in the fifteenth, sixteenth, seventeenth and eighteenth centuries—but not all of these have yet been given special names because we have not to this day been able to recognize their peculiar characteristics clearly. The only thing Courbet's realism had in common with these tendencies was the fact that it too was a reactive movement, a renunciation of imagination or a negation of the ideal. We may adopt Gerstle Mack's view[33] that this realism 'was in fact not a single idea but a combination of several diverse though related concepts: rebellion against classicism on one hand and romanticism on the

other; a determination to express contemporary life, the realities of existence, with particular emphasis on the common everyday activities of the proletariat and the petty *bourgeoisie* which had previously been considered unworthy of representation; a reaction against pomposity, elegance, sentimentality, and mere prettiness'. Only we must add that in this description the most important thing has been omitted—style, the positive form in which all this was carried out. Courbet had his own quite special and absolutely original style of realism. The main feature of it was, however, not the natural aspect[34] but 'a nature which seems more full of energy than the real world is'[35], the enhanced objectivity of objects[36]. We must then set Manet's *naturalism* against Courbet's *realism*—at least as Lemonnier understood the expression 'naturalism' in 1878, although it is true that at that time he considered Millet's art to be the most outstanding example of it. Lemonnier wrote: 'Naturalism, which has evolved from realism[37], worries more about psychology, characters and environment, it contains a philosophy which its predecessor did not possess'. Even if we find it difficult to regard Millet as a representative of naturalism, yet, if we regard the term thus as having evolved into the antithesis of realism, it does seem all the better to fit Manet who indeed concentrated his interest more and more on interpretation and away from the subject-matter itself. Even in comparison with landscape painters like Théodore Rousseau and Daubigny, indeed even in comparison with Corot, Manet is seen to be the more naturalistic artist, because he endowed his subjects with no deep significance or poetry but, in a prosaic and thus utterly natural way, accepted them as he found them and understood their psychology, portrayed their nature, their characters and what was natural about them. And in so doing he demonstrated once more his very definite way of looking at things, concentrating his attention on what was specifically natural in nature and reproducing it directly, namely the process of living, life's continual 'becoming and changing'. This element of transience is clearly illustrated by Manet's style, in the hastiness of his handwriting and also in the openness and lack of precision of his outlines.

To appreciate the full import of his naturalism, we must now look around somewhat further. Rigidity is common to everything that is the opposite of natural: in art, composition is subordinated to fixed forms and strict rules; in our civilization there are fixed rules for the game of social relations, rules for manners, rules in one's profession, in thinking of one's self-interest; there are even

rules for affectation and conceit. In contrast to this, Manet's art is full of the throbbing life of nature in general. This is going far beyond Monet, Renoir or Sisley, who reduced the inner agitation and instability of the natural world to the mere trembling and shimmering which light produces in objects. What caught Manet's eye was the very fact that the things he saw had something about them which was not fixed; he discovered mobility and animation even in fixed forms and illustrated them by breaking up solid masses with jerky strokes. His figures, the subjects he painted, had not the heavy and impenetrable objectivity of those painted by Courbet—on the contrary, they appear by comparison to be weightless and without heaviness and almost without corporeal substance. The reader can test and verify what is meant by this if he studies the bulky and well-nourished figure of the drinker in *Le bon bock*.

Let us then label Courbet on the one hand as a *realist* and Manet on the other as a *naturalist,* so long as we preserve the roots of the two terms in our minds when we do so, and regard Courbet as the painter of the objective, the solid, Manet as the portrayer of the unstable, the changing, the growing, that which has been born and which therefore must die. We can continue the comparison on identical lines: in Courbet we see the man who understands existence and what exists in an objective way but in Manet a man who perceives the 'becoming' of a whole which is perpetually dying, who measures all the facts offered by the real world by that one standard and makes use of distinctive forms only in so far as they enable this whole to function and so to be once again transformed. And we realize that *space* is what matters in Courbet's realism, whereas with Manet it is *time* which thrusts itself forward in the phenomena of the real world—the attraction of the momentary, as for example its instability and perishability. And the means of representation adopted by the two minds corresponds to all this: in the former the solidity of the texture of a picture, in the latter the liveliness of the mind, the *esprit*, the sketchiness of the execution[38].

For a study of Cézanne, it is essential to make the divergences and the antithesis between realism and naturalism absolutely plain, because Cézanne took up a quite explicit position towards both, accepting Courbet's realism but opposing Manet's naturalism. And this he did from a compulsive inner urgency; for his art was (as we have seen) by its very nature aimed at the objective and the permanent, the impenetrable and the unshakeable.

For this reason Manet's painting could be of no direct service to

him. Cézanne's understanding of nature may at first have been clouded over by his inner resistance towards Manet and have been expressed clumsily, yet it was foreshadowed even in the works of his early youth and, measured by this standard, Manet's attitude was merely a confusion of the incidental with the essential. To come to terms with the ephemeral aspects of the real world—and that merely for the sake of its visual charms—was bound to strike Cézanne as beneath him, something to which his inherent nature made it impossible for him to stoop.

Moreover, Manet's painting was basically no more than a variant of *l'art pour l'art*. Admittedly he took his subjects from the present day and from real life, but he still regarded them as mere pretexts for displaying the beauty of matter and perfection of workmanship in a work of art. This perfection, in turn, was not attained by a careful process of refining in the course of which every trace of the actual workmanship ultimately disappeared, but quite openly in a thoroughly modern way by the elegance, the speed and the sureness of the hand which created the work.

In spite of the modern and easily understandable *sujets* which he chose, the art of Manet was nevertheless an ivory tower, a precious and in many cases sealed vessel, remote from reality on account of its sublime and ingenious workmanship. It had naturalism and later impressionism in it, yet in spite of this its essence cannot be grasped by regarding it from the standpoint of either naturalism or impressionism, but only through an appreciation of his idealistic and subjective style, his method of representation. On the other hand, this is possibly what prevented it from being understood by the general public. Indeed, it did not draw life from the significance of its *sujets* but only through (and for) the beauty of the forms it produced, in which the very substance of the paint was refined. It was 'a perfect disengagement and a labour freed from every other interest, dedicated only to beauty itself', very personal, but only because of the inspired and refined delicacy of the handling of the colours of things seen. That is why Manet's art arrived at its goal and end through his manner of representation: it actually was brilliance, play, superiority, grace, intellect without feeling, but also intellect without depth and thereby the absolute antithesis of the painting of Cézanne. This fact explains why his style, the style of Manet's portrayal of nature, had no influence on Cézanne. Anyone who maintains the contrary (for example Venturi, whose view has been echoed by many others) is basing his judgement on

30  Landscape with Bridge, 1888–90 (V. 641), $25^1/_4'' \times 31^1/_8''$,
*Museum of Modern Western Art, Moscow*

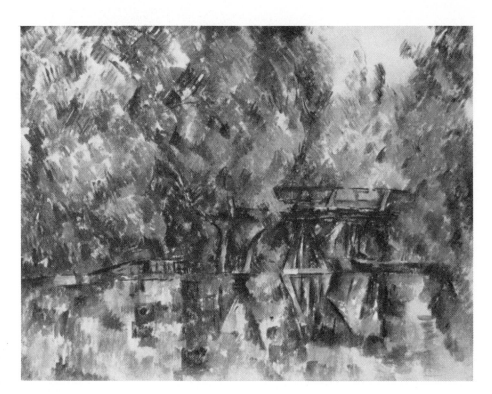

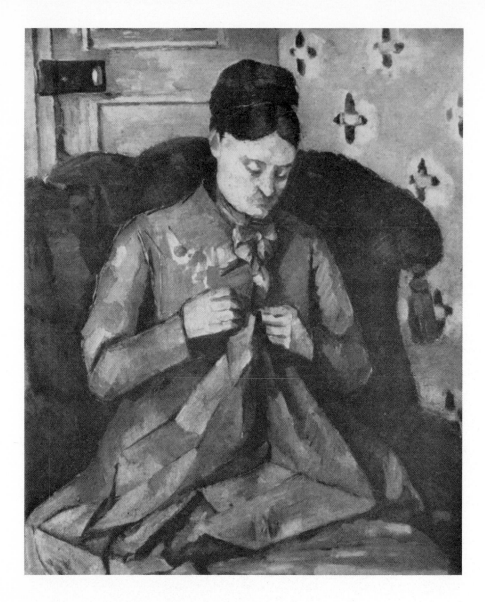

31 Madame Cézanne, about 1877 (V. 291), $22^7/_8'' \times 18^7/_8''$,
*Collection of Paul Rosenberg, Paris*

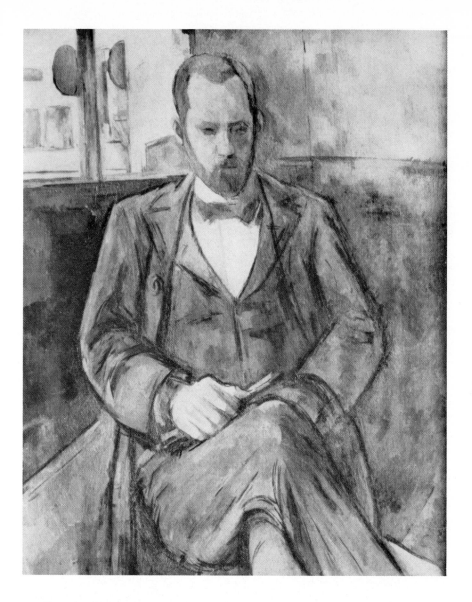

32    Portrait of Ambroise Vollard, 1899 (V. 696), 39³/₈″ × 31⁷/₈″,
*Musée de la Ville, Petit Palais, Paris*

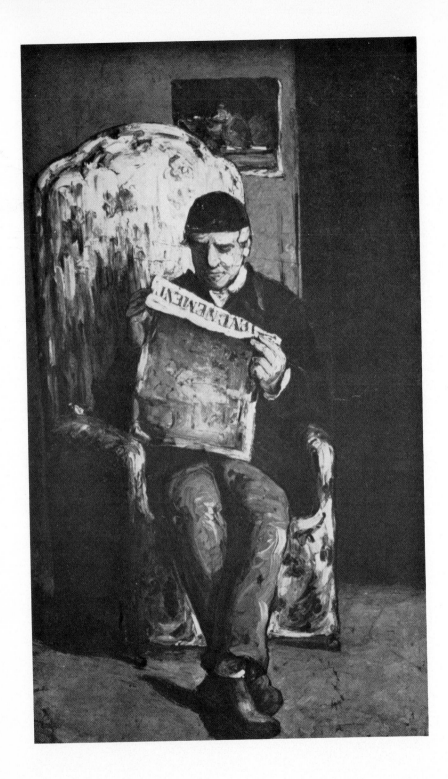

4  Frenhofer showing his Work (drawing), 1873–77
(V. 1575), 4″ × 6³/₄″,
*Öffentliche Kunstsammlungen, Basle (copper-engraving section)*

33  The Artist's Father, 1868–70 (V. 91), 78³/₄″ × 47¹/₄″,
*Lecomte Collection, Paris*

35  Landscape L'Estaque (drawing from a sketchbook),
    *The Art Institute of Chicago*

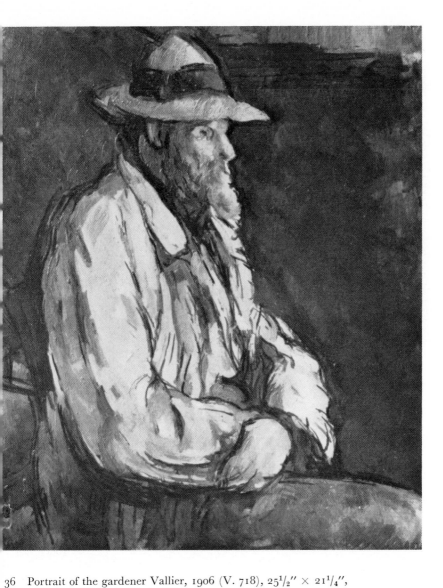

36    Portrait of the gardener Vallier, 1906 (V. 718), 25$^1/_2$″ × 21$^1/_4$″,
*Collection of Leigh B. Block, Chicago*

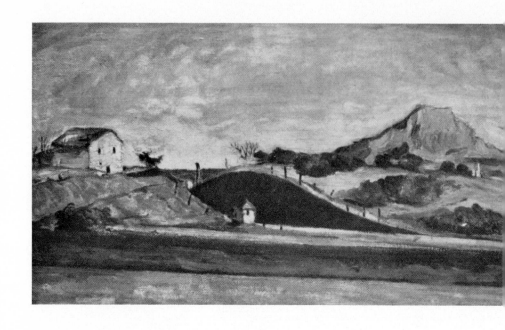

37    The Railway Cutting, 1867–70 (V. 50), $31^{1}/_{2}''$ × $50^{7}/_{8}''$,
*Bayerische Staatsgemäldesammlungen, Munich*

38    Pastorale, 1870 (V. 104), 25¹/₂″ × 31⁷/₈″,
*Collection of J. V. Pellerin, Paris*

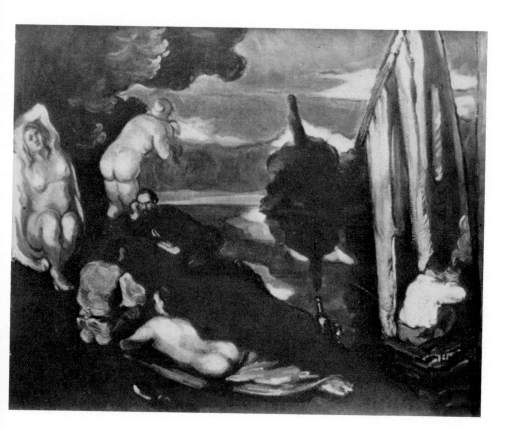

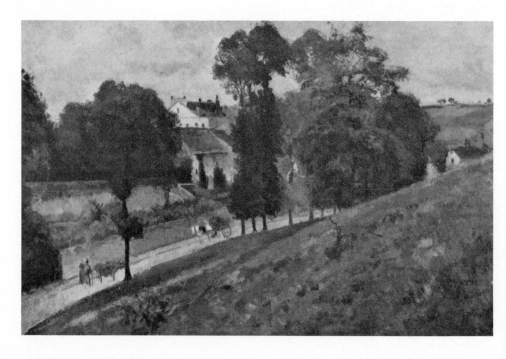

39   Camille Pissarro, L'Ermitage (Pontoise) (P. V. 304),
*Formerly Collection of A. Cassirer, Berlin*

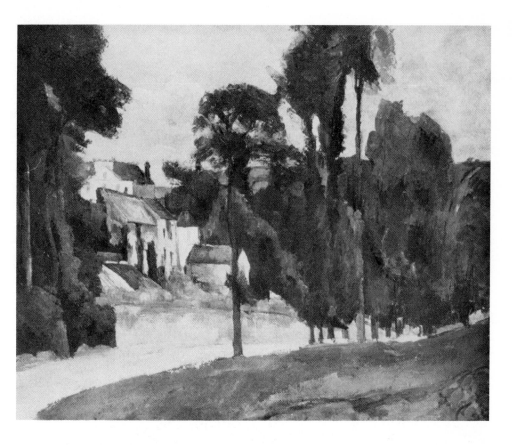

40 Cézanne, L'Ermitage (Pontoise), 1875–77 (V. 172), 22⁷/₈″ × 28″,
*Museum of Modern Western Art, Moscow*

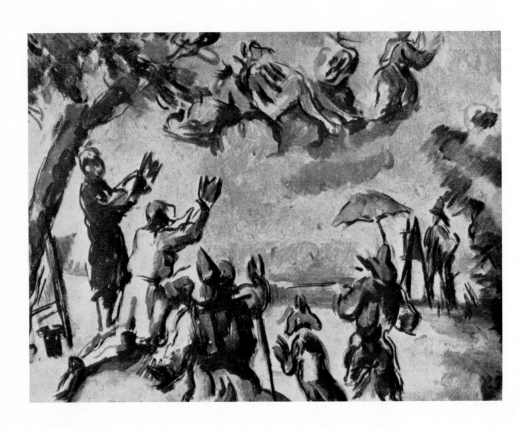

41   The Apotheosis of Delacroix, 1873–77 (V. 245), 10⅝″ × 13¾″,
*Collection of J. V. Pellerin, Paris*

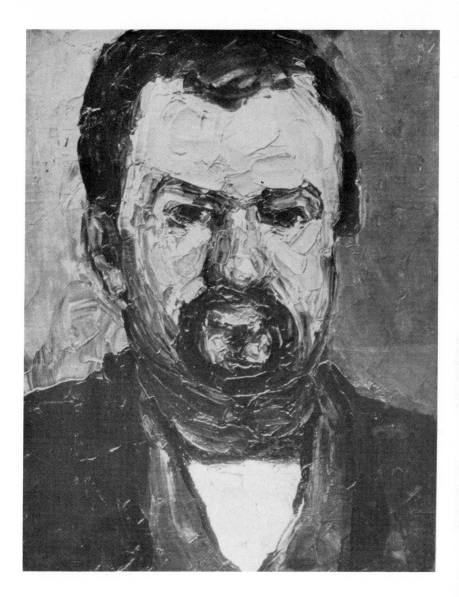

42   L'oncle Dominique, 1865–67 (V. 77), 16″ × 12½″,
*Collection of Adolph Levisohn, New York*

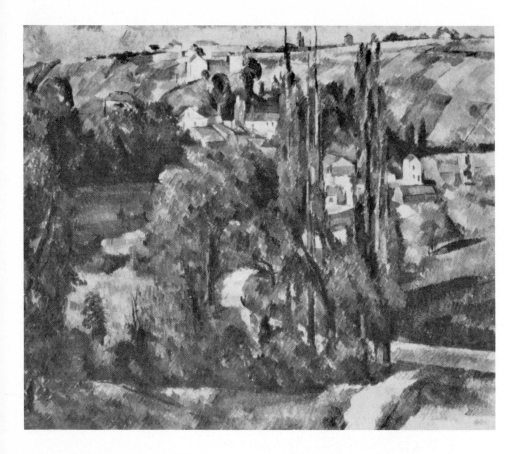

43  Landscape in Pontoise (La côte du Galet), 1879–82 (V. 319), $23^5/_8'' \times 28^3/_4''$,
*Collection of Carroll S. Tyson, Philadelphia*

44 Landscape near L'Estaque, 1898–1900 (V. 770), 38¹/₄″ × 30³/₄″,
*Formerly Collection of Dr. Lewin, Guben*

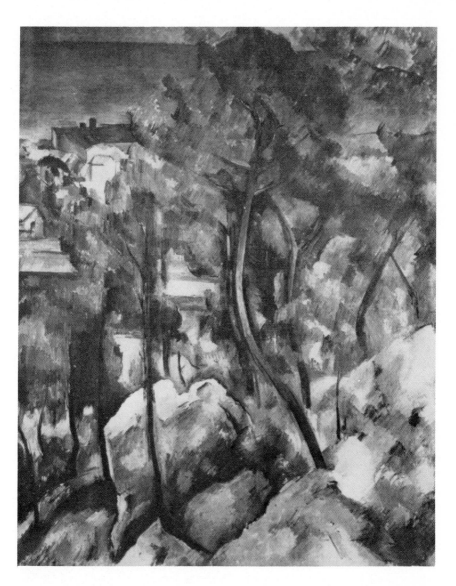

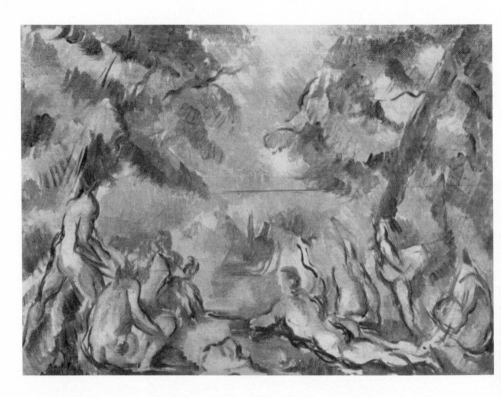

45　Bathers, 1900–1905 (V. 723), $11^3/_8'' \times 14^1/_4''$,
*Formerly Collection of Alphonse Kann, St. Germain-en-Laye*

inaccurate observation, and has taken the subject-matter too seriously without penetrating to the significance of the artistic construction. Zola summed up Manet's style very well: 'He sees *blonde* ('bright', 'light') and he sees in masses'. His colour scale is light, the light tones preponderate and no darkening of shades or pollution of colours is permitted (in the shadows). But he applies his colours in large masses, clearly separated from one another; they are local colours in a rich variety of nuances and the linking shades (e.g. between white and green, blue and pink) are omitted. That is why Manet loved brightly contrasting clothing, such as uniforms, or striking clashes between the colour of a figure and that of its environment. Moreover, he always regarded environment as a zone of lesser reality and lesser interest, of a different organization of forms where, as it were, things were to be depicted in a state of disintegration in order to facilitate interplay of colours; it is a glittering show without substance, whose whole charm lies in the ingenious way in which it is painted—all in all, a conception which has nothing whatsoever in common with Cézanne's aims, even in its external appearance.

Nevertheless Manet's *person*, unlike his *work*, does emerge as an important factor in Cézanne's creative development, because it was he who acted as a challenge to Cézanne, stimulating him to summon up his powers of resistance and to prove himself by undertaking certain specific tasks. This occurred in the following way: in 1863 when Cézanne first came to stay in Paris, Manet was already the centre of all discussions on art. He occupied the place which Courbet had held before him, he was the leader of the modern movement. The young painters of the *avant-garde*, themselves only just beginners and busy trying to discover their own style, all took his side, standing up for him and for the originality of his theories. They did not worry about the 'vulgarity' of his models, which enraged the general public; they were excited by Manet's manner of painting, by his freshness and verve—it seemed as though the true art of painting were being reborn. Zola had taken up the cudgels for Manet with the whole power and brilliance of his eloquence and had defended him passionately against the public and the reactionary critics.

What was Cézanne's attitude? Undoubtedly he too must have recognized Manet's skill, but there is no written evidence that he shared his friend's unrestrained enthusiasm for this outstandingly skilful artist's achievements. And Zola, who at that time knew

Cézanne's views very accurately, was aware that Cézanne had some reservations *vis-à-vis* Manet. For among the preliminary notes for *L'Œuvre* there is one which says 'Claude (that is, Cézanne) thinks there are only two worthwhile painters, Delacroix and Courbet'. On this point, however, Cézanne's pictures themselves speak an even plainer language: in them he did not adopt the style of Manet but only certain of his themes and these he did not take up as a basis for his pictures but as a challenge.

There is no doubt that Manet as a human and social figure—the *bourgeois* with the style of a dandy—the triviality of his work, the elegance of his *sujets*, his capacity to excite attention and to create a leading position for himself, all these things were an irritation to the young Cézanne; quite simply they made him envious, for he did not yet properly recognize his own vocation and was quite in the dark as to the rôle which he was destined to play, and so he probably believed that the artist he saw before him was occupying the place which should have been his. Yet at the same time he felt in his heart that he was superior to this greatly admired man, who, in his eyes, made things too easy for himself in many respects. He attempted, therefore, to defeat him on his own ground by taking up Manet's new motifs—and, what is more, those which had caused the greatest sensation, the *Déjeuner sur l'herbe* and the *Olympia*—and representing them in his own way (cf. Chapter II). In the sphere of still-lifes, too, he took up the battle, everywhere opposing Manet's lightness with his own heaviness, Manet's brilliance with his own gloom, Manet's malleability with his own violence, Manet's radiance with his own dreariness. This, however, did not take place until a considerable time after Manet's pictures had appeared. It was only in the 'seventies that Cézanne painted his 'black' still-lifes, his *Modern Olympia* and his *Déjeuner sur l'herbe* (Plate 38)—in fact, after he had found his own mode of expression[39]. With these gloomy and violent pictures he outdid Manet in a double sense, first by the weightiness of the entirely new personal content which gave these pictures an importance such as Manet's art never knew at any time, the overwhelming sense of a personal testimony to the heaviness of matter and of a tremendous suffering; and secondly by structural unity and completeness, by substituting an entity from his imagination for an extract from nature. This came out most forcefully in the 'black' still-lifes: pictures which were already dominated by the 'standing together' of objects, in which all the objects depicted had already acquired an equal validity and impor-

tance. Because of this, objects now no longer lay, as with Manet, on a tablecloth which merely served as an underlay and, from an artistic, compositional or functional point of view was of negligible value in comparison with them; instead, the folded or crumpled table napkins or table tops now possessed a significance of equal value to that of the fruits, utensils or other objects in the composition. In pictures of people painted at this time the personal element, the soul's need, might still be the principal determining factor; yet if one looks more closely at the structure one can discern the same process in them too. A quite distinct method of composition, radically different from Manet's manner, was asserting itself; musically speaking, a polyphonic phrase had now emerged in which several subject themes were developed against one another and interwoven with one another, instead of one slender melody.

It might perhaps be thought that it was Manet who helped Cézanne to overcome the touch of sentimentality which cropped up in many of his earlier pictures and which one can also perceive now and again in Courbet's pictures, the romanticism of realism, with which indeed Manet was the first to make a clean break. In its place, however, Manet left only a void, an absence of feeling; Cézanne, on the other hand, although he never reverted to a feeling of sympathy with his subject, nevertheless did not ever in later years create his compositions in a completely cool mood, but was always inspired by the deep excitement which accompanies all searching after and insight into the truth of the real world. In sensing and finding this truth he overcame whatever tendency towards sentimentality he had at first had. So in this respect too he kept himself independent from Manet.

All the same, in a historical context these two artists, though not dependent on one another, can be seen to be a couple of experimenters and discoverers, working independently of one another, on the problem of how to maintain flatness of surface in a type of painting which has been developed to the full in relation to space and volume. Both solved this problem in a new manner, based on a special way of exploiting colour, yet different in the case of each artist. Cézanne did not carry on with Manet's shadowless method of painting, in which the light-dark modelling of volumes was suppressed. He made both flatness and strongly plastic images visible at the same time, by bringing out in objects relationships of colour and form which were independent of the objects themselves and which had a non-spatial relationship to one another. But both

methods belonged to the series of paintings of 'The Cardplayers' whose influence was so inexhaustibly rich (cf. Chapter II)[40].

At the beginning of Cézanne's artistic career, in addition to objectiveness (realism) and aliveness (naturalism) still another, a third, way of portraying the real world in paint made its appearance. From 1874 onwards those who adopted this method took the name of impressionists. They saw nature as luminous, transfigured by and surrounded by light, and objects as themselves the 'deeds and suffering of light', namely as pure colour phenomena. Most of the members of the group who adhered to this conception were landscape painters. Their leader was Monet and they had developed their method by following the example of Jongkind, Boudin and Bonnington. They were of the same age-group as Cézanne. Although he had already met them all during his first years in Paris, he had nevertheless not had any close contact with them for almost ten years. At the end of the year 1872, however, he sought out the eldest of them, Camille Pissarro (born 1830), who was living in a small place called Pontoise, north-west of Paris, expressly in order to work in closest conjunction with him for two years. This decision had a vital influence on Cézanne's artistic career.

The reason for it lay in the new attitude to nature which Cézanne apparently acquired during the war years 1870–71 when, working alone on the Mediterranean, he had progressed to a point where he was faced with the problems involved in creating a type of landscape painting which he intended should illustrate the essence of nature through the portrayal of natural phenomena. He had not been able to find more than a partial solution to this idealistic task which was then taking fire in his mind. He had failed in his efforts to unify greatness and serenity—which had seemed to him to be the ultimate mission of the artist. He therefore looked around for help and turned to Pissarro. He had known him for a considerable time. The two painters had met each other in the Académie Suisse in Paris as long before as 1861. But during the first ten years of his creative activity Cézanne had not sought any connexion whatsoever with Pissarro's methods. Very probably these seemed to him too limited for his purposes at the time and too moderate; to one of his unruly temperament, which he was at that time driving to the extreme, they were doubtless of no interest. For of all the impressionists Pissarro was the most thoughtful and the one who most insisted on keeping within the limits which he had set himself and

which he respected as being necessary for his art. At that time he possessed, more than Monet or Renoir, the self-control required to keep within a restricted circle of problems and to adhere to methods of representation already tried out.

It was not till about the year 1871 that Cézanne's attitude began to approach that of Pissarro. Not that he shared it, but he had now arrived at a kind of thinking which was akin to Pissarro's, namely that the painter must subordinate himself to nature and receive instructions from her as to how to represent her and not impose his own doctrines on her. This is shown by the landscapes of that period which survive, such as the *Railway Cutting* (V.50, Plate 37) or *Melting Snow* (V.51). In both of these the landscape is already laid out in large groups of shapes, set opposite to one another, which correspond to and balance one another in such a way that a structure of solemn stability is created. Cézanne had, however, not yet attained (his future goal) the representation of the actual 'existence together' and interdependence of things as a symbol of what is permanent, of eternal 'being'. In order to achieve this he needed to find a method which would enable him to create a much more profound unity and homogeneity in a picture. In these landscapes the storm of inner excitement is still struggling against the serenity which reigns when once the artist submits to nature; but all the same the serenity is already there, is announcing its presence, and with it there comes a deeper insight into the relationships between things seen. The separate groups of forms are still agitated by the temperament of the artist who is reproducing them, yet they are held in firm bounds in relation to one another, established and built firmly into space; they stand opposite one another as though waiting. Passion no longer rules over the composition *as a whole*. Now the artist is seeking to give expression to a new relationship.

Pissarro seemed to possess a guaranteed method of producing this relationship pictorially. Cézanne felt that all that mattered was to learn this method—even if Pissarro's way of putting a picture together and so giving it coherence were a different one from that which was floating in Cézanne's mind. His method could at least indicate a path along which it would be possible to go further. So Cézanne made his way to Pissarro with the intention of serving a delayed apprenticeship with the master nine years older than himself.

From the painter Louis Le Bail we know what were the instructions and advice which he received there. Le Bail's writings date

from the years 1896–97 but we can assume that there was nothing different about Pissarro's teaching even twenty years earlier. For, as Pissarro's letters prove, he scarcely altered his basic conceptions of painting methods even when he attached himself for a few years to the pointillists. In what follows we can see that Pissarro's opinions were valid both for impressionism and for neo-impressionism. According to Le Bail[41] then, this is what Pissarro advised: 'Seek out for yourself a type of nature which suits your temperament. One should observe forms and colours in a motif rather than drawing. It is not necessary to accentuate the forms. One can realize them without that. Accurate drawing is dry and destroys the impression of the whole, it annihilates all sensation. Do not make the bounding lines of things too definite; the brush stroke, the right shade of colour and the right degree of brightness ought to create the drawing. With a mass, the greatest difficulty is not to give it an accurate outline, but to paint what is to be found within it. Paint the essential character of things, try to express it with any kind of means you like and do not worry about technique.

'When you are painting, look for a clear object, see what lies to the right and left of it, and work at all sections simultaneously. Do not work piece by piece, but rather paint everything at once, applying paint all over, with brush strokes of the right colour and brightness and observe in each case which colours are near to the object. Use small brush strokes and try to put down your observations directly. The eye should not be fixed on one point but should note everything, and in doing so observe the reflections which colours cast on their surroundings. Work at the same time on the sky, the water, the twigs and the ground, bring on everything evenly and go on tackling everything unceasingly again and again, until you have achieved what you wish. Cover the canvas in one sitting and work at this until you can find nothing more to add to it. Observe accurately the aerial perspective, from the foreground to the horizon, the reflection of the sky and of foliage. Do not be afraid to apply paint, make your work gradually more perfect.

'Do not proceed according to rules and principles, but paint what you see and feel. Paint strongly and without hesitation. For it is best not to lose the first impression . . . one must have only one master: nature; one must always ask her for counsel.'

There is no doubt that Cézanne accepted much of this advice. In his unfinished pictures we see traces of it to this day. Certain of Cézanne's own instructions to others on the right way to paint also

coincide with those of Pissarro. First there is the belief that colour should come before drawing, the idea that the right colour in the right place produces the drawing, i.e. the precise shape of things. Then there is the method of developing things as masses; not starting out from hard bounding lines but from flexible indications of plastic formations, from 'what is within the outlines', that procedure which later led Cézanne to construct the composition of his pictures out of masses composed of shadows and shadow-paths. Then there is the need to take the whole surface of a picture equally into consideration (never to paint one separate section to a finish and the rest afterwards, added piece by piece) which can be seen at every phase of execution of his pictures better in Cézanne than in any other painter. Very important too is the reference to the need always to pay attention to the colouring of adjacent areas when recording particular shades of colour observed in nature. Cézanne, we find, observed this rule and very often with extreme eloquence; indeed, it alone makes a certain part of his method intelligible: that is, when alongside a *forma*tive brush stroke of colour or a *forma*tive juxtaposition of colours he suggests purely colouristic 'continuations' in the direction of the centres of things. Then there is his use of small brush strokes, his observation of colour reflections. And lastly the fact that he recognized nature as the only master to whom he would put questions again and again.

Pissarro gave Cézanne all this and with it a generous share of his own methods. His counsels were moreover not only useful in themselves and already tested in practice—they had yet a further and entirely different significance for Cézanne, namely, that in part they were not new at all but were carrying on the tradition of French painting, as now developed into a 'refinement of painting', the antithesis of the rigid rules of the Académie. Thus through Pissarro Cézanne not only acquired a guaranteed and tested technique, but also a contact with the living tradition of his day. All in all then, he derived a quite extraordinary benefit from his spell with Pissarro, which had much to do with his later progress.

He was obviously also well aware of this himself; even in the last years of his life he described himself as a pupil of Pissarro[42]. And it was in 1905 that he uttered the now famous words of praise: 'le humble et colossal Pissarro'[43].

The nature of the relationship between the two painters during their shared studies in Pontoise and Auvers-sur-Oise is indicated in a letter from Pissarro to his son Lucien dated 22nd November,

1895[44]. On the occasion of the first exhibition of Cézanne's work organized by Vollard an article by Camille Mauclair was published, about which Pissarro then wrote: 'You will see how badly informed Mauclair is . . . there is no doubt that Cézanne was at first influenced by Delacroix, Courbet, Manet and even by Legros, as we all were; in Pontoise he was influenced by me and I by him . . . in this exhibition of Cézanne's works at Vollard's there are certain landscapes of Auvers and Pontoise whose similarity with mine is striking. Of course we were always together; but of this you can be certain: each of us preserved the one thing that really mattered, his own feeling ('sa sensation'). That could easily be proved.'

With this description Pissarro hit on the truth most accurately: Cézanne's pictures of that period were painted under Pissarro's influence, but Pissarro's works of those years showed the influence of Cézanne, namely a firmness in construction which was otherwise lacking in his *œuvre*. Nevertheless, in the relationship between the two painters Pissarro was the one who gave by far the most. Cézanne subordinated himself entirely to him. He even copied a picture of Pissarro's, a view of Louveciennes (V.153) and painted several motifs side by side with Pissarro (for example V.137 and 172, Plates 39 and 40). Pissarro's influence showed itself in various ways, in part transitorily, but in part permanently. For example we now find Cézanne employing for a short time in his landscapes the scheme of composition often used by Pissarro, a combination of near and distant views, starting directly at the feet of the painter. The practice of choosing to paint this kind of nature scene, of which there are many examples among the pictures of the impressionists, was undoubtedly a consequence of the capture of perspective in photographs. Before the invention of photography scenes of this kind were unknown in painting. They embrace a section of space such as a camera would take in in one exposure, but which the human eye on the contrary could only put together by combining two views, that is, by being first cast down and then raised to the level of the horizon. The relevant extract shows the vanishing lines of perspective (which link the depth of the scene to the standpoint of the spectator) rapidly diverging and falling away in the foreground, i.e. close at hand[45].

Perhaps these perspectives composed of a combination of near and distant views held some special attraction for painters; certainly they opened up landscapes in a new way, making them natural and easily accessible. From the standpoint of the spectator pictures

unrolled visibly and perceptibly without hindrance and without difficulty. However, because of this very quality these perspectives did not conform to Cézanne's interpretation of nature and so, as we shall now see, he altered them immediately he took them over from Pissarro. An important problem faced him here. When he began to paint in Pontoise, he had not yet discovered what his definitive attitude towards landscape was to be. That is to say, he had not yet mastered the problem of how to place his ego at a distance from its surroundings, which it is important that every artist should solve. He had started on some near views (V.26–48) in which his '*tempéra-ment*' caused him to mangle the details with fierce brush strokes and violent application of paint. Here, too, a revolution ensued in 1870. *The Railway Cutting* (Plate 37) and *Melting Snow* (V.50 and 51) were the first distant views which he *developed as unities*; his eyes had been opened to breadth. He had now found his standpoint, though it was based more on feeling than on actual experience. He was still not yet basing the compositions of his landscapes on inner relationships but on masses of volumes, which he linked with one another, so he had not yet succeeded in establishing his real (spiritual) attitude in relation to distance, which illustrates the spatial 'openness' of the earth. Pissarro had a ready-made solution for this problem—one in the tradition of Corot and under the influence of photography; and Cézanne tried to follow his example. But an inner resistance prevented him from reducing the problem to the Pissarro formula. He could not combine foreground and distance in one view, for distance as a symbolic form had become of the greatest importance to him. When, therefore, following the example of Pissarro, he painted pictures with roads, he thrust the motif away from himself and his standpoint; he removed it into the distance, suppressed the foreground and painted a smaller extract. This is clearly illustrated in V.137 and 172, paintings of motifs which are also to be found in pictures by Pissarro (Plates 39 and 40).

Now, however, under Pissarro's influence, Cézanne began to use a brighter palette and more harmonious colours; above all he painted his pictures from beginning to end 'in the presence of nature', keeping the various forms and colour relationships under continual observation, attenuating the masses of shadow and employing light colours even to reproduce dark areas. It is true that an echo of the massiveness of Courbet can still be perceived in Cézanne's most famous picture of this period, the *Maison du pendu* (V.133), but he used that dense painting technique here to create

new colour harmony; the colour scale was narrowed, it embraced yellow, orange, cinnamon, madder, blue, green, light or (in musical terms) 'high' notes. This is the inevitable consequence of painting in full daylight. The deep tones of the palette—the colours of night and of the earth—are missing. In exchange a refinement of the degrees of tone now appears—something at which Pissarro had particularly aimed[46]—and this was a decisive step forward in Cézanne's development. Simultaneously Cézanne began to study how the light of the open air affected both the forms and the colours of objects, not so much its power to decompose as, in accordance with the tradition of Corot followed by the early Pissarro, the power which reflections had to conceal and thereby to condense. In common with Pissarro however, Cézanne refrained from reproducing things by suggestion, from disregarding their material substance. Instead, he sought to capture their forms by quietly observing them. This he did with greater intensity than Pissarro, because he penetrated to the forms on which the entire outward appearance of things was based and related these forms to one another, placing them in unambiguously visible relationship to one another. He had scarcely familiarized himself with the new method when he was already surpassing Pissarro by the attainment of a quite exceptional plastic differentiation and by his capacity to organize a picture two-dimensionally and three-dimensionally at the same time; his clearly defined solids stood out from Pissarro's frequently uncertain and timid forms, as did also the firmness of his solids from the soft substance of Pissarro's, which deprived all objects of their weight. When both painted the same motifs they gave them a different significance; with Pissarro they remained the external appearances of things seen, with Cézanne they became symbols, evidence and fulfilment of an inner meaning which was revealed in them.

Compare *L'Ermitage à Pontoise*, painted by both: Pissarro gives us (Plate 39) a charming view of a landscape seized in passing and enlivened by people: Cézanne offers (Plate 40) a lonely monument, a composition of houses and trees constructed like a piece of architecture, the parts of which are firmly fitted into one another with the utmost skill. Cézanne's picture embraces only a part of Pissarro's motif, the foreground has been cut off and the whole has thus been pushed away from the spectator. The hard line of the edge of the road, drawn to cut diagonally across the picture, also prevents the eye from advancing easily into the depth of the picture. The motif

has lost its power of attraction. Now, the *further* the foreground is withdrawn, the *nearer* the distance appears. In Pissarro's picture we see the group of houses comfortably sited right at the back of the row of trees, which give them a friendly frame; in Cézanne's picture they are hemmed in between the trunks of the trees and stripped of their homely character, just as the trees have lost their character as vegetation; the interdependence of forms thus becomes more important and has a more potent effect than the particular way in which the houses are constructed, and the group of houses is thereby endowed with that 'symbolic' value which distinguishes all objects in Cézanne's paintings[47]. In Pissarro's picture the significance of the experience of real things is reduced from visible forms into something even more superficial, phenomenal and ephemeral[48], into the mere effect of a fateful light approaching them from outside, fateful because their weal and woe, their 'state of health', depend on it, its coming and going; in Cézanne's picture, although this was only 1873, the significance of the experience is taken beyond the visible forms into the things themselves and into their 'existing side by side', into their inmost essence and what is permanent about them.

It was only much later that Pissarro began to gain an insight into the difference between himself and Cézanne which we are here examining, and he was never granted the power to portray in his works that something else which Cézanne possessed and he did not. However, in a letter to his son Lucien sent from Éragny on 26th April, 1892[49], he wrote: 'I am more than ever in favour of impressions from memory: with them one preserves less of the thing (the reality) itself—the vulgarity about them vanishes and only the truth we glimpse and sense remains freely floating in the atmosphere'[50]. To gain a victory over external and everyday impressions, for the sake of the truth concealed and to be discovered in objects, was from the very outset something dear to Cézanne's heart. It was an error on the part of Pissarro to think one could capture this truth by painting from memory. Whether memory preserves the essential or not depends—generally speaking—on whether one has access to the truth from the beginning. In this particular case of painting scenes from nature, Cézanne possessed, he guessed at, he perceived, he sensed the true nature of things from their outward forms and appearances, regardless of whether he was working from nature or from memory. Possession of this inkling gave him a starting point for his painting and even pre-determined the impressions which he

received from the real world; it guided him by the process of 'realization' to this very truth.

Through Pissarro Cézanne came into direct contact with impressionism. Though he actually imitated Pissarro in certain respects, yet he deviated from the ideas of the impressionists in his fundamental attitude to nature and in this contradiction lies the reason why Cézanne's attitude to impressionism cannot be described in one word. It is impossible to say whether Cézanne was at bottom an impressionist or not. 'We must refrain from such a simple verdict', as Novotny stipulated in 1938[51]. 'Such a simplification does not elucidate, but rather confuses the issue, since it cannot do justice to the multiplicity of points of agreement and points of contradiction'—to quote part of the same passage by this author. It is also no solution to say, for example, that Cézanne employed impressionistic methods for a period but then replaced them by new technical 'discoveries'. Cézanne's fundamental divergencies from the impressionists were already in existence when he adopted their methods, and they continued to exist. On the other hand, we do find that, however far Cézanne later moved away from impressionism, he always retained certain constructional features of this form of representation, such as the predominance of colour over line and the obvious 'small structure' design (which contains the essential elements of the composition of a picture, such as the transformation of shadows into series of colours and colour contrasts). But if we look deeper we find that in fact there was an irreconcilable antithesis between Cézanne and Pissarro or even Monet, Sisley and the early Renoir.

Gustave Geffroy[52] wrote that impressionism was born out of an ' "exaltation" of the senses'. It was 'like man's pleasure in breathing, seeing, hearing and living'. In fact it was an outburst of freedom and joy; unhampered by the rules of schools or by traditions, and released from dusty studios, painters worked in the freedom of nature, dedicated to her splendid inspiration. To use an expression of Baudelaire's[53], their talents 'portrayed the beautiful hours of life, that is to say the hours in which one feels glad that one thinks and is alive'. In their best works they portrayed 'that almost supernatural state, that intensity of life in which the soul sings where it must sing, like a tree, a bird or the sea'. And indeed their souls did sing 'in the presence of' and out of enthusiasm for nature herself. That was something new and therein lies the basis of their originality. For Baudelaire and the romantics nature was wild, haunted by

catastrophes, dangerous and great and tragic; in contrast to this view of nature, ideal life was peaceful and harmonious, *supernatural*. The impressionists were the first to discover the joyful side of nature, her tenderness, her playful lovemaking, with which at times she surrounds and pampers man. In the time of Courbet, Michel, Rousseau and Millet, nature had continued to be pathetic, melancholy or grandiose, but not joyful and friendly.

But even the impressionists were far from creating reproductions of everyday experiences of nature. Their paintings always possessed the richness, the brilliance, the certainty of lyrical expression. For they were all lyricists, who sang of how their own souls were in tune with nature and of the indescribable enjoyment which this afforded them. They returned to nature as to a lost Eden, in which they rediscovered their own beings, which had now really blossomed. Everything—landscapes, men (whom they saw as flowers and plants) and objects (which their eyes turned into natural beings)—everything was joyfully transfigured for them, concentrated into a 'mixture of *splendour* and *light*'. Therein lay true reality for them, and this was how Pissarro also saw things, although he spoke only with a restrained and almost timid voice.

Cézanne, on the contrary, looked for something else and spoke with another voice. He recognized *shadows* as the fundamental forces for the portrayal of the world; brilliance and light were outside the scope of his colour scales. In shadows he had power, gloom and violence—profound and penetrating insight came later. Moreover, it was not his vocation to be a lyricist; however much he loved and honoured nature, worldly phenomena did not appear to him to be worthy of extolling, and it was not his mission to portray his feeling of joy in natural things nor yet to bemoan his earthly existence.

If we compare passages in letters of Cézanne's and of the impressionists, dealing with their attitude to nature, and if we undertake the task of reading through their works with an eye to this problem, Cézanne appears like a patient worker in the vineyard of a strange master, a giant in strength yet almost a penitent, while the others seem like the masters themselves who rule and give orders in their own property while at the same time working themselves with all their might and main[54].

But if we ask why, then, Cézanne ever became involved at all with the impressionists, then the answer is: because of their dedication to the subject-matter as a whole and to the method of giving

pictorial expression to this dedication possessed by the movement. The impressionists knew how to look patiently at things and to absorb from them an original and vital form of presentation. They understood how to keep their own particular human problems at a distance from their art and 'to become an eye' only, an empty vessel (even if one beautifully shaped by joy), into which nature could be poured. And in spirit Cézanne had also become an empty vessel, a man forgoing his own will by having accepted the destiny of absolute loneliness, that is to say aloofness even from nature. He also had need of a method which would help him to produce artistic creations out of this emptiness (even if it were of quite other significance than the emptiness of the impressionists). The differences between Cézanne and the impressionists were the result of the difference in their interpretation of the significance and meaning of this state of emptiness, of openness, of dedication, of waiting in front of nature (nothing but synonyms): Cézanne's firmness as compared with the looseness of the impressionists; Cézanne's chromatics which modelled and strictly modulated solids, as compared with the impressionists' clever interplay of colours which disintegrated forms; Cézanne's serious nature, his interest in permanence and self-preservation in contrast to their nature which was joyful, or at least cheerful, and interested only in the present moment.

### Cézanne and Symbolism

Anyone can see how Cézanne now gave a new significance to the artistic media used by the impressionists. He retained them in order to portray nature but he exploited them in order to convey meaning or content; he turned them from lyrical forms of expression into symbols. This procedure can also be set in a special sort of historical context.

We know that Maurice Denis attempted to bring Cézanne into association with the school of the symbolists to which he himself had belonged along with Sérusier, Gauguin, Émile Bernard (who was for a period Cézanne's pupil) and Anquetin. This attempt was ill-judged. Not only had Cézanne vehemently rejected the painting of Gauguin and Van Gogh; he had in fact never worked with any colour- or form-symbols which were established from the outset or *ad hoc*. Cézanne did not share Maurice Denis's theory[55] 'that between the colours, the forms and the beauty of the painted surface on the one side and our ideas and our feelings ('émotions') on the other

there exists a whole number of points of correspondence, which the artist seeks to expose ('dégager')'. For him there were no ideas and no feelings which his painting could and should lay bare, at least none such as could be described as 'ours', that is to say universally known and ordinary. What he was concerned to do was to show objects themselves, directly expressing some superior mystery. Whether one preferred to call this an idea or a feeling, it was at any rate the idea and the feeling of the objects themselves in their 'existing together' in relationship to a world and not something already known from some other source, which might have been brought in from outside, and which might have been made analogous through colours or forms.

But it must be said that the art of the symbolist painters about the year 1900 was not based on genuine symbols: on the contrary it merely contained allegories, colours and forms which were never wholly integrated with the intended meaning, that is to say the real meaning of their representation as a whole, but which retained an existence of their own up to a certain point, and within which the symbolical element was borne simply as a supplement to the things depicted[56].

Nevertheless this tendency in painting expressed a genuine trend of the period, the urgent aspiration to succeed in producing a kind of art which would go beyond mere representation of nature, an art filled with meaning and as momentous as had been the art of the 'Masters of the Museums' whose style actually made their creations into works of art, endowing them with a deeper meaning.

Cézanne had had an inclination towards this kind of symbolism of style (or of overall conception) from the beginning and long before the emergence of that group of painters who called themselves the symbolists. Even in his most maladroit early works he transformed the things which appeared in them into metaphors, into representative appearances—and he did this (as we have shown) for the purpose of his own needs and dreams. Later the basic theme changed; the problem of world harmony was given a higher place than the ego, but the objects retained their metaphorical character none the less. The highly intelligent Gauguin sensed this extraordinary fact at a time when it lay unnoticed by all others. This is shown in a passage from a letter published by Rewald, written to Pissarro in the summer of 1881[57]. There we read: 'Has Cézanne found the precise formula for a work, which is acceptable to everyone? When he discovers the prescription for condensing the power-

ful expression of all his feelings ('sensations') into one single process, then try to make him talk in his sleep by giving him one of those mysterious homoeopathic pills, and come straight to Paris and impart his own secret to us'. Gauguin recognized that the unusual power of Cézanne's works, their individual style, their weight and their seriousness, which surpassed the art of the impressionists, the realists and also the naturalists, was derived from the intense power of expression of his *sensations*. Cézanne 'manufactured' nothing with his mind, he invented nothing, he painted merely what he perceived. But—he perceived in an entirely individualistic way. And he possessed the *formula*, a method of expressing in painting his perceptions—feelings—understanding, that formula for which at the same time he went on searching, with the aim of making it ever more universally comprehensible, more comprehensive, more logical and therefore absolutely compelling for all. This formula was based on the whole, the sum total, of his perceptions (whereas the impressionists etc. played about with their perceptions, adding to them and subtracting from them): Cézanne's formula was the medium of expression for the symbolical exposition of the real world as a sign (as we have already shown) of the unshakeable objectiveness and unshakeable 'existing together' of objects. It emerged in his art in various forms, without however changing at the core. What was novel about it was that it turned all external appearances of real things into a symbol of 'being', 'which is eternal'.

By this original type of symbolism Cézanne attained an artistic consistency which was radically different from that of symbolical painting (at which Gauguin laboured). As Gauguin sensed that Cézanne alone was on the royal road, one can understand his desire to get at his secret.

But Cézanne's symbolism actually belongs to a quite different historical context. It is essentially akin to the poetry of the French symbolists which was flourishing during his lifetime. Here we have to do with an authentic case of spiritual synchronization, which enables us to recognize the interrelationship of different manifestations of the spiritual life of a people in a particular epoch. There is no question of any derivation or influence; we are dealing with the homogeneity of the spiritual life of a nation, being manifested in various fields simultaneously and in particular in the deepest stratum of aims and realizations, far deeper than differences between material and medium and between the ways in which different

individuals are attuned to life. In order to show the relationship between Cézanne's art and the works of Mallarmé, Gérard de Nerval, Villiers de l'Isle Adam or Verlaine, let me quote some statements from Arthur Symons' book, *The Symbolist Movement in Literature*[58]. According to Symons, 'symbolism . . . is an attempt to spiritualize literature, to evade the old bondage of rhetoric, the old bondage of exteriority. Description is banished that beautiful things may be evoked, magically . . . mystery is no longer feared, as the great mystery in whose midst we are islanded was feared by those to whom that unknown sea was only a great void. We are coming closer to nature, as we seem to shrink from it with something of horror, disdaining to catalogue the trees of the forest. And as we brush aside the accidents of daily life, in which man and woman imagine that they are alone touching reality, we come closer to humanity. . . .

'Here, then, in this revolt against exteriority, against rhetoric, against a materialistic tradition; in this endeavour to disengage the ultimate essence, the soul, of whatever exists and can be realized by the consciousness; in this dutiful waiting upon every symbol by which the soul of things can be made visible; literature, bowed down by so many burdens, may at last attain liberty and its authentic speech.'[59]

In these words I hear an expression of the most profound significance, the characteristic element of Cézanne's paintings. His interest was spiritualization, his constant worry was to evade the rhetoric, the pathos and the exteriority of the picture of everyday. He looked for the mystery, which leads out of the appearances behind appearances with a mixture of mystery and candour and which makes description impossible, in order to reveal truth through the beauty created by the artist. We have seen how he, more than any other artist, 'shrank from' nature and he it was who stripped the oaks, chestnuts, willows and cypresses of their names, or their identity, and in their place painted trees and thereby came closer to nature in an entirely new way; he it was who also turned his eyes from 'the accidents of daily life' in his art and thereby captured humanity as it was given to and imposed on his time.

'To evade the old bondage of . . . exteriority'—this is an expression of which we must take special note in order to retain in our minds the difference between Cézanne and the realists, naturalists or impressionists, and in order to express the meaning of his study of reality. Nothing can describe his purpose better. And the reason

for his avoiding exteriority was, precisely as Symons puts it, that Cézanne did not fear mystery, but had indeed understood the meaning of his lonely existence—as 'an islander'—and so had obtained a sight of the mystery. 'To him, physical sight and spiritual vision, by some strange alchemical operation of the brain, were one'[60]. On the other hand, it was this need to avoid exteriority in his artistic work which compelled him to pause and study with infinite patience the *interrelationship* existing between things *before* looking at the things themselves, until the separate objects emerged out of what united and bound them, to play their symbolic rôle in the picture as a whole. The result was that the process of painting became a process of realization (i.e. of construction and of con-figuration, giving things their full appearance and at the same time their true significance). That was how Cézanne achieved 'authentic' painting, free from every other purpose—not just 'pure' painting but its extreme antithesis, symbolical painting in which the process of construction itself was turned into something completely sym-bolical.

When that happened, however, something remarkable, or, it would be better to say, something natural and therefore worthy of consideration, emerged. This type of painting, which, like the literature which corresponded to it, had cast away so many burdens, obligations and ties, took a heavy load upon itself; 'for in speaking to us so intimately, so solemnly, as only religion had hitherto spoken to us, it becomes itself a kind of religion, with all the duties and responsibilities of the sacred ritual'. What Symons here says about symbolical poetry many people have already felt when faced with Cézanne's works: I would remind the reader only of Roger Fry's words about *The Cardplayers* (quoted in Chapter II, page 90).

To quote a further parallel: writing about Mallarmé, Symons said that it was essential that in every poem 'every word is a jewel, scattering and recapturing sudden fire, every image is a symbol, and the whole poem is visible music. . . . Words . . . are of value only as a notation of the free breath of the spirit; words, therefore, must be employed with an extreme care, in their choice and adjustments in setting them to reflect and chime upon one another. Yet least of all for their own sake, for what they can never, except by suggestion, express . . .'[61]. The word . . . is so regarded in a magnificent sense, in which it is apprehended as a living thing, itself the vision rather than the reality; at least the philtre of the evocation'[62]. Cézanne's colour-form images correspond to the words of a poem; they flow

together to form an entity of visible music; their rôle is to be a means of conjuring up a true picture of the real things depicted and never just to be there for their own sake, as were for example the beautiful colours or interesting linear figurations of other masters. 'The word, chosen as he, the symbolistic poet, chooses it, is for him a liberating principle, by which the spirit is extracted from matter'[63]. Cézanne proceeds in a similar manner with his colours. Mallarmé's artificiality in the use of words finds an echo in Cézanne's unusual way of coordinating colour-forms and with both of them this way of doing things is 'the paradoxical outward sign of an extreme discontent with even the best of their service'. Thus Mallarmé does away with normal syntax and Cézanne deviates from traditional perspectives, from the customary forms given to natural things, from the accepted distinctions between nearness and distance.

This analysis of the process of symbolistic writing enables us to appreciate correctly the important individuality of Cézanne's creative methods, which I have emphasized when discussing his use of colour shadow-paths to sketch the scaffolding forming the foundation of a picture, namely, the fact that an unbroken rhythm supports and holds together his compositions. Symons writes of Mallarmé that a 'sensation begins to form in his brain, at first probably no more than a rhythm'[64]. Into this rhythm of the whole he invents the thought-associations—the words are only gradually formed out of it by the poet; this process, the establishment of relationships between conceptions and pictures, has to be executed accurately and 'with an extreme care, lest it should break the tension on which all depends'[65]. So the exact relationships of colour and form in a picture, and simultaneously the objects being represented in it, grow only slowly out of the rhythmical images with which Cézanne's realization started. They must all be subordinated to the rhythmical tension and remain so, as Cézanne's pictures show and as he himself expressly said; it was for the sake of this basic rhythm (as he said to Vollard) that he could not entrust even the smallest spot of colour to chance.

In Cézanne's mind too the ideal of the symbolist poets floated as an aim, 'a flawless unity [from which] the steps of the progress have been only too effectually effaced'[66]. In his case, of course, this did not mean, as in the case of the academicians, the evocation of a unity of a mirror-like surface created by smooth obliteration of colour, but the production of an unbroken continuity, an objective image, from which the traces of its origin were erased in favour of

the relations of clearly separated degrees of colour in a fixed formal arrangement—separated strokes of paint, but with a significance quite other than, for example, those of Manet or of Frans Hals.

Cézanne obviously must have shared certain inner experiences with certain symbolist poets; for example with Mallarmé and Gérard de Nerval the knowledge that there are colour-form formations (as words) which have such an effective power of suggestion that they bring about a basic frame of mind for recognition of the truth; that a work of art should be 'not a hymn to beauty, nor the description of beauty, nor beauty's mirror; but beauty itself'[67]; yet the beauty of a work of art must not owe anything to the subject, but must exist in itself as truth realized in form. *This* kind of beauty contains and is the sole reality and thus the sole universal thing, which gives expression to a world. That is why Cézanne knew, as did Villiers de l'Isle Adam, 'that there is . . . no other universe than that conception thereof which is reflected at the bottom of' the thoughts in his pictures. In order to capture this aspect of the world, Cézanne had to 'hasten to become an intelligence free from the bonds and desires of the present moment.'

He was, as Symons says of Verlaine, 'a man, certainly, "for whom the visible world existed" but for whom it existed always as a vision'[68]. Cézanne's vision was, as I have shown, buried in the completeness of his *sensations*, in their interrelationship, in which the 'existence together' of things was made plain, an 'existence together' which was not only *more* than but something quite *different* from the sum of many perceptions however widely shared. And after a long time of struggle and of oscillation between victory and defeat there came for him too the 'moment when the phenomena of our customary consciousness, what we may call the consciousness of the passions of our normal relationships, no longer mean anything to us, no longer touch our real life'[69], that is to say his artistic life. This moment arrived when Cézanne accepted the utter loneliness of the creative artist. At that moment life, everyday life, became for him something unreal 'and his spiritual world became reality for him'. In later years, wherever he was, he talked only about painting, lived only in the world of his art. 'He . . . endured . . . what others called reality'[70], though for him the 'real' point about it was loneliness, the point from which genuine reality was revealed to him.

Realism, naturalism, impressionism, represented by Courbet,

## Cézanne's Composition

Manet and Pissarro; opposed to them Cézanne, in contact with all three, his art owing much to them in important features; the historical position is, however, marked by both interrelationship and contrast. The latter is significant for judging Cézanne's art as a whole. His painting went far beyond the circumscribed goal set by each of those three art movements, though it imbibed important inspiration from each separately. What was universally new about his art was brought out most clearly by his mode of composing a picture, for he set himself a task which embraced all others, treating figures, objects, space, planes, colour and line as mere media and, more exclusively than any other artist, he expressed his 'philosophy of life' through his *composition*.

### Cézanne's Composition

The significance of Cézanne's style of composition has not hitherto been properly appreciated. The term is indeed usually taken to mean merely the disposition of solids in space and on a surface by different methods or while giving preference to different methods, though, of course, the rôle of feeling in the distribution of masses may also be taken into account and the whole process is not necessarily regarded as a mere balancing of accounts between full and empty, heavy and light, near and far, above and below, right and left and such like. Nevertheless, in order to understand the real significance of Cézanne's style of composition we must radically alter our attitude towards the problem of composition in the visual arts as a whole, for by elevating it to a symbolical form he introduced something entirely new into his compositions. A few sentences of Théodore Rousseau's[71] may throw light on the subject, for although he puts it in a romantic style he does express what is universally essential in a quite excellent way. Rousseau distinguishes 'délinéation' from actual 'composition'. On the subject of the difficulties of perfecting the *composition* of a painting, he writes: 'The notes have long been completed; but under "composition" I understand what is in us and what penetrates so far as possible the outward appearance of real things. If it were otherwise a mason with a ruler could rapidly execute the composition of a picture which portrays the sea. It would suffice to draw a line across the canvas at whatever level you please. Who else then is to compose the sea if it is not the artist's soul? . . . We have a composition in front of us when the objects depicted are not there for their own sakes but in order that

they may contain ('contenir'), within the picture of things in nature, the echo which they have evoked in our souls'. The reaction which objects arouse in the soul of an artist is uncertain; it changes; one thing is sure, however, and that is that the artistic composition of a picture originates in the soul of the one who creates it, in the soul's conception and understanding of things. The composition therefore consists only apparently of the distribution of measurements and weights of shapes on the surface and in space, its essential element springs from the meaning of the representation and aims at illustrating this meaning. But before Cézanne's time every picture as a whole was composed of a pattern which started with objects and was concerned with a disposition of objects which had first been developed as single items by the painter. Once he had these constituent elements, i.e. the forms of solids and space, thus available and at his disposal the painter used them for his compositions, for the building up of a picture as a whole. If it is true that the method of construction in a particular picture depends on the meaning—the significance, which is expressed by the forms of the solids in it—none the less, each such composition as a whole first has its centre of gravity or point of origin in some established image ('established' as a shape and in its position), which fulfils the function of a theme, whether it be a figure, a part of a figure, a group, or some other type of subject-matter; and every composition is thematic, that is to say, evolved in relation to a theme (along with subsidiary themes which may also appear). Thus, then, the central theme of all compositions of earlier times was either a solid or a group of solids and the whole composition was at any given time in turn developed from them and towards them. In other words, this composition unfolded that theme to the point of complete fulfilment with the available subject-matter, within the space and surface of the picture. But Cézanne now introduced a complete reversal of this process: in his works the forms of objects were never established at the outset, each emerged only as the product of the scheme of composition as a whole, whose theme was the union between things, their being bound to one another. In Cézanne's case therefore, the theme was not an object, not an assembly of solids, but a universal potentiality of all objects, something intermediate.

If Théodore Rousseau had already pointed out that composition in its origin goes far beyond the formal and thus *signifies* more than firmness or looseness, simplicity or complexity, clarity or blurring (and such like) of forms, then Cézanne showed even more plainly

the area of intellectual creativity to which the composing of pictorial unities and entities belongs[72].

By reason of Cézanne's historical position, however, there is yet another particular question which must be discussed in connexion with his style of composition, namely, what was its relationship to the actual world of nature, to that 'extract from nature' which he took over as a theme (motif) from the masters of realism, naturalism and impressionism and which he retained, though with alterations?

Since every artistic composition is determined by the significance which the subject depicted (the objects or events) possesses for the individual artist, the 'extracts from nature' which Cézanne selected for himself stimulated him to an organization of his compositions quite different from that inspired in the artists of those movements by the extracts which they chose. That is why, as Novotny correctly says, one must 'see a radical cleavage between the impressionists and Cézanne in relation to the manner of composition of the harmonies of nature portrayed'[73]. Fundamentally, however, Cézanne's extracts from nature do not themselves differ from those of others; both in his works and theirs there are near and distant views, symmetrical and asymmetrical distribution of masses, motifs of diverse richness. The differences lie in the pictorial structure and are the result of his different way of handling the foreground, by drawing the distance nearer, by cutting off the access into the depth of the picture, by making fast each individual object depicted so that it becomes an indestructibly constructed unit built into the 'standing together' with other objects etc. All these are facts, factual consequences of the conception of the real world, and at the same time they constitute the elements of forms which go to make up a composition; last but not least, there are also the forms of solids clearly brought out by means of colours and gradations of colour, in contrast to the vivid dissolution of forms effected by the light of the impressionists. The direct consequence is that in the one the structure of the composition is concealed, in the other it is brought out emphatically.

Up to this point we have been demonstrating Cézanne's *position* in the historical foreground (that is to say, in relation to his own time) and his *significance* in relation to several of the leading artists and art movements of his own time. Let us now look at his art in the context of further historical perspectives, that is to say, within the predominant movements of French painting, the heritage of the

past, as they were before Cézanne's time. In doing so we must first record that Cézanne, radical innovator though he was in the world of painting, the man who—let us not forget—shook the foundations on which it had stood firm for centuries, looked backwards a great deal, and that he regarded it as essential to link himself to the great past. Yet as we very well know, he said himself that it was to the art of Delacroix and the art of Poussin that he looked for examples to follow.

The question we must now ask is: what are the facts behind Cézanne's well-known admiration for Delacroix and behind his declaration that the art of Poussin must be renewed 'sur nature'?

### Cézanne and Delacroix

Let us turn first to Delacroix. At first glance the works of Cézanne seem to have very little in common with those of Delacroix. None the less Cézanne's admiration for the great romantic was not merely theoretical. He painted six copies 'after' pictures by the 'altissime peintre' as (according to the evidence of Léo Larguier) he used to call him (V.125, 708, 754, 867, 868, 1623), copies which date from various years during the period 1865–1900, two of them being after originals which he owned personally (V.708 and 754). Motifs borrowed from Delacroix's *œuvre* are to be found only twice in Cézanne's works: *La toilette* (a woman in front of a mirror) (V.254) and in *L'éternel féminin* (V.247, 895, 1207, three versions of the same composition), for which *La Mort de Sardanapale* (in the Louvre) served as model. On the other hand Cézanne painted two versions of a sketch for an apotheosis of Delacroix (V.245 and 891, Plate 41). It is difficult to determine when these two sketches were executed, yet the date is important. Venturi dated the oil study between 1873 and 1877, the water-colour between 1878 and 1885. But there is a photograph of Cézanne, dated 1894[74], which shows him with brush and palette, and on the easel beside him the version of the sketch which he painted in oils. For this reason Novotny advanced the date of this sketch to 1894. Yet its style argues against it having been produced at the period of *The Cardplayers*. Its half-figures, cut off by the lower edge of the picture and seen from the back, make it seem most probable that it originated in the period of the 'pointed hats', which are liberally employed in it, that is to say the 'seventies. That Cézanne might have gone over the earlier draft sketch again in 1894 is—judging by the homogeneous appearance of the picture

in its present form—not very probable; paint has been applied only lightly and there are no corrections to be seen in it. Perhaps when someone asked if he might photograph him[75] Cézanne placed the old study on the easel and let himself be taken with it, in order to record his respect for Delacroix in documentary form, a respect which persisted right up to his death. In a letter dated as late as 12th May, 1904, he wrote to Émile Bernard that he was hoping to execute a painting based on this sketch. The fact that he expressed this intention at least serves to demolish completely the frequently uttered supposition that Delacroix was Cézanne's model only when he was starting to paint, at the time when, full of the romantic exuberance of youth, he had felt attracted to the leader of the romantic school[76]. Actually the connexion remained in existence much longer and existed, moreover, on a quite different level. It was not the exuberance contained in Delacroix's painting, his wildness and gloominess, and the equally exuberant, wild and gloomy spirit expressed in Cézanne's early pictures which formed the bond between the two artists; at bottom they were not really in agreement. Romanticism in the one was a different matter from romanticism in the other. Indeed there is another thing: the question forces itself upon us—was there genuine romanticism on both sides? This is a crucial question and because of the vagueness and ambiguity of the term it is important to find an answer.

## Delacroix and Romanticism

There is no doubt that there were certain typically romantic features in both the nature and the work of Delacroix—the *chef de l'école moderne*—features of romantic realism as well as of romantic idealism. Both are indispensable to the genuine romantic; for romanticism is perhaps at bottom nothing more than a thorough grasp of both these conceptions of life, and a quite special, in fact a romantic sort of fusion of them, and is certainly not a simple and unambiguous thing but a particularly complicated attitude of mind. It is definitely the essence of romanticism to be complicated, indirect and devious in that a romantic always thinks, dreams and acts elliptically, casts himself on the most distant point in order to reach right into himself and to find himself; sinks and loses himself in his own ego (in feeling), in order to attain the ultimate and highest, the truly supernatural experience, absolute truth, perfect beauty, complete innocence. In doing so he lives always in two realms simultaneously, in the heights

and in the depths, in the distance, in the infinite, the indeterminable and in the crude 'present-ness' of his own inadequate and insufficient existence; he is therefore nowhere at home and everywhere a stranger. And what is distant and vague, his dream, becomes something near, the only thing that is sure and real to him in his rootlessness, while his own imperfect existence becomes a splendid and splendidly sorrowful but entirely unreal dream.

Delacroix was most certainly an unusually complicated man, at one and the same time cosmopolitan and turned in on himself, candid and inscrutable, restless, sensitive and passionate, a genius who respected genius and at the same time suffered from it, burned up his life force in order to experience life more intensely, a man of ardent visions, a pathetic character full of pride in his own pathos and for all that at the same time a superior brain, a cool observer. This is how Baudelaire described him: 'Delacroix was passionately in love with passion and coldly determined to look for the medium through which he could express passion in the most lucid manner'. He loved to dream; and he loved to bestow an extremely real and powerful form on the dreams which he summoned up by reading passionate writings, or which were inspired in him by the real world in cases where it could be seen as the reflection of a distant dream world (as happened when he was in Africa). That was why he loved both idealistic and realistic passion and loved the elliptical permeation of his works by both, works which he created in a state of extreme excitement and then analysed with the coolness of ice, so that he might gain new force for loftier and richer fantasies from the vision thus obtained. Similar contradictions are combined in his attitude towards beauty and towards the imperfect real world. He respected perfection of form (in Mozart) and yet feared the lifelessness of all too perfect, entirely transparent forms cast in a standard mould; he shrank from the finality, from the unalterable definiteness from which all possibility of fresh opportunities is excluded. In Delacroix's opinion the beauty created by an artist ought to be a perfect ideal and yet at the same time still open to further unimagined intensification. But the real, natural world, despite all its normal inadequacies in detail, seemed to him more beautiful and more ideal than the perfect ideal because of the strength of its formations; more interesting and more authentic because of its perpetual self-renewal. In his creative work he was constantly attempting to attain beauty by destroying pure, beautiful forms which conformed strictly to the rules, and revitalizing them with

natural forms; not as his academic predecessors had done by means of rules and an ideal perfection which is turned into a law, but by acting with extreme freedom, and bringing his creations forth from the living spirit. But if this freedom was inspired in him by the infinite richness and inexhaustible potentialities of nature and of natural beauties, among which those of his own palette played no small rôle, then he found himself forced back from that position to within the restrictions of his ever alert brain because it hankered after order in appearances and also after transparency and lucidity of form, and found it intolerable to create something which was not distinguished by the nobility of its appearance. Romantic *noblesse* plays a prominent rôle in his work. Even Delacroix's assassins and robbers, even his wild riders and his animals, have something distinguished about them, an ideal grace. He seemed to be conscious of the 'breed' (rather than the single representative of it)—in the sense of 'having breeding'—and therefore he endowed both people and animals with a wildness and a passion for existence which make them surpass real creatures by the ideality of their power of expression and their lucidity. Thus by intensifying reality he forced nobility of appearance increasingly into something ideal and realized an ideal *noblesse* by means of a fire which burned with increasing passion; indeed he even replaced beauty by an ideal distinction, characteristic of the subject portrayed though frequently ugly.

As for the relationship between his creative personality and the theme and form of his works, Delacroix was an artist of extreme subjectivity; he was convinced that artistic production was entirely bound up with the uniqueness of the person creating. This uniqueness in turn he saw with romantic idealism as man's potentialities driven to the extreme, as humanity brought to a white heat, in which reason and feeling were fused into one single ability to see, by force of which he was in a position to appreciate all the power and richness of life and to give it form. But at the same time his subjectivity was by contrast quite romantically realistic in that he made the content and form of art dependent on the predilections of his limited ego. Art was justified only by these predilections and all demands of a general type made by life on art, such as effective service to religion or to the general well-being, were completely rejected. With Delacroix, however, romantic idealism and romantic realism interpenetrated each other in this field too, in an extremely romantic manner. His ego, afire with inspiration, transformed his

own limitations into a comprehensive law-giving force for him; the bizarre, pathetic, indeed pathological ego of the creative artist became the chief law-giver in the realm of art; it alone set all standards, determined the appropriateness of subjects and their formal realization. The public had to submit to his genius and because of its overwhelming mastery was dominated by it.

Genius as seen by Delacroix did not, however, display its secret problems, only its perfected dynamics. In Delacroix's works there is no self-testimony of a psycho-pathological type. He once said to Théophile Silvestre: 'if by the term romanticism we understand the free manifestation of one's impressions, then I am not only a romantic now but was one when I was only fifteen years old'[77]. In his art, then, it is a question of subjective impressions, not inert states of mind.

Nevertheless Delacroix, the romantic, possessed still another and quite different sort of gift and an ambition directed at another goal. This asserted itself in different ways. He did not suffer from the 'inadequacy of real things' so typical of the romantics. In his art there is a great deal of 'gratitude for happiness enjoyed', which Nietzsche described as the source of the 'art of apotheosis', 'of which Raphael and Rubens were great exponents'. Delacroix was also one of the painters who were intellectually akin to those two. Rubens was the model he respected greatly and he also admired Raphael, even if his way of looking at him was different from that of the academicians and classicists. Along with those two masters he stood in the succession of the ancients and, like them, did so not because of any regularity contained in their art but because of the freedom which arose out of being inherently in tune with nature. Delacroix had too an inclination towards classicism, demonstrated in his writings by their lucidity, hardness and naturalness, which actually cancel out his romantic concentration on his own self; in his works this emerges as an element which restrains and limits his romantic passion[78]. In his day this was not by any means unique. True, the smaller talents were at that time either driven right into the arms of romanticism or right into classicism which, looked at from the point of view of its essence, was itself only another form of romanticism. But a one-sided view of this kind did not suffice for any of the great spirits of the epoch, such as Goethe or Schiller, or Beethoven or Stendhal, or Delacroix. They were all romantics with a classical element, which, however, because it aimed at being classical in spirit and not just in conformity with a formal set of rules

laid down by the ancients, stood in direct contrast to the (romantic) classicism of an Ingres or Canova. What the great men of that time hoped to find in the ancients was a stimulus to clarity, powerfulness and naturalness and a great, universally valid conception of nature, not, like David and his pupils, recipes for the beauty of draperies, balanced gestures and perfect, ideal figures which had the effect of intimidating them in their own representations and realizations.

The classicism which, according to a frequently quoted anecdote, Delacroix claimed explicitly for himself, is not easily perceived in his works. Here Maurice Denis led the way, being the first to succeed in discovering the classical element in Delacroix's methods. In *Nouvelles Théories*[79] he examined the relations between painting and imitation of nature in general. In doing so he found that there were two kinds of procedure opposed to one another—'two extreme contrasts: the one group executes imitation in general, the other in detail'. The first was the method of the Greeks which was revived in the Renaissance, the second was preferred by the artists of the northern countries. Maurice Denis then went on to compare the art of Ingres and of Delacroix with reference to imitation of nature. Because of its importance I now quote this passage word for word. 'With Ingres imitation takes place through detail: the personal conception which his drawings express is transferred wholly into his pictures, whose structure ('économie') is arbitrary and whose subject is ideal. With Delacroix the whole painting is born of a strong natural excitement and, whatever it represents, it expresses something living and human; on the other hand the details, far from being taken directly from the model, are drawn and painted in an almost routine way ('chic') that is to say, from memory, after other masters, in accordance with anatomical conventions, in a word: in accordance with a universal and common conception of the natural objects.

'With Ingres memory is weak and apprehension ('vision') direct (from the model). Delacroix's memory is filled to overflowing with forms; in it he finds as in an inexhaustible storeroom all the details which his powerful imagination evokes[80]. That is the procedure of the Renaissance masters, of Michelangelo and of the Venetians. They are familiar with all the elements normally found in their compositions: human bodies, clothing and architecture are known to them and that not from purely visual conceptions, not from fleeting impressions captured by drawing directly from nature, not from a study of nature; they know them with all their senses as

objects, by means of a knowledge which might be called scientific, so far is it from being in any special way artistic. . . . There we have arrived at the centre of classical art whereas we started out from a conception of imitation of nature which Delacroix was the only person in the nineteenth century to maintain.' That is why he described himself once as a 'pure classicist'. And he was absolutely right, for he did not create '*after* nature' with all her details and particulars, but '*like* nature *in general*'; out of that universal understanding of nature which is Graeco-Latin and classical (in contrast for example to the ideas of the Byzantine artists and the northerners up to the time of Netherlands late-Gothic), and which sets a limit to all subjective distortions, a limit which springs from the conception of what is normal and what has grown in a natural way.

Within the difference between the classicism of David and Ingres and the classicism of Delacroix, embedded in romanticism, there is contained still another radical variation between them with respect to artistic construction. Ingres copied details, adding them one at a time and then co-ordinating them; for to him each detail was of equal value within the general conception, and therefore demanded the same meticulousness. On the other hand Delacroix, who wanted to imitate nature as a whole, the essence of nature in its effectiveness, treated the details in a subordinating and super-ordinating manner; he selected those details which would serve him to endow the essence of the whole with special effectiveness, elaborated them proportionally and gave them the place appropriate to them in the composition as a whole.

If it were not for Delacroix's basically classical attitude, it would be difficult to understand why Poussin is to be found[81] among the few artists about whom he has written, and still more to grasp his individual conception of Poussin's art. It is true that he criticized a certain lack of connexion between the figures in Poussin's paintings and also a lack of coloration and colour harmony, yet he praised the truth of Poussin's expressions and of the characters depicted, as well as his good and varied distribution of light. However, there was something about Poussin which seemed to Delacroix even more important and which seemed to indicate something in common with his own nature and ambitions, namely 'the sincerity of his genius in its search for expression and for genuine effects . . . its independence of all convention'. He regarded him 'as an innovator of the rarest kind', in comparison with the Carracci. 'As an accurate and at the same time poetic observer of history and of the human heart,

Poussin is unique among painters'[82]. Thus it was not the contrast of style which stirred Delacroix, but the similarity of character. Yet it is extremely surprising that Delacroix regarded Poussin (and Lesueur) as the two great French masters who 'have pioneered an entirely new road into the future, . . . who are paving the way for the modern schools, have broken with the conventional and have sought at the source itself those influences with which painting is able to work on the power of the imagination'. For this 'source' was nothing more than the painter's personal feeling, his personal power of imagination and of realization—qualities which are formed by actual experience. In Delacroix's opinion then, David, Le Gros and Prud'hon looked to those two 'fathers of French art'; those two 'in a word, laid the foundation for the artist's independence of tradition, in that, with due respect for all that was useful in it (tradition), they taught that one must have the courage to set one's feelings before everything'. It is remarkable that Delacroix should have seen in this way what establishes a link between one great artist and another and disregarded their differences in style, and that he saw that this link was founded on the fact that they shared a historical destiny which imposed on them both the rôle of innovators and liberators. It is all the more extraordinary and noteworthy in that Cézanne in turn did exactly the same in connexion with Delacroix. This proves that there are more and other bridges with which to establish historical continuity than those which we are ordinarily accustomed to recognize and that the *appui moral* for which Cézanne was on the look-out throughout his life was of importance to other artistic natures too. Poussin was in Delacroix's view a great man simply because his life and his struggles against envy and disfavour for the sake of his convictions were 'a wonderful example for all who dedicate themselves to art'.

There was a second reason why he admired him, however, one which has to do with style, and this was connected with the first in so far as style is, after all, formed by character. 'Poussin's art', wrote Delacroix, 'which stands there without models and without rivals, the conjunction of buildings and majestical trees with stimulating and always harmonious motifs, gives the mind an impression of greatness and gentle melancholy'. 'The charm, the greatness, the simplicity of his works, the fact that he never repeated himself, never became banal, gave to each thing the degree of significance which was its due and did not take pleasure in exaggerated elabora-

tion of the single items'—this aspect of Poussin's classicism, his bearing, his moderation (that of the ancients), was what Delacroix most respected in him. Because of this he found even Poussin's imitation of the ancients acceptable. Poussin 'did not imitate the material features of reliefs and statues, he resuscitated the mighty genius of the ancients in human forms and passions'. That was precisely the classicism towards which Delacroix himself was struggling, which he even believed he had found in life itself—in the course of his journey to Morocco where he observed the classical dignity and classical bearing, full of natural freedom, of the Arabs and Jews, who were untouched by European civilization. The style of this African culture, which seemed to him unspoiled by the modern world, was to influence him his whole life through, a style whose classicism only a romantic was capable of perceiving.

Delacroix's romanticism was therefore an enormously complex spiritual manifestation, full of contrasts, tensions and fanciful relationships. The decisive, determinative and also special feature about it was that it was based on passion as the original experience and the original form of artistic inspiration. Let Camille Lemonnier speak: five years after Delacroix's death, while he was still completely under the influence of his vital personality, he wrote[83]: 'Delacroix was the last great painter; he revolutionized art with thunderbolts.— He had the soul of a fighter. His thirst to be a hero made his outoutbursts of rage, attacks of fever, breakdowns and deifications inevitable. He lived in a superhuman environment, which was a no-man's world; his artistic domination was partly due to his rebellious audacities. He was always, as it were, straining to break chains, to abolish serfdom and to set up a wild independence. He climbs to mountain tops, wavers over realities, seems to despise the things of this world. He painted only what he imagined, and visualized mankind as somehow more violent. When he deals with landscapes it is only to endow them with his own special wild greatness; he creates nature anew, as he does mankind . . . he has a sense of the awful . . . lonely on a rock he is a man of power, hardness and force; he is tragic.'

And now the young Cézanne—timidly choleric, entirely thrown in on himself, shut off, as it were, from the world and unhampered by any traditional means of expression—how did this alleged romantic behave in the face of the romanticism of the enormous, grandiose, superhuman nature of Delacroix, of a man of the generation of Balzac, George Sand, Victor Hugo, de Musset, Michelet,

Gautier, Lamartine and Stendhal? Was there anything at all in his nature or in his art which can seriously be described as romantic?

Rintelen[84] came to the conclusion that Cézanne's art developed in the opposite direction from that of Manet and in so doing drew 'aid and reinforcement' from romanticism. 'The romantic force and the romantic soul embodied in the artists Delacroix and Daumier' had, he believed, operated as a spur to Cézanne—'the glow of colour and the most uncanny, most penetrating fantasy', and in addition 'the passionate *pathos*'. In Cézanne's earliest pictures Rintelen saw 'truly horrifying abysses of the wildest romanticism' and noted also that Cézanne never broke away 'from romantic violence' his whole life through, in that he 'did not trouble to draw solids correctly' but always strove only after 'the force of mass, the basic plastic phenomenon of the solid in space'. He admitted that 'the classical also fought its way up against the romantic' in Cézanne. We can account for this judgement by the fact that Rintelen wrote at too short a distance from Cézanne's work; his comments reveal plainly how the novelty and the frightening elements of Cézanne's art affected and accompanied the process of becoming familiar with it. Anything vehement or violent was categorized as 'romantic'; the choice of such themes as *L'Enlèvement* or the *Temptation of St. Antony* was regarded as a continuation of the romantic tradition.

In complete contrast to Rintelen, Roger Fry[85] spoke of 'the exuberant romanticism of his temperament'; he found Cézanne romantic on account of his youthful impetuosity, his passion and excitedness, his violent will to express himself. But the English tend generally to regard all such characteristics as romantic, that is to say as indicating a want of healthy human rationality, of 'common-sense'. His qualifying Cézanne as romantic is therefore not historically determinative. Thus when describing the picture *Reading aloud at Zola's* (V.118), Fry says[86]: 'The picture proves how completely the ardent and restless romanticism of Cézanne's temper outweighs the visual data of any factual scene'. Yet the peculiar lack of normal vision which Fry noted in this picture was not the consequence of romantic tendencies similar to those of the romantic artists.

Novotny[87] wrote: 'The romantic in Cézanne never ceased to exist, even long after the content of his art had developed into something which appears to us the absolute opposite of romantic. He retained this trait from then on, always plainly recognizable in the artist's own human appearance, but also, even though often

only in a submerged way, influential in many of his works, for example in his figure compositions and sometimes also in the landscapes, right to the end of his life'. Then he continues[88]: 'Wherever else romanticism in its broadest sense breaks through in the ultimate art-form of Cézanne, in his inclination towards free invention in composition, in his themes, in diverse forms of monumentalization and hero-ization. . . .' Moreover, Novotny also mentions 'exceptions' such as 'many of the free figure compositions in which (even) the space in the picture deviates, in the sense of an intensification of romanticism of the spatial element too, from the otherwise dominant form'. In his view there runs through all Cézanne's work a 'conflict between romanticism and the negation of everything romantic'[89]. Cézanne had, he said,[90] 'a romantic affection for the bizarre rock formations of the quarry landscapes and of Mont Sainte-Victoire'.

Lionello Venturi on the other hand spoke of Cézanne's 'romantic errors'[91], his 'romantic violences'[92] and his 'romantic prejudices'[93]. He compared Cézanne with Flaubert and was of the opinion that 'both originated in a provincial romanticism'. In the pictures V.103, 104, 107 and 108, that is to say those in which figures of massive fleshiness and exaggeratedly curving forms are to be seen, he saw a Cézanne 'who was disturbed by a romantic nightmare', who strove to express his passion with 'imagined forms and colours', 'which do not exist in life' ('en dehors de la vie'). In the pictures painted about 1870 his palette was 'still romantically dark but from then on he sticks to life'. Venturi even felt that the 'black' still-lifes were romantic ('de l'intention romantique').

Unfortunately, in all these expressions of opinion romanticism 'in the broadest sense' has been taken to mean an inclination towards the unusual and unrealistic; but at the same time it is also quite indefinite. From a historical point of view the so-called romanticism of Cézanne remains unexplained. Is it true, as Novotny suggests, that his works—either the earlier ones alone or even all of them—have something definitely in common with the style of Delacroix? Have they something which can be clearly shown in their form and significance to be common to other romantics, such as Victor Hugo, Flaubert or even the Germans?

Let us start with the question of subject-matter. Even in Cézanne's early days there were no tales of miracles or of knights in armour which he might have painted in descriptive fashion with anxious attention to historical accuracy, that is, as romantically ideal and at the same time realistic dreams. We have already seen that the

story of St. Antony and similar pictures had a special meaning for him, that they were self-portraits—which explains their completely unromantic style. An excellent example of this is Cézanne's drawing for Balzac's 'Frenhofer' (Plate 34). It is astonishing how far this is from reproducing the romantic world of the writer's imagination and what a sobering impression it makes. The same is also true of other compositions of Cézanne's which contain 'romantic' historical figures. The difference can be seen to be even deeper. Compare the two who are closest to each other: Cézanne and Delacroix. For the latter the romantic *sujets* which he took from literature are expressions of romantic and revolutionary concepts, such as: infinite freedom, progress, humanity, the victory of the good and the strong, the grandeur of violent emotion. Cézanne did not share these concepts in the remotest fashion and therefore he painted no romantic motifs. His drive towards independence and his revolt were absolutely personal, unliterary and un-ideal, indeed out-and-out egoistical. A path leads from the person of every single romantic directly to universal 'mankind', the work of each has the nature of a mission, a redemption either of all men or at least of a few chosen people. There is nothing like this about Cézanne. That is why one can also find no trace of uncertainty in him, in contrast to the romantics who so frequently shrank fearfully from their enormous task. In contrast to the intellectualism and cultural emotionalism of the typical romantic there is nothing but realism in Cézanne's themes, even when they are imaginary, and in them too he is nothing but a single-minded nature entirely centred on and confined to itself. The art of the true romantics was based on memories full of presentiments about concepts, heroes and world destinies, on dreams of fulfilling almost indescribable wishes or of infernal disaster, but the works of Cézanne depict in every instance a present-day view, a remembrance of something near and actually experienced.

Now for the language of form. Formally, there is something special which distinguishes at least the youthful works of Cézanne—is this distinguishing characteristic romanticism? In them his language is certainly violent, exaggerated, gloomy, over-burdened with stresses and contradictions—exactly what people have always been eager to regard as a sign of romanticism. But the genuine romantic artists are distinguished by a strange feebleness in their creation of forms, by the evaporation of their aims, by formlessness and ineffectiveness. Their great themes actually suffer from being represented with inadequate forces. Delacroix remains the sole exception. Yet

even he was for long perturbed by feverishness and wavering uncertainty and his works acquired firmness only in his fifties. He did not owe this to romanticism but to the amalgamation of romanticism with a new classicism, into which his work was elevated by his genius. And Cézanne? Surely his figures resemble those created by the great baroque masters: they have the same positive physical energy, the vigorous modelling and the tremendous sensuality of something captured from life, and the characteristic of being completely unhistorical, the air of not being infected by pallid fidelity to historical accuracy. By contrast, when the romantics depicted man their distinguishing characteristic was that they took such extreme pains with physical aspects and represented his existence as fluctuating and flickering, flaring up in a state of extreme tension.

The earliest works which bear witness to Cézanne's individuality[94] already show how far removed he was from the instability of romantic painting, in which people and things are consumed, burned up and dissolved in feeling, in passion, in suffering or in hysteria. Even his most violent compositions contain nothing comparable to the lack of restraint which seduced the romantics into dreaming on and on about the content of pictures, nothing which released sweeping moods and great thoughts. Quite the opposite of Delacroix, for example, whose creations, with all the opulence of their material and of visual values in realization, possessed this stimulant in very high degree, Cézanne worked out the themes of his compositions to the very end by means of the visible data. There remained not the slightest possibility of asking more about what was in fact visible in them or even of adding to them with a view to completing them: the representation exhausted its subject in truly classical manner.

Certainly no trace of a romantic idealism could be found in the young Cézanne. Nor did he know the *noblesse* of the romantics. His world lay on no higher plane than that of the everyday world which he had himself experienced, so far as landscape was concerned, and the sort of people who inhabited it. He preferred to seek out the most barren corners, those most lacking in charm, or to give expression to his sorrows by means of the juxtaposition of very ordinary sights. His vehemence did not create a more perfect world, but a real world intensified into something which 'is'. To do this he went ahead in a quite uninhibited way and with brutal bluntness. Even when he was handling a literary theme, one which was 'remote' such as that of St. Antony or Don Quixote, he managed it in an arbitrary

manner, by eliminating the story and banalizing the theme for his own purposes (i.e. of inner expression). Admittedly, one could perhaps interpret this intensified and forcibly coarsened realism as being in itself a romantic conception—by analogy for example with Balzac or the early Zola—as the fruit of the 'romantic demon of emphasis'. Yet even the most depraved of his depraved inspirations, such as *L'Après-midi à Naples* (V.112, 223, 224, etc.) or *The Murder* (V.121 and 123) or the phantasy *L'éternel féminin* (in which the composition echoes that of Delacroix's *Sardanapale*), have nothing of the exaggerated, theatrically pathetic aspect found in the inventions of the romantics; in their strength and striking power they represent the most stark realism, which permits nothing ideal to appear, only something which 'is'. These paintings were not inspired by outside stimuli, but by the need to express inner emotions which the painter himself had experienced. An important difference must be noted here. The romantic, and with him Delacroix, Delaroche, Balzac and Victor Hugo, becomes conscious of his own existence, of his maximum capacity for experience, only by realizing himself through strange, great, extravagant figures of a dream world of fearful passions, longings, catastrophes. He may invent such figures or simply take them over from the hands of others. Whatever he puts into these figures, however, is and remains for him an impression which affects him from outside, through which alone, progressing from a general mood to a clearly defined achievement, he obtains complete fulfilment for himself. Cézanne by contrast went in the opposite direction. He achieved complete fulfilment for himself through the uneventfulness of his own destiny, significant precisely because it expressed all the tragicness of his total isolation; and that (his isolation) is what he depicted in his art in the most varied ways and in the most varied disguises. Once he had experienced a strong impression from outside, it became absorbed into his inner existence, and he analysed it in an entirely personal way; and he could treat as experiences only those things which he was able to make his own inwardly, to interpret as resembling his own destiny and his own nature. Impressions from outside had then a disturbing effect on him—not in themselves, but only in so far as they were reflections of an inner suffering already present within him, which thus became real. This then was the effect which nature, the countryside and all the figures which he intended to portray, had on him—even objects assembled for a still-life. Think how different it was with Delacroix, who transposed himself into his

subjects, intensified them and could only thus develop his intellectual powers to the full! This difference explains why Cézanne's experiences did not open up a more sublime world to him.

Then there is still another difference. The emotions experienced by Cézanne were not at all the same as the expression of the sort of immense conceit, indeed arrogance, typical of romantics like Beethoven, Byron or Poe, men whose vehemence drove them to daemoniacal blasphemy, to the glorification of rebelliousness as such. Cézanne's gloomy scenes contained no daemoniacal glorification. They were not expressing pleasure in the 'infernal part of man' or wallowing in its analysis: in them we have merely the suffering of a man who was still revolting passionately against being forced to suffer, who was not yet capable of accepting suffering, who raged and ranted in his suffering, but never contemplated himself. In contrast to the self-analysis of the romantics, the early Cézanne was completely, silently and doggedly absorbed in his experiences; his art was simply a part of life exactly as he lived it and was constructed on the same foundation as his life.

Lastly, there is Cézanne's attitude to nature. From the outset he treated nature quite unromantically. So much so that even his earliest experiments make nature as portrayed by Courbet still seem like some 'force which is worshipped'. Long before Cézanne discovered Courbet's art, he was superior to him in the sort of realism which opens up the road to the nature of real things and their 'being'. Cézanne never went in for a 'cult' of nature, nor yet the romantics' adoration of natural life with all its pantheistic undertones. Nature depicted by him concealed no 'natural mystery' as in the case of all the romantics—neither the all-embracing life-force nor the empire of freedom. This is due to (or looked at from the opposite point of view it proves) the fact that Cézanne was by nature thoroughly unromantic, even if he was enthusiastic about Victor Hugo, de Vigny and de Musset as a schoolboy. And he remained unromantic during the whole of his life. Even the agitation of his latest works and their remoteness from the real world familiar in everyday life had nothing to do with romanticism[95].

All in all, Cézanne did not spend his life in a struggle against an innate romanticism. Neither Zola (who thought that Cézanne had lost this battle) nor Gasquet (who believed that Cézanne had won it) understood him properly. It was not the case that, as Gasquet wrote[96], in him 'the classical heritage of France, her Latin realism, sought to overcome that evil thing, this horrible but tough roman-

ticism'. For, convincing as it may sound to the superficial listener, it was not true that 'Cézanne was to give up the wrong great themes'. He was not to subordinate himself to his subject-matter and he was to go on dreaming—though, it is true, with an altered attitude towards life, as a result of which his art was to be transformed to an extraordinary degree. That, however, had no more to do with romanticism than with classicism, within the meaning of these terms as understood in the nineteenth century.

But let us now return once more to Delacroix.

If it was not romanticism which linked Cézanne to Delacroix, what was then the reason why he meant so much to him? This question can be answered in one sentence: Delacroix possessed the gift of personal creation and with this he had revitalized and revived painting. He had made room in it for *freedom*, the freedom of the artist to follow his personal inclinations in portraying the world, a closed picture of the world, and to stake them unhindered against the claims of a past age and against an absolutely fixed, rigid, un-alterable art-ideal derived from works of art which had already been created. He did not refuse to learn from individual great masters, but he elected as his models these with whom he felt an affinity, those whose originality appealed to him. He had not let himself be handicapped by any general doctrines about the way to perfec-tion in beauty, such as had grown up out of an accumulation of the views of different teachers throughout history. This is how Dela-croix's genius was seen by all the important painters of Cézanne's generation, i.e. those born around 1840. Cézanne shared this view, with this difference, that he thought it out further than any of the others had done and did so to quite a different purpose. The others learned from Delacroix how to use artistic media in a free and inventive way, instead of employing them merely in order to copy details. His discovery that the free play of shades of colour could be used to portray an intellectual idea in a form perceptible by the senses was exploited by each of them according to his own natural talents, in order to paint in colour a living, effective picture of the real world. Cézanne, however, seized on Delacroix's freedom and used it to liberate his own talents: he produced a representation of the world which 'is', by going beyond the facts which the senses perceive and use as a guide to the everyday world, while other painters aspired only to harmonize them.

There was a certain resemblance between the temperaments of

Delacroix and Cézanne. According to Baudelaire[97], Delacroix possessed 'a chaste sensuality, a burning passion for the good and the beautiful; beneath an assumed egoism he was devoted to his favourite ideas', lived not for himself, but only for them. He had been endowed with 'a goodly portion of wildness; that was the most valuable part of his soul, that part which was dedicated entirely to painting. . . .' Cézanne was very similarly constructed; above all he possessed the same passionate feeling for his art. And this he retained throughout his whole life. Wild and violent at the beginning and vehement once again at the end of his career, he was indeed in the interval, in his so-called classical period, cool and relaxed, yet only apparently so. A closer view reveals that the passion of realization existed in Cézanne's 'classical' pictures also, though there it was restrained and controlled. Even in those serene compositions, how much more fire we see burning than there is beneath the emotional sweetness of Renoir's pictures! This passionate feeling underlies a process of intensification. At first it was expressed in great intentions (the many square yards of great canvases he meant to cover with paint), in the tempo of the portrayal, in the vehement brush strokes or brutal sweeps of the spatula, in the violation done to natural shapes and in his choice of gloomy themes. Then this same passionate feeling took possession of the deeper layers of his creativity. It affected the construction of the very framework of his compositions, forcing him at first to simplify and unify them. Then little by little, driven by a positively superhuman fervour and perseverance, he began to divide them up and analyse them into ever finer constituent parts and to introduce ever closer and more complicated relationships into them. In the last years of his life Cézanne began to employ this method with increased vigour. I am unable to agree that he reverted to the methods he used at the beginning of his career (as has occasionally been stated). There was no reappearance of darkening or violence of technique. His passionate feelings were more than ever concentrated on formal realization and on the inner meaning, the 'standing together' of things. They grow together more closely than ever before and attention is drawn positively and forcefully to the indissoluble union of their 'existing', by their being subordinated with a hitherto unattained openness and unconcealed clarity to this 'meaning of their being'. In this way and for this purpose Cézanne actually changed his entire method of painting; he made it more and more independent of the objective data of separate shapes and thereby rendered the process

itself more visible. But, in making this change, he was aiming forwards, towards new goals: with this new technique, which now revealed more plainly than before the passion latent in him, he was in no way falling back into methods practised at earlier stages of his development.

So it was passion, 'the enormous passion which was doubled by a frightful will' (Baudelaire on Delacroix), which linked Cézanne with Delacroix and caused them both to have the same views on the freedom of artistic creation. It was passion too, which caused both painters to be for so long so misunderstood, as none of their contemporaries had been. And it is perhaps passion too which is to blame for the misunderstandings which are current about both again today—in a period of rigid art rules and of mass laws.

The connexion between the two masters can now be expressed in terms of technique and methods. Cézanne's artistic use of colour was made possible only after Delacroix had reached a new stage in painting out of colour and by means of colour. He had already discovered how to use the medium of colour to express vitality, passion, horror, courage, nobility and a most delicate inner link between figures and objects themselves, and between them and space. Drawing, although fully developed and in a certain sense revived and revitalized, still played only the rôle of a hand-maiden in his paintings; it was kept concealed and was also itself influenced by painting methods; its power of expression was, in comparison with colours, limited. In the same way Delacroix had already given a largely new interpretation to *clair-obscur* in colour and had transformed it into colour contrasts. And in colour we find the most extreme form of his audacity. The same was true of Cézanne, but with him the transformation was even more radical, though it is true that he declined to exploit the psychological values of colours, their sensuous and moral effect, as Delacroix had done, because in his art he had a more universal goal, not accessible through subtle distinctions and modes of expression of a psychological type.

Then again, Cézanne had set himself a special task: to create a symbolic representation of the transient external appearances of things in such a manner as to reveal their 'eternal being'. This could be achieved only with the aid of intuitive imagination—the problem could not indeed be solved in any other way—but it was only after Delacroix had shown the way that Cézanne was able to tackle it effectively. Delacroix had used his imagination to develop his rich, surging coloration and the glowing interplay of colour

combinations and colour contrasts and had demonstrated how a painter's imagination could give him the power to use colour as a medium on which to construct a picture. Apart from any other factors, it was essentially through sacrificing something that Delacroix achieved this, through that important process of 'sacrifice' so characteristic of him, which distinguished him from all the other artists of the first half of the nineteenth century—the sacrifice of what the mind of the common man regarded as accuracy in favour of unanimity, consistency and effectiveness in artistic realization.

What this 'sacrifice' was Delacroix has himself described in the following words[98]: 'The great artist concentrates interest, by suppressing useless, repugnant or stupid details; his hand creates order, stabilizes things, adds or suppresses and deals freely with them, for they are his property; he is moving in his own kingdom and offers you a feast there to his own taste.' What Delacroix sacrificed was detailed fidelity to nature, all that was unimportant or insignificant, whatever did not speak to the mind through the eyes. He could do this only because he knew from the outset what he wanted and did not depend on his models; this then actually made it possible for him to 'realize' pictures in quite new ways. Cézanne imitated him in this, although he generally worked in front of a model. The numerous unfinished works from his hand are visual testimony to the fact that he proceeded precisely in accordance with Delacroix's instructions, 'concentrated the interest, omitted the unnecessary, established first a general arrangement of the composition' and only when that had been done progressed to depicting separate objects. His whole procedure was based on 'sacrifice'. Here all we have tried to do is to draw attention to this procedure in its historical context.

Let us now do the same even more meticulously for Cézanne's use of colour 'in modulations'. Delacroix employed a palette uncommonly rich in nuances, with countless tones of colours, often very close to one another, often also linked by contrast. The stage of coloration which he reached has been described by Théophile Silvestre[99]: 'As his experience increased', so wrote Silvestre, 'he had arrived at a free-floating (*absolu*) colour system. Instead of simplifying the local colours by making them general, he augmented the tones into an infinite number and opposed them to one another in order to give each of them a doubled strength. He saw nothing as monochrome. The pictorial effect of Delacroix's pictures is therefore created by contrasting encounters. Where Rubens's paint

sparkles like a calm sea Delacroix's flashes like a river ruffled by a storm.' This excellent simile makes the stages of development extremely clear: Delacroix based himself on Rubens's theories of colorization, but Cézanne took Delacroix as the starting point for the realization of his mature works through colour. We can pursue the same line in studying the different methods of *applying* paint. Already Rubens had in later life set tones of neighbouring colours in a 'free' manner side by side; Delacroix went further, marking the separations more sharply, and ultimately Cézanne carried them to a systematic conclusion. In adopting this procedure all these painters were aiming at minimizing the rôle of linear drawing as a particular element of artistic realization—in contrast to other artists who continued to use drawing as a basis and simply filled it out with sparkling colours (as for example Pissarro)[100]. All in all, this meant that the painter used colour harmonies to construct his picture in preference to reproducing natural details in an imitative manner; so a picture as a whole was constructed out of freely placed and logically developed colour sequences. It is unnecessary to stress the importance to Cézanne of this method, which Delacroix evolved above all in his late works. The phenomenon called 'small structure', of which Novotny made such an exhaustive study and whose full significance for Cézanne's art he was the first to recognize, appeared in preliminary form in Delacroix's late works, where indeed it was to a great extent developed.

Summing up we can therefore say: Cézanne shared Delacroix's urge for freedom and passionateness in producing his artistic creations; he was in agreement with him in his determination to achieve a personal method of creation which scorned the rules of the schools; and from him he learned realization through the use of colour as an exclusive and dominating medium in any style of painting which aims at being more than mere imitation of nature and enquires what is the inner meaning or the significance of an object. On the other hand, he saw this significance differently from Delacroix and therefore disregarded the latter's romanticism (in his way of thinking and of realization), because it was unacceptable and alien to Cézanne's nature.

There is, however, yet another important respect of which it can truly be said that the same cause—i.e. their different natures— created a division between the works of the two masters, that is, Delacroix's dramatic exposition of existence as against Cézanne's epic style of representation.

# Cézanne's Historical Position and Significance

Delacroix was a born dramatizer, a true follower of his master Rubens. His art is based on a form of treatment which concentrates on the highlight of a moment. In this he makes its whole meaning and power, and at the same time also the life-force and the passions of all the participants, shine forth as though transfigured by an illuminating splendour. This is how Delacroix saw even nature and landscape—full of action. Cézanne by contrast made only a few attempts to create any dramatic pictures and those came to a standstill in their early stages (V.51, 55, 121, 123). Later he gave up this type of painting entirely. Among his works we find no dramatic compositions depicting action, no leading and subsidiary figures, no concentration on one decisive moment. Even such a theme as the temptation of St. Antony he illustrated by introducing the participating figures calmly, one after another, giving each the same degree of visibility and placing the principal figure in the most unlikely position. Then again he never 'composed' the colours in such a way that they all led the eye to one isolated but central point or resulted in a concentration of extreme intensity at one spot, as for example in the paintings of Rembrandt (who can very well serve as a counter-example in this connexion).

Some may, however, perhaps wish even to deny Cézanne the description of epic painter, on the grounds that he rarely depicted any action whatsoever and because his works do not relate a story, and may regard him instead as a painter of 'pictures of situations'. But in 'pictures of situations' (in the sense which Jakob Burckhardt has given to the expression) the painter merely depicts several figures side by side, rows of passionless saints, sacred conversation pieces in which each figure is immortalized by itself and long after its most important actions have been performed. In 'pictures of situations' figures resemble memories of themselves; they live in the seclusion of the thoughts they have late in life, resting from their past deeds. Cézanne's pictures are not like this. In them people and things are seen in an eternally real interrelationship, closely connected to one another—a relationship which indeed alone determines their significance—in the uninterrupted representation of their 'existing together', where the fact of their being linked is stressed. This interrelationship of meaning contains within it a perpetual reference of one object to the other and on that account demands for its portrayal a procedure which binds the objects to one another and simply does not allow separate pictures of them. That is what is epic about them. The rhythmic *progression* contained in this kind

of art is not, it is true, shared by the objects portrayed, for they remain in repose, but it is the repose of the interrelationships created for them by the poet-artist.

So it was Cézanne's epic style of representation which was the inmost cause of even the smallest fragment of his work being so unforgettably and so significantly distinct from that of his 'lyrical' contemporaries, the impressionists; the cause of its acquiring the character and the *niveau* or 'centre of gravity' of earlier painters of historical themes, whose status, according to the theories of the French Academy, depended on the very fact that they were the first to attain ideal and poetical (i.e. true) representation of nature, whereas all other painting—portraits, landscapes, still-lifes—remained only 'pure and simple imitation, a copy of ordinary nature', as Diderot put it. But those very motifs which had formerly been regarded as inferior were elevated by Cézanne to the rank held by the earlier paintings of historical themes. He did not intend to be content like Manet or Monet to take the 'ordinary' view of nature seen by the light of every day and to transfigure this with the touch of a connoisseur. According to his own statement, what he wanted was to paint 'parallel to nature'. This parallelism (at a higher level, naturally) he attained by means of his epic theory in accordance with which the figure of the creator (the poet) is withdrawn completely behind the truth, which then becomes visible in the objects themselves.

In Cézanne's lifetime the realization of this aim signified an immense anachronism and meant examining afresh many long forgotten problems to which Poussin had found the solutions in his work, where they had formed a landmark in earlier French painting. Poussin's compositions were bound to contain something which Cézanne could use as a model from the moment when he became aware or even only half aware of his special vocation as an artist, which was to represent the relationships between objects. It was this classical element in Poussin, who re-introduced the epic method of 'continuity' as it had previously been practised in antiquity, to place events in a perpetual, great and gentle stream, a procedure which Poussin alone of all the later painters in Europe had understood how to use both in the larger view and in detail—it was this which Cézanne strove to re-create, in his own words: 'refaire Poussin sur nature'[101].

# Cézanne's Historical Position and Significance

## Cézanne and Poussin

Although Cézanne did not actually copy a single picture of Poussin's[102], his work began at a very early date to show impressive evidence of aspirations pointing significantly in the same direction as Poussin's. This trend made itself visible before Cézanne's 'impressionistic' period, in the very pictures which marked the fundamental 'conversion' which occurred in his artistic career. An example of the new feature can be seen in a picture as early as *The Railway Cutting* (V.50, painted about 1870): individual objects were strictly singled out from the general impression of nature, in this case plots of land, bare patches, bushes, house and mountain; they were also uniformly and clearly spaced out in the picture; then the picture as a whole was constructed out of these regular details, each of which rested on its own in a state of equilibrium, and all of which were then again combined in evenly balanced groups. It is immaterial whether the style of the landscape layout was in this case directly inspired by Poussin or not—on the left side of *The Burial of Phocion* in the Louvre there is a stratification of the earth and an arrangement of light and shadow which in many respects corresponds to those of *The Railway Cutting*—the important point is that here Cézanne was already using the same device as Poussin—relating motifs in space to one another in a rhythmically balanced alternation of light and dark, and uniting them with one another by means of similarities in form, although of course he used a different medium from Poussin, namely colour (which was Delacroix's!). There again we have already an example of the classic-epic interpretation common to both.

But earlier still Cézanne showed a tendency towards an epic manner of displaying things, even though it was somewhat indefinite and confused with other stylistic elements. This style is noticeable in the 'black' still-lifes, where all the objects have equal pictorial value, so that a tablecloth or a napkin, which, along with curtains etc., played a subservient rôle in the still-lifes of the older masters by setting off the main objects exhibited, e.g. fruits, animals or utensils, now took on an importance equal to that of the other items which made up the whole. Indeed, this same epic form of representation was already evident in the profile of his father (V.25) and likewise in the portraits of his uncle Dominique (V.72–80), which in execution and formation are throughout in similar style. Another work which is extraordinarily revealing in this respect

is Cézanne's portrayal of his sister playing the piano, while his mother sits beside her listening (V.90). Just because it is executed in the epic manner it is infinitely remote from the musical *'genre'* representations of the Dutch painters of the seventeenth century, and from the atmospherically overcharged music-pieces painted in the nineteenth century; it is a representation executed with archaic heaviness, in which the allusions latent in the subject are drowned by those of colour and form and by the evenly progressing rhythm which carries the weight of the whole. Then there is *La Maison du pendu*, obviously comparable to *The Railway Cutting* (Plate 37), in which Cézanne now employed an impressionistic technique as heavy as that of Courbet in order to create an epic in art and so produced a hybrid of an absolutely individual kind. The manner in which he here employed the impressionistic method of painting and seeing, to produce representations of objects which were of like shape, of uniform strength, clearly distinguished from one another and securely linked to one another, proves that an inclination towards the epic form was deeply rooted in Cézanne's nature, and it was this which gave him his inner kinship with Poussin. From the end of the 'seventies onwards his trend towards the epic style of 'continuity' developed until it became unquestionably the foundation on which he based his art. Poussin's influence thus took positive effect. Roger Fry[103] and Sir Kenneth Clark[104], for example, have expressly declared this. Here let us only recall a later example, *The Cardplayers*, wherein the apparent paradox of the solemn representation of an insignificant activity can be explained as an epic representation of the everyday world in which an important personal experience was disguised. Let us also turn to Cézanne's portraits, in order to study an example of something apparently as remote as possible from the epic and note how superior they are to portraits of earlier epochs. Each of them is a poem unrolling in solemn rhythm, a poem which deals with the existence of man in the world of things and how this is embodied as universal destiny in separate individuals. Because of their epic representation these portraits are superior to those which are merely likenesses, or which show people who are typical or representative, such as are to be found in the works of Titian, Velazquez or Manet; they become an exposition, uniform and adhering to one and the same standard, of the 'being' of man and of the things in the world around him. With Cézanne's still-lifes and landscapes the position is analogous. Anyone eager to understand their epic character thoroughly and

clearly need only compare them in memory with Corot's lyrical transfigurations or the dramatic intensification which Delacroix knew how to give to fruits and trees.

The real, inner reason why Cézanne chose the epic style of representation is, however, the fact that the significance which he discovered in visible things and which we can discover in his pictures, the significance of their 'interrelationship', of 'existing together' and 'self-preservation together', inevitably demanded the epic method of representation. Cézanne's transcendental themes required that particular style, for it alone was capable of guaranteeing the uniform and unbroken union of different motifs and of the objects which appear in them, as well as the *emphasis* on the uniformity of the connexion between all the separate forms which he wished to express. And it was the manner in which Poussin 'organized' his transcendental themes which made Cézanne choose him as a model—not of course everything about his art, only his method of composing a picture. The hardness with which Poussin depicted solids, as also his handling of colour, were bound to leave Cézanne unsatisfied; he was not interested in Poussin's trend towards the ancients, his use of psychology, his drawing of character, those of his themes which tell a story or moralize, or all the different '*modi*' of treating the material which goes along with them nor in his '*pathos*'. On the other hand, Poussin's method of composition contained several points of importance for Cézanne: a very special representation of things and space and of the relationship of both to one another; a very special conception of plasticity and depth in their relation to the surface of the picture and to its rhythmic division; a realization exemplary in its unexceptionalness; and, over and above all, the one determining principle: the indissoluble interrelationship of the whole formed out of the symmetry of the relationships of all the parts. The same standard for all things—in clarity of form, plasticity and power of expression—that was the basic, distinguishing feature of all Poussin's compositions; it was the ideal which Cézanne aimed to realize. Not the same meticulousness, but that uniformity of effect which takes into consideration the importance and the status of every single thing, which is uniform because of the fact that it gives to the form of each thing what is its due, in order that its essence may be depicted, and that it may contribute something essential to the overall structure of the whole.

What was it which enabled, indeed forced Poussin to perceive that this was the mission which his art must accomplish? According

to his own words it was 'good sense' for 'it compels us not to trans-gress certain limits and in all our works to observe order with skill and moderation, whereby everything is preserved in its own essence' ('l'ordre déterminé par lequel chaque chose se conserve en son essence'). This remark goes to the roots of the profound inner kinship between Poussin and Cézanne; Cézanne also (in contrast to all his contemporaries) painted with an intuitive 'good sense' which forced him so to construct his works that if 'every thing' was not precisely 'preserved in its essence' it was yet 'realized' and revealed. In the time of Poussin a divine order had still reigned out of which every-thing had been given its essential 'being', but this very order had disappeared and remained hidden from sight until Cézanne came on the scene, and what Cézanne sought and undertook to portray in his own art was something which could take the place of this. Even if this innovation had to be something different, namely an *a priori* category (of existence) in place of a fixed order, yet the ultimate aim remained the same: to depict a world in which the essence of every single object was fully developed—with Poussin to the significance corresponding to its importance, with Cézanne to its unshakeable realness in the 'existing together' of things. Despite apparent differences, this is fundamentally one and the same thing, as is clearly demonstrated by a comparison of a single object depicted by Poussin or by Cézanne with one realized by, for example, Delacroix. What neither Cézanne nor Poussin would permit was that one thing should exercise an influence on another with an effect prejudicial to form, through one being accentuated at the expense of the other—something which occurs continually in drama and in Delacroix's dramatic art, and appears in tragedy and in Rembrandt's tragic pictures (in Rembrandt's case through the special use of light).

The common ultimate aim of both artists resulted in Poussin's and Cézanne's adopting a common way of expounding nature. Poussin's method has been described by Félibien[105], who was writing under his direct influence. He said: 'The eyes . . . rely only on themselves, believe only in things which affect them and want to have things portrayed only as they see them. But nothing is so easily deceived as our sight . . . therefore the painter must try so far as possible to bring sight and "good sense" into agreement so that he creates nothing which is not acceptable to both.' And 'in paint-ing, as in the other sciences, judgement must retain the principal control of the work; if this is so, the work will have the advantage

for the spectator that the longer he studies it the more knowledge and beauty he will find it contains'[106].

Cézanne too was continually checking his observation by making judgements. While he was painting he was thinking. This we know from those who watched him painting, as for example Émile Bernard or Vollard. They have said that his creating was contemplation. He looked at a model for a long time or walked up and down in the studio scrutinizing it, thinking over what he had seen. He hesitated before applying a single touch of paint and went over certain parts of a picture many times. The difficulty which caused him to act in this way was that of 'bringing what he saw into agreement with "good sense" ', that is to say with the demand of reason that the same standard must be adhered to in representing different things seen in order to evoke the special inner meaning of the things seen. It is probable that some of his remarks about the difficulties of making observations in accordance with 'good sense' have really not yet been properly understood. When he said that he could not capture an outline and frequently did not finish those parts of his pictures which were contours, this was not because he was incapable of observing the contour of a thing in the ordinary sense—in isolation. What evaded him was making a plastic appreciation of the contour by the same standard as the solids to which it belonged, in its correct relationship to the masses which went on being modelled without interruption. The general problem which his 'good sense' set before his eyes in a picture was the contour in its rôle of meeting place of colour-forms of things adjacent to one another, and how to apprehend it by the same standard as these things: Cézanne's remark that he intended his art to be 'parallel' to nature must indeed also be understood as something which had its origin in 'good sense'.

But what had actually been the effect of 'good sense' in Poussin's method of realization? His aim was to construct a picture as a whole, as an indissoluble harmony composed of forms representing the essence of individual things. This led him to absorb or neutralize what was the merely charming and incidental aspect of material phenomena by presenting them in plastically clear, simple forms, but furthermore also to refrain from using 'empty' space. (which can in fact be understood as the particular phenomenon of the atmospheric, the negation of the material) as a means of realization in his compositions and instead to portray it also as something constructed with the aid of groups of solids. By using these two

devices, Poussin eliminated the contrast ordinarily felt between solids and air or, as the case may be, air space. At the same time he dispensed with the varied impressions created by the sensory data of matter, until ultimately the sole material he used for his art was the plastic object, reappearing in every part of the picture: by this repetition of the same thing he was able to produce a particularly positive kind of homogeneity.

Cézanne also used this sort of unity, created by condensing all multiple sensory impressions into one unified unbroken materiality in a picture, in contrast to other artists who gave unity to a painting by means of their calligraphy, by a system of lines, by the control of light or by going over the whole with one uniform shade of colour. Still following Poussin's example, Cézanne developed this unity more and more completely. Here the two artists had in common the fact that the materiality which they had created was enriched and made more comprehensive, more universal, more super-real by both of them in the course of their work—by Poussin through his sculptural plasticity and by Cézanne through his manner of creating forms by modulation of colour.

Cézanne's efforts to integrate the plastic images of his compositions with the surface of the picture and to turn that surface into something real and tangible, something the eye could perceive as an experience, had also a connexion with Poussin's art. And on this point too it was from Poussin that he learned how to assure an overall harmony in a picture through the division of the surface of the picture by means of rhythmically disposed sequences of forms following on one another. One can study this process in Poussin's drawings, where it reminds one quite strikingly of Cézanne, even if Poussin did not in his time use it so wholeheartedly as Cézanne did. In those drawings, groups of solids can be seen, linked together by the lines he drew and masses to which he gave a new meaning, using them to divide up the surface, by rhythmically changing and rhythmically repeating themselves, remaining closely bound to one another and yet, to the critically calculating brain, widely separated from one another in the pictorial space. The result of this procedure is that, despite perfectly clear differentiation, the foreground and background of a picture lose their effect of straining apart, and of contrast between the moods they evoke. On the other hand the pure existence of the objects, whose forms are thus interrelated, gains in effect thereby.

What here united the two painters most profoundly, what caused

the younger to turn as a pupil to the elder or to 're-create' him, was the renunciation of time and temporality, of the representation of movement and change, common to the art of both of them. Cézanne scarcely ever represented movement and change at all; Poussin, who—in accordance with the conventions of his time— was obliged to paint many events and actions, arrived at a halting of movement which seemed to be effected by time standing still.

The same common purpose also affected the way these two painters represented space. In order to turn space into something which cannot be measured in relation to time, one must prevent the beholder from pacing it off in his imagination and experiencing its different parts in a smooth, unbroken sequence. That is to say, one must make impossible the kind of experience which first became both inevitable and feasible with the introduction of correct linear perspective into painting, for, by representing space with continuity and homogeneity, perspective guides the eye of the beholder to just such an experience. Now, both Poussin and Cézanne altered the generally accepted form of linear perspective in a special way, and both did so by the same method, namely by bringing to a standstill the vanishing lines visualized in spatial perspective. In his comprehensive and frequently quoted study, *Cézanne und das Ende der wissenschaftlichen Perspektive* ('Cézanne and the end of scientific perspective'), Novotny has described in minute detail how Cézanne effected this. Here it must be said that efforts to achieve this aim can already be noticed in Poussin's later works, where they actually appear in a form which strongly influenced Cézanne. If he desired to 're-create' Poussin's art then there is no doubt that he intended this also to apply above all to the manner in which Poussin handled problems of perspective in his art, for Cézanne regarded Poussin's methods as exemplary for the portrayal of the *essence* of nature, and also for the accomplishment of his own task—to create 'the picture in general'.

Like Cézanne, Poussin too neither eliminated nor abolished linear perspective, but he denied it a function in the foundation of a picture's composition—the portrayal of an empty space ready to receive a world of solids. Although he fairly frequently constructed interiors, which outwardly resembled a 'box space' or a 'space box', he illustrated space primarily by means of solids which he portrayed plastically by extension of their volumes in the clearest way, while letting the interior be supported by the parts of its architectural structure which were in their turn plastic images of the spatial

extension of the solids. But then—and this is of decisive importance —Poussin already absorbed lines converging towards the depths of a picture, and also masses of solids developing towards the depths, into interrelationships flatly bound to the surface. This he did by relating the shapes of different objects to one another by means of lines and colours reiterating one another in explicit contradiction to their distance from one another in space. Two artistic devices which make an unusual contribution to the stability of a composition were developed by Poussin, which Cézanne studied very intently and then, after modifying them to suit other requirements of his own technique, applied to his own use. These were: a framework of lines, traceable in every one of his pictures, which gives an impression of being anchored in the picture plane and which holds the balance between the plastic and the in-depth representation; and a system of colour distribution employed to make certain shades of colour appear as parts of one plane, which runs through the entire picture, yet, being frequently concealed by the representation, gleams forth only here and there, and does so at important points.

Lastly, the all-embracing problem of realization. Here, too, Cézanne could regard Poussin as a model to follow and as next in importance to Veronese (who in this respect is closely related to him). His pictures were above all distinguished by an evenness, attained scarcely anywhere else, in the perfection of their portrayal of both spiritual and material matters. The same meaningful clarity is given to their content as to the things which appear in them, and that both together and separately. With Poussin there is no 'almost', no allusions, not even in the most incidental things. Basically, he recognized nothing incidental in his art, as he himself said, on account of the 'remarkable notion of perfection' which he possessed and which Félibien had already praised as one of his characteristics. The objects which he depicted—men and animals, trees and buildings, mountains and clouds—have not only a genuine objectiveness, because they have been perfectly, fully and evenly reproduced in their plastic forms, but also a perfect naturalness; they possess a particular, intrinsic significance, the greatest they can possibly have, and also a significance for the action or for the event in which they play a part. In that they combined these two qualities of realism and naturalism, they made an impression of being ideal; but their ideality was, as Cézanne understood the word, nothing more than a comprehensive realization such as he likewise sought to achieve in his own way.

Because of his historical position Cézanne lagged behind Poussin in this respect. The very *scope* of the latter's realization was much greater than Cézanne's; it covered all the spiritual elements, all the sacred and profane incidents with their varied characters and expressions of emotion, which Cézanne could not use as themes. By explaining that he wanted to 're-create' Poussin *sur nature* Cézanne was unintentionally admitting how greatly the potential scope of artistic realization had been narrowed for him. In addition, the themes available to him for artistic realization contained far fewer potentialities than the richly peopled and living world in which Poussin lived and out of which he created his works and for whose inhabitants he worked. For that world was itself full of real things which no longer existed in Cézanne's time.

A brief historical survey of the relationship between Cézanne's work and Poussin's must now be made, for this relationship is of outstanding importance in assessing the historical significance of Cézanne. I have already pointed out that as early as 1870 Cézanne was using certain elements of Poussin's method of composition, namely the construction of unity in a picture out of objects all equally distinct, sharply separated from one another and then again formally co-ordinated (V.75). The realization of solids characteristic of Poussin (with stressed axes of direction and with contours tied to the surface despite modelling and extensions) and his linear structure, uniting the solids in the picture plane, appeared (expressed in his own style) in certain compositions of Cézanne's which Venturi dates between 1872 and 1875: *L'Après-midi à Naples* (V.223/4), *La partie de campagne* (V.234), *Le déjeuner sur l'herbe* (V.238), *La tentation de Saint Antoine* (V.240/241), all of the same period. But whereas Poussin was capable of drawing the lines uniting his figures to one another and to the picture plane, in such a way that they did not impede the free movement of the figures in any way and that the structural framework of the composition in no way restricted natural freedom in the representation, Cézanne was able to hold his compositions together only by linking them pictorially through shadows, by 'deforming' the natural forms of solids and of objects. This 'unskilfulness' reflects Cézanne's historical position as a painter at the end of the nineteenth century, of a world in ruins, in which the individual had lost all freedom and was held in fetters, and in which a genuine, unconventional harmony of several individuals was as yet possible only under bitter compulsion.

When, however, Cézanne tried to represent nature in self-sufficient units, this was the outcome of that same compulsion, for he was forced to use this method if he desired to capture the essence of nature, that is to say, to portray each extract as representing the entire 'being' of nature. That is why, even in a landscape of such a high degree of perfection as Cézanne's *La côte du galet à Pontoise* ('Landscape in Pontoise') (V. 319, Plate 43), painted from nature in 1881, the natural impression is subordinated to a strict order, particularly by means of the emphasis on the vertical direction of the poplars; other images of vertical tendency are specially picked out in various areas of the picture and linked to these, so that, for example, the houses in the distance (their walls over-emphasized by the vertical lines defining them) go together with the trees of the main group. Then we see the curves running between the orthogonals, particularly clear in the fields on the hillside, but also repeated several times in the most important group of trees, namely in the left-hand part of them, to which the wings of the foreground correspond. The third direction selected for this composition is to be seen in the horizontals rising slightly to the right: in the silhouette of the hill to which at a lower level the shadow-path at the foot of the hill corresponds, and repeatedly in the great dark patches of shadow on the bottom of the valley. By contrast, the stimulating and agitated curve of the road (which we know from Pissarro's version of the same motif) has been suppressed. So far as Cézanne was concerned it had no right to existence—psychologically because (as we have already pointed out) Cézanne would never 'accept' anything which opened up a way into a landscape, as it was contradictory to his conception of nature; compositionally because the S-curve of this road created a line too independent of the basic lines of direction which held the whole landscape together. However, Cézanne not only suppressed this motif because it was independent and spoke directly to the beholder, but also did the same thing to the natural freedom of the entire picture. Nothing is depicted in it as uninhibited, free and natural, able to pursue its desire to 'become' and to grow easily and pleasantly and without hindrance.

Throughout the 'nineties the same strict inevitability still persisted in Cézanne's works. There is no need to give particular examples since it is sufficient to remind the reader of the various versions of *The Cardplayers* which were painted during this decade.

About 1900, however, with the onset of old age, a new trend appeared in Cézanne's style, though because of his death this was

never brought to ultimate fruition. The three portraits of Vallier (V. 716–718, Plate 36), the last landscapes (for example V. 762–805, Plate 44) and some of the compositions of those years in which many nude figures appear, reveal the liberation which slowly set in. And so the true significance of these pictures is revealed as the exact opposite of that hitherto ascribed to them. The loose brush strokes and the use of rounder shapes have made people think they saw in these late works of the master a return to the so-called baroque style, even to his 'youthful romanticism', in both cases because they observed the technique far too superficially and externally, that is to say, in isolation. If, however, we look not only at the way in which the painter worked but at the rôle played by the forms he employed, then we see that the figures and the natural formations in these works move more freely and exist side by side with less constraint, without their cohesion being shaken in the slightest. In these pictures for the first time in the work of Cézanne, we see classical composition combined with naturalism now become more free, which means that these works do not belong to any sort of romantic, baroque art, but to a 'more complete' classicism, as Poussin understood and realized it.[107]

Let us try to make this even plainer: in the landscapes of this late phase of Cézanne's art, nature as portrayed seems more remote from the original than in all his earlier works, more remote from reality as understood by the ordinary man, reality such as can be verified by a camera. But this verifiable resemblance is in no sense the point at issue—in any painting the colour alone inevitably surpasses anything which is comparable with reality. What is seen in these pictures, however, is the universal essence observed in nature and at the same time the freedom of the individual formations of nature, a freedom which they acquire through being bound to one another. It may be that La Montagne Sainte-Victoire (Plate 29) does appear in these pictures as much simplified and even distorted if compared with our ordinary way of seeing, yet here for the first time it towers up and establishes itself, quite freely dominating various little groups of houses and trees in the valley, while they in turn are no longer fettered in their 'standing together'. Here is the spirit of Poussin, even though he expressed himself by other methods. And the studies for the *Bathers* (V. 723, 728 and 729, Plate 45), made at this time, actually attained almost the appearance of a sketch for a picture by Poussin. In them bodies and trees exist freely in their setting in the compositions as a whole which link them and carry them. This

effect is all the more impressive as these pictures do still contain figures in the same attitudes as those found in versions of the *Bathers* which Cézanne had composed earlier; precisely as before, the purpose and the significance of these compositions depend on the indissoluble 'standing together' of all the things seen, to form an unshakeable whole, in which the complete realness of each single object is first experienced. Yet each single figure is now freed from its rigidity, its compulsion, or rather seems actually to be in process of freeing itself from its compulsory rigidness. Nevertheless, this liberation was not completely fulfilled and successful. For Cézanne had to pay with a loss of realization for the freedom in stability and immobility of his figures and objects: not one of these, his last pictures, is so far successful as to realize completely all the things which appear in it. So far as they are seen at all they are free, but they have the air of being incomplete, partly veiled in mist, partly standing out in crystalline universality.

These few statements, however, by no means fully explain the ultimate import of this phenomenon which made its appearance in Cézanne's late works: on the contrary, for this purpose we must make a special survey of the style of Cézanne's old age.

## The Style of Cézanne's Old Age

From all I have read in the literature hitherto written about the master it seems to me that what I mean by the style of Cézanne's old age is what is least understood in all his work. For the labours of the last five years of his life have as yet scarcely been subjected to any conclusive examination at all.

Is there in the relevant sense of the words any 'style of old age' to be seen in these works regarded as a whole? A style expressive of something attainable only by a person of advanced age when he sets about adding up the enormous total of experiences of a lifetime? I do not know if anyone has given a positive answer to this question: Novotny, such a careful and penetrating investigator, explicitly denied it.[108] Dorival spoke only of Cézanne's 'vieillesse baroque', of the 'baroque style of his old age', but he too, in agreement with many other biographers of Cézanne, seems to have seen a falling off in the late works, a crippling of his strength. This could easily be explained by a weakening of his physical constitution, from which we know he suffered: in the last years of his life Cézanne was diabetic. But it remains to be considered whether a weakening of

the physical constitution and the accompanying diminution of sensitivity towards the confusing multiplicity of exteriors might not become equivalent to a gradual liberation of the spirit in the direction of higher receptivity towards what is essential, particularly in the case of a nature such as Cézanne's whose chief aim was to penetrate exteriors with all their charms and to get at the essence, what is permanent and in 'being'; and whether the fact that his physical organism was restricted in vigour—not indeed tottering to ruin or impotent, but certainly subdued—did not make it all the more willingly and freely enter into the service of the spirit. In any case, ageing of the body and accompanying ill-health are not adequate grounds for assuming a decline of mental powers, and particularly not in those who possess creative gifts. We must consult the works themselves, in order to discover whether or not they reveal a genuine 'style of old age'. We can start by addressing ourselves to such indisputable and consistent creations as the late works of Michelangelo, Titian, Rembrandt, Frans Hals, but also those of Donatello, Poussin, Goethe, Beethoven, to the *Œdipus at Colonos* of Sophocles or Shakespeare's *Tempest*. Out of the wealth of these examples, despite all their differences arising from the differences in time and place, there emerges plainly one common factor to which we must direct our attention. It is the eye of old age, grown mature and wise, with which all these men ultimately observed the world. This 'evening eye' no longer lingers on physical appearances, no longer examines them with inquiring and curious glance; instead it absorbs them all and looks through them. As a result of having surveyed the interrelationships of life as a whole, it has learned to regard all forms of the real world as mere symbols and similes and to perceive that they are thereby related to one another, and it creates its own forms for itself, forms which represent material appearances as the direct expression of a universal spiritual element which it sees in the world and life. It is these very specially created forms which bring out what all genuine works of old age have in common, despite the fact that the various artists and poets have such contrasting starting points and in spite of differences in their characters. In them the creative eye becomes independent, to a degree not attained elsewhere, of those formations which the ordinary intelligence, directed at practical things, can observe and which still possess a more or less strong determining influence on the works of the greatest minds in youth and manhood; it uses its own symbols to seize on the overall interrelationship of things from which all

formal individualization then vanishes. From this point of view alone we can say that in Cézanne's late works we have before us the evidence of a genuine and highly significant 'style of old age'.

But what are the characteristics of the forms created by an artist in the wisdom of his old age? They lack the separateness which otherwise clings to shapes as a consequence of the precision which is an essential feature of everything formed by the hand of man. In the works of old age mere definition becomes unimportant, indeed it is positively transformed into something transient. The plastic reproduction of things in full detail and their clear-cut separation from one another are replaced by a universal, all-uniting, all-united element, by a common factor, freely moving, overlapping, in which every kind of 'being special' or individuation is in turn itself revealed and unfolded. These forms of the 'style of old age' bring about the disappearance of corporeal substance, with its heaviness and impenetrability; they convert corporeal, resistant matter to a state of powerlessness, of impotence and of fragmentariness; they even take away from moving bodies their confident purposefulness and their resolution, making them uncertain and clumsy, but they do all this only in order to interpret them in a new way. For, by making matter lighter and less resistant, they make it receptive, indeed, positively transparent, to spiritual expression, and they use the diminished organic elements, from which the special power of cohesion has almost been eliminated, to display a greater whole. But this, this 'being' itself, in which all things now participate equally and in which all things are related to one another, surpasses each single thing and each single action and is the foundation of those movements which seem to be executed in the transitory forms with infinite tenderness, seem to be rather a receiving and an awaiting, an embracing of the filled void, reaching out in an unfinished gesture and missing any determined goal. The style of old age in fact transforms space into such a void, in that it makes it lose the intensity of even its peculiar attribute, limitless extension, and makes it powerless, untense and fragmentary. This makes space and solids resemble each other more and more in appearance and, through their being interwoven, the whole picture turns into a state of withdrawal from reality. The 'style of old age' illustrates Goethe's sentence: 'Old age is gradual retreat from appearance' and surpasses it in that it transforms the retreat into an all-pervading universal thing, something essential.

There is no longer anything in our sensory experience of seeing which corresponds as a whole to what thus becomes visible; what is

shown is rather the visible picture of the concept of freedom. For the thing common to all these forms of the 'style of old age' is two-faced: negatively it is a liberation from isolation and resistance, positively a liberation to the serious gentleness of freedom.

Now, even Cézanne's later pictures possessed the same tendency. They add the expression 'in freedom' to the scenes from nature, which declare the essence of the world to be 'existing together', a mutual self-supporting and carrying of things. That is what is new in them, what differentiates them from the earlier works of the master, even from the magnificent achievements of the 'nineties.

The works painted between 1890 and about 1895 still depict objects as individualized and linked to one another by the medium of colour-form composition and thus things and their 'existing together' are still seen as inherently antagonistic, with separation and isolation on one side, union and cohesion on the other, the latter sternly dominating the former.

Slowly, unevenly and spasmodically, however, there now emerged and evolved a fundamental change in the artist's purpose, which demanded and developed a new style. This process began in the second half of the 'nineties. If the *Boy in the Red Waistcoat* (V. 681) is still one of the main works of Cézanne's manhood, there is no doubt that the *Portrait of a Peasant* (V. 712) is characteristic of the style of his old age. Similarly, the decisive transformation occurred between two still-lifes: such as the one with the cupid and the fire-place (V. 707), and the one with the ginger jar, sugar bowl and fruit dish with four apples which seem to be buried in a carpet (V. 738). Landscapes such as V. 778 and 788, the *Quarry of Bibémus* and the *Park of the Château Noir* also belong wholly to the late phase of Cézanne's work.

In this phase we can distinguish three groups of pictures. In the first the colour scale he used was broadened by the introduction of an intense red in great quantities; in the second, a new depth of tonality was added to painting; in the third, blue advanced as the 'carrying' colour of composition to a degree far beyond that to which it was hitherto used.

Now, there is no work of Cézanne's in which these three trends were combined or brought into equilibrium with each other; to that extent therefore it can be said that his late style remained unfinished.

In the first group, to which for example the *Young Italian Girl* (V. 701) and the *Still Life with Sugar Bowl and Ginger Jar* (V. 738) just mentioned belong, we see the colours red and green elevated

to the same compositional significance as blue and ochre (yellow). The colour framework was thus doubled, extended to a colour field of four basic colours, and was thereby freed from the limitations which previously applied to it. Instead of the series of colours yellow, green, blue, which had also been seen as a series of darkening, diminishing light values, and in which red appeared only isolated or weakened as one of the degrees of shadow for violet blue, there were now four basic colours of equal value. Red was added to blue and yellow, and green thereby inevitably received a new significance; it was given independence as the complementary (contrast) colour for red. In addition, acting as an intermediary between yellow and blue, green now emerged with a value entirely its own. The four colours which together now 'carry' the pictures, also appear to be of equal value in their function as foundation colours: each ranging from the darkest shade right up into the lightest. Colour relationships were thus enriched to an extraordinary degree: instead of a combination of colours presented as one series—blue, green, yellow—with which all other colours were contrasted and by which all contrasting colours were 'carried', each of the four basic colours now developed a direct relationship with each of the others and a comprehensive system arose in which all the basic colours were able to enter into a completely free relationship with one another.

In the second group, which is represented by the tremendous pictures of old Vallier with his cap (V. 717), the *Portrait of a Peasant* (V. 712) and by such landscapes as the two views of La Montagne Sainte-Victoire (V. 798 and 801), the light colour scale of the impressionists, to which Cézanne had formerly clung, was broadened by the introduction of deep colour tones of all kinds. This removed any restrictions in respect of values. Dark green and dark brown now appeared next to dark blue—earthy tones which took their place in the company of the others, with values and importance equal to those of the 'carrying' blue. This broadened the colour basis; blue was even taken so far as to turn into black, in such a way that an entirely new freedom was won for the development of the different colours step by step. The dark areas of pictures now occupied a larger space than before; pictures as a whole became dark, like old masters, in such a way that their lightest high points could not be produced by the use of colour tones paling off into white, but instead only by strong local colours. The obvious explanation for the darkness of these works would now be to suggest that it was a darkness of death, overshadowing the creative activity of an

ageing master, but a comparison with the blackness of Cézanne's early works (before 1870) precludes any such interpretation. In those days, in the chaos of revolt, his work was near to death; now in old age his dark colours were as full of life as the deep notes of the organ and—conclusive evidence—they were tuned to one another in fully resonant harmony; they created eloquent combinations of tone which are entirely lacking in the early works.

In the third group there are landscapes, but the most important pictures are the last versions of the *Bathers* (V. 723, 725, etc.), compositions absolutely drenched in a mysteriously floating milky blue, the blue of a dove's wing, the blue of a parma violet, which very nearly swallows up all the local colours, so that these compositions appear, on account of their coloration, irreconcilable with those of the two other groups. Whereas the trends of the other two groups complement each other and converge towards a unified solution, it is as though Cézanne were once again treading a completely new road in this group. More than the two others it is a direct consequence of that fundamental feature of Cézanne's painting, his reliance on blue as a basic colour; different as this group is from the others yet it does have this one essential factor in common with them, that it presses on with the *broadening* of the painter's viewpoint. In the others, the network of colour relationships was freed from the limitations which formerly ruled; in this group the relations with reality were relaxed to the greatest possible extent.

This broadening of the painter's media was evoked by and serves to make effective the will, displayed by Cézanne in all the three groups of works of his old age, to overcome the isolation of separate things, which had hitherto persisted in his work, that is to say the very thing which he had earlier striven above all to realize. Things hitherto firmly welded to one another, but clearly isolated from one another, lost their separateness, they emerged from their restrictions and underwent a process of fusion. They did not lose their identity, they remained clearly recognizable, but they ceased to be held in the grip of compulsive rules, which had formerly turned each of them back into its own existence. Now they were concealed in deep darknesses or in floating tones, woven into a mixture of all colours or a fantastic blue; they were vaguer in their separate forms and so they now expressed with complete freedom the existence of 'being', into which they withdrew, becoming apparently quite immaterial and transparent. Seen in this way they represent Cézanne's ultimate vision and in the same way they become more

and more representative of one another, more ambiguous and mysterious. This is made magnificently clear in the portraits and landscapes alike, which were Cézanne's final works—some merely begun, some tortured to a finish with most painstaking work and yet not completed. The unfinished works exhibit in the highest degree the whole 'music' of colours, so characteristic of all Cézanne's art, which gleams forth even from the outline of a picture he has just begun, transcending all the separate forms in patches of colours —a perfection created out of his ability to see to the heart of things, to penetrate exteriors, which made technical perfection cease to have any importance.

Let us now sum up. In this phase Cézanne broke his last connexion with the ordinary way of looking at things. He saw the objects of the real world revealed to him as having a voluntary existence and being therefore free in a state of 'existing together'. If one merely sees the outlines which mark them off as individual items, one does not attain the deepest possible understanding of them, but if one possesses such an understanding these things then appear to be free within their bounding lines and appear to have an effect on the preservation of a whole, over and beyond their own boundaries. Both the individual item and the whole have the same significance.[109]

We can say then that Cézanne acquired the individual style of his old age by approximating his method of composition in an essential respect to that of Poussin. Until about the end of the century the shadow-path had been the element out of which his pictures were actually constructed. The pattern formed on the surface of a picture by the fitting together of the paths of deepest shadow held the picture together, integrated it and gave it rhythm. Lighter zones of shadow joined the deepest shadows, the former receiving their support and being given their function in the picture from the darkest strokes. They were carried and supported by them, but, in addition, as definite shadow areas themselves, they formed an essential part of the framework which 'carried' the whole. Yet, wherever the light (light coloration) increased and finally the character of lightness predominated, the components of pictures which resulted did not themselves 'carry' but were merely 'carried.' If the shadows were the 'supports' the light parts were the coloured 'loads' of the picture, which were 'carried' by the 'supports'. Even if the most intense colour relationships existed between the supports and the load, a certain conflict in the significance of the colour values yet remained perceptible. But in the late works, whose purpose

Cézanne himself expressed in the words 'the whole object is to establish the greatest possible relationship' ('rapport')[110], the light areas, as indeed all the colours, were developed into mutual supports and thus a new unity was attained, a new compactness of construction and likewise a new stability of structural harmony. Lightness and darkness acquired the same kind of rating as had hitherto been possessed by the values of the middle zones alone; both became simultaneously supports and load, for it was no longer only the deep colours, from below, which exercised the function of carrying, but also the light shades above. Cézanne made it possible for the light colour tones to assume this new rôle, by increasing the intensity of colour to an enormous degree, a phenomenon which Roger Fry has emphasized as characteristic of the style of his old age. In Cézanne's earlier works there had been a contradiction between the significance of different colour values, a variation in their significance, which had expressed a tension and a lack of freedom, but this now fell away; and it was only now that he attained the classical conception which Poussin possessed. For the latter had always made use of light and shadow in equal proportions to construct his compositions. In so doing he had himself followed the classical artists of the ancient world and, in the composition of his pictures, had adopted their method of constructing solids in that he so organized the compositions that every 'carrying' part was at the same time a 'loading' part. Thereby he had gained the same unshakeable and at the same time unforced, functional harmony of the whole as is exhibited in unsurpassed form by the Greek temple and the human figure created by Greek sculptors.

Poussin's art, however, shows a distinct inclination to illustrate an ever greater measure of freedom within the stability of the composition. In his last works, of which the Louvre possesses such outstanding examples as *The Four Seasons* and *Apollo and Daphne*, he illustrated the unity of bondage and freedom with inimitable tenderness and regard for every single detail. It was these late pictures of Poussin's which exercised the greatest influence on Cézanne's late style.

In the foregoing we have considered Cézanne in relation to five great masters of French painting. They were hardly his teachers, rather a constellation under the magical influence of which he grew up to become an artist. Each of them shone a different light on him.

It is by the *diversity of its links* with the chief problems of French

painting that the historical position and significance of Cézanne's art can be judged: it appropriated all the essential trends which had till then existed side by side but had been incompatible, it overcame the contradictions and in so doing produced something new and quite individual.

Cézanne assimilated, as did no other painter of his time, the methods and the conclusions of realism, naturalism and impressionism, without subscribing to any one of these movements; he made use of certain features of all three to form a synthesis. The principal characteristic of this synthesis was that it combined the nineteenth century way of portraying *nature* with two antagonistic styles of portraying an *ideal* world, which both originated as long ago as the seventeenth century but continued to dominate the art-life of France until about the middle of the nineteenth century, namely 'Rubenism' and 'Poussinism'.

If Cézanne's historical *position* is clear from his relationship to Poussin, Delacroix, Courbet, Pissarro and Manet, his historical *significance* within the evolution of art consists in the fact that his own development was determined by the last three—painters of the present day, of the actual and the factual—whereas he himself determined the history of painting by continuing to pose the problem and further the endeavours of Poussin and Delacroix and ultimately producing a combination of both. Here Delacroix is to be seen as the 'pupil' of Rubens and as representative of the 'Rubenists' of the seventeenth century.

A study of the history of French painting in the nineteenth century shows that it is characterized by a confusing number of tendencies opposed to or running parallel to one another, but that about 1900 all these different movements had ceased to exist as independent trends. Singlehanded, Cézanne accomplished a fusion through which painting regained once more the whole field which it had possessed in the seventeenth century—the representation of a world with an integral existence, even if frequently in fragmentary form and without definitive realization. The 'world' is here to be understood as the opposite of mere 'nature', as Cézanne himself put it in the sentence in which he said he wanted to 're-create' Poussin, that is to say Poussin's artistic world, *sur nature*.

By accentuating this contrast Cézanne drew attention to a fundamental discrepancy in French painting, which, since the sixteenth century, had adopted both Italian and Nordic trends. For the sake of sharper definition let us over-simplify and call these 'Roman' and

'Dutch'. The 'Roman' tradition of the French seventeenth century
was concerned mainly with religious, historical and allegorical
themes; it was an art which dealt with great human destinies, which
even regarded nature from this point of view as something fatefully
motivated, accompanying and reproducing the fate of man. Its
great media were plastic figures and plastic forms, and the main
representatives to be taken into account for our purpose were Rubens
and Poussin, or rather their partisans in the Paris Academy. The
most important signpost of this tradition for the road of historical
evolution was the fact that it cultivated the art of *invention* and used
the real world only as a reservoir of ideas, as a 'dictionary' (an
expression of Delacroix's).

The 'Dutch' tradition in French art of the seventeenth century
was concerned with the reproduction of data from the real world,
with portraits, *genre* pictures, landscapes and still-lifes. It selected
themes of everyday life, ordinary and present-day subjects, which
it presented not, admittedly, just for their own sake, but with
particular interest in the phenomena of light and atmosphere.
Outstanding among the artists of this school were La Tour and the
brothers Le Nain. The most important feature of their work in a
historical context was that they were designers rather than inventors;
their accomplishment was that they enriched the potentialities for
construction from data of the real world to an infinite degree and
that they transfigured the world of nature. Even man seemed to
them to be only a piece of nature and they perceived no connexion
between him and his spiritual existence and his destiny.

In the seventeenth century, French painting was taken up by the
struggle between the Poussinists and the Rubenists and victory of
the latter, while the Dutch tradition continued to exist alongside,
less striking but still fully acknowledged.

For examples from the eighteenth century let us name Watteau
as a Rubenist, Fragonard as a mixture of Rubenistic and 'Dutch'
features and finally Chardin as a still-life painter of pure 'Dutch'
persuasion.

The Revolution caused an upheaval in painting too. The 'Roman'
tradition reappeared, now markedly classicist, in David and his
successors down to Ingres. They continued to dominate the painting
of the first half of the nineteenth century, although with a romantic
tinge. Alongside them Delacroix represented the Rubenistic variant
of the 'Roman' movement. But in relation to both these movements
the 'Dutch' theories and manner of posing problems still attracted

an ever greater respect for themselves until ultimately they held the field alone.

Then followed, roughly speaking, Courbet, Pissarro and Manet. For their work started out from momentary impressions of everyday nature. Their modernity, the contemporariness of their art, as they saw it themselves and as it was also seen by their contemporaries, lay in the very fact that they had broken off every link with classicism and romanticism. For ideality they had substituted nature as conceived by the 'Dutch'.

The first fact of importance for the historical significance of Cézanne's art is that he not only engaged in a conflict, like other artists, with the two main tendencies of the 'Roman' tradition of French painting, but that he conducted this dispute on the ground of the modern school of present-day art. And he did this in such a way that, though he did indeed choose nature as the subject and the guiding principle of his art, he did not see it at all in the 'Dutch' sense, but interpreted it as formerly the 'Roman' painters had interpreted the world, as the world of man, symbolically and ideally, as the bearer of a metaphysical significance hidden behind ordinary appearances. If then he dedicated himself wholly and more thoroughly than any other artist before him to constructing natural interrelationships and did not invent anything, but at best assembled studies from nature in a free manner, yet he did not follow the 'Dutchmen' in their comprehension of nature or in their adoption of motifs to paint given to them by nature. Instead he put an end to this very conception of nature and natural interrelationships and fitted the 'Dutch' tendencies of French painting once again into the 'Roman' tradition. That is why it is radically wrong to regard Cézanne as directly related to the French impressionists; for this kind of painting came straight from the atmospheric studies of the Netherlanders. Even though Cézanne did receive a great deal of practical instruction from Pissarro, yet the fact that he worked alongside him was historically irrelevant, as was also his choice of the same motifs and the same palette. These facts lost their significance because Cézanne gave a metaphysical interpretation to natural harmony when he used it as the subject of his art and he was thereby put under the necessity of attaching himself once more to the 'Roman' tradition.

The second historically important fact about Cézanne's art is, however, that he found himself compelled to form a link with both Poussin and Delacroix and that by looking back to both of these

painters he produced the greatest synthesis to date, out of a combination of Poussin's method of composition and the colour structure of the Rubens tradition.

*Why* he had to attach himself to the two rival tendencies has already been discussed above. In creating this synthesis he was merely pursuing a tendency which had appeared before in the work of other painters, although Le Gros, Prud'hon and Chassériau (who had tried earlier to reconcile the two antagonistic tendencies of French painting) had never got further than a feeble kind of ideality to which they subordinated the realistic trend. Cézanne, however, effected his synthesis in the free space created by the art of the present day, *in the realm of nature*, in the sphere of the interrelationships of the real world inspired by nature, and in so doing he attained what had been denied to those others, a complete and perfect penetration. For the challenge of artistic realization offered by natural harmony enabled Cézanne to free himself completely from the bondage of style imposed by *both* schools and to apply himself solely to the means which they used to create forms. He was not stirred by either baroque *pathos* or antiquarian classicism, with their ideological undertones, although they had nevertheless fascinated his predecessors in this field. On the other hand, however, he had not the slightest intention of trying to reconcile the differences between the schools as they existed when he encountered them in Paris at the beginning of his career. That is an exceedingly important point: he did not just join on to the last phase of the plastic tradition as represented by Ingres. He did not turn to Ingres, the artist of the line, but to Poussin, the master who composed from plastic volumes, who knew the secret of preserving the picture plane in his representations of space. But he saw Delacroix too in a special light, not as a romantic who cultivated *pathos* but purely as a master of the manipulation of colour, as proxy for Rubens and on this point his perfector.

From passages in Cézanne's letters we know that he wanted to give new life to painting in order to produce something which could hold its own with 'the art of the museums' in durability. He believed that the way to do this lay in producing a repetition of Poussin, in reintroducing what Poussin achieved in painting. This he effected by means of colour, by his colour modulations, whose history can be traced back to Rubens, and so he unconsciously accomplished the closing of the rift within French painting. That is the reason why Cézanne towers so far above his contemporaries, why his work

appears so incomparable. His painting is rich and deep in artistic content and historically it has likewise exceptional significance for the progress of French painting and the painting of the whole Western world in general.

Even though I have explicitly stated that I did not intend in this book to examine the influence of Cézanne's art on present-day painting, I may perhaps be permitted to cast a quick glance from the heights of the understanding we have gained of it, at those realms which, in Cézanne's own time, were seen as the future.

Cézanne has been called the 'father' of modern painting. Perhaps it would be better to call him its 'destiny'. It was he who so outstandingly combined different traditions and carried them further, and anyone following him would have had to continue from where he left off. Attempts have indeed been made to do that without success: inevitably so, because Cézanne advanced to such depths of understanding of 'being' in his art that it was impossible for anyone else to continue in the same direction. This is what Matisse has said. It is the consequence of Cézanne's art that completely new roads had to be found, new subjects for art discovered. He had exhausted the old ones, drunk their significance to the dregs. For once, the road to art had been trodden to its end, whence there was no further road. Gauguin, the symbolists, the fauves and even the cubists have indeed taken over Cézanne's most universal challenge—the preservation of the picture plane as an element of pictorial composition and the construction of a picture out of plastic images alone—but none of these movements produced a continuation of what is so completely individual in his accomplishment: the ordered depth of his pictures, the impenetrable substantialness of the objects of his world, the stability of his compositions and his spiritual conception of the forms of things concretely present in the real world.

(10th July, 1955)

### NOTES (CHAPTER V)

1. Friedrich Rintelen, 'Paul Cézannes geschichtliche Stellung'; introduction to a lecture on Cézanne (between 1915 and 1917); reprinted in Friedrich Rintelen, *Reden und Aufsätze*, Basle, 1927; and K. von Tolnay, 'Zu Cézannes geschichtlicher Stellung' in *Deutsche Vierteljahrsschrift für Literaturwissenschaft und Geistesgeschichte* XI, Halle a.d.s., 1933.
2. *Théories*, p. 246, 4th edition, 1920: 'Il avait fait un effort vers le style.'
3. Ibid., p. 248.
4. Ibid., p. 204. 'Cézanne paraît quelque vieux maître sévère, au style châtié, le Poussin de la nature-morte et du paysage vert.'

5. *Théories*, p. 251. 'Un effort vers une juste combinaison du style et de la sensibilité.'
6. *Théories*, p. 251. 'La conception traditionelle du tableau composé.'
7. Ibid., p. 250. 'Presque unanimement pour l'unique raison de l'œuvre d'art.'
8. Cézanne, Manet, Degas, Fantin, Renoir, Pissarro. . . .
9. Alberti's *Velo* lingered long in the memory of painters. For example Pietro Testa mentions it in a treatise 'per far la veduta' (about 1650).
10. At this point in the treatise we come upon a very daring sentence, which was obviously written with Cézanne in mind, for at that time Zola still entertained the highest hopes for his artistic future. 'An artist of genius,' says Zola, 'will always be permitted to show us Creation in green, blue, yellow or any other colour he likes; he can offer us rectangles for curves, interrupted lines for straight ones, and we shall have nothing to complain about. It will be sufficient for us that the images he reproduces possess the harmony and brilliance of beauty.' Zola's wondering, and at bottom uncomprehending, admiration for Cézanne's early works is expressed in these words.
11. Reprinted in *Émile Zola, Correspondance, Les Lettres et les Arts*, pp. 16 and 17, Paris, 1908.
12. *Philosophie du Salon de 1857*, Paris, 1858.
13. *Philosophie du Salon de 1857*, p. 8.
14. Ibid., p. 12.
15. Ibid., p. 16.
16. Champfleury, *Du Réalisme*, p. 272, Paris, 1857, from a letter to George Sand dated 2nd September, 1855: 'I fear schools as I do cholera and my greatest joy is to meet strong personalities.' Courbet, in the programme for his studio dated 25th December, 1861: 'I believe that every artist ought to be his own teacher. I can teach neither my own art nor that of any school whatsoever, for I deny that art can be taught, or, in other words, I maintain that art is something absolutely individual which can only be found by each artist in his own talent, which in turn has its origin in his own inspiration and his own study of tradition.' Burger-Thoré, *Salon de 1863*, pp. 374/5: 'After fifteen years' imprisonment in the École des Beaux-Arts of Paris or the Villa Medici of Rome, how could even the liveliest character retain his independence, under the constant pressure of old professors, old examples, old routine and old theories?'
17. *Du réalisme*, p. 144.
18. Gautier, *Tableaux à la plume*, p. 36, written 1849.
19. *L'Art romantique*, p. 333.
20. Gautier, *Les beaux arts en Europe*, I, p. 170, 1855.
21. *L'Art moderne*, p. 136, Paris, 1856.
22. Théodore Duret's statement that 'Courbet's realism was basically equivalent to Cézanne's way of existing' is quite incorrect.
23. *Mes Haines*, p. 279.
24. The impressionists also used their relatives and friends as models, but they never connected these figures in their pictures with the problems of their own persons. On the contrary they saw them as detached from themselves and free from any kind of spiritual problems.
25. All the quotations in this paragraph are from Castagnary, *Salon 1857*.
26. Camille Lemonnier had already said this in his excellent study, still very well worth reading today, *Courbet et son œuvre*, Paris, 1868, p. 23: 'Courbet created a sensation: Life in all its materiality. He gave the impression of a certain rich existence which was merged into the development of things; in his works life was lived to the full.' He continued, on p. 25, 'Courbet had the marvellous gift of expressing materiality; that was his distinguishing mark.' And on p. 53: 'Courbet studied in particular the volume, the space content of things, their mass rather than the refinement of the contours behind layers of transparent air, the force, the weight, rather than the lightness of the effect.' 'His nudes,' he added on p. 48, 'are carved out of

solid blocks of matter.' All in all, his 'plastic realization ('la formule plastique') is admirable.'

27. Roger Marx, 'Le Salon d'Automne' (1904) *Gaz. des beaux Arts*, XXXII, p. 462, has already pointed this out: 'Of the founders of impressionism Cézanne is the one who has remained most faithful to Courbet. . . . His figures and portraits are modelled with thick pigment in the light of the pure tone; in his landscapes the breadth which we normally associate with Courbet's methods is accompanied by deep and delicate nuances.'

28. The tree trunks in Rousseau's famous *Allée des marronniers* (Louvre, Paris) are painted with the palette knife. See A. Sensier, *Souvenirs sur Th. Rousseau*, p. 104 and also p. 199, Paris, 1872.

29. A striking example is the little landscape V.36, which can hardly have been painted later than 1865. Both in its technique and in its effect on the eye it is quite monstrously brutal and is not easily recognizable as a work by Cézanne, even the young Cézanne. Against a background of a whitish-blue sky there are trees of very dark green; the foreground is almost black with streaks of brownish-greyish-red superimposed, which depict nothing comprehensible. At the lower edge there is a blood-red patch. We see from the house on the right that the picture was begun, in a thoroughly timid way, with the brush (perhaps even by another hand?): it has been left standing for the sake of its clear brick-red shade of colour and not smeared over by the spatula like the remainder of the picture. Coarse the execution may be, but it is interesting because it displays an attempt to create a composition in colour with masses, which has interested the painter much more powerfully than a mere objective reproduction. In the process the spatula has been used *furioso*.

30. The problem involved here is as follows: the term *milieu* means the actual setting of a person, the immediate surroundings which are familiar, ordinary and usual to him; objects seen in it are homely, recognized by his fingers and eyes, taken for granted by the person living among them. On the other hand '*milieu*-type' surroundings of a person are filled with objects—no matter whether close packed or scattered—to such an extent that there is no room for empty space, strangeness or loneliness and so one can feel no doubts or question about existence here. Instead, the oppressive closeness of the objects to one another seals up the character of the person living in their midst.

Now Courbet saw the forest, the rocks, the various views he enjoyed from his home and even the clothing of his figures as *milieu*, as a means of 'placing' with faithful accuracy the subjects he was portraying; but he gave no further revelation concerning their 'being' and their life, whether they were human beings or things. One becomes explicitly aware of this if one simply casts a glance in the direction of Corot, who never uses landscapes or clothing in his works as a means of 'portraying a *milieu*' in this disastrous way: they have always the charm of things which are fresh, untouched and unfamiliar, in contrast to Courbet's far too well-known velvetiness, dampness, fleshiness. There is no need to mention more ordinary artists who simply murdered *milieu*, using it as contrasting atmosphere—showing, for example, a tyrant, an assassin, or a poacher (that is to say exclusively repulsive individuals) in the surroundings familiar to them and thus creating an effect of homeliness in the beholder.

31. *Journal*, 1st April, 1853 and 3rd August, 1855.

32. *Mon Salon*, 1866.

33. *Gustave Courbet*, pp. 88/89, London, 1951.

34. The Goncourt brothers certainly went very far when they remarked in their diary on 18th September, 1867: 'it is noteworthy that this master of realism does not study nature.'

35. Georges Riat, *Gustave Courbet, peintre*, p. 67.

36. This also distinguishes Courbet's pictures from the 'pathetic' realism found in Gros (*Plague in Jaffa*, 1804) or Géricault (*Medusa's Raft*, 1819), or from

the realistic precision of Ingres and his pupils, against which the young people surrounding Courbet used to storm. Cf. George Boas, 'Courbet and the naturalist (!) movement', Baltimore, 1938 (*Essays read at the Baltimore Museum of Art*, 1938, by various authors).

37. Castagnary and Théophile Silvestre had actually used the new expression 'naturalism' earlier, Castagnary already in his *Philosophie du Salon de 1857*.

38. The foregoing paragraph is an attempt to distinguish between realism and naturalism in the painting of the nineteenth century according to the content of the pictures, a distinction which, as will be seen shortly, is an extremely useful aid to an understanding of Cézanne's art. It is aimed moreover particularly against the view now expressed by authors writing in English (e.g. George Boas and his circle, but also Arnold Hauser in his *Social History of Art*, London, 1951), that this distinction is mere hair-splitting and of no practical value. To me it appears, on the contrary, that Paul Mantz was absolutely right when he wrote in the 'Salon de 1865' (*Gazette des beaux arts*, XIX, July, 1865, p. 7): 'The minute the creator of 'Olympia' can be regarded as a realist—and this is the label given to him by M. Fantin and the critic of *Le Siècle*—it must be admitted that the confusion of Babel starts once more; words become meaningless, or rather—there are no longer any realists.'

39. In Cézanne's painting V.882 a recollection of Manet's *Nana* can be traced, not an obvious one, but one lingering in the mind. Both pictures deal with the same subject—an elegant gentleman watching a woman at her dressing table. In Manet's picture we see the *cocotte* in her petticoat, in Cézanne's the subject-matter is coarsened—the girl is naked.

40. Some early pictures of Cézanne's reveal a link with Daumier, but I am not pursuing this point further since it is of no importance in Cézanne's work as a whole or in the evolution of his style. The element of caricature in Daumier's work was useful to Cézanne for a short time, as it helped him to express his hate; but it had no other significance for him.

41. Published by John Rewald, *History of Impressionism*, p. 356.

42. John Rewald, *Cézanne, sa vie, son œuvre, son amitié pour Zola*, p. 382.

43. Cézanne, *Correspondance*, p. 276.

44. *Camille Pissarro, Lettres à son fils Lucien*, edited by John Rewald, p. 390, Paris, 1950.

45. One can obtain one's picture most easily if one stands in the middle of a road, not too high, and takes a photograph, with one's lens pointing downwards or slightly inclined, in the direction of the road running straight away from one. When photographs of this kind first appeared artists thought they were fakes. In a book by an anonymous author, *Eugène Delacroix, sa vie et ses œuvres*, pp. 406/7 (published by Piron, Paris, 1865) Delacroix is quoted as having written: '(even) the most stubborn realist will improve the rigid perspectives produced by the camera, which by reason of its correctness actually falsifies the appearance of things.' By 1870, however, painters had already accepted this.

46. According to Lucien Pissarro: 'exploration of the values of closely adjacent colours' was 'the outstanding characteristic of his father's art.' (*Lettres*, p. 501).

47. The same can be said of the motif, *La côte des boeufs*, Pissarro, London, National Gallery No. 4197, Cézanne V.173.

48. Pissarro himself used this expression with reference to Monet's sunsets (letter dated 5th May, 1891); at that period many artists were already showing that they felt the need of a firm outline.

49. *Lettres*, p. 278.

50. 'C'est moins la chose même—la vulgarité disparaît pour ne laisser flotter que la vérité entrevue, sentie.'

51. *Cézanne und das Ende der wissenschaftlichen Perspektive*, p. 135.

52. *Claude Monet, sa vie, son temps, son œuvre*, Paris, 1922.

53. *L'Art romantique*, p. 368, where he is talking of Théodore de Banville.

54. This means that the theories expounded by Wolfgang de Boer (*Merkur*, No. 2, January 1953, page 32) are doubly wrong. He said: 'There is no doubt that we can already perceive the natural experiences of the senses being made abstract in the "pure" vision of the impressionists, which was so to speak distilled from the natural harmony of the senses. Here the artist's vision has already so thoroughly demolished the links with the world of space and solids which are always implicit in "natural vision" that the world of the human senses has already been abandoned and there is already an overwhelming inclination to turn away from it, even though this may not yet have reached its most extreme form. The way to total abstraction has been prepared and Cézanne is to bring it almost to fulfilment—at any rate to point the way thither.' I have quoted these sentences deliberately because they reflect a conception very popular at the time. Those who held it aimed at creating a 'genealogy' as long as possible for abstract painting—this being the dominant style of the present day. So we find that they not only claimed Cézanne as evidence to support them but even drew a straight line back into history as far as the impressionists. This is, however, a perversion of the truth. In the works of the impressionists there is no sign of 'the natural experiences of the senses being made abstract'. On the contrary, the impressionists live and enjoy 'the experiences of the senses' to the full and 'the world of the human senses' is preserved whole in their pictures—if indeed without literary references, yet strongly marked by feeling, in particular the feeling of joy and of love for things. Cézanne in turn did not pursue the impressionist trend in his conception of the real world. Nevertheless, though he took a different turning, he did not move towards abstraction: instead he evolved a new kind of symbolism.
55. Quoted in *Nouvelles théories*, p. 27, Paris, 1925.
56. Take for example the figure compositions of Gauguin. In assessing their artistic merit the spectator of today no longer takes into account their literary content and the interpretation which the painter intended to put on their colours.
57. *History of Impressionism*, p. 358.
58. Op. cit., London, 1899.
59. Ibid., p. 9.
60. Ibid., p. 82 (on Verlaine).
61. Ibid., pp. 129/130.
62. Ibid., p. 131.
63. Ibid., p. 131.
64. Ibid., p. 132.
65. Ibid., p. 132.
66. Ibid., p. 133.
67. Ibid., p. 34.
68. Ibid., p. 91.
69. Ibid., p. 165.
70. Ibid., p. 41.
71. From a letter to Alfred Sensier, according to *Souvenirs sur Th. Rousseau par Alfred Sensier*, p. 278, Paris, 1872.
72. Here I must indicate in a few words what Novotny said about Cézanne's style of composition (see *Cézanne und das Ende der wissenschaftlichen Perspektive*, pp. 96 et seq., Vienna 1938). In the course of his research Novotny comes to a point where he speaks of 'the questionable, uncertain position of "composition" throughout in this art.' He maintains 'that Cézanne's composition contains little of the strength of older, pre-impressionistic styles of composition, that the strength of his pictures lies in other factors, which cannot tolerate any composition in the ordinary sense alongside them.

'In Cézanne's painting there is no "composition" at all in the sense in which the term can be applied to all art before his time.'

Novotny arrived at this theory by drawing up the following definitions. 'The term "composition" can be interpreted in two ways. In one sense there

is "composition" in every picture, for there is always a distribution of defined masses, proportions in surface and space, in brief all the relationships which result from the partition of the rectangle of the picture. Alongside this "composition" there exists "composition" in the other sense of the word, i.e. a distinctive structural element, appropriate to the content of the picture and consciously artistic. The significance of composition of this second type is more limited in scope. It is not of course restricted to composition in the academic sense, yet it does seem to be tied to one of two preconditions: if one is to be able to speak of composition in this second sense at all then every picture must contain a minimum of effective power either of line or of modelling. In Cézanne's method of pictorial realization there is no such minimum, either of line or of plastic modelling.' Novotny therefore continues: 'In Cézanne's case one might speak of a mysterious absence of composition concealed behind an outwardly monumental form.

'However closely Cézanne's composition in broad outlines may be related to older types of composition on the surface, it certainly is not in the slightest degree so related in essence.

'One must differentiate between composition as a structural element and Cézanne's composition, which as a result of a multitude of different developments has been devalued and has lost so much of its independence that one could call it apparent composition.

'This devalued kind of composition is one of the characteristics of Cézanne's painting with which it is most difficult to come to terms.'

I have quoted this selection of Novotny's statements on the problem of Cézanne's composition because they are little known and have hardly been subjected to any investigation at all; this is indeed true of almost all the conclusions in his book, which is far too seldom read, and which has pursued the elucidation of the problems of Cézanne's art further than any other. I do not personally share his views, as will be evident without a shadow of doubt from what I have been saying. But even Novotny sensed that there was something unique about Cézanne's methods of composition and that is what makes his analysis so specially important. What is novel about Cézanne's composition is, however, the fact that it is throughout composition 'in the sense of a distinctive structural element, appropriate to the content of the picture and consciously artistic,' indeed it is so in the highest degree. It is no contradiction of this statement to appreciate that in Cézanne's works line and modelling emerge in a new form and a new rôle. In his pictures they are not lacking in 'effective power' at all; they are effective, although one cannot 'grasp' them or isolate them in the usual way. Cézanne's methods of composition have their place in the history of colour composition although, because of their deep pictorial significance, they are fundamentally different from their predecessors in this field too. Yet there were also styles of composition before him in which line and plastic modelling took second place to the principle of construction in colour. Earlier, this method was used by Delacroix, who was not without influence on Cézanne. 'Because he knew these principles and studied them thoroughly, after having already anticipated them by intuition, Eugène Delacroix was one of the greatest colourists of recent times,' wrote Charles Blanc in his *Grammaire des arts du dessin.*

Then again, Novotny's division of composition into two types—a merely mechanical partition of the picture rectangle and a consciously artistic structural element—is in my opinion not justifiable. The first of these is merely the academic, dead perversion of the second, which is present in all living art, though never in such a way that it could 'tolerate' anything else 'alongside it', but always as a foundation and as the most comprehensive elaboration of every single work (cf. in addition the words of Th. Rousseau quoted above). An inconsistency in his analysis of the term 'composition' then prevented Novotny once again from seeing the way to complete recognition of Cézanne's special achievement in this field, in that, in

addition to the definitions I have just quoted, he defines 'composition' further (p. 48 of the same book) as 'arbitrary invention in relation to the facts of nature'. Because of this it seems to him 'that we find side by side in Cézanne's works the most extreme type of composition, formal and in a derivative sense harmonious (in the sense of a renaissance type, baroque or romantic style), and on the other hand also the most extreme kind of organization of a picture, "uncomposed" and aimless.' (ibid. p. 53). Artistic composition is not, however, in any way restricted to 'invented' themes, does not engage in getting together and making ready the objects to be portrayed, but in realization i.e. in the shaping or (trans)formation by the artist of objects presented by the real world, whether these are actually present in the context before the painter's eyes or only in his imagination, which adds details from memory. No worthwhile work of art can contain 'organization of a picture, "uncomposed" and aimless': its whole merit springs from the fact that it is a composition. There is indeed nothing of this kind in Cézanne's works. On the contrary—let me stress it once more —his pictures are without exception very impressively and obviously 'composed'. Here Tolnay (quoted by Novotny in Note 43 of p. 50 of his book) and popular opinion (p. 96) are absolutely right.

73. *Cézanne und das Ende der wissenschaftlichen Perspektive*, p. 98.
74. See John Rewald, *Cézanne, sa vie, son œuvre, son amitié pour Zola*, Plate 51.
75. This photograph, in which he poses as a painter, is very different from all others known of him; there may have been some special and personal reason for it.
76. Incidentally, in *The Apotheosis of Delacroix* we can see not only the body of Delacroix borne towards heaven by angels, and the figures of Monet and Cézanne himself, but also a figure which Cézanne himself has told us represents the collector Chocquet. Cézanne had been closely connected with him from very early days—in fact precisely on account of their common admiration for Delacroix.
77. See Paul Jamot in the Introduction to the catalogue of the *Centenaire du Romantisme, Exposition E. Delacroix*, Musée du Louvre, 1930.
78. Cf. W. Pach on Delacroix's classicism, in *L'Amour de l'Art*, June, 1930.
79. Paris, 1925, pp. 41–43.
80. Gautier once expressed this view beautifully (*Les beaux arts en Europe*, Vol. I, p. 17, 1855): 'Delacroix's inner world ('création') does not, so to speak, depend on the outer world; he draws from it what he needs to suit the requirements of the subject which he is treating, not copying something which lies around him; so a wonderful harmony arises, the secret of which one does not at first understand.' Let me add: a harmony as in nature.
81. First appeared in *Moniteur* of the 26th, 29th and 30th June, 1853; reprinted in *Eugène Delacroix, sa vie et ses œuvres*, anon., published by Piron, 1865.
82. *Journal* of 28th April, 1853.
83. Camille Lemonnier, *G. Courbet et son œuvre*, p. 7, Paris, 1868.
84. *Reden und Aufsätze*, p. 155, Basle, 1927.
85. *Cézanne, a Study of his Development*, p. 30 (see note 8 to Chapter II).
86. Ibid., p. 25.
87. Novotny, *Cézanne und das Ende der wissenschaftlichen Perspektive*, p. 11.
88. Ibid., p. 94.
89. Ibid., p. 130.
90. Ibid., p. 10.
91. *Cézanne, son art, son œuvre*, Paris, 1936. *L'Art de Cézanne, étude critique*, p. 65.
92. Ibid., p. 23.
93. Ibid., p. 25.
94. That is to say, all the pictures painted in his youth with the exception of Nos. V.1–11.
95. Of this more later.
96. *Cézanne*, pp. 63 and 72, new edition, Paris, 1926.
97. *L'Art romantique*, p. 26.

98. *Journal*, 28th April, 1854.
99. *Les Artistes français.*
100. Because the subject is so important I give below some more details about Delacroix's colourism. Paul Signac gave a very clear description of it (*D'Eugène Delacroix au néo-impressionisme*, pp. 36, 37, 39 and 41, Paris, 1899). He wrote: 'Delacroix makes a colour resound and vibrate by placing touches of it on top of another shade or touches of a closely adjacent colour on the first one. For example: a red is invested ('martelé') with touches either of the same red in a lighter or darker shade, or of a different red, which may be somewhat warmer (tending towards orange), or somewhat colder (more violet).

'After he has intensified colours in this manner, by making them vibrate and by shading off one tone on top of another and using small intervals, he places two far-apart colours side by side and so creates a third tone, which arises from the two being optically mixed [i.e. mixed by the eye, not on the palette]. If he wants to make a slight change in a colour, to soften or moderate it, . . . he obtains the effect at which he aims by applying delicate cross-hatchings on top of it which affect the original colour in the desired way without prejudicing its purity. In order to create a striking impression and to produce an effect of magnificence, Delacroix uses contrasting complementary colours, which he opposes to one another. On the other hand, when he wants grey tones he obtains them by optical mixing; these are not "dirty" and could never be produced so finely and brilliantly by any amount of mixing on the palette.

'By means of this juxtaposition of neighbouring or contrasting elements, altering their quantitative proportions and their strength, he creates an infinite series of shades of colour which were hitherto unknown and which are strong or delicate according to his purpose.'

'This mastery of colour, which permits Delacroix to harmonize the tiniest details of a picture with one another and to embellish its smallest particles, helps him also to construct colour compositions and to achieve a universal harmony by means of fixed rules.'

In his later years, that is to say in the decade which preceded Cézanne's arrival in Paris, Delacroix introduced 'multi-colour elements which had no basis in Nature.' Till then he had enlivened monochrome materials by means of small patterns in contrasting colours and had introduced contrasting colours by importing multi-coloured objects into his pictures, leaving flesh colours relatively uniform. 'Later', however, he 'learned to rise above chilly precision' and was 'not afraid to enhance flesh colours with freely contrived cross-hatchings in order to obtain greater luminosity'. At that time he was developing 'a more vigorous coloration', and 'extending it over the whole surface of his canvases'. Delacroix then 'eliminated black and earthy colours from his pictures and simultaneously also 'les teintes plates',' that is to say colour masses of uniform shape which give a flat effect; he 'replaced them by pure, vibrating shades; this gave his colour the appearance of being immaterial and spiritualized'. Thus, for example, he modelled flesh 'by means of green and pink hatching', added freely contrived shades of yellow to the blues in the sky and used pink and light green colour hatchings in order to enliven a white surface without making it lose its own peculiar colour. In the frescoes of St. Sulpice, says Signac, 'each local colour is heightened to its greatest intensity, but always in harmony with the colour next to it which it affects and which is affected by it. They are all fused with light and shade into one harmonious, coloured whole in a perfect equilibrium, in which nothing is out of place.' Delacroix's procedure was based on a twofold law: 'the concord ('l'accord') of the similar colours and the correspondence ('l'analogie') of the contrasting ones.' He selected shades in such a manner that those which were similar, adjacent to one another or related to one another were kept apart, distinct and at a recognizable interval from one another, but were attuned to one another in

harmony, in concord; whereas the contrasting colours appeared to respond to one another (in extent, in intensity, in brief—in effect). Essential features of Cézanne's colour methods can already be seen in this procedure: the fact that the individual colour patches did not depend on the natural colours of the model, that there was no direct imitation item for item, that each single dab of colour was subordinated to the general effect, but most of all the way in which each colour which could be applied by means of a brush stroke was selected out of the representation in colour of a picture as a whole.

101. Or, as Camoin and Larguier put it (see Venturi, *Cézanne*, p. 54, Paris, 1936), 'vivifier Poussin sur nature', which makes no difference.

102. Venturi cites only one drawing of Cézanne's, a cupid (V.1388), taken from Poussin's *Concert* in the Louvre. On the other hand Dr. Gertrude Berthold has recognized that V.1387 and V.1393 portray two figures from Poussin's *Et in Arcadia Ego* in the Louvre (she was kind enough to give me this information orally).

The motif of *Arbres en X* (V.937, 938) can be seen in the picture *St. Jean baptisant le peuple* in the Louvre, in a conspicuous position on the lefthand side.

In the catalogue of the Cézanne Exhibition, Edinburgh and London, 1954, Professor Lawrence Gowing draws attention to the fact that in *Bethsabée* (V.253) 'the nude is depicted in an attitude which is derived from Poussin's *Jeunesse de Bacchus* in the Louvre'.

103. *Vision and Design*, p. 214.

104. *Landscape into Art*, p. 123, 1949.

105. *Entretiens sur la vie et les ouvrages des plus excellents peintres*, Paris, 1666.

106. According to André Fontaine, *Les doctrines d'art en France*, pp. 50 and 49, Paris, 1909.

107. Let me take this opportunity to say a few words about Cézanne's connexion with baroque art. There are many books in which this connexion is discussed; most writers attach great importance to the fact that Cézanne copied a few pictures by masters of the baroque style (V. 84, 86, 376) and left behind him countless drawings of works of High Baroque. Maurice Denis and Novotny go further, for they claim that they can distinguish an element of baroque style in Cézanne's art. Here is what Maurice Denis has to say ('L'Influence de Cézanne' in *L'Amour de l'Art*, December, 1920): 'Has anyone noticed that for the style of composition he adopted in his landscapes, still-lifes and sketches, he made use of grandiose and pompous media, which resemble those of the masters of baroque?' and he even declares that he perceives something baroque in the folds of Cézanne's table napkins, in the movements of his curtains and flowered materials, in the figures of his nudes, in the fruits and foliage of his pictures. This is a case of identifying one style with another great style without any justification and simply for the sake of proving that it too is great.

Novotny (*Cézanne und das Ende der wissenschaftlichen Perspektive*, footnote 70 on page 78, Vienna, 1938), writes: 'Another example of lines taking on an independent existence is offered by the still-life of a garden urn with roses (V.756), a picture which is crammed with ornamental flourishes and baroque-style curves. In the background we see parts of a building with baroque statues. This late flower piece, therefore, which was doubtless copied from a model, is one of the works which testify to Cézanne's preference for baroque art, for baroque forms and compositions. This preference is very significant in connexion with the incidental meaning which complexes of agitated curves have in his art. In addition to his many drawings of pieces of baroque sculpture, sketches such as the one of a rococo clock also occur in one of the sketchbooks (V.1330) and in another there is the drawing of a rococo *cartouche*. The still-life with apples and sugar bowl which belongs to the middle of the 'seventies (V.207) has a wallpaper decorated with a baroque design.'

These statements may be unexceptionable, but the interpretation they

# Notes

offer is not in the least convincing. Even if we could multiply the cases where Cézanne used baroque models for his painting, their number would still be small and would show—as does the fact that the chief example is based on a model—how little Cézanne used baroque outlines when he was not following a model but working independently. His 'complexes of agitated curves' stand for a way of thinking and an ideology so completely unbaroque that it is not permissible to think that either they or his preference for baroque forms as models for practice drawings should be accorded any profound significance from the point of view of style. Impressive proof of this is the way Cézanne set about giving a new interpretation to the agitated '*pathos*-outlines' of High Baroque, when he became involved with them. Only see what he made of a Rubens figure, a Puget or Coysevox!

It was in the nature of things that Cézanne should reproduce the outlines of baroque plastic art of this kind by means of curving shadows; his models were full of them and he simply could not avoid them. But Cézanne divested the sequences of agitated curves found in the models of their chief meaning and so of their baroque significance, for these curves always indicated a concentration of power in specific places and an overflowing of forces into the space surrounding them, a 'pathetic' damming of power. His way of constructing the curves which reproduce the lines of his models is quite different. They are interrupted at many points and they are motionless because they are bound to the depth by numerous parallel lines and hatchings and restricted to the rôle of shadows firmly fixed in the surface. Their function is radically different from that of the curves of baroque art; they arrest and make fast what baroque flourishes, linear or plastic, set in motion. But if anyone is at a loss to understand why Cézanne copied so many items of baroque plastic art in the Louvre and why, when he was drawing from plastic models, he so obviously gave preference to baroque works over those of antiquity, of the Quattrocento and the Renaissance, he need only compare these drawings from stylistically relevant models with one another and he will see what Cézanne was able to gain from the various styles. The exaggerated modelling and subtle surface divisions of baroque forms offered him the most clear, most rewarding and most intense vision of natural appearances broken up into simple relationships of light and shade, figuring as separate plastic forms and as individual items which emerged out of clearly defined areas of shadow by means of purposefully diminishing graduations of shadow into a uniform degree of lightness. Thus baroque models had the most to offer him in the field which he wanted to study and his preference for them is nothing more nor less than evidence of the significance of Cézanne's drawings for his art as a whole; in other words they are methodical exercises, as opposed to whatever other kind of significance drawings may have for a painter.

In the course of the years Novotny seems to have come to realize the difficulties which arise if one ascribes inherent baroque trends to Cézanne's art—in *Cézanne als Zeichner* ('Cézanne as draughtsman'), 1950, p. 234, we read that it seemed to him that 'classical, renaissance-type art' was 'more evidently Cézanne's ideal than baroque art.' On p. 235 he tries to arrest the interpretation suggested by others and adopted by him, saying: 'The sole reason for his (Cézanne's) preference for baroque art is psychological. It originated in the unruliness and passion of his temperament. It was indeed only in the works of his early beginnings that it found a direct outlet and later on in his use of baroque-style linear expression, a feature which I have already mentioned—otherwise it remained suppressed and concealed.' But even this attempt at elucidation is not satisfactory. It is precisely because of their anarchistic, rebellious psychological attitude that the early works of the 'wild and unruly' Cézanne are not baroque. And, vice versa, baroque art is not unruly—on the contrary, the fundamental sense of security which they enjoyed in their lives reduced the expression of passion to immense and yet always completely controlled gestures in the works of the great masters

332

of baroque art. There was also no psychological link between the 'temperament' of the young Cézanne and the vigorous mentality of both artists and ordinary men of the baroque era, satisfied only with an expression of life produced in a manner which was extremely exaggerated and yet completely controlled. In brief, whatever similarity may exist between Cézanne's style and baroque art is purely an outward resemblance and does not touch the real nature of art.

Those who maintain that Cézanne had baroque tendencies have also alleged that his art possesses an inner relationship to that of El Greco (who was a mannerist!) on the grounds that he painted a copy of one of his pictures, taking it from a woodcut in Charles Blanc's *Histoire de peintures de toutes les écoles, école espagnole* (Paris, 1869), a fact first confirmed by Ludwig Burchard in *Kunst und Künstler* ('Art and Artists') (September, 1919, p. 516). According to Rewald, on the other hand, the model is to be found in the magazine *Pittoresque*. In any case to make such a deduction from this fact is to exaggerate wildly. Moreover the allegation is even less important than most of the people who repeat it assume, for in 1880 El Greco did not enjoy the reputation which now surrounds him, of being an extraordinary and abnormal type of person, such as Cézanne was also popularly supposed to be. We can be sure that Cézanne knew nothing at all either about El Greco's style as a whole or about the kind of mind he had and he did not feel he had any psychological affinity with him either. He copied the reproduction just as he copied a Lancret from time to time or a page from a fashion magazine.

108. 'It has rightly been pointed out that we must not imagine that we can see the purest expression of Cézanne's painting in the works of his last period.' (*Cézanne und das Ende der wissenschaftlichen Perspektive*, p. 75, Vienna, 1938).

109. Let me offer another graphic description of the late period of Cézanne's art—an extract from § XVI of Roger Fry's *Cézanne*, London, 1927 (2nd edition 1932), for he has written more fully and better than any other writer about this period: 'Once more at the end of the century there supervenes a new phase in Cézanne's art. It . . . includes considerable variations. Thus in some ways it shows a continuance of the water-colour technique, an even extended use of pure transparent glazes of colour; in other examples there is a return to impasto laid on to the preparation directly, in loaded brush strokes. In those in which glazes predominate broad washes of colour tend to replace the hatchings of his penultimate period. The colour is again simplified and also greatly intensified. There are canvases in which pure transparent cobalts predominate, accompanied by pure viridians and intense oranges. The colour thus attains to incredible depth and saturation, and the handling is freer than ever.

'But whatever the technique we find in this last phase a tendency to break up the volumes, to arrive almost at a refusal to accept the unity of each object, to allow the planes to move freely in space. We get, in fact, a kind of abstract system of plastic rhythms, from which we can no doubt build up the separate volumes for ourselves, but in which these are not clearly enforced on us. But in contradistinction to the earlier work, where the articulations were heavily emphasized, we are almost invited to articulate the weft of movements for ourselves.

'. . . the disintegration is pushed to such a point, the volumes are so decomposed into small indications of movement scattered over the surface, that at first sight we get the impression of some vaguely patterned carpet of embroidery. But the more one looks the more do these dispersed indications begin to play together, to compose rhythmic phrases which articulate the apparent confusion, till at last all seems to come together to the eye into an austere and impressive architectural construction, which is all the more moving in that it emerges from this apparent chaos. It is perhaps in works like these that Cézanne reveals the extraordinary profundity of his imagination. He seems in them to attain to heights of concentration and elimination

of all that is not pure plastic idea, which still outrange our pictorial apprehension. If for us the great masterpieces of the penultimate period like *The Cardplayers* and *Geffroy* remain the supreme achievements of Cézanne's genius, one may none the less have a suspicion that for certain intelligences among posterity, the completest revelation of his spirit may be found in these latest creations.

'In all of these latest landscapes one notices above all this intense concentration. All is reduced to a single motive . . . *Mt. Ste. Victoire* . . . the *Château Noir*. . . . Every particle is set moving to the same all-pervading rhythm. And the colour, sometimes exasperatedly intense, sometimes almost uniform in its mysterious greyness, upholds the theme by the unity of its general idea, the astonishing complexity and subtlety of its modulations.'

It seems to me that the time has indeed now come to recognize that these last works of Cézanne represent his supreme achievements. Despite their fragmentary condition, we can see that they were created by a master who has attained an intellectual level superior to that on which he worked during the 'nineties. And it is not that he has moved in the direction of abstract painting, but that he has reached this position through discovering how to portray vividly the freedom which is inherent in the unshakeable 'existence together' of things.

110. 'Le tout est de mettre le plus de rapport possible,' *Correspondance*, p. 284, written in 1906.

# INDEX OF PICTURES

Index of pictures by Cézanne referred to in the book (listed in the sequence of the Venturi catalogue numbers) with the Venturi catalogue titles, and the pages of the book on which they are mentioned.

OIL PAINTINGS

25 Portrait de Louis-Auguste Cézanne, père de l'artiste, 153, 182, 300
26 Paysage romantique, 263
27–33 Paysages, 263
34 Coin de rivière, 152, 263
35 Paysage, 263
36 Paysage, 263, 325, n.29
37–48 Paysages, 263
50 (Plate 37) La Tranchée avec la Montagne Sainte-Victoire, 152, 193, n.31, 259, 263, 300, 301
51 La Neige fondue à L'Estaque, 193, n.31, 259, 263, 298
54 Paysage provençal, 193, n.31
55 Le village des pêcheurs à L'Estaque (Plate 28), 156, 193, n.31, 298
72 Portrait, 300
73 Portrait, 300
74 Portrait de l'avocat (l'oncle Dominique), 300
75 L'oncle Dominique, 300, 308
76 L'oncle Dominique, 300
77 L'oncle Dominique (Plate 42), 166, 300
78 Portrait, 300
79 L'oncle Dominique, 300
80 L'oncle Dominique, 300
83 Le Baigneur au rocher, 115
84 Le Christ aux Limbes, 146, 191, n.12, 331, n.107
86 La Douleur ou la Madeleine, 331, n.107
88 Portrait d'Achille Empéraire, 153, 182
90 Jeune fille au piano, 301
91 Portrait de Louis-Auguste Cézanne, père de l'artiste (Plate 33), 153, 182, 184
100 Portrait du nègre Scipion, 115
101 L'Enlèvement, 111, 287
103 La Tentation de Saint Antoine, 111, 115, 249, 287, 288
104 Pastorale (Plate 38), 96, 103, 115, 249, 256, 288
105 La Toilette funéraire, 115
106 Une moderne Olympia, 102, 115, 249, 256
107 Déjeuner sur l'herbe, 96, 103, 115, 288
108 Les voleurs et l'âne, 115, 288
112 L'Après-midi à Naples ou le punch au rhum, 96, 291

118 Lecture chez Zola (Plate 25), 153, 287
120 La Conversation, 115
121 Le Meurtre, 291, 298
123 La Femme étranglée, 291, 298
125 La Barque de Dante, d'après Delacroix, 278
133 La Maison du Pendu à Auvers, 263, 301
137 Effet de neige, 262, 263
153 Louveciennes, 262
158 Le mur de l'enceinte (Plate 23), 152
172 Le Clos des Mathurins à Pontoise (Plate 40), 262, 263, 264
173 La Côte des Bœufs, 326, n.47
196 Pommes et gâteaux, 160
207 Le plat de pommes, 331, n.107
210 Le plat de pommes, 160
223 L'Après-midi à Naples, 291, 308
224 L'Après-midi à Naples, 96, 291, 308
225 Une moderne Olympia, 102
230 La Partie de pêche, 96
231 La Conversation (Plate 20), 95, 96
232 Au Bord de l'étang, 96
234 La Partie de campagne, 308
238 Le déjeuner sur l'herbe, 308
240 La Tentation de Saint Antoine, 111, 308
241 La Tentation de Saint Antoine (Plate 21), 111, 308
242 La Seine à Bercy, 191, n.17
243 Scène fantastique, 191, n.17
245 Apothéose de Delacroix (Plate 41), 112, 278, 329, n.76
247 L'éternel féminin, 96, 102, 278, 291
249 La Moisson, 191, n.17
251 La Vie des champs, 191, n.17
253 Bethsabée, 331, n.102
254 La Toilette, 278
264 Cinq baigneuses, 167
265 Baigneuses, 167
269 Trois Baigneuses, 167
270 Trois Baigneuses, 96
283 Portrait de Victor Chocquet (Plate on jacket), 167, 183, 186
286 Portrait de l'artiste, 183, 185
287 Portrait de Cézanne au chapeau de paille, 185
290 Portrait de l'artiste (Frontispiece), 37, 185

# Index

291 Madame Cézanne cousant (Plate 31), 183

292 Madame Cézanne dans un fauteuil rouge, 183

311 Dans la vallée de l'Oise (Plate 24), 152, 164

312 La Campagne d'Auvers, 152

313 et seq. La Campagne d'Auvers, 152

319 La Côte du Galet, à Pontoise (Plate 43), 309

341 Compôtier, verre et pommes, 160

373 Portrait de Chocquet, 153, 186

375 Portrait de Chocquet, 186

376 Femme à la fourrure, 331, n.107

379 La Lutte d'amour, 112

380 La Lutte d'amour, 112

390 Baigneurs (Plate 27), 49, 155

397 Maisons à L'Estaque (Plate 6), 81

454 La Montagne Sainte-Victoire (Plate 1), 38

552 Mardi-gras (Plate 19), 94–6, 107–9, 113, 187

556 Les Joueurs de cartes (Plate 10), 89, 120

557 Les Joueurs de cartes (Plate 11), 89, 122, 129, n.32

558 Les Joueurs de cartes (Plate 12), 89

559 Les Joueurs de cartes (Plate 9), 89, 93

560 Les Joueurs de cartes (Plate 8), 89, 93, 119

563 L'Homme à la pipe, 89–90, 119, 122, 129, n.30

566 L'Homme à la pipe (Plate 13), 89–90, 120

568 Le Joueur de cartes, 89–90, 119

569 Madame Cézanne dans la serre, 187

570 Madame Cézanne au fauteuil jaune, 153

626 Allée à Chantilly, 169

627 Allée à Chantilly, 169

628 Allée à Chantilly, 169

637 Au Bord de l'eau, 169

638 Eaux et feuillages, 169

639 Les reflets dans l'eau, 169

640 L'Aqueduc et l'écluse, 169

641 Le Pont sur l'étang (Plate 30), 168, 169

661 La Montagne Sainte-Victoire, 169

662 La Montagne Sainte-Victoire, 169

663 La Montagne Sainte-Victoire, 169

664 La Montagne Sainte-Victoire, 169

665 La Montagne Sainte-Victoire, 163, 169

666 La Montagne Sainte-Victoire, 163, 169

681 Le Garçon au gilet rouge, 314

685 Homme aux bras croisés (Plate 18), 122

689 Homme aux bras croisés, 122

692 Portrait de Gustave Geffroy (Plate 26), 153, 187, 188, 334, n.109

696 Portrait de M. Ambroise Vollard (Plate 32), 187, 188

701 Jeune Italienne accoudée, 314

702 La Vieille au chapelet (Plate 22), 149, 150, 190

707 L'amour en plâtre, 314

708 Agar dans le désert, d'après Delacroix, 278

712 Portrait de paysan, 169, 314, 315

713 Paysan assis, 169, 190

714 Portrait de paysan, 169

715 Le Jardinier, 169

716 Portrait de Vallier, 190, 310

717 Portrait de Vallier, 190, 310, 315

718 Portrait de Vallier (Plate 36), 169, 190, 219, 310

719 Grandes baigneuses, 96

723 Baigneuses (Plate 45), 155, 310, 316

725 Ébauche des grandes baigneuses, 316

728 Baigneurs, 310

729 Esquisse de baigneurs, 310

738 Vase paillé et sucrier, 314

754 Fleurs et verdure, 278

756 Le vase au jardin, 331, n.107

762 Paysage, Lac d'Annécy, 310

763 La Montagne Sainte-Victoire, 163, 310

764 La Montagne Sainte-Victoire, 163, 310

765 La Montagne Sainte-Victoire et le Château Noir, 163, 310

766 La Montagne Sainte-Victoire vue de Bibémus (Plate 29), 157, 160, 161, 163, 310

767 Carrière de Bibémus, 310

768 La Meule, 310

769 Bords d'une rivière, 310

770 La Mer à L'Estaque (Plate 44), 49, 310

771–777 Paysages, 310

778 Carrière de Bibémus, 310, 314

779–787 Paysages, 310

788 Arbres et rochers (parc du Château Noir), 310, 314

789–793 Paysages, 310

794 Le Château Noir, 164, 310

795–797 Paysages, 310

798 La Montagne Sainte-Victoire, 163, 310, 315

799 La Montagne Sainte-Victoire, 163, 310

800 La Montagne Sainte-Victoire, 163, 310

801 La Montagne Sainte-Victoire, 163, 310, 315

802 La Montagne Sainte-Victoire, 163, 310

803 La Montagne Sainte-Victoire, 163, 310

804 La Montagne Sainte-Victoire, 163, 310

805 Le Cabanon de Jourdan, 310

### WATER COLOURS, DRAWINGS, ETC.

808 Fleurs et fruits, 38

814 La Route, 38

867 La Medée de Delacroix, 278

868 Scène pour le Faust, d'après Delacroix, 278

880 La Tentation de Saint Antoine, 111

882 Olympia, 326, n.39
891 Apothéose de Delacroix, 268
895 L'éternel féminin, 103, 278
904 L'éternel féminin, 103
937 Les Arbres en X, 331, n.102
938 Les Arbres en X, 331, n.102
983 Arbres secoués par le vent (Plate 2), 45
1038 Parc du Château Noir (Plate 4), 39, 48
1085 Joueur de cartes, 89, 90, 119
1086 Joueur de cartes (Plate 16), 89, 90, 119
1088 Étude pour un joueur de cartes, 89, 90, 120
1154 Nature morte (Plate 3), 45

1207 L'éternel féminin, 103, 278
1212 La Conversation, 95
1214 La Tentation de Saint Antoine, 111
1330 Pendule rococo, 331, n.107
1387 Esquisse d'une femme de profil, 331, n.102
1388 Détail du 'Concert' par Poussin, au Louvre, 331, n.102
1393 D'après 'Les Bergers d'Arcadie', par Poussin, au Louvre, 331, n.102
1482 L'Homme au chapeau, 89, 90, 120
1483 Le fumeur (Plate 14), 89, 90, 120
1575 Peintre au travail (Plate 34), 211, 227, n.39, 289
1623 Portrait de Delacroix, 278

WORKS WHICH HAVE NO VENTURI NUMBER

Plate 5—not mentioned in the book (relevant to page 220)
Plate 7—pp. 92 et seq.

Plate 15—pp. 89 et. seq.
Plate 35—pp. 220 and 221

# INDEX OF SUBJECTS

Accuracy, exactitude, fidelity to nature, slavish copying or imitation, mere reproduction—in art, 23, 27, 28, 33, 42, 53, 70, 76, 94, 126, 205, 206, 208, 214, 224, 237, 239, 240, 241, 242, 247, 260, 269, 283, 296, 297, 299
Animals in Cézanne's pictures, 112, 129 (n.22), 152, 300
Application and handling of paint (Cézanne's), 25, 37, 38, 47, 48, 88, 166, 167, 245, 263, 297
'Appui moral'—'moral support', 35, 241, 285
'L'Après-midi à Naples' (paintings by Cézanne), 96, 291, 308; paintings mentioned in the book, V.112, 223, 224
L'Art pour l'Art (Art for art's sake), 26, 27, 28, 254
Atmosphere, absence of, in Cézanne's works, 170, 231, 249, 250

Baroque, 34, 59, 71, 75, 77, 78, 79, 168, 189, 208, 233, 290, 310, 311, 322, 329 (n.72), 331 (n.107), 332 (n.107), 333 (n.107)
Bathers in Cézanne's pictures, 104 (Plate 27), 11 (Plate 45), 49, 80, 88, 92, 96, 115, 124, 154, 155, 156, 167, 310, 311, 316; paintings of Bathers mentioned in the book, V.83, 264, 265, 269, 270, 390 (Plate 27), 719, 723 (Plate 45), 725, 728, 729
'Being', the state of, in Cézanne's works, 82, 149, 157, 158, 163, 164, 168, 171, 172, 173, 176, 179, 181, 190, 216, 244, 259, 270, 290, 292, 294, 295, 301, 309, 312, 313, 316, 320
Billiard balls, style of painting, 114, 115, 249

'Black' still-lifes (Cézanne's), 143, 146, 250, 256, 288, 300, 316
Blue, 25, 43, 47, 48, 53, 55, 56, 57, 58, 59–72 incl., 79, 80, 81, 82, 84 (n.25), 84 (n.26), 84 (n.38), 84 (n.41), 85 (n.48), 85 (n.50), 86 (n.51), 116, 119, 120, 228 (n.58), 255, 264, 314, 315, 316, 324 (n.10), 325 (n.29), 333 (n.109)
Brown, 42, 43, 48, 53, 55, 60, 67, 68, 69, 71, 72, 80, 81, 84 (n.24), 116, 119, 315, 325 (n.29)
Brush-strokes, Cézanne's use of, 37, 48, 115, 165, 166, 167, 261, 263, 294, 310, 331 (n.100), 333 (n.109)

Cardplayers, 9 (Plates 8–17), 25, 30, 87–130, 153, 187, 212, 258, 272, 278, 334 (n.109); see also Ugolino; paintings and sketches of the Cardplayers mentioned in the book, V.556–560 incl. (Plates 8–12), 563, 566 (Plate 13), 568 1085, 1086 (Plate 16), 1088, 1482, 1483 (Plate 14); no number, Plate 15; not by Cézanne, Plate 17
'Carpet' technique, 'Tapestry' style, 164, 166 (n.167), 333 (n.109)
Chairs in Cézanne's pictures, 92, 96, 119, 184
Children in Cézanne's pictures, 89, 92, 98, 99, 103, 113, 114, 117, 118
Classicism, Classicists, Classical, 34, 71, 87, 89, 137, 168, 216, 229, 231, 233, 235, 236, 237, 238, 240, 251, 282, 283, 284, 286, 287, 290, 292, 293, 294, 299, 300, 310, 318, 320, 321, 322, 329 (n.78)
Cloth, cloths, in Cézanne's pictures, 54, 160, 257, 300, 331 (n.107)

# Index

Clothes, clothing in Cézanne's pictures, 92, 119, 145, 164, 183, 184, 185, 244

Clouds in Cézanne's pictures, 160, 161, 214

Cold colours: see Warm and Cold colours

Colour, Cézanne's use of, 22, 23, 25, 28, 29, 33, 37–49 incl., 50–58 incl., 79–82 incl., 83 (n.5–7 incl), 84 (n.14), 116, 129 (n.28), 157, 158, 164, 165, 168, 178, 179, 193 (n.31), 215, 216, 217, 218, 221, 222, 225, 230–3, 245–6, 257, 261, 263, 264, 266, 267, 268, 269, 272, 273, 274, 275, 277, 287, 295, 296, 297, 300, 301, 304, 305, 310, 314, 315, 316, 317, 318, 322, 325 (n.29), 328 (n.72), 329 (n.100), 333 (n.109)

Colour, relationships in painting, 43 (n.5), 44, 48, 215, 220, 231, 257, 263, 273, 315, 316, 317, 318

Colour, symbolism, 60–72 incl., 79, 81, 82, 84 (n.41), 86 (n.51), 268

Complementary colours and contrasts in colours, 29, 38, 39, 49, 53, 57, 71, 80, 83 (n.5), 84 (n.12), 84 (n.13), 85 (n.50), 172, 245, 266, 295, 296, 315, 330 (n.100), 331 (n.100)

Composition, Cézanne's methods, 39, 40, 45, 46, 47, 49, 50, 53, 55, 56, 71, 80, 83 (n.5), 87, 92, 113, 117, 155, 157, 161, 168, 171, 211, 213, 221, 222, 230, 257, 261, 262, 263, 275, 275–78 incl., 290, 294, 298, 307, 308, 310, 325 (n.29), 327 (n.72), 328 (n.72), 329 (n.72); see also Technique

Contours, outlines in Cézanne's pictures, 45, 47, 49, 49–58, 84 (n.8), 120, 158, 159, 161, 178, 192 (n.31), 203, 211, 212, 216, 217, 218, 220, 221, 236, 260, 261, 304, 308, 317

'Conversion', Cézanne's, 15, 30, 142, 143, 143–80 incl., 189, 191 (n.16), 300; see also Religion (Cézanne's)

Copies made by Cézanne of the works of other artists: Delacroix, 276, V.125, 708, 754, 867, 868, 1623; Manet, see under Olympia and Le Déjeuner sur l'Herbe; del Piombo, 146, 191 (n.12), V.84; Pissarro, 262, V.153; Poussin, 300, 331 (n.102), V.1387, 1388, 1393

Cubists, 35, 158, 323

Curtains in Cézanne's pictures, 97, 118, 160, 188, 300, 331 (n.107)

Curves in Cézanne's works, 46, 54, 115, 159, 160, 168, 236, 309, 324 (n.10), 331 (n.107), 332 (n.107), 333 (n.107)

Death, 59, 61, 97, 98, 99, 150, 170, 171, 175, 178, 180, 181, 315, 316

Le Déjeuner sur L'Herbe (paintings by Cézanne and Manet), 10 (Plate 38), 96, 103, 115, 209, 249, 256, 288, 308; paintings by Cézanne mentioned in the book, V.104 (Plate 38), 107, 232, 234, 238

Detachment, alienation, apartness of Cézanne from his subjects, 30, 89, 122, 144, 147, 152, 153, 154, 172, 174, 182,

183, 189, 191 (n.18), 192 (n.29), 193 (n.31), 243, 277

Distance, 54, 69, 71, 72–82 incl., 152, 161, 162, 163, 167, 169, 193 (n.31), 262, 263, 265, 273, 277

Distortion, deformation in Cézanne's works, 31, 124, 127, 141, 142, 160, 225, 237, 308, 310

the Dramatic, in art, 112, 291, 297, 298, 302, 303

Drawing and drawings by Cézanne, 47, 83 (n.1), 92–4, 96 et seq., 119, 120, 216, 219, 220, 221, 227 (n.39), 228 (n.59), 261, 287, 289, 297, 332 (n.107); see also Plates 5, 7, 34, 35, Ugolino, Frenhofer, Pencil Contours, Lines

'Epic' style of Cézanne, 297–302 incl.

'L'éternel féminin' (paintings by Cézanne), 96, 102, 103, 278, 291; pictures mentioned in the book, V.247, 895, 904, 1207

'Existing together' in Cézanne's works, 15, 30, 31, 46, 52, 82, 142, 156, 162, 172, 179, 180, 185, 216, 221, 222, 223, 250, 259, 265, 269, 270, 274, 298, 302, 303, 314, 317, 334 (n.109)

Fauves, 35, 323

Flatness in painting, 115, 116, 129 (n.28), 166, 167, 169

Fragmentariness of Cézanne's work, see Unfinished State

Fruit in Cézanne's pictures, 45, 158, 160, 161, 164, 193 (n.31), 214, 243, 257, 300, 302, 331 (n.107), 314

Genre pictures or painting, 90, 91, 92, 107, 117, 238, 301, 320

Geometrical or stereometrical shapes (cubes, cylinders, cones, etc.), 150, 158, 159, 164, 232

Gold, see Yellow

Gravity, solemnity, dignity, monumentality of Cézanne's works, 21, 22, 89–92 incl., 107, 113, 118, 122, 152, 156, 164, 173, 176, 181, 182, 184, 187, 188, 259, 264, 288, 301, 328 (n.72),

Green, 38, 43, 47, 48, 53, 55, 56, 57, 60, 63, 67, 68, 69, 71, 80, 81, 84 (n.50), 228 (n.58), 233, 246, 248, 255, 264, 314, 315, 324 (n.10), 325 (n.29), 330 (n.100)

Grey, 39, 42, 53, 67, 68, 69, 246, 325 (n.29), 334 (n.109)

Hell, inferno, 9 (Plate 7), 98, 99, 100, 101, 102, 103, 105, 113, 118, 128 (n.13), 129 (n.15), 146

Historical themes in art, 26, 123, 137, 238, 299, 320

Houses in Cézanne's pictures, 38, 52, 158, 159, 160, 192 (n.31), 193 (n.31), 214, 264, 265, 300, 309, 310, 325 (n.29)

Human beings in Cézanne's works (not portraits), 95, 96, 111, 112, 115, 151, 152, 161, 173, 181–90, 191 (n.17), 214, 250, 278, 287, 288, 291, 298, 308, 325 (n.27), 326 (n.39), 331 (n.102), 331 (n.107); see also, Bathers, Mardi

# Index

Gras, Olympia, *Le Déjeuner sur l'Herbe*, Frenhofer, *L'éternel féminin*, *L'Après-midi à Naples*, *La tentation de St. Antoine*, Delacroix; pictures with human beings, by Cézanne, mentioned in the book, V.84, 86, 101, 105, 108, 120, 121, 123, 125, 230, 231, 232, 234, 242, 243, 249, 251, 253, 254, 376, 379, 380, 708, 867, 868, 882, 1212, 1387, 1388, 1393

'Idylls' (Cézanne's), 95, 146, 155

Impressionists, impressionism, impressionistic, 17, 29, 31, 34, 35, 51, 55, 57, 58, 71, 72, 78, 79, 81, 82, 108, 124, 138, 143, 145, 146, 147, 152, 178, 209, 210, 211, 216, 217, 224, 229, 230, 231, 232, 233, 254, 258, 260, 262, 266, 267, 268, 270, 271, 274, 277, 299, 300, 301, 315, 319, 321, 324 (n.24), 325 (n.27), 326 (n.41), 327 (n.54), 327 (n.57), 327 (n.72)

Inner significance in Cézanne's works, 21, 22, 26, 92–109 incl., 121–4 incl., 131, 219, 248, 264, 272, 294, 304; see also Symbols in Cézanne's work, and Self-portrayal

Interrelationships between objects, figures, forms in pictures, 13, 22, 23, 30, 31, 33, 37–8, 39, 40, 41, 44, 46, 47, 49, 52, 70, 77, 81, 82, 110, 127, 143, 144, 151, 155, 156, 157, 160, 161, 162, 168, 169, 172, 191 (n.16), 191 (n.18), 199, 205, 213, 214, 217, 222, 223, 230, 250, 257, 259, 263, 264, 265, 272, 273, 274, 294, 298, 299, 300, 302, 304, 305, 307, 312, 313, 318, 321, 322

Landscape, landscape painting and painters (excl. Cézanne), 26, 66, 72, 76–9 incl., 123, 135, 162, 191 (n.16), 191 (n.18), 237, 262, 264, 267, 286, 298, 299, 320, 325 (n.30), 331 (n.104)

Landscapes, landscape painting by Cézanne, 9 (Plates 2, 4, 6, 23, 24, 28, 30, 35, 37), 11 (Plates 43, 44), 28, 38, 39, 45, 48, 49, 55, 80, 81, 87, 152, 153, 156, 160, 164, 168, 169, 186, 191 (n.17), 191 (n.18), 192 (n.31), 193 (n.31), 221, 233, 257, 259, 262, 263, 264, 288, 290, 300, 301, 309, 310, 314, 315, 317, 325 (n.27), 325 (n.29), 326 (n.47), 331 (n.102); see also, La Montagne Sainte-Victoire; landscapes by Cézanne mentioned in the book, V.26, 27–33, 34, 35, 36, 37–48, 50 (Plate 37), 51, 54, 55 (Plate 28), 133, 173, 337, 153, 158 (Plate 23), 172 (Plate 40), 242, 243, 249, 251, 311 (Plate 24), 312, 313 et seq., 319 (Plate 43), 397 (Plate 6), 626–628, 637–640, 614 (Plate 30), 762, 767–769, 770 (Plate 44), 771–797, 805, 814, 937, 938, 983 (Plate 2), 1038 (Plate 4); no number, Plate 35

Lapis lazuli, 62, 66, 79, 80, 84 (n.41)

Letters of Cézanne, 83 (n.1), 87, 92, 98, 104, 106, 108, 116, 128 (n.1), 128 (n.2), 140, 141, 159, 180, 190 (n.9), 194 (n.39),
194 (n.40), 194 (n.41), 194 (n.42), 194 (n.43), 211, 212, 213, 214 (quoted), 215 (quoted), 216 (quoted), 219, 223, 227 (n.40–53 incl.), 228 (n.60), 228 (n.62), 230, 233, 261, 267, 318 (quoted), 322, 326 (n.43), 334 (n.110)

Light (sunlight, daylight) and lighting— the effect, function and power of light in Cézanne's and other painters' works; also (in this connection) 'Light' or 'Blonde' colours, 39, 50, 52, 55, 72, 78, 81, 84 (n.13), 115, 116, 129 (n.28), 138, 164, 170, 178, 204, 209, 210, 217, 220, 224, 231, 247, 253, 255, 258, 264, 265, 267, 277, 288, 303, 305, 315, 317, 318, 320

Lines in art, 22, 25, 32, 71, 203, 211, 216–21 incl., 228 (n.59), 236, 237, 244, 261, 266, 305, 307, 308, 332 (n.107)

Local colours (Cézanne), 25, 29, 38, 42, 45, 54, 55, 58, 315, 316; (other painters), 65, 68, 69, 246

Loneliness, solitude, isolation, 30, 31, 32, 59, 111, 112, 123, 131, 132–43 incl., 143–56 incl., 173, 174, 181, 182, 183, 184, 190 (n.6), 190 (n.7), 191 (n.18), 214, 223, 231, 244, 264, 268, 272, 274, 286, 291, 314, 325 (n.30)

Love affair, Cézanne's, in Aix, 1885, 112, 141

Lyrical style in painting (incl. Cézanne), 189, 267, 268, 299, 302

Mardi Gras (painting by Cézanne), 10 (Plate 19), 94–6 incl., 107–9 incl., 113, 124, 187; painting mentioned in the book, V.552 (Plate 19)

'Milieu', 242, 250, 325 (n.30)

Modelling, 39, 42, 48, 55, 115, 116, 120, 129 (n.28), 164, 208, 218, 249, 257, 268, 290, 304, 328 (n.72), 325 (n.27), 332 (n.107)

Modulation, 37, 42, 44, 45, 46, 48, 80, 83 (n.5), 116, 129 (n.28), 164, 230, 245, 268, 296, 305, 322, 334 (n.109)

*La Montagne Sainte-Victoire*, 9 (Plate 1), 10 (Plate 29), 38, 87, 110, 157, 160, 161, 163, 169, 288, 310, 315, 334 (n.109); paintings of the mountain mentioned in the book, V.454 (Plate 1), 661–666 incl., 763–765 incl., 766 (Plate 29), 798–804 incl.

Movement, arresting of: Cézanne's technique for creating immobility and repose in his works, 48, 90, 151, 159–63 incl., 164, 166, 168, 169, 170, 175–6, 180, 217, 218, 221, 247, 306, 311, 332 (n.107)

Museums—'Art of the Museums', 233, 269, 322

Music in painting, 37, 40–9 incl., 53, 54, 55, 56, 57, 83 (n.5), 172, 222, 225, 257, 264, 273, 301, 305, 316, 317

Mysticism in Cézanne, 148, 149, 175

Naturalism, naturalists, naturalistic, 31, 34, 120, 174, 231, 251, 252, 253, 254, 258, 270, 271, 274, 277, 307, 310, 319, 326 (n.36), 326 (n.37), 326 (n.38)

# Index

Nature and art (excl. Cézanne), 23, 24, 31, 32, 57, 70, 72, 78, 79, 94, 116, 126, 132, 135, 138, 179, 181, 191 (n.18), 200, 201, 205, 206, 208, 211, 216, 224, 231, 235, 236, 237, 238, 240, 243, 247, 250, 251, 252, 260, 266, 267, 268, 269, 281–4, 292, 298, 299, 319, 320, 321, 325 (n.34), 329 (n.80), 330 (n.100)

Nature and Cézanne, 29, 32, 33, 39, 56, 77, 80, 121, 127, 147, 151, 152, 163, 176, 177, 179, 180, 181, 191 (n.18), 194 (n.44), 211, 212, 213, 214, 215, 216, 217, 221, 222, 223, 224, 225, 226, 237, 239, 240, 243, 254, 257, 259, 261, 262, 263, 265, 266, 267, 268, 271, 277, 278, 291, 292, 299, 303, 306, 309, 310, 314, 319, 321, 322, 329 (n.72) ; see also 'parallel to nature'

Neo-classicists, 35

Neo-impressionists, 170, 171, 260

Nudes in Cézanne's pictures, 45, 88, 96, 102, 103, 250, 310, 326 (n.39), 331 (n.102), 331 (n.107) ; pictures of nudes, mentioned in the book, V.104 (Plate 38), 106, 107, 225, 247, 253, 270, 882; see also Bathers, Olympia, L'éternel féminin, Le Déjeuner sur l'Herbe, La Tentation de St. Antoine

Objectiveness, objectivity in Cézanne's works, 31, 33, 52, 223, 225, 253, 258, 270

L'Œuvre (by Zola), 17, 56, 57. 84 (n.17–20 incl.), 108, 129 (n.16), 210, 211, 212, 227 (n.34–7), 256

Old age, works of artists', 25, 46, 110, 124, 125, 140, 141, 153, 163, 168, 174, 181, 189, 219, 238, 274, 309, 311–23 incl., 333 (n.108), 334 (n.109)

Olympia (paintings by Cézanne and Manet), 102, 111, 114, 115, 128 (n.14), 249, 256; Cézanne's paintings mentioned in the book, V.106, 225

Order, 81, 82, 195, 230, 303, 309

Paints, Pigments, 37, 38, 56, 62, 66, 79, 80, 85 (n.47), 245, 246, 248, 254, 325 (n.27), 333 (n.109)

Palette knife, spatula, 116, 166, 245, 246, 247, 248, 294, 325 (n.28), 325 (n.29)

'Parallel to nature', 33, 81, 168, 299

Peasants and workers, 90, 91, 109, 110, 128 (n.11), 187, 190, 191 (n.26), 192 (n.26) 243, 314, 315; portraits of peasants, etc., mentioned in the book, V.712, 713, 714, 715 ; see also Vallier and the Cardplayers

Pencil, Cézanne's use of in drawings, and pencil strokes, 39, 40, 46, 47, 83 (n.1), 195, 219–21 incl., 332 (n.107) ; see also Drawing

Permanence, eternity, lastingness, 'Preservation', in Cézanne's works, 15, 22, 82, 144, 145, 150, 151, 155, 157, 158, 160, 161, 164, 168, 170, 172, 175, 176, 180, 186, 188, 190, 213, 214, 215, 217, 225, 253, 259, 265, 268, 270, 295, 302, 312

Perspectives (general), 23, 58, 74, 78, 81, 192 (n.29), 205, 234, 260, 262, 326 (n.45)

Perspectives (Cézanne), 22, 53, 92, 156, 161, 162, 263, 273, 306

Photography, photographs, 33, 96, 126, 192 (n.31), 262, 263, 278, 279, 310, 326 (n.45), 329 (n.75)

Pointed hats, 95, 97, 107, 108, 128 (n.12), 278

Pointillists, pointillism, 55, 170, 171, 260

Portraits by Cézanne, 10 (Plate 18), 10 (Plate 22), 28, 80, 87, 89, 115, 122, 143, 149, 150, 153, 154, 166, 167, 181, 181–90, 287, 301, 314, 315, 317, 325 (n.27) ; portraits mentioned in the book, V.100, 681, 685 (Plate 18), 689, 701, 702 (Plate 22); see also Cézanne's father, sister, uncle, wife, Chocquet, Empéraire, Geffroy, Vallier, Vollard, Zola and Self-Portraits, also Peasants, Cardplayers

Post-impressionists, 229

Purity of Cézanne's painting, 25, 26, 28, 52, 83, 124, 172, 173, 177, 178, 181, 272

Realism, realists, realistic, 34, 75, 123, 126, 138, 155, 163, 230, 233, 235, 236, 237, 238, 239, 241, 242, 243, 250, 251, 252, 253, 257, 258, 270, 271, 274, 277, 279, 280, 281, 289, 291, 292, 307, 319, 322, 324 (n.16), 324 (n.17), 324 (n.22), 325 (n.34), 325 (n.36), 325 (n.38), 326 (n.45)

Realization, Cézanne's problem, 22, 27, 33, 42, 49, 54, 55, 58, 83 (n.1), 110, 182, 195–228 incl., 266, 272, 273, 294, 296, 297, 299, 302, 307, 308, 311, 319, 322, 328 (n.72), 329 (n.72)

Red, 38, 43, 55, 56, 60, 63, 64, 67, 68, 69, 70, 71, 80, 81, 82, 83 (n.5), 85 (n.50), 96, 116, 164, 228 (n.58), 314, 315, 325 (n.29), 333 (n.109)

Religion and art, 31, 61, 132, 133, 134, 150–1, 173, 182, 191 (n.16), 272, 281

Religion (Cézanne's), 31, 32, 143, 145–51 incl., 156, 157, 181, 191 (n.16), 192 (n.26), 272; see also Religious Themes in Cézanne's works

Religious themes in art, 26, 31, 32, 150, 151, 191 (n.16), 238, 320; see also Religion, Religious themes in Cézanne's works

Religious themes in Cézanne's works, 146, 191 (n.12), 278, 331 (n.102), 331 (n.107) ; pictures mentioned in the book, V.84, 86, 253, 708

Revolution (French), 26, 131, 135, 320

Revolution (industrial), 131

Rococo, 75, 331 (n.107)

Romanticism, romantics, romantic, 34, 60, 62, 71, 78, 123, 124, 128 (n.14), 135, 137, 148, 204, 210, 216, 217, 229, 231, 233, 235, 236, 237, 238, 251, 257, 266, 275, 278, 279–97 incl., 310, 320, 321, 322, 329 (n.72), 329 (n.77)

Schools (of art), 22, 35, 60, 116, 126, 137, 195, 235, 237, 239, 240, 241, 243, 266, 279, 297, 321, 322, 243 (n.16)

# Index

Sea in Cézanne's pictures, 116, 158

Self-portraits (Cézanne's), 9 (frontispiece), 25, 37, 181, 183, 185, 186; mentioned in the book, V.286, 287, 290 (Plate—frontispiece)

Self-portrayal (inner) and self-depiction (external) by artists in their works, 25, 102, 103, 123, 124, 125, 131, 238, 239, 243, 244, 289, 329 (n.76)

'Sensations', Cézanne's, 28, 157, 180, 213, 216, 222, 262, 270, 274

Shadows, Cézanne's use of, 38, 45, 46, 47, 49, 50, 52, 53, 54, 55, 56, 80, 81, 82, 83 (n.7), 84 (n.8), 84 (n.14), 119, 120, 121, 129 (n.28), 163, 164, 220, 221, 261, 263, 266, 267, 308, 309, 317, 318, 332 (n.107)

Shadow-paths, 49, 49–58, 80, 82, 83 (n.8), 84 (n.8), 119, 120, 214, 221, 261, 273, 309, 317

Silver, 42

'Small structure' in Cézanne's works, 165, 166, 266, 297

Space, Cézanne's treatment, 29, 30, 33, 39, 40, 48, 49, 52–4, 81, 120, 121, 152, 153, 156, 157, 158, 161–3, 166–9, 172, 184, 185, 187, 219, 225, 232, 257, 259, 275, 276, 288, 295, 300, 302, 305–6, 313, 322, 325 (n.30), 328 (n.72), 332 (n.107), 333 (n.109)

Spatula, see Palette knife

Spectator, beholder, observer—the person looking at a picture, or a view, 23, 28, 32, 41, 45, 53, 70, 72, 73, 74, 75, 77, 78, 81, 122, 151, 152, 153, 160, 162, 163, 166, 170, 172, 183, 185, 192 (n.29), 193 (n.31), 213, 218, 226, 249, 262, 264, 304, 306, 309, 312, 325 (n.30), 327 (n.56), 333 (n.109)

'Standing together' in Cézanne's works, 15, 33, 142, 171, 172, 176, 222, 223, 225, 230, 256, 277, 294, 310, 311

Still-lifes by Cézanne, 9 (Plate 3), 28, 38, 45, 80, 118, 153, 160, 193 (n.31), 233, 256, 278, 291, 301, 314, 331 (n.107); pictures mentioned in the book, V.196, 207, 210, 341, 707, 738, 754, 756, 808, 1154 (Plate 3), 1330

Symbols in Cézanne's works, 30, 32, 72, 96, 106, 107, 108, 112, 113, 114, 116, 121, 128 (n.12), 131–94 incl., 215, 259, 263, 264, 265, 268–74 incl., 275, 295, 321, 327 (n.54)

Symbolists, symbolism, 31, 32, 35, 75, 138, 154, 166, 224, 235, 268–74 incl., 312, 323

Symmetry and asymmetry, 45, 66, 90, 92, 93, 94, 97, 114, 117, 118, 277, 302

T-outline, see V-outline

Tables in Cézanne's pictures, 89, 92, 93, 96, 100, 109, 113, 118, 120, 122, 160, 188, 191 (n.26), 257

Technique (Cézanne's), 22, 25, 37–86 incl., 119, 142, 165, 166, 170, 171, 180, 220, 223, 245, 248, 260–1, 263, 294–5, 301, 307, 325 (n.29), 333 (n.109); see also, Application and handling of paint (Cézanne's), Brush strokes (Cézanne's use of), Colour (Cézanne's sense of), Composition (Cézanne's methods), Contours, outlines (Cézanne's), Curves (Cézanne's), Drawing(s) (Cézanne's), Light, Lines in art, Local colours (Cézanne's), Modelling, Modulation, Movement, arresting (Cézanne's), Palette knife, Pencil (Cézanne's use of) Perspectives (Cézanne's), Shadows (Cézanne's), Shadow-paths, 'Small structure' (Cézanne's), Unfinished state (Cézanne's). Water colours (Cézanne's)

Temperament in artists, 38, 44, 114, 125, 126, 127, 128, 129 (n.34), 130 (n.34), 133, 136, 165, 208, 213, 223, 235, 248, 258, 259, 260, 263, 287, 293, 332 (n.107), 333 (n.107)

La Tentation de Saint Antoine, 10 (Plate 21), 111, 112, 115, 129 (n.18), 146, 249, 287, 288, 289, 290, 308; paintings mentioned in the book, V.103, 240, 241 (Plate 21), 880, 1214

'There-ness' in Cézanne's works, 40, 46, 48, 49, 52, 53, 58

Time, timelessness, the rôle of time in painting and Cézanne's achievement of timelessness (his victory over transience), 138, 144, 145, 150, 155, 186, 187, 213, 214, 215, 224, 252, 253, 306

'Togetherness', 'being together' in Cézanne's works, 89, 155, 157, 162, 174; see also, Existing together, Standing together

Trees in Cézanne's pictures, 9 (Plate 2), 38, 45, 48, 52, 53, 54, 80, 88, 92, 96, 121, 158, 160, 161, 167, 192 (n.31), 193 (n.31), 214, 221, 264, 265, 271, 302, 307, 309, 310, 325 (n.29), 331 (n.102)

'Trompe l'œil' in art, optical illusion, 239, 240, 241, 242, 247

Truth in art, 23, 24, 27, 29, 36 (n.7), 157, 177, 206, 214, 223, 224, 225, 226, 241, 257, 265, 266, 299

Ultra-human, 173, 175, 178, 181

Unfinished state and fragmentariness of Cézanne's work, 37, 39, 46, 217, 218, 260, 313, 317, 319, 334 (n.109)

Unity, wholeness, entity in Cézanne's works, 30, 40, 142, 144, 150, 154, 155, 158, 163, 164, 166, 169, 183, 186, 217, 222, 224, 246, 248, 256, 258, 259, 263, 273, 277, 294, 304, 305, 308, 311, 313, 334 (n.109)

Utensils in Cézanne's pictures, 54, 118, 122, 160, 161, 164, 243, 257, 300, 331 (n.107), 314

V-outline and T-outline in certain of Cézanne's pictures, 93, 94, 95, 96, 107, 108

Warm and cold colours, 58, 59, 69, 71, 72, 84 (n.24), 84 (n.25), 138, 330 (n.100)

Water in Cézanne's pictures (not Sea q.v.), 10 (Plate 30), 80, 168, 169, 214 paintings of water by Cézanne mentioned in the book, V.637–640 incl.,641 (Plate 30)
Water-colours by Cézanne, 37–86 incl., 119, 120, 278, 333 (n.109); paintings in water-colours mentioned in the book, V.808, 814, 891, 983 (Plate 2), 1038 (Plate 4), 1085, 1086 (Plate 16), 1088, 1154 (Plate 3)

Yellow (includes gold), 42, 43, 48, 53, 55, 56, 63, 64, 65, 69, 71, 80, 82, 84 (n.41), 84 (n.50), 119, 228 (n.58), 264, 315, 324 (n.10)

# INDEX OF NAMES, PEOPLE AND PLACES

Academy (the Paris, the Swiss, the Rome), 104, 116, 136, 219, 258, 261, 299, 320
Adam, Villiers de l'Isle, 271, 274
Africa, 280, 286
Aix-en-Provence, 9 (Plate 17), 17, 18, 88, 90, 104, 117, 122, 125, 141, 183, 238
Alberti, Leone Battista, 132, 234, 324 (n.9)
Alexis, Paul, 91
Anquetin, 268
Arabs, see Africa
Auvers-sur-Oise, 17, 261, 262

Balzac, 202, 203, 204, 211, 217, 286, 289, 291
de Banville, Théodore, 326 (n.53)
Barbizon, 135, 191 (n.18)
Basler, A., 129 (n.26)
Baudelaire, 27, 36 (n.7), 40, 41, 60, 83 (n.2), 110, 111, 112, 129 (n.34), 137, 148, 156, 183, 191 (n.18), 196, 204, 216, 226 (n.7), 228 (n.57), 240, 266, 280, 294, 295, 324 (n.19), 326 (n.53), 329 (n.97)
Beethoven, 123, 207, 282, 292, 312
Bellini, Giovanni, 69, 176
Berger, Ernst, 84 (n.37)
Bernard, Émile, 83 (n.7), 56, 57, 84 (n.15), 84 (n.23), 80, 129 (n.28), 138, 159, 191 (n.14), 211, 227 (n.38), 228 (n.62), 268, 279, 304
Berthold, Dr. Gertrude, 331 (n.102)
Bertrand, Louis, 111, 129 (n.18)
Blanc, Charles, 328 (n.72), 333 (n.107)
Blanche, J.-E., 115
Boas, George, 326 (n.36), 326 (n.38)
de Boer, Wolfgang, 327 (n.54)
Bonnington, 258
Bosse, Abraham, 109
Boudin, 191 (n.18), 258
Bril, 76
Bronzino, 133
the Brueghels, 76
Brunelleschi, 192 (n.29)
Bruyas, A., 190 (n.7)
Burchard, Ludwig, 333 (n.107)
Burckhardt, Jakob, 91, 128 (n.10), 298
Burger-Thoré, 216, 227 (n.54), 324 (n.16)
Byron, 292
Byzantine art, 31, 51, 73, 284

Café, Guerbois, 114
Camoin, Charles, 83 (n.1), 331 (n.10)
Canova, 283

da Caravaggio, Polidoro, 76
Carolingian, miniatures, 66, 85 (n.46)
the Carracci, 284
Castagnary, 115, 200, 201, 203, 226 (n.11), 226 (n.12), 226 (n.13), 238, 244, 324 (n.12), 324 (n.13), 324 (n.14), 324 (n.15), 324 (n.25), 326 (n.57)
Cavalcaselle, 91
Cézanne's father, 10 (Plate 33), 17, 89, 103, 104, 105, 106, 107, 108, 112, 113, 129 (n.16), 153, 182, 184, 300; portraits mentioned in the book, V.25, 91 (Plate 33)
Cézanne's mother, 18, 301
Cézanne's sisters, 145, 148, 301; portraits mentioned in the book, V.90, 78
Cézanne's son, 9 (Plate 3), 17, 95, 109
Cézanne's uncle (l'oncle Dominique), 11 (Plate 42), 166, 300, 308; portraits mentioned in the book, V.72–80, esp. 75 and 77 (Plate 42)
Cézanne's wife, 10 (Plate 31), 17, 153, 161, 181, 183, 184, 185, 186, 187; portraits mentioned in the book, V.291 (Plate 31), 292, 569, 570
Champfleury, 129 (n.34), 239, 251, 324 (n.16), 324 (n.17)
Chappuis, Adrien, 195, 225 (n.4)
Chardin, 20, 58, 320
Chartres, 85 (n.48)
Chassériau, 322
Chemin des Lauves, studio, 89
Chesneau, Ernest, 202, 226 (n.14)
Chevreul, 53, 84 (n.12), 84 (n.13)
Chinese art, 129 (n.28)
Chocquet, 38, 116, 153, 167, 181, 183, 184, 186, 329 (n.76); portrait (*on the jacket*), V.283; portraits mentioned in the book, V.283, 373, 375
Clark, Sir Kenneth, 301, 331 (n.104)
Claude Lorrain, 76, 77, 162
Cornelius, Peter, 129 (n.34)
Corot, 49, 78, 162, 191 (n.18), 226, 252, 263, 302, 325 (n.30)
Coste, Numa, 122
Constable, John, 135, 247, 248
Constant, Benjamin, 190 (n.6)
Correggio, 75, 134
Courbet, 34, 35, 78, 110, 114, 115, 123, 127, 137, 145, 184, 190 (n.7), 209, 230, 237, 238, 239, 242, 243, 244, 245, 246, 248, 249, 250, 251, 252, 253, 255, 256,

# Index

257, 262, 263, 267, 274, 292, 301, 319, 321, 324 (n.16), 324 (n.22), 324, (n.26), 325 (n.27), 325 (n.30), 325 (n.33), 325 (n.35), 325 (n.36), 326 (n.36), 329 (n.83)

Courtauld Institute, 9 (Plate 11, V.557), 89, 122

Coysevox, 332 (n.107)

Cross, 21, 170, 181

Crowe, 91

Dante, 98, 99, 102, 105, 106, 113, 128 (n.13)

Daubigny, 191 (n.18), 237, 252

Daumier, 91, 114, 137, 145, 165, 204, 231, 287, 326 (n.41)

David, J. L., 248, 283, 284, 285, 320

Degas, 114, 115, 138, 191 (n.22), 324 (n.8)

Delacroix, 11 (Plate 41), 19, 29, 34, 35, 38, 40, 41, 71, 103, 112, 127, 128, 128 (n.13), 129 (n.34), 136, 136 (quoted), 137, 138, 149, 164, 170, 183, 190 (n.5), 190 (n.6), 196, 199, 201, 204, 205, 206, 207, 208, 209, 211, 216, 223, 224, 226 (n.6), 226 (n.10), 227 (n.17), 227 (n.19–32 incl.), 228 (n.57), 228 (n.58), 228 (n.63), 230, 231, 232, 233, 237, 238, 241, 250, 256, 262, 278–300 incl., 302, 303, 319, 320, 321, 322, 325 (n.31), 326 (n.45), 328 (n.72), 329 (n.76), 329 (n.77), 329 (n.78), 329 (n.80), 329 (n.81), 329 (n.82), 330 (n.98), 330 (n.100); pictures by Cézanne, connected with Delacroix, mentioned in the book, V.125, 245, 708, 754, 867, 868, 891, 1623

Delaroche, 241, 291

Denis, Maurice, 21, 25, 26, 28, 31, 36 (n.3), 36 (n.4), 36 (n.8), 36 (n.11), 36 (n.13), 57, 166 193 (n.32), 229, 233, 268, 283, 323 (n.2–4 incl.), 324 (n.5–7 incl.), 327 (n.55), 329 (n.79), 331 (n.107)

Diderot, 26, 299

Dominique, see Cézanne's uncle

Donatello, 312

Don Quixote, 146, 290

Dorival, 87, 112, 153, 154, 191 (n.19), 191 (n.20), 191 (n.21), 191 (n.23), 191 (n.24), 311

Dostoevsky, 143

Dupré, Jules, 227 (n.18)

Dürer, 76

Duret, Théodore, 324 (n.22)

Dutch (Netherlands) (Holland) (Nordic) (Northern) art or style, 66, 74, 75, 76, 78, 153, 165, 185, 232, 284, 319, 320, 321

Eckhart, Meister, 151

Egyptian art and paints, 61, 62, 79, 90

Eichendorff, 62

Elsheimer, 76

Empéraire, Achille, 140, 153, 182; portrait mentioned in the book, V.88

Épinal, 115

Euripides, 84 (n.26)

the Van Eycks, 74

Fantin, 324 (n.8), 326 (n.38)

Félibien, 303, 307, 331 (n.105)

Fichte, 123

Fiedler, Conrad, 23

Fielding, Copley, 38

Fiquet, Hortense, see Cézanne's wife

Flanders, Flemish, 232, 251; see also Dutch

Flaubert, 29, 111, 112, 129 (n.18), 129 (n.19), 288

Fontaine, André, 331 (n.106)

Fragonard, 320

della Francesca, Piero, 68

Frankl, Gerard J. R., 28, 29, 51

French art, painting, 34, 35, 60, 71, 72, 84 (n.31), 226 (n.14), 230, 233, 234, 239, 251, 261, 277, 285, 299, 318, 319, 320, 321, 322, 323

Frenhofer, 10 (Plate 34), 202, 203, 204, 211, 217, 227 (n.39), 289; portrait mentioned in the book, V.1575 (Plate 34)

Friedrich, Caspar David, 29, 31, 123, 135, 180

Fry, Roger, 90–3 incl., 128 (n.8), 272, 287, 301, 318, 329 (n.85), 329 (n.86), 331 (n.103), 333–4 (n.109)

Gardanne, 17, 168

Gasquet, 181, 212, 292, 329 (n.96)

Gauguin, 21, 32, 36 (n.3), 36 (n.12), 124, 129 (n.28), 138, 139, 166, 193 (n.32), 268, 269, 270, 323, 327 (n.56)

Gaunt, William, 22, 36 (n.1)

Gautier, Théophile, 23, 26, 27, 36 (n.5), 36 (n.6), 111, 112, 129 (n.20), 129 (n.34), 216, 217, 227 (n.31), 227 (n.55), 228 (n.59), 239, 239 (quoted), 241, 287, 324 (n.18), 324 (n.20), 324 (n.21), 329 (n.80)

Gavarni, Paul, 190 (n.7)

Geffroy, Gustave, 10 (Plate 26), 153, 187, 188, 251, 266, 326 (n.52), 334 (n.109); portrait mentioned in the book, V.692 (Plate 26)

Geiger, Lazarus, 62

Géricault, 165, 227 (n.31), 228 (n.59), 325 (n.36)

Gibert, Professor, 104

Gillet, Louis, 128 (n.13)

Giotto, 67, 73, 74, 90, 157

Gladstone, 62

Goethe, 22, 29, 43, 59, 60, 82, 84 (n.27), 84 (n.28), 84 (n.32), 85 (n.50), 123, 148, 189, 226, 282, 312, 313

Van Gogh, 21, 32, 56, 124, 139, 145, 148, 149, 226, 268

Goncourt brothers, 190 (n.7), 325 (n.34)

Gowing, Professor Lawrence, 88 (quoted), 128 (n.5), 129 (n.32), 331 (n.102)

El Greco, 75, 192 (n.29), 333 (n.107)

Greek art, 62, 63, 84 (n.26), 84 (n.39), 283, 284, 318

Gros, 129 (n.34), 228 (n.59), 325 (n.36)

Guillaume, Louis, 95

Haeberlein, Fritz, 84 (n.36), 85 (n.45)

Hals, Frans, 139, 165, 246, 274, 312

# Index

Haupt, Gothfried, 84 (n.35), 84 (n.40), 85 (n.42), 85 (n.43), 85 (n.44)
Hauser, Arnold, 326 (n.38)
Hetzer, Theodor, 67 (quoted), 70, 81, 85 (n.49)
Hölderlin, 142, 148
Holland, see Dutch
Homer, 60
Horace (theory of art), 26
Huet, Paul, 196
Hugo, Victor, 286, 288, 291, 292

Indians, 62
Ingres, 34, 71, 115, 136, 237, 239, 283, 284, 320, 322, 326 (n.36)
Isabey, 112
Italian art and style, see Roman

Jamot, Paul, 329 (n.77)
Japanese style, 115, 116
Jas de Bouffan, 18, 89, 91, 118
Jews, 62, 286
Jongkind, 258
Jung, C. G., 61, 105, 113, 114, 128 (n.12), 129 (n.15)
Justi, Carl, 132, 133, 190 (n.1), 190 (n.3), 198, 226 (n.8), 226 (n.9), 230

Kandinsky, 59 (quoted), 84 (n.29)
Kant, 180
Kierkegaard, 123, 148
Klee, 124
Klingsor, Tristan, 117, 129 (n.29)
Kokoschka, 124

Lamartine, 287
Lancret, 333 (n.107)
Lantier, Claude, hero of L'Œuvre, by Émile Zola, q.v., 56, 57, 210, 211, 256
Larguier, Léo, 220, 278, 331 (n.101)
La Roche Guyon, 17, 141
La Tour, 320
de la Tour, Quentin, 60
Le Bail, Louis, 42, 57, 83 (n.3), 84 (n.22), 259, 260, 326 (n.41)
Le Gros, 285, 322
Legros, 262
Leibl, 191 (n.13)
Lemonnier, 250, 252, 286, 324 (n.26), 329 (n.83)
Le Nain, Louis and his brother, 9 (Plate 17), 117, 192 (n.26), 320
Leonardo da Vinci, 74, 75, 76, 132, 157, 197, 198, 202
L'Estaque and paintings of L'Estaque, 9 (Plate 6), 10 (Plate 28), 10 (Plate 35), 11 (Plate 44), 17, 49, 81, 116, 156, 193 (n.31), 221, 259, 263, 298, 310; paintings mentioned in the book, V.51, 55, (Plate 28), 397 (Plate 6), 770 (Plate 44); no number, Plate 35
Lesueur, 285
Limburg brothers, 74
Lippi, Filippo, 68
Louveciennes, 262
Louvre, 9 (Plate 12), 88, 89, 91, 219, 220, 278, 300, 318, 325 (n.28), 329 (n.77), 331 (n.102), 332 (n.107)

Mack, Gerstle, 251, 325 (n.33)
Magnus, 62
Mallarmé, 271, 272, 273, 274
Manet, Édouard, 21, 34, 35, 57, 102, 103, 114, 115, 116, 124, 127, 128 (n.14), 129 (n.27), 129 (n.34), 138, 139, 145, 149, 182, 183, 209, 210, 227 (n.33), 230, 231, 237, 238, 239, 251, 252, 253, 254, 255, 256, 257, 262, 274, 275, 287, 299, 301, 319, 321, 324 (n.8), 326 (n.39)
Mantegna, 68
Mantz, Paul, 326 (n.38)
Marx, Roger, 325 (n.27)
Masaccio, 67, 68, 74
Matisse, 323
Matthaei, Rupprecht, 85 (n.50)
Matthiesen Ltd., 9 (Plate 15), 128 (n.7)
Mauclair, Camille, 262
Meier-Graefe, 129 (n.26)
Méryon, Charles, 190 (n.7)
Mesnard, 128 (n.13)
Michel, 267
Michelangelo, 91, 132, 133, 134, 157, 189, 190 (n.1), 190 (n.3), 197, 198, 199, 207, 215, 283, 312
Michelet, 286
Millet, 110, 137, 209, 252, 267
Mirbeau, Octave, 25
Monet, Claude, 21, 28, 57, 81, 114, 124, 138, 139, 147, 162, 178, 209, 226, 253, 258, 259, 266, 299, 326 (n.48), 326 (n.48), 326 (n.52), 329 (n.76)
Morocco, see Africa
Mozart, 207, 280
Munch, 124
de Musset, 286, 292

Napoleon, 135
National Gallery, 9 (Plate 1, V.454), 10 (Plate 22, V.702), 70, 326 (n.47)
Nattier, 60
Nazarenes, 31, 71
de Nerval, Gérard, 271, 274
Netherlands, see Dutch
Nietzsche, 19, 32, 60, 84 (n.30), 63, 123, 143, 148, 181, 282
Northern, see Dutch
Novalis, 61, 62, 84 (n.33)
Novotny, Fritz, 51, 52, 55, 83 (n.5), 83 (n.8), 84 (n.8), 84 (n.9), 84 (n.10), 84 (n.11), 128 (n.9), 152, 161, 162 (quoted), 162, 165, 167, 171, 173, 174, 175, 176, 177, 178, 192 (n.27), 192 (n.28), 192 (n.30), 193 (n.33–6 incl.), 218, 266, 277, 278, 287, 288, 297, 306, 311, 326 (n.51), 327 (n.72), 328 (n.72), 329 (n.72), 329 (n.73), 329 (n.87–9 incl.), 331 (n.107), 332 (n.107), 333 (n.108)

Orangerie, Musée de l', 128 (n.6), 129 (n.22)
Ostade, 42
Ostwald, Wilhelm, 44
Ottonian artists, 66

Pach, W., 329 (n.78)

344

# Index

Paris, 17, 18, 25, 31, 60, 95, 104, 105, 106, 114, 127, 136, 140, 155, 234, 251, 255, 258, 270, 322, 330 (n.100)
Père Alexandre, 89, 120
Perronneau, 60
Petrarch, 76
Pfuhl, Ernst, 84 (n.39)
Picasso, 61, 62
del Piombo, Sebastiano, 191 (n.12)
Pissarro, Camille, 10 (Plate 39), 17, 31, 34, 35, 79, 81, 116, 124, 126, 138, 143, 147, 152, 230, 258–67 incl., 269, 275, 297, 309, 319, 321, 324 (n.8), 326 (n.44), 326 (n.46–50 incl.)
Pissarro, Lucien, 261, 265, 326 (n.44), 326 (n.46)
Pliny, 62
Poe, 292
Polygnotos, 63
Pompeii, 58, 63, 165
Pontoise, 10 (Plate 39), 10 (Plate 40), 11 (Plate 43), 17, 258, 261, 262, 263, 264, 309; paintings of Pontoise named in the book, V.172 (Plate 40), 309 (Plate 43)
Pontormo, 133, 134, 190 (n.4)
Poussin, 34, 35, 60, 70, 71, 76, 82, 177, 189, 192 (n.29), 207, 227 (n.39), 230, 231, 233, 278, 284, 285, 286, 299, 300–11 incl., 312, 317, 318, 319, 320, 321, 322, 323 (n.4), 331 (n.101), 331 (n.102)
Pre-Raphaelites, 71
Provence, 55, 128 (n.11), 160
Prud'hon, 285, 322
Puget, 201, 332 (n.107)

Quattrocento, 68, 69, 332 (n.107)

Racine, 207
Raphael, 75, 91, 134, 157, 177, 192 (n.29), 207, 282
Rappard, 140
Ratisbonne, Louis, 128 (n.13)
Rebeyrolle, 172
Redon, Odilon, 32
Rembrandt, 31, 42, 51, 134, 154, 157, 165, 173, 181, 189, 191 (n.15), 191 (n.16), 199, 200, 246, 247, 248, 298, 303, 312
Renaissance, 79, 134, 207, 283, 329 (n.72), 332 (n.107)
Renoir, 17, 21, 22, 33, 36 (n.13), 115, 124, 138, 139, 147, 154, 155, 184, 188, 225, 226, 253, 259, 266, 294, 324 (n.8)
Rewald, John, 28, 36 (n.9), 57, 83 (n.3), 84 (n.15), 84 (n.22), 115, 128 (n.1), 128 (n.2), 129 (n.17), 129 (n.21), 129 (n.25), 190 (n.8–10 incl.), 194 (n.39–43 incl.), 227 (n.40–53 incl.), 228 (n.60), 228 (n.61), 269, 326 (n.44–4 incl.), 326 (n.49), 327 (n.57), 329 (n.74), 333 (n.107), 334 (n.110)
Riat, Georges, 252 (quoted), 325 (n.35)
Rilke, 52, 58, 179, 180, 215
Rimbaud, 59
Ring, Grete, 60 (quoted), 84 (n.31)

Rintelen, Friedrich, 191 (n.26), 192 (n.26), 231, 287, 323 (n.1), 329 (n.84)
Ripa, Cesare, 86 (n.51)
Rivière, Georges, 91
'Roman' art styles and schools, incl. Italian, 63, 64, 65, 66, 68, 69, 76, 78, 85 (n.50), 251, 319, 320, 321; see also Venetian art, Quattrocento, Renaissance, and names of various artists
Rosso, 133
Rousseau, Jean, 209
Rousseau, Théodore, 42, 59, 83 (n.4), 191 (n.18), 202, 209, 226 (n.15), 227 (n.18), 237, 248, 252, 267, 275, 276, 325 (n.28), 327 (n.71), 328 (n.72)
Rubens, 31, 34, 71, 76, 170, 177, 192 (n.29), 201, 202, 206, 207, 208, 233, 245, 282, 296, 297, 298, 319, 320, 322, 332 (n.107)
Runge, Philipp Otto, 31
Ruysdael, 77

Sainte-Beuve, 128 (n.13)
Sand, George, 286, 324 (n.16)
Schapiro, Meyer, 128 (n.11), 129 (n.31), 191 (n.17)
Schiller, 282
Schlegel, 123
v. Schlosser, J., 85 (n.47)
Schmarsow, 85 (n.48)
Schopenhauer, 123
Schubert, 123
Schumann, 123
Sedlmayr, Hans, 25, 177, 178, 180, 181, 194 (n.37), 194 (n.38)
Sensier, Alfred, 83 (n.4), 196, 202, 226 (n.5), 226 (n.15), 226 (n.16), 227 (n.18), 325 (n.28), 327 (n.71)
Sérusier, 25, 36 (n.3), 268
Seurat, 21, 124, 170, 181
Shakespeare, 189, 207, 312
Signac, Paul, 10 (Plate 24), 170, 303 (n.100)
Silvestre, Théophile, 245, 282, 296, 326 (n.37), 330 (n.99)
Simmel, Georg, 133 (quoted), 150, 190 (n.2), 191 (n.15), 191 (n.16)
Sisley, 81, 124, 138, 147, 253, 266
Sophocles, 84 (n.26), 312
Soulier, Édouard, 38
Steinert, Walter, 84 (n.34)
Stendhal, 29, 123, 282, 287
Sterling, Charles, 128 (n.6)
Stifter, 29, 148
Symons, Arthur, 271, 272, 273, 274, 327 (n.58–70 incl.)

Testa, Pietro, 324 (n.9)
von Tieck, Ludwig, 61, 62, 84 (n.34), 123, Tikkanen, J. J., 85 (n.46), 85 (n.47)
Tintoretto, 75, 192 (n.29)
Titian, 34, 42, 69, 70, 81, 82, 85 (n.49), 86 (n.51), 91, 165, 177, 189, 206, 208, 227 (n.21), 301, 312
Tolnay, Karl von, 28, 36 (n.10), 81, 86 (n.52), 231, 232, 323 (n.1), 329 (n.72)
Toulouse-Lautrec, 124, 138

# Index

Tourneux, Maurice, 227 (n.32)
Troyon, 237

Ugolino and the Ugolino drawing, 9 (Plate 7), 99, 103, 104, 105, 106, 107, 109, 112, 113, 117, 118, 121, 122, 129 (n.15)
Ur of the Chaldees, 84 (n.41)

Valabrègue, Antony, 234, 240
Vallier, 10 (Plate 36), 89, 110, 169, 190, 219, 310, 315; portraits mentioned in the book, V.716, 717, 718 (Plate 36)
Vasari, 190 (n.4), 216, 217, 227 (n.56), 240
Velazquez, 139, 301
Venetian art and artists, 34, 66, 69, 128 (n.14), 232, 245, 283
Venturi, Lionello, 9, 36 (n.12), 88, 89, 111, 112, 119, 120, 128 (n.3), 149, 169, 187, 195, 226 (n.1–3 incl.), 254, 278, 288, 308, 329 (n.91–3 incl.), 331 (n.101), 331 (n.102)
Verlaine, 271, 274, 327 (n.60)
Vermeer, 71
Veronese, 42, 208, 307

de Vigny, Alfred, 128 (n.13), 292
Virgil, 98, 99, 102, 113, 207
Vitruvius, 62
Volbehr, Theodor, 84 (n.38)
Vollard 10 (Plate 32), 18, 57, 88, 89, 112, 114, 128 (n.4), 129 (n.24), 181, 187, 188, 219, 262, 273, 304; portrait mentioned in the book, V.696 (Plate 32)

Watteau, 134, 320
Weiditz, Hans, 76
Wilenski, R. H., 22, 36 (n.2)
Wolff, Albert, 129 (n.23)

von Zesen, Philipp, 59
Zola, Émile, 10 (Plate 25), 17, 25, 35, 36 (n.14), 56, 57, 83 (n.3), 84 (n.17–20 incl.), 92, 101, 102, 103, 104, 108, 109, 113, 115, 116, 121, 122, 125, 126, 127, 128, 128 (n.2), 129 (n.16), 129 (n.27), 130 (n.35), 140, 141, 145, 146, 147, 153, 191 (n.11), 209, 210, 211, 212, 227 (n.33–7 incl.), 231, 234, 235, 237, 239, 240, 242, 243, 251, 255, 256 (quoted), 287, 291, 292, 324 (n.10), 324 (n.23), 325 (n.32; V.118 (Plate 25)